# TROUBLE IN PARADISE
Examining Discord between Nature and Society

February 28 - June 28, 2009

TUCSON MUSEUM of ART
AND HISTORIC BLOCK

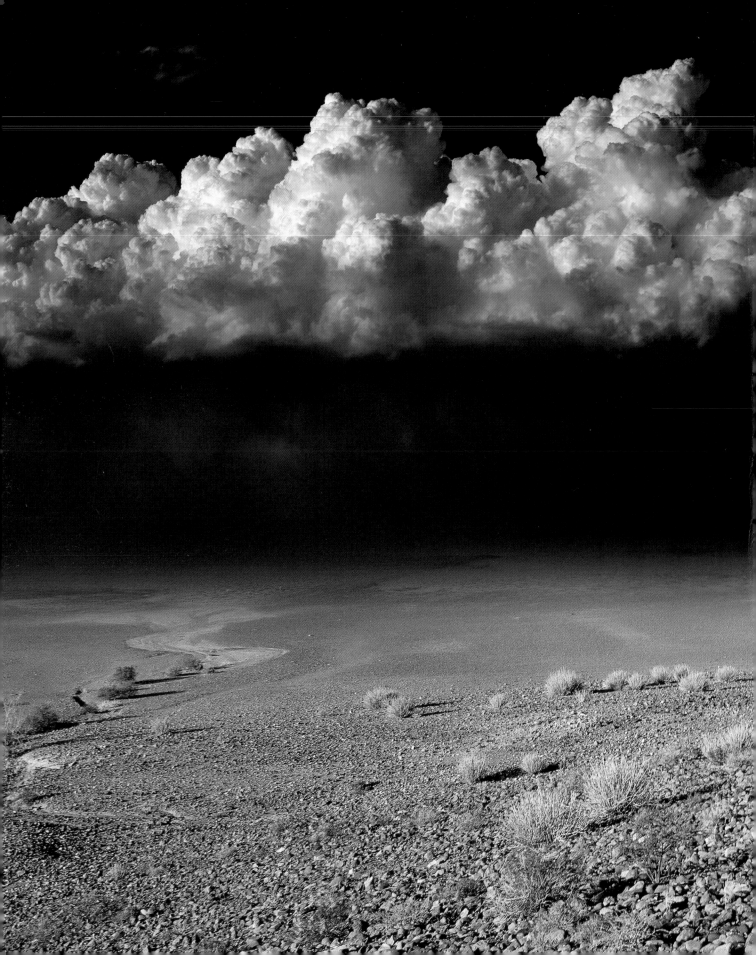

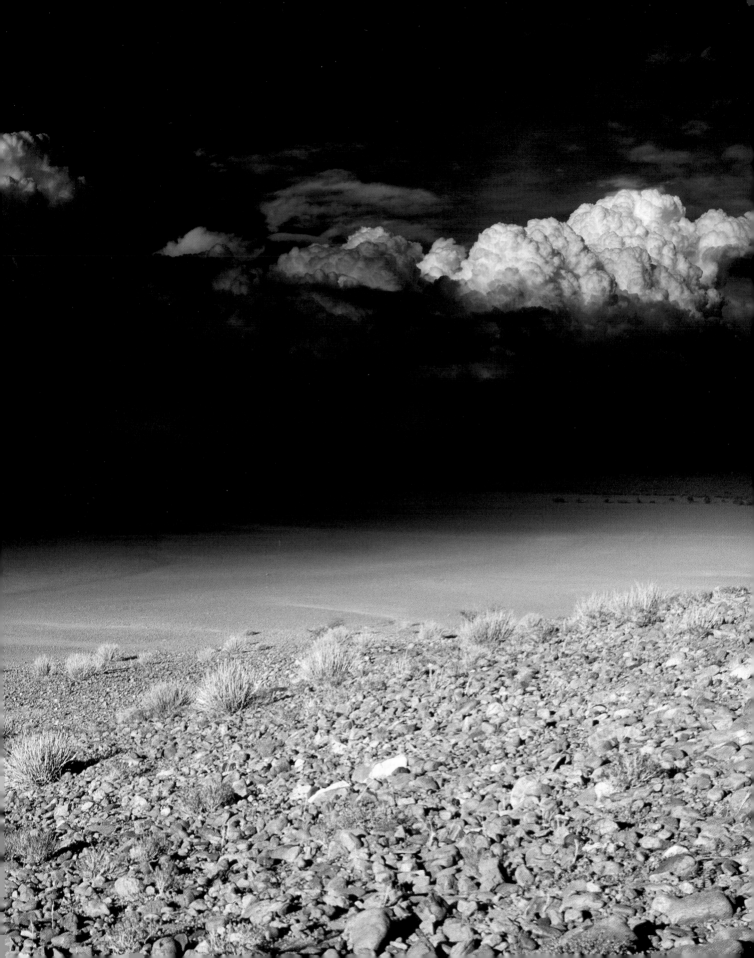

Published on the occasion of the exhibition *Trouble in Paradise: Examining Discord between Nature and Society* organized by the Tucson Museum of Art, ©2009 Tucson Museum of Art

Tucson Museum of Art
February 28 – June 28, 2009

Curated and organized by Julie Sasse, Chief Curator and Curator of Modern and Contemporary Art, Tucson Museum of Art

Artist Texts Written by:
Julie Sasse
Emily Handlin

Artist Biographies Compiled by:
Lindsay Russell

Copy Editor:
Vanessa Mallory

Editorial Assistant:
Mary Sasse

ISBN 978-0-911611-37-3
Library of Congress Control Number: 2008904350

Tucson Museum of Art
140 North Main Avenue
Tucson, Arizona 85701
520-624-2333
www.TucsonMuseumofArt.org

Catalog Design: PS Studios, Inc., Phoenix, Arizona
Printed by Ben Franklin Press, Tempe, Arizona

Page 2-3: Johann Ryno de Wet, **Thirst**, 2006, *detail*

# CONTENTS

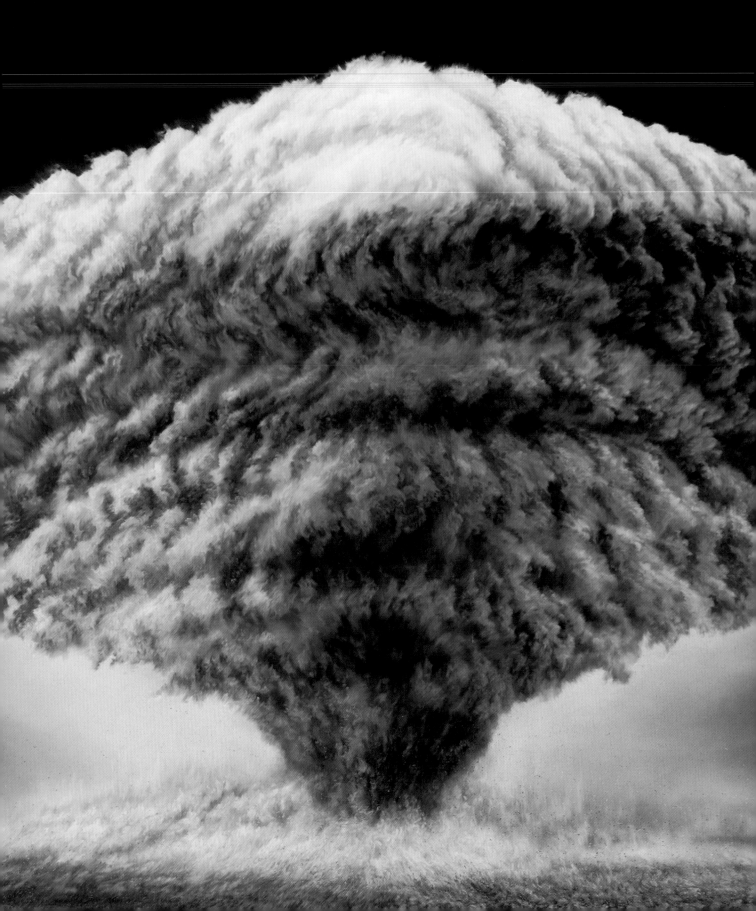

# FOREWORD AND ACKNOWLEDGMENTS

This we know: The earth does not belong to man; man belongs to the earth.

This we know: All things are connected like the blood which unites one family. All things are connected.

Whatever befalls the earth befalls the sons of the earth. Man did not weave the web of life; he is merely a strand in it. Whatever he does to the web, he does to himself.

— Chief Seattle (1786–1866), Suquamish Tribe

Trouble in Paradise is an arresting, if not prophetic, title for the Tucson Museum of Art's aesthetic exploration into naturally occurring and man-made environmental phenomena. The artists in this exhibition have all responded in some way to nature, and many have done so without judgment or moralization.

While Trouble in Paradise posits no unified ideology or political agenda, there are artworks that reflect issues and concerns of over-population, global warming, and the destruction of land. That said, the exhibition may best be understood as an artistic exaltation of nature as a Janus-headed beast—both a sublime beauty and a powerful, unpredictable temptress.

As an example, there are few things throughout the world more mundane, yet compelling, than thunderstorms. They are nature's celestial fireworks on a heroic scale and have always been part of tribal myth and lore. The raw, unbridled power of thunderstorms are at once exhilarating and humbling, but their intrinsic elements (lightning, wind, and rain) can also prove devastating to property and life. They speak to us on a primal level, as do other powerful natural spectacles like volcanoes, earthquakes, and tornadoes. All are nature's voice.

Left: Ellen Wagener, **Koyaanisqatsi**, 2008 (from "Life Out of Balance" series), *detail*

## The Weight of the World

Imagine a world without blue skies, pine trees, or polar bears. Imagine not being able to exercise outside. The environmental decisions we make today will foretell the world of our future.

In examining the discord between nature and society, few can argue with the fact that, within the last century, technological advancements have far outpaced our understanding of their long-term effects and potential problems. In a Faustian pact, the world's environmental soul has been sold to the highest bidder.

As the pilgrim Dante was led through the seven levels of Purgatory, the world's sins against nature are exacting their toll and ushering us to our own demise. Greed, pride, envy, sloth, lust, gluttony, and wrath, in the guise of technological progress, industrialization, prosperity, terrorism, and war, have forged a negligent path of unintended consequences, unabated demand, and rampant consumption.

We've forgotten that for every action there is an equal and opposite reaction, and like Icarus flying too close to the sun, hubris will ultimately be our fall from grace.

In the Old Testament, the earth was entrusted to Adam and Eve. This Judeo-Christian doctrine set man apart from nature and, by extension, gave him the divine right to subjugate and exploit its bounty.

As viewed from space, the earth is a symbiotic, interrelated ecological system. But up close, it is under attack as we've laid waste to the environment.

The majority of the world's leading scientists now believe climate change is human-induced. The one-two punch of carbon dioxide emissions coupled with aggressive deforestation has altered the makeup of the atmosphere. When the temperature rises even a few degrees, entire weather patterns are altered. Rising ocean temperatures, severe and more frequent hurricanes, drought, glacial melting, and the extinction of animal species are seismic indicators that there is indeed trouble on the horizon.

It's time to take the long view, and to think through the ramifications of technology and our rapacious consumption. We must come to understand and embrace the fact that our most valuable asset is a balanced and sound environment.

As witnessed by the sudden meltdown of international economic markets, we live in an interconnected world. The tidal wave of destruction by economic, terroristic, or natural causes can be swift and devastating. We've learned all too well that global social-political-ecological systems are fragile and extremely vulnerable. One major nuclear war has the potential to destroy the earth as we know it.

## Art for the World's Sake

Artists respond to, and reflect upon, the world around them. They are often the canaries in the coal mines, acting as our truth tellers, shamans, and philosophers. The health of our planet is a non-partisan issue that transcends religion, economics, and borders. In a world that eschews personal responsibility, it's time to pony up. We can no longer bury our collective heads in the sand.

I thank those artists who have shared their visions of the beauty and majesty of nature. I also thank those who stripped away artifice and reflected the state of the world back onto us. As Chief Curator Julie Sasse notes in her essay, this exhibition should not be interpreted as one full of negativity, but one of caution and hope. It is saying, "Pay attention."

But the obvious question remains, "Can paradise be saved?"

Bertrand Russell stated, "The trouble with the world is that the stupid are cocksure and the intelligent are full of doubt."

Let us hope we are smart enough to learn from our past ... and wise enough to change our ways.

Exhibitions and scholarly publications require the dedication and collaborative efforts of many individuals. Heartfelt thanks to all who have contributed to the creation and implementation of this project.

The Tucson Museum of Art's Board of Trustees and their Contemporary Art Society provided early encouragement and much needed funding to help make this exhibition a reality.

Special thanks are extended to the all the lenders for sharing their art treasures, and to our donors for their sponsorship contributions. Projects of this caliber would be impossible without the support provided by collectors and patrons such as these.

Sincere appreciation is extended to the Museum's professional staff for meeting the challenges of the exhibition's demanding deadlines. Special thanks to Stephanie Coakley, Director of Education, for planning the project's extensive public programming components; Leslie Schellie, Director of Development, for raising funds and strengthening our critical relationships with sponsors; Alison Sylvester, Grants Manager, for conceiving, writing, and overseeing our many grant applications; Meredith Hayes, Director of Public Relations and Marketing, for developing a comprehensive marketing campaign; Serena Tang, Graphic Designer, for creating our beautiful print and web-based design work; Carol Bleck, Deputy Director and CFO, for monitoring the overall project budget; Delmar Bambrough, Chief of Security, for ensuring the exhibition's safety; Alan Uno, Building and Grounds Supervisor, for countless contributions to everything the Museum undertakes; Gaye Lynn Kreider, Secretary to the Trustees and Administrative Assistant, for being the liaison between the Museum staff and its public; John McNulty, Retail Manager, for always supporting our exhibitions with appropriate merchandise; Fatima Brecht, Curator of Latin American Art, for contributing to our curatorial efforts; and the collections and preparatorial team of Susan Dolan, Collections Manager, Rachael Shand, Assistant Registrar, and David Longwell, our ever-vigilant and good-humored exhibition designer and preparator, for all their efforts in coordinating the handling, movement, and installation of the art.

Thank you also to the many unnamed staff of the Tucson Museum of Art whose unheralded contributions add significantly to every project undertaken by our institution.

Finally, I extend a special note of appreciation to Chief Curator and Curator of Modern and Contemporary Art Julie Sasse. I thank Ms. Sasse for her conceptual inspiration and curatorial adroitness in bringing *Trouble in Paradise* to fruition. As always, Ms. Sasse has given her life to this project, and last summer was granted a prestigious Clark Art Institute Fellowship to conduct research for the accompanying catalogue essay. Thank you, Julie, for yet another compelling and timely exhibition and scholarly inquiry.

Robert E. Knight
*Executive Director, Tucson Museum of Art*

# TROUBLE IN PARADISE
Examining Discord between Nature and Society

**JULIE SASSE**

Featuring some of the cataclysmic disasters of the last century or so, a special issue of *Life* magazine in 1994 entitled "Natural Disasters" dedicated ninety-six pages of photographs to the four basic elements of nature: earth, wind, water, and fire. Enthralling images of major disasters like the 1889 Johnstown flood in Pennsylvania, the 1906 San Francisco earthquake, the 1930s Dust Bowl, and the 1966 flooding of Florence, Italy, as well as the 1980 Mount St. Helens volcano eruption, and the 1988 fires at Yellowstone National Park all appear in its pages.[1]

Fourteen years later, in 2008, another issue of *Life* highlighted "Nature's Fury," an historic survey of disasters from ancient times to the present. It has double the number of pages of the previous issue and considerably more text describing each devastating event in statistical detail. Added to this new issue is the thirty-five year long Ethiopian drought that first began in 1973, Europe's brutal heat wave in 2003, the Indian Ocean Tsunami in 2004, and Hurricane Katrina in 2005. Probably because of publication deadlines, the devastating earthquake in Sichuan Province, China, the springtime flooding of the Midwest, the

fearful state of polar ice caps, and disappearing snow in the Alps—all of which occurred in 2008—were not included.[2]

Perhaps the expanded size of this issue was prompted by the increase in environmental disasters that had occurred in recent years. Yet the text seems not only to feed an audience hungry for more information and thrilling images, but also to placate the anxious reader that such disasters have always occurred and will continue to do so—the apocalypse is not upon us, all will be well. We are aesthetically captivated by the power and beauty of such images, but we are increasingly concerned, if not terrified, by the dystopia of a world that has become the mainstay of our everyday awareness. Such photographs bear witness to the dramatic power of nature undergoing a state of environmental siege and serve as visual proof of the alarming statistics that reveal a crisis at hand due to global warming and the pervasive lack of stewardship of the earth.

Long attuned to expressing their reactions to the land and nature, as well as to the social and political structures that contribute to their shaping,

Left: Francesca Gabbiani, **Rise**, 2007, *detail*

While the focus of this exhibition may appear at first to be negative, these artists address real-life concerns and anxieties. To dismiss their observations is to ignore one of the benefits of artistic expression—that of insight and reflection.

contemporary artists who find environmental crisis a compelling, if not urgent, topic are growing in numbers and in artistic, social, and scientific sophistication. The exhibition *Trouble in Paradise: Examining Discord between Nature and Society* provides a platform for a range of expression about nature in crisis. Driven by a moral imperative to make statements that impact society at large in order to affect change, these artists display an intellectual rigor in their artistic inquiries.

Artists who address nature and its degraded condition have not come upon their ideas solely from empirical observations. Historically, art has been inspired by the need to comprehend the natural world. Ancient myths developed within these imperatives and underpin a vast number of works relating to nature in its state of unrest, primarily the myths of paradise and the Fall, the deluge, and the apocalypse. In *Mythologies,* Roland Barthes explains that myth is a form of depoliticized speech that the world supplies with an historical reality. He explains, "Semiology has taught us that myth has the task of giving an historical intention a natural justification, and making contingency appear eternal."[3] Passing from history to nature, myth becomes an essential understanding that stands by itself, and therefore, resonates with universal justification. Such a concept is intrinsically important to the artists in this exhibition, because they use a common subject of mythical proportions to address the human condition and its perilous future.

Working within the framework of the beautiful and the sublime, artists have endeavored to portray mythical paradise and to articulate the apocalypse, addressing their own concerns for life, death, and transcendence. Several aspects of artistic inquiry in this exhibition embody these concepts, informed by historic precedents in eighteenth- and nineteenth-century landscape painting. Such historical works were created as much out of fascination for the forces of nature and the changing environment as they were an examination of the nature of human desire and perceptions of a perfect world—territory still investigated in the works presented in this exhibition.

Of the many compelling images in *Trouble in Paradise*, several of the photographs follow the evolutionary path from the sublime to straight photography to the "new topographics" genre of the 1970s, which reveals the shift from romanticized portrayals of untouched land to brutally realistic, yet disengaged documents of the human-altered environment. Other works embody the concept of bearing witness, infused with a sense of socio-political activism inspired by the ecology movement and ecofeminism. Still others are imbued with metaphoric content in the depiction of the forces of nature and the ravages inflicted on the land in haunting, yet poetic constructs.

The painters, photographers, videographers, and sculptors in this exhibition do not offer solutions. However, by addressing the fragile condition of

our environment, they remind us not to ignore the trajectory we are on and potentially compel us to do something about it. While the message of this exhibition may appear at first to be negative, these artists simply address real-life concerns and anxieties. To dismiss their observations is to ignore one of the benefits of artistic expression—that of insight and reflection. Defending the intent of his challenging 2000 exhibition, *Apocalypse: Beauty and Horror in Contemporary Art*, curator Norman Rosenthal declares:

> For all its apparent pessimism and depiction of human dysfunction, this exhibition is no more an argument for cultural despondency than is a startling performance of King Lear. Artists in a real sense are like 'birds in a cage' and our job is merely to listen or watch and allow their thoughts to enter our own heads, giving us some insight into our own existence. Anticipation of apocalypse is, after all, a permanent state.[4]

*Trouble in Paradise* can be seen as an artistic reflection of our times, a portent of things to come, or a call to arms. Artists provide a stunning reminder of the beautiful, often terrifying, forces within our environment and the delicate balance that exists between nature and society through both honest and emotional portrayals. In one form or another, the artists included here address political, ecological, and philosophical ideals. Ultimately, these works are not just about the landscape or humankind's impact on it, but also a contemplation of our existence in the modern world.

### In the Beginning: The Concept of Paradise

If we are to believe that there is indeed "trouble in paradise" in the form of environmental unrest, it is important to first review the philosophical concepts of paradise and its different manifestations. The idea of paradise has long been associated with two major elements: the physical manifestation of an idyllic place of unchanging tranquility, abundance, and delight, as in the garden; and as the spiritual place where righteous souls transcend or await resurrection, as in heaven. Historic roots exist for each ideal that extend to the beginning of humankind. The origin of this word came from *pairidaēza* of the old Iranian language, Avestan, which refers to a wall enclosing a garden or orchard, a common feature of a royal residence in the Middle East of long ago. The Septuagint translation of Genesis used the Greek word *paradeisos* to refer to the Garden of Eden, and by 1200, it was used in Old English translations of the Bible.[5] The late Latin *paradisus* has been defined as a garden or an enclosed park, but paradise as we know it has most often been related to the Garden of Eden, the original dwelling of Adam and Eve.

While the image of the garden is the most prolific depiction of paradise, other terms have become associated with this idyllic place of abundance, tranquility, and immutability. Noted environmental activist and author Rebecca Solnit identifies the distinctions among the paradisiacal model. She describes Eden as the original paradise before history, *paradise* as the term to define an idyll outside of history, Arcadia as a place infused with a sad self-consciousness of its own fragility, and the Promised Land as a future paradise. To Solnit, "Eden and paradise represent what we often desire when we go to the unaltered landscape for pleasure or alter the landscape to make it suit us, and Eden, paradise, Arcadia, and the Promised Land lurk behind most political and environmental arguments, since they are arguments about how to make the world better."[6]

In the eyes of modern technology, however, paradise can also be seen as the transformation of nature through biotechnology in the form of genetically engineered fruits and life-extending drugs, its locus in the enclosed shopping mall. "This Garden in the City," observes Carolyn Merchant, "recreates the pleasures and temptations of the original garden and the Golden Age where people can peacefully harvest the fruits of earth with gold grown by the market."[7]

In Western civilization, one cannot easily visualize the Garden of Eden without associating it with the Judaic and Christian accounts of Adam and Eve. Subject to multiple interpretations, this biblical narrative stems from myths of the Tigris-Euphrates valley of Sumeria from the fifth to the third millennium B.C., and the Mesopotamian culture of Al-Ubaidi from around 5,000 B.C.[8] In the most common version (Genesis 2:7, 18–23, 3:4–24), God first created heaven and earth and planted a garden in Eden. He then formed Adam, Eve, and birds and animals. After giving in to temptation (suggested by a serpent) to eat fruit from the forbidden tree of knowledge, Adam and Eve were banished from the garden by God who committed them to a life of toil and suffering. Pictorial scenes of the garden, the serpent, the fruit, and the expulsion (fall from grace) have been richly metaphoric for centuries.

**The Deluge**

While the connection between paradise and the Adam and Eve myth is integral to understanding the visualization of the environment in its myriad forms, the catastrophic deluge, or the flood, is equally as captivating a story for its terror-inducing imagery and its metaphoric content. The flood has been the subject of powerful works of art throughout history. Cultures the world over have embraced the notion that a moral decline in the character of humanity caused a divine intervention, a devastating flood of water to cover the earth as an act of retribution and cleansing. Deluge tales were told by classic Greeks (the story of Atlantis), Babylonians (the Epic of Gilgamesh), and Native American cultures, including Yurok, Navajo, Algonquin, Hopi, and Hawaiian—each have established their own stories of the cycle of flood and renewal, often in concert with creation myths.[9] While other myths of worldwide catastrophes such as fires, earthquakes, and plagues have also been widely documented, arguably no other tale has the impact and the pervasiveness of the deluge.

Perhaps the most resounding story of flood and renewal is about Noah's Ark, established by Judaic and Christian religions and documented in the Book of Genesis. According to Genesis 6–9, God was intent on destroying the world because of the wickedness of man and regretted that he had created him. He thus instructed righteous Noah to build an ark and then gather his family, representative animals, and birds to protect them from the devastating flood, which God sent to destroy life on earth. After 150 days, the ark came to rest on Mount Ararat. First sending out a raven and then a dove, Noah saw the dove return with an olive branch, indicating that land had finally reappeared. In gratitude, he made a sacrifice to God for being spared, and God vowed to never again curse the ground because of man, nor destroy all life in this manner. Such a story underscores the cataclysmic forces that set into motion a devastation and subsequent renewal of the earth because of society's aberrant behavior and inability to live in harmony.

Of all the visual accounts of a cataclysmic flood, artists have most often depicted the story of Noah's Ark. In the Middle Ages, they composed group scenes that focus on the image of Noah and his family

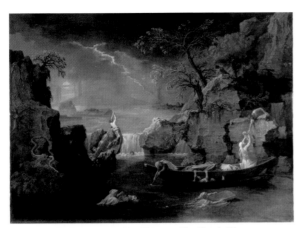

Nicolas Poussin (1594-1665), **Winter**, or **The Flood**. Oil on canvas, 118 x 160 cm.; INV7306; Louvre, Paris, France
Réunion des Musées Nationaux/Art Resources, NY

building the ark and preparing the animals for the ensuing flood. Michelangelo's (1475-1564) *Universal Flood*, 1508-1512, painted for the Sistine Chapel, marks a shift away from this paradigm by focusing more on the emotive qualities of the suffering of those about to perish than on Noah and the biblical narrative. Concentrating on the physical sensation of a rush of water from heaven, rather than biblical references, Albrecht Dürer (1471-1528) portrayed a deluge scene in 1512, inspired by a nightmare about the terrific force of nature.[10] By the seventeenth century, however, religious subject matter was designed more and more for secular display, which ignited another shift in depictions of deluge narratives.

Just as Michelangelo had shifted the focus from the methodical Noah to suffering people, Nicolas Poussin (1594-1665) directed the viewer's attention away from the narrative to an atmospherically charged landscape with turbulent water, jagged rocks, and convoluted trees in dark, moody colors.[11] Poussin created a seminal painting on the deluge theme, *Winter* (also known as *The Flood),* painted between 1660 and 1664. The unique treatment of this apocalyptic painting, displayed at the Luxembourg palace in the late eighteenth century and later at the Louvre in the early nineteenth century, became the inspiration for six decades of artists in France and Great Britain, including John Constable (1776-1837) and J. M. W. Turner (1775-1851).

American artists, including Thomas Cole (1801-1848), Frederic Edwin Church (1826-1900), John Trumbull (1756-1843), John Gadsby Chapman (1808-1889), and James Henry Beard, (1811-1893), also found the subject of the deluge intriguing and infused it with their own perspectives. For instance, Beard took a trip to the South in 1849 where he witnessed the devastation and ensuing violence due to a widespread cholera outbreak that affected states from Ohio to New Orleans. Soon after, he began work on *The Last Victim of the Deluge*, a large, dark painting revealing despair and pessimism. Beard was a member of the Whig party, a political group that feared the mounting social chaos and threat of national disintegration at the time. Art historian Gail E. Husch suggests that this painting can be seen as a prophetic warning to an errant nation. She explains, "It was a lesson aimed perhaps at those unruly segments of American society—speculators, slaveholders, annexationists, imperialists, secessionists, and radical abolitionists—whose sins had invited the terrible retribution of cholera then scourging the nation."[12] Similarly, in contemporary times, artists depicting scenes of flooding comment on the political forces that induce it. As they observe, all too often, policies made by the government exacerbate global warming—the earth's condition is thus the condition of humankind.

*Although paradise has been depicted as a place of heavenly bliss, after the fall of mankind, the present world is paradise lost.*

## The Apocalypse: The End of the World as We Know It

Although paradise has been depicted as a place of heavenly bliss, after the fall of mankind, the present world is paradise lost. While there are many accounts of the end of the world and its renewal, in Christian ideology, the apocalypse is known as the Revelation of Saint John the Divine, documented in the Book of Revelation in the New Testament. This series of narrative episodes prophesizes the end of the world in a cosmic upheaval followed by dead silence—nature is enlisted to punish and destroy in order to purify.[13] The apocalyptic catastrophe that ensues—the battle between good and evil—is the battle of Armageddon. Taken from the Greek word *apokálypsis*, the apocalypse means unveiling or uncovering and refers not only to the divine secret knowledge that is revealed in the apocalypse, but also the destiny of the world of the here and now.[14]

Upon the end of the world, both the righteous and the sinners are to be resurrected, judged, and either rewarded with eternal joy or punished with eternal torment. Many different religions have described and interpreted the present world, the world to come, and the spiritual counterpoints in myriad ways. Artists throughout the centuries, long before the apocalypse was accepted into the canon of the Eastern Church in the fourteenth century, have depicted the cataclysmic forces that set these events into motion. Apocalyptic images have been seen in Byzantine mosaics, medieval manuscripts, fifteenth-century works by Dürer and Hieronymus Bosch (ca. 1450–1516), eighteenth-century watercolors by William Blake (1757–1827), twentieth-century etchings by Max Beckmann (1884–1950), and countless other secular works in contemporary times.

## Sublime Nature

The most compelling concept that links the dichotomy of paradise and the apocalypse is the sublime. Describing the sublime as elevated thought or language that inspires awe and veneration, Longinus wrote his treatise *On the Sublime* in the first century A.D. To Longinus, the sublime cannot be identified solely with beauty, but also with that which causes bewilderment, surprise, and even fear. The effects of this state of sublimity are loss of rationality, an alienation leading to identification with the creative process, and a deep emotion mixed with pleasure and exaltation. His writing (later rediscovered and translated by the French and the British in the late seventeenth and early eighteenth centuries) ignited new discussion about the sublime's impact on aesthetics. Several British philosophers of the seventeenth century developed distinctions between the sublime and the beautiful as it relates to qualities in nature. Anthony Ashley Cooper, third Earl of Shaftesbury, John Dennis, and Joseph Addison made sojourns into the Alps and returned with their exhilarating and horrifying experiences, which they framed in aesthetic and philosophic terms. To Shaftesbury, the infinity of space was not a sublime quality that placed it in opposition to beauty. Instead, he thought the sublime of grander importance than beauty. Dennis, on the other hand,

reflected on the qualities in nature that shifted sensations of delight and reason to one of horror and despair. Addison identified three pleasures of the imagination that related to the understanding of the sublime: greatness, uncommonness, and beauty. He first used the sublime to describe Homer's heroes and the "struggle of noble beings" in his epics *The Iliad* and *The Odyssey*.[15]

One of the most influential philosophers to write about the sublime was the eighteenth-century Anglo-Irish statesman Edmund Burke, who elaborated on his predecessors' views to argue that beauty and the sublime are mutually exclusive. Burke delineates the difference in specific terms:

> **For sublime objects are vast in their dimensions, beautiful ones comparatively small; beauty should be smooth and polished; the great, rugged and negligent; beauty should shun the right line, yet deviate from it insensibly; the great in many cases loves the right line, and when it deviates, it often makes a strong deviation; beauty should not be obscure; the great ought to be dark and gloomy: beauty should be light and delicate; the great ought to be solid, and even massive.[16]**

To Burke, the sublime belongs to the domain of fear; it is found in anything that excites the emotions of pain and danger, in contrast to beauty, which elicits sensations of pleasure. While this dichotomy posits an antithetical contrast to Plato's classical notion of beauty, Burke believed that the sensations of terror and pain are much stronger than pleasure. The sublime can be considered exhilarating and have a deeper emotional resonance than beauty, especially when the beholder is aware that danger is at a distance and therefore not imminent. To this extent, Burke suggests that the highest degree of the effect of the sublime can be found in nature in the form of astonishment, which he distinguishes from the "inferior" effects of admiration, reverence, and respect.[17]

While Burke's understanding of the sublime was empirical in essence, the German Enlightenment philosopher Immanuel Kant took a moral and spiritual stance that looked to the sublime as a boundless entity related to transcendence. Like Burke, Kant believed that the sublime arouses awe and admiration in three basic forms: the terrifying sublime, the noble, and the splendid. Unique to other philosophers, however, is his observation that the sublime and the beautiful are also embodied in human nature. In his *Observations on the Feeling of the Beautiful and Sublime*, published in 1764, Kant explains that the beauty of human nature stirs the affections of love, which is transitory, but the dignity of human nature is the stronger, sublime emotion and exerts the powers of the soul.[18] Kant's views about nature are also delineated by the opposites of the sublime and the beautiful:

> **The sight of a mountain whose snow-covered peak rises above the clouds, the description of a raging storm, or Milton's portrayal of the infernal kingdom, arouse enjoyment but with horror; on the other hand, the sight of flower-strewn meadows, valleys with winding brooks and covered with grazing flocks, the description of Elysium, or Homer's portrayal of the girdle of Venus, also occasion a pleasant sensation but one that is joyous and smiling.[19]**

Kant's interest in the sublime in nature was inspired in part by the works of Swiss botanist Jean-

Jacques Rousseau, who suggested in his *Discourse on Inequality*, 1754, that the "noble savage" was free and pure, because he lived close to nature. Similarly, Kant shared his belief that the sublime qualities of soaring mountains, stormy oceans, and the wilds of nature were capable of purifying the mind and the soul.

Other views on the sublime emerged in the works of eighteenth-century British art critic and theorist John Ruskin. Emulating Kant's thoughts on beauty, Ruskin wrote, "Any material object which can give us pleasure in the simple contemplation of its outward qualities without any direct and definite exertion of the intellect, I call in some way, or in some degree, beautiful."[20] His ideas about the sublime are also generalized to encompass anything that elevates the mind. In his *Modern Painters*, 1843, Ruskin elaborates, "Greatness of matter, space, power, virtue, or beauty, are thus all sublime, and there is perhaps no desirable quality of a work of art, which in its perfection is not, in some way or degree, sublime."[21] Rather than separating beauty from the sublime as did Burke and Kant, Ruskin believed that the sublime was the highest form of beauty. Additionally, Ruskin took issue with Burke's concept of fear as an element of the sublime. Instead, Ruskin believed that it is the contemplation of death, not the fear of it that conjures the sublime state.

Ruskin's control of the critical discourse of art had a great influence on British and American painters, in particular his heralding of Turner for his views on the moral value of nature and as the most noteworthy artist of his time. Eschewing the practice of melding images from observation with the imaginary to create sublime effects, as was common during the eighteenth century, Ruskin rejected beautiful, sublime, and picturesque conventions in favor of a "truth to nature." To Ruskin, truth in art meant a faithful statement either to the mind or the senses and the stoic rejection

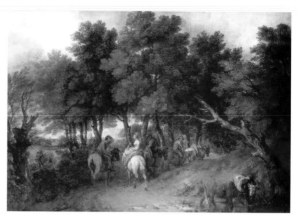

Thomas Gainsborough, **Returning from Market**, 1767-1768, oil on canvas, Toledo Museum of Art. www.abcgallery.com

of the hypocrisy of imitation. To reinforce this notion, he placed an emphasis on such aspects of landscape painting as perspective, attention to atmospheric nuances, the shape of rock formations, and the multitude of specific details that articulate the clouds.

## The Sublime in Art:
## An Historical Overview
### The Turbulent Land

Traditionally, the sublime in art has been considered in relation to landscape paintings created during the late eighteenth and early nineteenth centuries that encompass both imaginary and empirically created compositions of the most dramatic and romantic aspects of nature. Portraying the landscape was identified with three basic characteristics: the beautiful, identified with pastoral serenity and natural order in a classical sense; the picturesque, marked by poetic depictions of rustic scenery; and the sublime, marked by awe and terror of the ruggedness of nature in its pristine glory.

Each of these qualities of the beautiful, the picturesque, and the sublime are evident in eighteenth-century British landscape painting

> To Ruskin, truth in art meant a faithful statement either to the mind or the senses and the stoic rejection of the hypocrisy of imitation.

and aesthetics, encouraged by such patrons as Lord Shelburne. He commissioned three important paintings for his home in the late 1760s to foster a school of British landscapes. Prior to that time, many British landscapes were often created by immigrant Dutch and Flemish painters or by artists creating topographical depictions of estates and cultivated land. When Thomas Gainsborough (1727–1788) painted his poetically charged *Returning from Market*, ca. 1767–1768, for Shelburne, however, he heralded a shift from the idealized, classical depictions of the cultivated countryside in smooth tonalities to picturesque, romantic expressions of the countryside that were more atmospheric and expressive in execution.[22] Artists such as Constable and William Gilpin (1724–1804) followed Gainsborough's lead and strove for a more natural approach with attention to the details of light and atmosphere by painting the Lake District in England, an increasingly popular area for tourism.

Other countries in Europe developed their own landscape traditions, inspired in part by new developments in science through observation, examination, and exploration. Painters joined the ranks of naturalists by depicting geologic formations in the late eighteenth and early nineteenth centuries in Germany, the Netherlands, France, and Scandinavia. At the time of the Paris Salon (1748–1890), two forms of the sublime were apparent—the chaos of the primordial landscape and nature as eternal and transcendent. While it was often thought that French painters were not keenly interested in aspects of sublimity in landscape painting during that time, many artists developed the genre as part

of a national commitment to support natural history as a discipline.

When Swiss scientist Horace-Bénédict de Saussure published groundbreaking research on the Alps in the late eighteenth century, he inspired many French explorer/painters such as François-Auguste Biard (1799–1882) to paint the terrifying rocky outcrops, snow-capped peaks, and panoramic vistas of the Alps in the ensuing decades. Illustrations and artistic impressions of the forbidding mountain terrain encouraged public interest in the area, and adventurers soon organized their own expeditions. Additionally, the writings of Rousseau calling for a return to nature fostered a cult of nature worship in France that extended well into the European artistic community.[23] The sublimity of the Alps attracted British artists as well, including Turner. He was drawn not only to the mountain terrain of North Wales and northern England, but also, like many other artists of his time, traveled to the Alps for the potent effects of its rugged terrain and tumultuous storms. The burgeoning awareness of nature through science and aesthetics affected philosophers and artists alike, which encouraged new ways of thinking and seeing that broke from traditional canons.

After years of fervent land clearing for cultivation and early urban development in the United States, a shift in thinking emerged during the Golden Age of the mid-nineteenth century. Prior to that time, the elements of nature were dangerous impediments to settlement and progress, but by the mid-nineteenth century, many began to understand that the untamed wilderness was a distinctive characteristic

of the United States and a source of national pride.[24] They saw the land not as a primeval, ominous force to be subdued, as in the mindset of early settlers beset with the daunting task of taming it, but in the contemporary spirit of such notable transcendental writers as Ralph Waldo Emerson as a return to reason and faith. Emerson believed in the trinity of Truth, Goodness, and Beauty as equal aspects of the Deity, and nature as an important part of God's handiwork.[25] Close friend and colleague Henry David Thoreau shared Emerson's views about art and nature and put his beliefs into practice by living for two years alone in the woods on Walden Pond, where he built his home and grew his own food. Thoreau's writing about freedom and communion with nature influenced generations of artists who sought inspiration in his ideas about the art of living and the life of art.[26]

Well grounded in the formulas, subjects, and aesthetics of British landscape painting and charged with a new outlook on nature and art through the writing of Emerson and Thoreau, American landscape painters created their own distinctive interpretations of their environment. Nature was not depicted in a fundamental struggle with society, but in harmony with it, as seen in bucolic pastoral scenes and inviting woodland terrain.[27] This reverence for the natural world was revealed in serene depictions that were atmospheric and compositional constructs of the artists' imaginations—often a melding of sketches from different locations.

American landscape artists of the nineteenth century were religiously inspired and saw beauty in the land, emulating popular opinion of the interdependence of culture, religion, and virtue. They believed in a moral purpose to their work and imbued their paintings with a sense of the sacred.[28] The most influential of these painters was Thomas Cole (1801–1848) who founded the Hudson River School. Cole, known for his allegorical narrative paintings with theatrical lighting, was guided by the beliefs and writings of Ruskin. Although he was born in England and studied in Europe, Cole found distinctiveness in America's unsettled wilderness, seeing it as an untouched Eden, and began to sketch and paint in the Hudson River Valley in the 1820s. Impressed by the "wildness" of the American landscape, he was so moved by the growing decadence of civilized life that he painted (among many other works on the theme) *The Course of Empire*, 1836, a series of five large paintings that portrayed the evolutionary stages of humankind, from its primal beginnings to its destructive ends.[29] Such dramatic works were quickly noticed by a country growing tired of neoclassicism, which had reigned for at least fifty years.

Thomas Cole, **The Course of Empire: The Savage State** (1st in series), 1833-1836. Oil on canvas, 39 1/4 x 63 1/4 in.; negative #6045c
Collection of The New York Historical Society

Cole's romantic style of landscape painting soon attracted other painters to the Hudson River School, including Asher Brown Durand (1796–1886), Jasper Francis Cropsey (1823–1900), and Frederic Edwin Church (1826–1900). Durand, attuned to Ruskin's morally inspired realism and his "truth to

nature" manifesto, was still hopeful in his outlook of a sentimental benevolence at the heart of nature.[30] Cropsey, on the other hand, was keenly interested in the painting methods of Cole and Turner and often used the color black as symbolic of the threatening and brooding presences of nature.[31] Church was Cole's first pupil, and he was profoundly influenced by him, especially in his allegorical references and his concern about the course of the American Empire. He was not alone in his views. Emerson was actively writing about civilization's "invasion of nature" at that time, and Thoreau was lamenting the vanishing wilderness. Church would ultimately feel the need to travel to the Andes of Ecuador and other regions in South America to find unspoiled subject matter for inspiration. To further emphasize the transcendental nature of the American landscape, Luminist artists Sanford Gifford (1823–1880) and George Inness (1825–1894) experimented with the qualities of light in their tranquil landscapes by using aerial perspectives and concealing visible brushstrokes. Additionally, the spiritual effect in the landscapes of the Hudson River School artists was perfected by the illusion of vast space through panoramic vista and infinitely receding light.[32]

In the later part of the nineteenth century, a few intrepid artists from the Hudson River School marked the apex of the sublime in American painting, including Albert Bierstadt (1830–1902) and Thomas Moran (1837–1926), who portrayed the American West with an invigorated sense of naturalism. As New England became more settled, fewer unaffected wilderness areas were left to paint. By the mid-nineteenth century, the United States had grown considerably in population; Texas had been annexed, as were the western states of California, New Mexico, Arizona, Utah, and Nevada. The vast untamed wilderness beckoned adventurous Americans with promises of discovery, exploration, and ultimately settlement. Artists were fully aware of the impact that society could exert on their beloved subject matter, yet they were drawn to its visual splendors nonetheless, at first in the employ of surveyors and explorers who were engaged in mapping the terrain.

Bierstadt took his first journey west in 1859 as part of Frederick West Lander's government-sponsored expedition to explore the Rocky Mountains, following in the footsteps of Karl Bodmer (1809–1883), Alfred Jacob Miller (1810–1874), John Mix Stanley (1814–1872), and others who had earlier been employed to illustrate the land on exploratory missions.[33] Returning to his New York studio with sketches and photographs, Bierstadt set to work creating oil paintings that merged the special characteristics of the Rockies (albeit with pastiches of sketches from different areas of observation) with the sublime painting style perfected by European and Hudson River School painters.

By then, the use of the camera to aid both expeditions and artistic concerns was commonplace throughout the world of explorers. After seeing a powerful exhibition of sublime photographs by Carleton Watkins (1829–1916), Bierstadt was drawn to the Yosemite Valley in 1862. His dramatic paintings of Yosemite's unique geography, inspired by the verisimilitude of the photographic medium, were profoundly influential in the signing of a bill in 1864 by Abraham Lincoln to preserve the area from invasive industry or agriculture. "This acknowledgement of the vulnerability of the land and the need for active measures of preservation," observes Andrew Wilton, "was deeply and causally linked to the wilderness aesthetic of landscape painters."[34]

Moran was another painter and engraver enticed to travel west on an expedition who became

influenced by photography in his sublime depictions of the wilderness. Traveling to Yellowstone with geologist Ferdinand Vandeveer Hayden, Moran met photographer William Henry Jackson (1843–1942), and the two made studies of similar scenes. Just as Bierstadt's paintings inspired the passage of a bill to protect Yosemite, Moran's paintings and Jackson's photographs became moving documents of Yellowstone's majesty. When Hayden returned to Washington, D.C., he effectively exhibited both images to lobby for the preservation of the area, and a bill was signed for its protection by Ulysses S. Grant in 1872. Often heroic in scale, Moran's paintings reveal the grandeur of the rugged American West. Such stirring scenes at once aided in protecting wilderness areas and encouraged a massive influx of visitors to untouched landmarks such as the Grand Canyon, an area that the Santa Fe Railway hired Moran to depict as part of a successful advertising campaign for tourism.

**The Stormy Sea**

Of course, the sublime was not only expressed in landscape paintings. The awesome power of tempests and storms had been depicted for centuries, further developed in the pictorial painting traditions of seventeenth-century Dutch and Italian seascapes and made popular during the nineteenth-century Romantic period throughout Europe and America. In such works, turbulent skies, rocky coastlines, and the destructive forces of rivers and oceans reinforce the notion of discord between nature and society. Such artists as Turner, Moran, Gustave Courbet (1819–1877), and Winslow Homer (1836–1910) looked to their Dutch and Italian predecessors for compositional structures and dramatic motifs in two expressive prototypes. First, they concentrated on

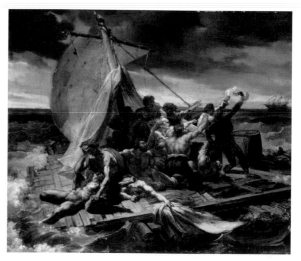

Théodore Géricault (1791-1824), **The Raft of the Medusa**, first sketch, Inv. No. RF2229. Photo: Hervé Lewandowski; Louvre, Paris, France Réunion des Musées Nationaux/Art Resources, NY

close-up views of the emotional and physical torment of figures in peril on the sea, often seen in earlier works for allegorical content. Second, they depicted panoramic vistas of rocky coastlines, waves, and clouds—with or without vessels made diminutive by the power of the forces of nature.[35]

In the Romantic era, historical accuracy became an integral aspect of disasters at sea, and new subjects entered the narratives such as castaways, smugglers, outlaws, and explorers. Actual historical events became known to a wider audience, encouraging artists to paint such scenes as the hazards of Arctic exploration and shipwrecks. One of the best-known examples of this type of depiction using contemporary subjects is Théodore Géricault's (1791-1824) *Raft of the Medusa*, 1819, in which anguished castaways cling to a raft tossing on a stormy sea. This painting took its inspiration from news accounts of a French government ship that wrecked off the coast of Africa. Only fifteen of the one hundred and fifty crewmen and passengers survived (and five died shortly thereafter)

when officers took the few lifeboats for themselves. This work not only reveals in terrifying detail the agony of death and despair from starvation, thirst, and exposure, but is also a scathing commentary on the corruption of government.[36] Géricault chose not to depict the triumphant moment of salvation when the survivors were rescued, but the moment of their greatest terror to reinforce the universal struggle between human will and the forces of nature.

While realistic compositions from actual events were new developments in the seascape tradition, American art of this genre was heavily steeped in symbolic content and allegory, such as Cole's *Voyage of Life*, 1839-1840. Clouds, rapids, and open sea overtly suggest the polarities of birth and death, creation and destruction. However, influenced by Ruskin's call to "truth to nature" in his writings about art, as well as new developments in meteorological studies (such as the formulation of "thermal theory" and the establishment of weather observation stations in the United States), paintings of storms and turbulent seascapes began to concentrate on the specificity of natural detail.[37] By the end of the nineteenth century, personal expressive concerns coalesced with empirical aims as seen in *The Flying Dutchman*, ca. 1887, by Albert Pinkham Ryder (1847-1917), in which a mythological ghost ship doomed to sail the oceans forever is rendered in a loose, expressive style.[38] In the early part of the twentieth century, artists were still intent upon depicting the tempestuous forces of nature, such as *Northern Seascape—Off the Banks,* 1936-1937, by Marsden Hartley (1877-1943), and *Seascape*, 1934, by Jackson Pollock (1912-1956), but increasingly, in keeping with the artistic trends of the modern era, such expressions were becoming primordial in focus and abstract in style.

## The Winds of Change

At the end of the nineteenth century, the landscape tradition of the sublime slowly declined as the land began to change throughout the country, and religious and nationalistic imperatives loosened. Just as photography affected much of the early artist/explorers in their magnificent paintings of Yosemite and the Grand Canyon, it also had a strong impact on painters who chose the inner city to make statements about the crowded and industrialized areas of the country. Even painters who were known for their portrayals of the sublime in the wilds of nature found expressive possibilities in the city. In 1880, for example, Moran painted lower Manhattan in its dark, gritty atmospheric best with towering skyscrapers and industrial waste.[39] In the spirit of Moran, Ashcan artist George Wesley Bellows (1882-1925) looked to the squalor of a typical New York City tenement neighborhood to portray urban life without romantic editing. In *Cliff Dwellers*, 1913, Bellows captures the throng of humanity, but does not strip it from his subjects. Still, the smoke, the congestion, the poverty, and the heat are palpable.[40]

Turning from the city to the vast rural areas of the country, some artists no longer found majestic splendor in the open spaces and rolling hills of America. Alexander Hogue (1898-1994) was one such artist of the 1930s who looked to the increasingly parched earth to make statements that were at once artistically formal and overtly political. In Hogue's *Mother Earth Laid Bare,* 1938, he renders the earth as a denuded female form that lies at the blade of a deep-furrow plow, the implement used for "dry farming" and one of the causes of the Dust Bowl of the Great Plains.[41] Soon, however, the landscape would be the source of modernist concerns, as seen in the organically inspired compositions of Arthur

At the end of the nineteenth century, the landscape tradition of the sublime slowly declined as the land began to change throughout the country, and religious and nationalistic imperatives loosened.

Dove (1880–1946) and Georgia O'Keeffe (1887–1986) and the geometric abstractions of Charles Sheeler (1883–1965) and Stuart Davis (1894–1964). By the close of World War II, the economic stability that ensued encouraged artistic expression of new concerns, primarily in a form of the abstract sublime created by such artists as Mark Rothko (1903–1970), Barnett Newman (1905–1970), and Pollock, among others.[42]

## New Strategies
### Earth Day

While artists' responses to the land shifted from the beautiful to the sublime to the harsh realities of twentieth-century urban life and then to pure abstraction, by the early 1960s, a new awareness of the environment caused shifts in thinking and artistic expression. Much of this thinking was inspired by the political climate in response to Post–World War II consumerist excesses and the rise of a counter culture during the Vietnam War era, which examined the world and reacted to its failings with activism. While American chemist Ellen Swallow Richards had established a science of environmental quality as early as 1892 called "oekology" (later known as "home ecology" and the genesis of home economics), it was not until seventy years later that real strides were made in examining the environment in order to better it.[43] When marine biologist and nature author Rachel Carson published *Silent Spring* in 1962, she revealed the hazards of the pesticide DDT and incited a groundswell of anti-technology sentiment. In 1963, the declining state of the environment was thrust

into the political mainstream when United States Senator Gaylord Nelson of Wisconsin persuaded President John F. Kennedy to join him on a national conservation tour.

Garnering Kennedy's support, Nelson embarked on a multi-year speaking tour on April 22, 1970, intent upon rallying the student anti-war energy with activist passion for the environment. This nationwide grassroots demonstration became a catalyst for unheralded public awareness about the growing environmental crisis. Sweeping college campuses, secondary schools, and local communities, over twenty million demonstrators participated.[44] This pivotal event helped to shape the mindset of artists and the American public alike. Earth Day is celebrated annually still, and while the event shifted from active political advocacy into what could be considered a mere festival of spring, its relevance in today's environmental climate has turned it into a teaching platform for recycling, energy conservation, and organic farming.

### Ecofeminism and Art

At the same time as the ecology movement was beginning to blossom, the women's liberation movement became influential in the development of new forms of art that looked to the environment, symbolized by Betty Fridan's *Feminine Mystique*, 1963. Feminist social theory neatly coalesced with the aims of environmentalists in what Solnit describes as a shared systemic worldview at a time when theorists were positing that language provided the primary metaphor

of relatedness and contextual truth. According to Solnit, the shift in art that happened concurrently with the rise of postmodernism, the environmental movement, and feminism is a gesture that "celebrates the sensory, the tangible, the contingent, the fecund; it is mutable, shifting, ambiguous, immanent (generating what would have once been a contradiction: a spirituality that emphasizes the bodily, the mortal, and the material)."[45]

Merchant was one of the first writers to discuss the ecology movement in relation to women's liberation. In her book, *The Death of Nature: Women, Ecology, and the Scientific Revolution*, 1980, Merchant suggests that the ancient identity of nature as a nurturing mother was undermined by the rise of a market-driven culture and the scientific revolution:

> **Both the women's movement and the ecology movement are sharply critical of the costs of competition, aggression, and domination arising from the market economy's modus operandi in nature and society. Ecology has been a subversive science in its criticism of the consequences of uncontrolled growth associated with capitalism, technology, and progress—concepts that over the last two hundred years have been treated with reverence in Western culture.[46]**

To Merchant, the two movements together suggest new values and social structures based on the interconnectedness between nature and culture. Many women artists at this time looked to their bodies and to nature as a source of inspiration, finding common ground with their artistic and philosophical aims of a new, egalitarian world. No longer was the landscape the sole signifier of nature; nature itself was seen metaphorically through the body/earth works of such artists as Ana Mendieta (1948–1985) and Carolee Schneemann (b. 1939). By using their own bodies in context to the earth and its fecundity, they reinforced the notion of woman embodying substance, nature, and earth. Feminist theory combined with environmental awareness and social activism not only affected art practice, but it also became an integral part of the changing culture in general.

## The Rise of Earth Art

Just as Earth Day brought the rapid degradation of the environment into focus, many artists found common ground in the movement and looked to the land and nature for inspiration. As an outgrowth of post-minimalist concerns in the early 1960s, painters, sculptors, and photographers were eager to find new forms of art making that followed neither Abstract Expressionist tenets nor the sleek, machine-honed minimalist sculpture prevalent at the time. American artists in particular were seeking to break free from the precious objectivity of standard modes of expression and the gallery/museum system. They found new meaning in manipulating the earth itself or engaging the environment as an integral element in their art. Heavily reliant on photography to document their often-ephemeral works, these artists employed a multitude of materials, equipment, literary sources, environmental concerns, and conceptual approaches to aid and inform their work.

These artists were not environmentalists per se, but were interested in how art and nature could come together in new ways that broke with the traditional art canons of the past.[47] For instance, using the earth itself as a medium, Michael Heizer (b. 1944) cut two large trenches into the eastern edge of Mormon Mesa

in Nevada to produce *Double Negative*, 1969–1970, considered by the artist to be a sculpture without form. Robert Smithson (1938–1973) reordered the land by using heavy road building equipment to create *Spiral Jetty*, 1970, in the Great Salt Lake in Utah. Nancy Holt (b. 1938) and Walter De Maria (b. 1935) have taken a different approach by constructing interactive spaces in the land. For example, placing a large concrete pipe into a sand dune on the coast of Rhode Island, Holt created *Views Through a Sand Dune*, 1972, to provide a limited vision of sand, water, sky, and sun. De Maria created *Lightning Field*, 1974–1977, by erecting four hundred stainless steel poles, each eighteen feet high, placed in a rectangular grid and spaced 200 feet apart over a total area of one mile by one kilometer in the eastern desert of New Mexico.

Other artists, such as Christo and Jean-Claude (both born in 1935) created site specific, temporary engagements with the land using thousands of yards of fabric. In the late 1950s, they wrapped objects from books to furniture; within ten years they were wrapping coastlines, buildings, and canyon walls in Europe, the United States, and Australia. And they also surrounded islands in Biscayne Bay with fabric and erected a long fabric fence that ran through two California counties into the Pacific Ocean. Each of these monumental works was created with the effort of hundreds of workers and engineers in a delicate orchestration of the land, art, and local politics. These works often involve a tendentious dance between freedom of expression and oppressive control.

Still others have created new environments as acts of restoration or healing. For example, the "pioneer of public green art" Alan Sonfist (b. 1946) created the first urban earthwork, *Time Landscape*, proposed in 1965 and realized in 1978, in New York.

In this work, he reintroduced pre-Colonial flora and fauna that were once indigenous to the area. On a New York landfill, Agnes Denes (b. 1931), also interested in art as cultivation, created *Rice/Tree/Burial Project*, 1968, where she planted a rice field, chained a group of trees to signify interference with the life process, and buried a time capsule (first with haiku and later with a message to the future) to be opened in a thousand years.[48] Pioneers of the eco-art movement, Helen Mayer Harrison (b. 1929) and Newton Harrison (b. 1932) create multimedia works that reflect on the metaphors and narratives that arise from polluted and problem sites. Additionally, Mierle Laderman Ukeles (b. 1939) deals with nature by focusing on substances and systems, such as wastewater treatment plants.[49] Other artists also continue to manipulate and interface with land and nature with aesthetic and lyrical aims. Among the most adventurous are Andy Goldsworthy (b. 1956), Hiroshi Teshigahara (b. 1927), Nils-Udo (b. 1937), and Dominique Bailly (b. 1949) who reorder leaves, trees, stones, and ice into poetic two- and three-dimensional constructions.[50]

**Photography and the Environment**

Responding to changes in critical thinking as much as to the environment itself, photography too has evolved in ways that affect our perceptions about nature. While expedition survey photographers once made their mark by depicting the sublime landscape, they had newly discovered dramatic reality at their disposal with little need for artificial manipulation of their scenes. The rugged wilderness areas of Yosemite and the Grand Canyon afforded them the panoramic vistas, soaring rock formations, and symphonic atmospheric conditions conducive to such associations, and in the early stages of these

American artists in particular were seeking to break free from the precious objectivity of standard modes of expression and the gallery/museum system. They found new meaning in manipulating the earth itself or engaging the environment as an integral element in their art.

explorations, few people to intervene. Photographers and painters informed each other in regards to composition, lighting, and the choice of scene to elicit the sublimity they sought.

Photographers and painters became inadvertently complicit in fostering tourism and rampant development when stereographs and reproductions of paintings depicting the grandeur of the American West were created for leisure consumption and tourist brochures. Images of the sublime were tempered by artistry when stereoscopes offered nineteenth-century nature lovers, viewing the images at a comfortable distance in their Victorian parlors, a heightened sense of reality because of their three-dimensional capability. Fostered in part by automobile and hotel industries that commissioned such photographs and reproductions for their advertising campaigns to encourage leisure travel, the West was dramatically romanticized.[51] By the 1920s, over one million tourists had visited national parks.

During that surge of wilderness travel and rapid encroachment on pristine lands, new developments in photography were also underway that would affect how the environment would be depicted. In keeping with a shift in painting from pictorial concerns to formalist investigations of abstraction stemming from Cubism and other postimpressionist styles, photographers such as Paul Strand (1880–1976) and Alfred Steiglitz (1864–1946) began to work in a manner termed "straight" photography. Their progressive works, shown at Steiglitz's Gallery 291

in New York and in *Camera Work* magazine, became the leitmotif of a new generation of photographers. They eschewed descriptive, referential aspects of photographs in favor of capturing majestic moments that were based on intuition and spiritual revelation through conscious camera placement and a thorough knowledge of materials and technical processes.[52]

Acknowledging a stylistic and philosophic debt to Strand and Steiglitz, two important photographers emerged who greatly impacted artistic practice and environmental advocacy. Edward Weston (1886–1958) believed in the valorization of the moment of exposure as the essence of photographic genius, and Ansel Adams (1902–1984) furthered such aims with a technical scheme to produce the desired range of negative densities at the moment of exposure called the "zone system."[53] To these artists, the act of photographing was intellectually driven and detached from content. As Deborah Bright explains, "both Weston and Adams spoke of the act of choosing the 'correct' tonal values as emotionally and spiritually guided, independent of the subject at hand and therefore universalized and transcendent."[54] The sharp contrasts of light and shadow were paramount in gracefully rippling snowdrifts, undulating sand dunes, austere moonlit deserts, stormy skies, and soaring mountains. Such images became contrapuntal to the prevalent New Deal photographs that documented the Dust Bowl and other social and environmental plights of the 1930s, as well as atrocities during World War II.

## New Topographics

While such heroic, yet straight photographs by Weston and Adams were the mainstay of environmental imagery for much of the first half of the twentieth century, a new direction in photography echoed the times of the 1970s. In keeping with the developments in artistic practice combined with the political climate and an increased awareness about the environment, photographers were spurred to react in dramatically new ways. The pivotal event that marked this shift in vision was the exhibition *New Topographics*, mounted in 1976 at the George Eastman House and curated by William Jenkins. The title of the exhibition alluded to the aesthetic disinterest of the land surveyor as opposed to the sanguine visions of vast wilderness of earlier photography. Instead of portraying works that exuded impressions of nationalism, democracy, and economic abundance, this exhibition presented the "man-altered landscape" in all its harsh reality.

Nine photographers, including Robert Adams (b. 1937), Frank Gohlke (b. 1942), and Lewis Baltz (b. 1945) were included in this groundbreaking exhibition that reversed the orientation of the camera to look squarely at approaching civilization as opposed to outward into the vast unknown. Examining the dichotomy between the American past and present, these artists were interested in depicting the phenomenon of change that permeated the landscape. As Robert Adams elaborates, "The frontier that is photographed is the intersection of reality and myth, technology and wilderness, rural independence and industrial dependence."[55] An example of this dichotomy can be seen in his *East of Eden, Colorado*, 1977, in which a western scene of the timeless winds on the desert sand dunes so poignantly photographed in the early 1950s by Ansel Adams, is now laden with dune-buggy tracks lacing the desert floor. While Adams helped to reinforce the myth of the American West during the Cold War era, explains Kelly Dennis, "by contrast, during the post-Vietnam war era, western landscape photography by new topographic photographers challenged the ideology of such longstanding myths of nature and the West."[56] Thus, the new topographers provided an alternative to the legacies of picturesque, sublime, and straight photography and paved the way for future explorations of the environment through the medium.

## Trouble in Paradise: The Mediated Message

Just as new topographic artists shifted the paradigm in the 1970s by looking frankly at the interface between nature and society in an unemotional way, the contemporary artists represented in *Trouble in Paradise* reveal a shift in thinking from traditional canons of the sublime to an anxious ambivalence.[57] Presented for the most part within a pictorial tradition, their works are informed not only by the philosophies and images of the past, but are also inspired by a contemporary fascination with news media and its packaged symbols of chaos. The artists in this exhibition are not necessarily motivated by the belief that we are doomed to live in a ruined world, nor are they complacent bystanders looking objectively at the environment and what society has done to it. By using abject imagery, they express a world in peril to underscore in literal and metaphoric terms the concepts of suffering, loss, and death. Sidestepping overtly eco-political overtones through its appeal to beauty, this art resonates with a deeper existential meaning, all the while connecting to the iconic power of the mediated message.

Drawing from ubiquitous media sources thus becomes a critique of our information systems and

how we rely on filtered information. Such filtering creates a sense of distance and removal from the crisis as the viewer becomes separated from the original image. When artists use such icons of disaster, they comment on how environmental discord is packaged and delivered to us through the Internet, television, and print media. Funnel clouds, ravaged landscapes, lightning bolts, floods, and the atomic bomb mushroom cloud become symbols that we instantly recognize because of frequent media bombardment.

To reinforce the notion of one such iconic symbol of disaster, in the digital pigment print *Jpegs*, 2006, Thomas Ruff (b. 1958) lifted an image of the violent eruption of Mount St. Helens from the Internet and retained the pixilation of the low-resolution image to reinforce its digitized form. By appropriating this image, Ruff suggests the imposition of technology on the natural world and comments on our dependence on mediated messages. "Our image models are the images in the media," he explains. "For that reason, my images are not depictions of reality, but show a kind of second reality, the image of the image."[58] Because of the obvious geometric pattern that appears from the pixilation, the viewer must scrutinize the image from different perspectives in order to clearly ascertain the subject. The multiple bits of image information thus emulate what the viewer must do in society in order to gain true perspective in a mass media-controlled world.

Another artist who uses iconic images selected from documentary sources is Ellen Wagener (b. 1964). Known primarily for her wind-swept panoramas of the prairies of the Midwest rendered meticulously in chalk pastel, more recently Wagener has focused on Western landscapes, such as the charred remains of a Ponderosa forest fire in eastern Arizona and atomic bomb mushroom clouds. Instead of appropriating the image from the Internet or other news sources, she paints and draws her subject matter in a photo-realistic style to retain the verisimilitude of a photographic image. By working in this manner, she acknowledges the power of the photographic image while returning it to the sublime landscape tradition of shock and terror. In this case, the terror is not the overwhelming power of nature, but the deadly power of humankind.

While some artists convey their concern for images appropriated from the media as an act of distancing and commentary on the proliferation of images of disaster, other artists reflect on the dichotomy between realism and fakery. For example, in *Summer: Blue, Yellow, and Gray,* 2004, Kim Keever (b. 1955) does not sample media for source imagery. Instead, he refers to primeval history in toxic-infused landscapes with murky atmospheres and scarred surfaces that appear to be created by old photographic techniques marred by time. In reality, he creates photographs of constructs assembled in a small aquarium in the comfort of his studio. Such works refer to uncertainty about the authenticity of the photographic image and the elaborate means that Hollywood and the media use to manipulate audiences. Similarly, German artist Sonja Braas (b. 1968) constructs elaborate mockups of volcanoes and other natural disasters to symbolically control nature. In her work, she creates a pretense for authenticity while questioning the very notion of our ability to assert our dominance over the uncontrollable.

## Tragedy, Trauma, and the Land

Some artists in this exhibition make images of environmental disaster as vehicles of expression related to the mediated message, while others dig deeper into the psyche to express concepts of

While some artists convey their concern for images appropriated from the media as an act of distancing and commentary on the proliferation of images of disaster, other artists reflect on the dichotomy between realism and fakery.

tragedy and trauma as they relate to catastrophe. These states of being are inextricably connected with the land when considering violent disruptions in the environment. In particular, events that appear cataclysmic in nature trigger associations with suffering and death. Such fears, engrained in the unconscious, are reinvigorated through graphic visual reminders in the media. To philosopher Terry Eagleton, tragedy is connected to catastrophe, calamitous reversals of fortunes, pollution and purgation, and suffering. It is imbued with a fearful, horrific quality that shocks and stuns; yet it is poignant because of its cleansing, life-affirming aspects.[59] In regards to environmental tragedy, artists need not necessarily depict the actual state of tragedy in terms of suffering—engrained in the image of the tragic event are the human implications of drama, death, and renewal.

Of course, the idea of catastrophe has changed over time. In medieval times, for instance, such natural occurrences as solar eclipses, comets, and earthquakes were considered signs of divine anger against human sins. With the rise of Enlightenment secularism, however, society viewed disasters as acts of nature, but associated them with humankind's moral and mental capacities. In his *Critique of Judgment*, 1790, for instance, Kant described his notions about the sublime in nature, using recollections of the Lisbon earthquake that took the lives of over 250,000 inhabitants in 1755, an event

he eagerly followed through newspaper reports as a young man. He compared the mind's agitation to a tremor, a deep shuddering vibration, or trauma.[60] In contemporary times, this pragmatic attitude has been displaced with the skeptical belief that ruinous environmental situations are caused by acts of people and, in particular, government irresponsibility and malevolence.

Interestingly, studies have shown that natural disasters have the effect of inspiring altruism in people, such as the outpouring of financial and physical support during the 2004 Indonesia Tsunami and the 2005 Katrina disaster. Such destructive forces, while reminding us of our weaknesses and helplessness, also foster social resilience and solidarity. Freud observed these phenomena, noting:

It is one of the few noble and gratifying spectacles that men can offer, when in the face of an elemental catastrophe, they awake from their muddle and confusion, forget all their internal difficulties and animosities, and remember the great common task, the preservation of mankind against the supremacy of nature.[61]

But in recent times, the shift of response to trauma and tragedy has gone from one of acceptance and comprehension to a new vulnerability paradigm, a term associated with the phenomenon of "man-made" toxic and technological disasters and a

dangerous world out of control. Far more extreme in psychological impact, such disasters (and perhaps the belief that otherwise natural disasters are also the product of human interference) create a "corrosive community" where blame, mutual recrimination, and conflict are the consequence.[62] A deep-seated anxiety sets in as the full consequences of technological disaster are unknown and the destruction extends over a long period of time. These disasters also appear to be growing in scale and number. For artists, this state of vulnerability in the face of a discordant world is psychological territory ripe for artistic investigation.

## The Witness

Traditionally, the act of bearing witness is generally thought to be photographic documents of traumatic historical events, such as the nuclear bombing of Hiroshima and the Holocaust. It can also be applied to images of the ravaged environment, potentially threatened with eminent doom. In this exhibition, Richard Misrach's (b. 1949) *Dead Animals #327*, 1987, Edward Burtynsky's (b. 1955) *Oxford Tire Piles #8*, 1999, and Paul Fusco's (b. 1930) *Ukraine, Prypiat*, 1997, are among the many first-hand photographic accounts of human-caused devastation and discord that resonate with powerful impact.[63] In such works, the act of destruction is frozen in time as if complete; the damage is done and all we can do is reflect on our avarice and carelessness. The act of witnessing in this context can be seen not only in the traditional sense of advocating for change to ameliorate environmental problems, but also as part of a cultural obsession with memory in a growing "wound culture," where victims are elevated to a position of moral superiority, if only by their absence.[64]

Witnessing is not relegated to the photographic medium alone. For instance, Susan Crile's (b. 1942) painting, *Encrusted Tar*, 1994, documents the aftermath of the 1990–1991 Gulf War when defeated Iraqi forces detonated over 600 oil wells in what is considered the greatest deliberately engineered ecological disaster in human history. Crile spent ten days in the oil fields sketching and photographing the apocalyptic scene as part of an artistic strategy to depict the media-saturated disaster in a new way—and to reinvigorate viewers who have become disassociated with it.[65] She documents the environmental atrocity with a visceral quality in an emotional commentary on a crisis of place. She and other artists working in this manner strive for aesthetic goals and exert a moral imperative through the vehicle of their expression. By sharing their revelations in visual form with a wide audience, they bear witness to the ongoing affront to the environment as a way to effect change as much as to document it. "Within the context of bearing witness," explain Frances Guerin and Roger Hallas, "material images do not merely depict the historical world; they participate in its transformation."[66]

While there is much discourse about the veracity and ethicality of images that portray trauma, when it comes to the environment, contemporary artists are less inclined to depict actual suffering.[67] Instead, they express the poignant moments of the cataclysmic event or its immediate aftermath, devoid of human presence. This lack of presence augurs the imminent suffering in striking ways. A.T. Willet's (b. 1963) *Gruver, Texas, Tornado*, 1993, for example, places the artist at the most dramatic point in a fierce tornado. Willet is the potential victim here by his proximity to the whirling wind, but as viewers we know what destruction this twister can inflict on the land and

its inhabitants. Our own imaginative leaps, dramatic cinematic fabrications, and personal histories aided by graphic media coverage, instill the terror of the disaster and conjure our own notions of pain, suffering, and death.

In DoDo Jin Ming's (b. 1955) photograph, *Free Element, Plate XXX*, 2002, her point of reference creates the illusion of anticipation just before being submerged under surging waves, generating a palpable state of potential peril. Does it matter if she was actually there to witness the roiling waters, or that she manipulates her negatives (she does) to conjure such terrifying force? Viewers already know such dangers exist, but because they are removed from reality by virtue of the photographs themselves, they can gaze at such works like voyeurs instead of victims.

Some artists, however, look at the aftermath of a disaster, because that is often where the trauma truly begins. For instance, Sasha Bezzubov's (b. 1965) *Tsunami #7, Thailand*, 2005, shows the eerie calm of a devastated resort after an immense wave of water killed 225,000 people. The worldwide live news broadcasts showed more violent depictions of human suffering from this cataclysm, but Bezzubov's solitary focus on what was once paradise, now leveled bare, is a chilling reminder of the power of nature and its implications to society. To Bezzubov, his photographs are a form of witnessing that becomes a kind of guilty pleasure. The artist derives satisfaction in capturing a moment of truth about the fragility and impermanence of nature, yet he realizes the suffering of others, and by extension, each of us.

Witnessing can also be enacted through assembling objects and photographs taken directly from the site of trauma as in Luis Cruz Azaceta's (b. 1942) installation *At the Bottom of the Pot*, 2007. In this work, actual pots retrieved from Hurricane Katrina are installed in a modernist grid formation on the wall. Affixed to the bottom of each pot is a photograph of anguished sufferers of the deluge, captured at the time of their greatest despair. Does it matter that the pots are truly recovered objects or that the photographs are of actual victims of the disaster? In such works, the artist is not necessarily creating the works as therapy, but as a vehicle for contemplation as part of the experience of living, of which traumatic events are a part.[68] The viewer has already encountered images in the news media that are much more immediate and verified, yet this work stands as a poetic testament to the event long after the horror has lapsed into history.

**Aestheticizing Disaster**

The act of witnessing can document a tragedy, yet it can have aestheticizing results such that the works lose their power of terror, sublimated by the beauty of composition, lighting, and contemplative effects. Susan Sontag discusses the moral and political failings of photography in such instances. "Photographs can and do distress," she notes, "but the aestheticizing tendency of photography is such that the medium which conveys distress ends by neutralizing it."[69] To Sontag, the photograph can create sympathy at the same time it distances the emotions. In examining "new objectivity" photography as an object of mass consumption (primarily through the press), noted philosopher Walter Benjamin asserts that such photographs can have the opposite effect of conjuring the tragic. He continues by saying, "For it has succeeded in transforming even abject poverty—by apprehending it in a fashionably perfected manner—into an object of enjoyment."[70] To Benjamin, the vehicle that gives documentary photography revolutionary power is

A deep-seated anxiety sets in as the full consequences of technological disaster are unknown and the destruction extends over a long period of time. These disasters also appear to be growing in scale and number. For artists, this state of vulnerability in the face of a discordant world is psychological territory ripe for artistic investigation.

the descriptive text caption, which "wrenches it from modish commerce."[71] Artists engaged in documenting the clash between nature and society often employ the pairing of aesthetic photograph and grounded text. Among such photographs in *Trouble in Paradise* are Burtynsky's *Uranium Tailings #12*, 2004, and David Maisel's (b. 1961) *Lake Project #11*, 2001. These artists often enhance their dramatic scenes with statistics and details nearby, so that viewers witness the works on both a visceral and intellectual level.

Aerial photography has documented the ruins of war and the ravages of the land since World War I. Yet from this perspective, the scenes of destruction become artificial spatial arrangements that tend to numb their viewers to the horrors of war. During the post-war period, such photographs became traded on the art market because of their aesthetic qualities, further transforming them from their original intent.[72] Barthes explains that the bird's eye view enables us to decipher the separate, yet familiar elements we see on the ground and, through the power of "intellection," to reconstitute a larger whole; in other words, panoramic vision allows us "to see things in their structure."[73]

In the hands of contemporary photographers attuned to the aesthetic power of their medium, aerial photography has served to reveal abstract qualities in the destruction of towns from hurricanes and tornadoes, as well as the scarred and stained land from mining and other human-caused inflictions. While the distinctively beautiful patterning of a megalopolis or the rich coloration of a toxic waste dump are rendered beautiful by the artists, they do so consciously to capture the attention of the viewer in order to make profound statements about what has caused such aesthetic responses.[74] Consider the case of Matthew Moore (b. 1976), who not only documents the land from above, but also creates the scene that is photographed to emulate the duality of beauty and environmental crisis. In his photograph, *Rotations, Single Family Residence*, 2006, Moore manipulates this genre by documenting a twenty-acre crop of barley that he planted on land nearby his family's farm. In the field, Moore meticulously ploughed the outline of a single-family home's floor plan. Thus, the artist comments on the amount of land (and therefore water and other resources) that is taken up by space-gobbling developers fast encroaching on the farm lands that have occupied the area for decades.

### Humor in the Face of Environmental Tragedy

Just as beauty has been a vehicle for capturing the viewer's attention regarding the discord between nature and society, so too is humor used as a way to entice and attract the audience to pause and reflect. In Tom Palmore's (b. 1945) painting *Run, Sparky, Run!*, 2004, for example, a bewildered terrier, reminiscent of Toto in the *Wizard of Oz*, stands in the foreground

while an ominous tornado fast approaches. We are torn between the sense of terror for a poor little dog standing before impending doom and the absurdity of a quirky little canine and its relationship to a fantastical world and happy endings. The little dog, as comic as it appears, ironically represents humankind—frozen in apprehension about what to do in such a predicament, and, in a broader sense, alerts us to our role in the ever-increasing environmental disasters that beset us.

Irish artist Nevan Lahart (b. 1973) presents a similar conundrum, using Santa Claus as the victim of global warming in his painting *Ch. 91: The Sun Sets on Santa's North Pole Operation*, 2007. In this commentary on the mediated message and the environment, Lahart frames his composition with the image of a cheap, portable television. The black and white "screen" broadcasts a gruesome image of what appears to be the last remaining polar bear eating Santa Claus, who too has lost his home. Perhaps we find the scene humorous because we assume that Santa Claus is a fictitious character, and that this scene is a figment of the artist's imagination by its painted format. But it also speaks for our sense of denial that there is perhaps an irreversible problem with the environment. We can laugh at the absurdity of Lahart's painting, because the truth is too terrifying to acknowledge.

Freud discusses this type of humor as "tendentious," because it is created with a clear point of view or message in mind. "Humorous displacement" is the defensive mechanism used to deliver the message with a pleasurable veneer. Freud notes:

**It scorns to withdraw the ideational content bearing the distressing affect from conscious attention as repression does, and thus surmounts the automatism of defence [sic]. It brings this about by finding a means of withdrawing the energy from the release of unpleasure that is already in preparation and of transforming it, by discharge, into pleasure.**[75]

Distracting images of dogs and Santas in compromising situations allow viewers to laugh at their fears, because such images appear to be directed away from the viewer as victim, yet they often reach those who are least likely to want to hear the message that is being delivered.

Political satire is alive in the staged photograph, *Raft of G. W. Bush*, 2006, by Joel-Peter Witkin (b. 1939). In this humorous take on Géricault's *Raft of the Medusa*, 1819, Witkin replaces the imperiled sailors with Bush administration members, including Secretary of State Condoleeza Rice, Vice President Dick Cheney, and President George W. Bush. Emulating Géricault's political critique of government self-interest, Witkin brings his flair for the dramatic and impish wit to an otherwise serious subject. While Witkin's intended target may be more than environmental concerns, the artist is fully aware of the number of disasters that have been affected by current policies, so it is fitting that he uses discord between nature and society as an effective social strategy to articulate his concerns.

Witkin's photograph is a humorous vehicle for protest and subversion, made possible by fracturing reality and allowing us to laugh at ourselves, as well as holding ourselves morally superior to the butt of the joke. In this way, Witkin encourages the viewer to process what Heike Munder calls the "dark shadow of the past." Drawn into the comic scene through outrageous props and uncanny impersonators, Witkin subtly makes us think about his message in order to regain our moral fortitude. Munder notes, "The most intelligent form of humour is subversive—that of the

# Artists engaged in documenting the clash between nature and society often employ the pairing of aesthetic photograph and grounded text.

'snipers'—and here infiltration occurs from within the ranks, affirmatively, not inciting revolutions, but incurring subtle, incremental changes instead."[76] The parody and flippancy of Witkin's exaggerations is a leveling force that strips the power of these leaders through humor.

**Metaphor, Allegory, and Parable**

The visual impact of a sublime landscape or a dystopic environment often manifests in visceral acknowledgements of the physical scene as somehow outside of ourselves. Yet such works also act as metaphoric extensions of the body and psychological states. Nature itself is in a state of continual change; its cycles are the primordial life and death continuum that touches the very core of our being. Artists acknowledge, indeed embrace, the turbulent, ever-changing condition of the environment as much as they muse about humankind's place in it. Martin Friedman explains the analytic subtext inherent in such works:

As they perceive it, the word landscape refers not just to nature's scenic aspects but to the principles and systems underlying the natural world. Because landscape, in their view, is an all-encompassing theme affected by many aspects of contemporary American culture, it is not just a vehicle for aesthetic exploration. It is, more profoundly, a metaphoric means of eloquently expressing their subjective reactions to contemporary social, psychological, and technological concerns.[77]

The anxious, often violent, aspects of nature emulate our internal struggles; the abject terrain suggests our own solitude and sense of loss; and works that address science serve as cautionary tales about humankind's ability to at once enhance and destroy through the manipulation of nature. Such works demand that we hold a mirror to ourselves, replete with reflections of our fears, vulnerabilities, and fantasies.

Metaphoric content is a strong component in Vernon Fisher's (b. 1943) *Inscribing the World with Water*, 1994. This painting, from his well-known series of blackboard works, resembles the dark charcoal of a slate board reinforced by a wooden shelf that holds an eraser and white chalk. The "shelf" divides the canvas into upper and lower sections (in itself symbolic of landscape and of heaven and hell). The predominant image of this painting is a linear drawing of the earth; dotted lines delineate polar caps and current flows. Erased and redrawn in palimpsest fashion, the diagram stands as a symbol of the earth under constant natural change and imposed revision.

Superimposed on the earth are fragile, leafless saplings, while above them, a reddened drawing of a hand pours liquid from a glass beaker that extends down the full length of the canvas, as if offering the saplings a much needed drink (the color red serving also as a metaphor for life blood). In three of the quadrants that result from the intersection of chalk shelf and downpour of water, thick tree trunk logs reveal deeply scarred wounds. This work recalls not only how reliant we are on water to sustain ourselves and the plants that nourish us, but also that this life-

sustaining element could be our downfall by way of flooding as a result of global warming. The hand pouring the water recalls our society's "hand" in this dilemma—how much of the environmental "mess" we have gotten into is the result of our own devices and how much are we able to repair. From beginning, with the didactic connotations of the blackboard, to end, with the detailed diagrams explaining the earth's fragility and dependence on water, Fisher's metaphoric content speaks volumes about the interconnectedness of nature and society.

The content in Fisher's painting is illustrative of Kant's two accounts of metaphor: first, it plays a symbolizing role, especially in the moral sphere, and second, it serves as an aesthetic idea that forms the core of artistic expression to serve broader interpretive aims. Kirk Pillow elaborates that the key issue in assessing the cognitive status of the Kantian metaphors is their strong creativity. Pillow notes, "On the interactionist view, powerful metaphors create affinities between components of experience and the world, transform our understanding of those features, and hence transform the world sculptured [sic] through our metaphor-inflected perspectives on it. Metaphor does not merely compare the furniture of our worlds, it helps to craft it." [78]

Just as metaphor operates on an unconscious level to create associations that trigger responses from our own memories, allegorical works serve to tell stories that resonate for us on a personal level. In Anne Coe's (b. 1949) *Life Examined*, 1998, a large sheep with a bold blue ribbon, reminiscent of a state fair prize, stares out at the viewer. In the distance, a white-coated scientist pours a toxic green elixir while lab monkeys anxiously await their fate; an apocalyptic landscape further reinforces the ominous tone of the composition. Recalling "Dolly" the cloned sheep,

one is sharply reminded of what this story is telling. Allegorically, it is the story of our technological world and how much on the experimental edge we are without knowing its consequences. Metaphorically, the sheep can be seen as representative of ourselves, sacrificial lambs to power and advancement.

While metaphor and allegory work as powerful devices to express concern about discord between nature and society, so too can parables become effective tools for artistic intent. In Randy Bolton's (b. 1956) *Never Take More Than You Need*, 2004, for example, a large, colorful banner illustrates an anthropomorphized beaver who has just chopped down the last of the trees in the forest. An axe at his side and looking perplexed, the so-called beaver realizes it has now destroyed the forest that sustains it. The cautionary words, "Never take more than you need," are emblazoned on a nearby tree stump. The beaver is commonly known to voraciously chew the trees of his environment to dam up the water, construct lodges, and create deep, still ponds. While such activity creates wetlands for other wildlife, it drastically alters the ecosystem and can affect the spawning grounds of fish and flood the surrounding terrain. Just as the beaver is capable of changing the environment for good, it is also capable of causing significant disaster—thus, the warning to the beaver is a warning to us all not to place immediate gratification over long-term stewardship of the earth.

**Conclusion**

Through the eyes of the artists in *Trouble in Paradise*, the world is a paradise lost in the classical tragic sense, one that Eagleton would associate with "an ethics of crisis and confrontation—of revelations, momentous turning-points, dramatic disclosures, and existential moments of truth."[79] Discord between

The anxious, often violent, aspects of nature emulate our internal struggles; the abject terrain suggests our own solitude and sense of loss; and works that address science serve as cautionary tales about humankind's ability to at once enhance and destroy through the manipulation of nature.

nature and society is, in one sense, an opportunity to revel in a sublime state of terror and wonder, to witness and interpret the apocalyptic drama unfolding before us. The level of activism apparent in the artists' work is of secondary importance to the viewer's reaction. Already provided with a plethora of media information about nature under assault by humankind, the viewer reacts to these works of calamity and crisis either with intellectual passivity or emotional commitment. By far, the majority of the artists in this exhibition expect that their works will be motivating factors for change to make the earth sustainable and return it to a paradisiacal condition.

Emotional memory is one of the most compelling motivators in the efficacy of the images presented in this exhibition. Whether it is actualized memory or the collective memory derived from an empathetic response to the media, images of environmental disaster and the implications of our mismanagement of the environment conjure emotions that bring to the surface the underlying fears of death and suffering that nature can inflict. Philosopher William James argued that we could revive the felt experience of certain emotions by recalling a situation that produces those sensations. Art historian Jill Bennett elaborates on James' ideas noting, "In other words, affect, properly conjured up, produces a real-time somatic experience, no longer framed as representation."[80] We respond emotionally to the terrifying image

of a tornado or a volcano, not necessarily out of a real, personal memory of the event, but by the information that surrounds us every day as we are informed of the devastation and suffering it brings.

On an emotional level, we are more apt to respond with a greater sense of urgency if we are to believe that society has had any hand in the discord that is ever present and growing in our environment. Whether it is sheer wonder, intellectual curiosity, or political/ecological activism that motivates the artists in this exhibition, they present striking images of the sublime in nature, as well as the tangible result of our technological zeal to exert our control over it. Noted art historian Hal Foster sees the media's fascination with the traumatic event as involving the subject in a three-part role of survivor, witness, and testifier who is "evacuated and elevated at once."[81] Discord in nature may be the stuff of exciting *Life* magazine spreads and powerful television documentaries, but appealing "green" television commercials are not enough to ignite the level of change that needs to be sparked to truly reverse our current environmental trajectory. We will all be subject to trauma if we continue to allow the unchecked waste of resources and other situations that accelerate global warming. These artists provide a startling wake-up call for action. Noting a trend toward a "new sinister beauty," art critic and historian Max Kozloff declares:

We have been schooled to contemplate a pictured landscape far more than to hoot and yell in common cause to rescue the screwed-up territory it may show. We feel that landscape is "there" for us, and if for any reason we are given country that puts us off, we turn elsewhere. Arcadia, even a sad Arcadia, was inviting. But how are we to be aroused by a spectacle we reject: an American wilderness we ourselves have done in?[82]

The works of art in this exhibition provide a forceful rallying cry. Perhaps we will be inspired to appreciate the beauty of dissonance in nature as much as to finally hoot and yell.

### Endnotes

1    Only two paragraphs of text and small captions with each photograph describe the devastation pictured, with little mention of humankind's impact on the land, rather the reverse. See Robert Sullivan, ed., "Nature's Fury: The Illustrated History of Wild Weather and National Disasters," *Life* (New York: Time-Life, 2008).

2    Robert Sullivan, ed. "Nature's Fury: The Illustrated History of Wild Weather and Natural Disasters," *Life* 8, no. 2 (January 14, 2008).

3    Roland Barthes, *Mythologies* (New York: Hill and Wang, 1972), 142.

4    Norman Rosenthal, et al, *Apocalypse: Beauty and Horror in Contemporary Art* (London: Royal Academy of Arts, 2000), 22.

5    Joseph P. Pickett, ed., *The American Heritage Dictionary of the English Language, Fourth Edition* (Boston: Houghton Mifflin, 2000), 1274.

6    Even suburbia can be seen as an intended paradise—an ordered intersection between culture and nature. See Rebecca Solnit, *As Eve Said to the Serpent: On Landscape, Gender, and Art* (Athens, GA: The University of Georgia Press, 2001), 1.

7    Carolyn Merchant, *Earthcare: Women and the Environment* (New York: Routledge, 1996), 51.

8    Richard Heinberg, *Memories and Vision of Paradise: Exploring the Universal Myth of a Lost Golden Age* (Wheaton, IL: Quest Books, 1989), 41.

9    Heinberg, 105.

10   Ibid., 103.

11   Other notable artists who were influenced by Poussin's deluge painting include Giovanni Battista Cipriani, Mauritius Lowe, Jacob More, Philippe Jacques de Loutherbourg, Benjamin West, Joshua Shaw, Thomas Milton, James Jefferys, and Francis Danby. See Morton D. Paley, *The Apocalyptic Sublime* (New Haven: Yale University Press, 1986), 8.

12   Gail E. Husch, *Something Coming: Apocalyptic Expectation and Mid-Nineteenth-Century American Painting* (Hanover: University Press of New England, 2000), 126.

13   Frederick Van Der Meer, *Apocalypse: Visions from the Book of Revelation in Western Art* (New York: Alpine Fine Arts Collection, 1980), 23.

14   This text was written around 190 A.D. as an empowering tract against the oppressive Roman Empire with the promise of Christian salvation. See Norman Cohn, "Biblical Origins of the Apocalyptic Tradition," in Frances Carey, ed. *The Apocalypse: and the Shape of Things to Come* (Toronto: University of Toronto Press, 1999), 28. The full book from which this chapter comes offers an in-depth look at the Apocalypse in art from its earliest manifestations through the twentieth century, including film.

15   Andrew Wilton, "The Sublime in the Old World and the New," in Andrew Wilton and Tim Barringer, *American Sublime: Landscape Painting in the United States 1820–1880* (London: Tate Publishing, 2002), 11.

16   Edmund Burke, *A Philosophical Enquiry into the Origin of our Ideas of the Sublime and Beautiful* (London: Robert and James Dodsley, 1757; 1759); ed. Adam Phillips (New York: Oxford University Press, 1990), 113.

17   Burke, 53.

18   Immanuel Kant, *Observations on the Feeling of the Beautiful and Sublime* (first pub. 1763), trans. John T. Goldthwait (Berkeley: University of California Press, 1990), 51.

19   Kant, 47.

20   John Ruskin, *Modern Painters,* vol. I, part I-II (New York: John W. Lovell Company, 1850), 92.

21   Ruskin, 108.

22   Joseph D. Ketner II and Michael J. Tammengra, *The Beautiful, the Sublime, and the Picturesque* (St. Louis: Washington University Gallery of Art, 1984), 11.

23   For a thorough examination of French landscape painting of the nineteenth century, see Barbara C. Matilsky, "Sublime Landscape Painting in Nineteenth-Century France: Alpine and Arctic Iconography and Their Relationship to Natural History," PhD diss. (New York: New York University, 1983).

24   Gwendolyn Owens, *Golden Day, Silver Night: Perceptions of Nature in American Art 1850–1910* (Ithaca, NY: Herbert F. Johnson Museum of Art, 1982), 8.

25   Later, Emerson came to believe that art created by man was only an imitation of nature and therefore ignoble. He called for creation over imitation in art. Charles R. Metzger, *Emerson and Greenough: Transcendental Pioneers of an American Esthetic* (Westport, CT: Greenwood Press, 1954), 14, 52.

26   Francine A. Koslow, *Henry David Thoreau as a Source for Artistic Inspiration in the Twentieth Century* (Lincoln, MA: DeCordova and Dana Museum and Park, 1984), 7.

27   Owens, 9.

28   James F. Cooper, *Knights of the Brush* (New York: Hudson Hills Press, 1999), 17.

29   Frank Murphy, *The Book of Nature: American Painters and the Natural Sublime* (Yonkers, NY: The Hudson River Museum, 1983), 11.

30   Murphy, 21.

31   Wilton, 82.

32   Gene Edward Veith, *Painters of Faith: The Spiritual Landscape in Nineteenth-Century America* (Washington, DC: Regnery Publishing, 2001), 16.

33   Wilton, 59.

34   Ibid., 61.

35   In Dutch and Italian seascapes, tempests were often juxtaposed with images of calm and order to intensify biblical narratives, such as the story of Noah's Ark and the deluge. See Lawrence O. Goedde, "Elemental Strife and Sublime Transcendence: Tempest and Disaster in Western Painting ca. 1650-1850," in Hardy S. George, ed., *Tempests and Romantic Visionaries: Images of Storms in European and American Art* (Oklahoma City: Oklahoma City Museum of Art, 2006), 27, 28.

36   Hardy S. George, "A Search for the 'Turneresque' in Nineteenth-Century Storm Painting," in George, 39. Two artists in *Trouble in Paradise: Examining Discord between Nature and Society,* Sue Coe and Joel-Peter Witkin, present works that reference

Gérricault's epic tale of the sea. They each emulate his notable painting with a similar eye, critiquing government actions as well as nature's wrath.

37  Mark Mitchell, "The Eye of the Storm: Symbols and Expressions in Nineteenth- and early Twentieth-Century American Art," in George, 104.

38  Robert Rosenblum, "The Primal American Scene," in Kynaston McShine, ed., *The Natural Paradise: Painting in America 1800–1950* (New York: The Museum of Modern Art, 1976), 35.

39  Ibid., 64.

40  Barbara C. Matilsky, *Fragile Ecologies: Contemporary Artists' Interpretations and Solutions* (Flushing, NY: Queens Museum of Art, 1992), 27.

41  Matilsky, 31.

42  John Beardsley, "Gardens of History, Sites of Time," in Martin Freidman, et al, *Visions of America: Landscape as Metaphor in the Late Twentieth Century* (New York: Harry Abrams, 1994), 45.

43  Merchant, 140.

44  Senator Gaylord Nelson, "How the First Earth Day Came About," *earthday.envirolink.org/history* (30 July 2008).

45  Solnit, *As Eve Said to the Serpent*, 58.

46  Carolyn Merchant, *The Death of Nature: Women, Ecology, and the Scientific Revolution* (San Francisco: HarperSanFrancisco, 1980).

47  For an in-depth look at environmental art, see Alan Sonfist, ed., *Art in the Land: A Critical Anthology of Environmental Art* (New York: E.P. Dutton, Inc., 1983).

48  Matilsky, 51.

49  Solnit, "Elements of a New Landscape," in Freidman, et al, 115.

50  For an interesting compilation of writing about later twentieth century environmental art that encompasses artists from around the world, see Vittorio Fagone, ed., *Art in Nature* (Milan: Edizioni Gabriele Mazzotta, 1996).

51  Peter J. Schmitt, *Back to Nature: The Arcadian Myth in Urban America* (Baltimore: Johns Hopkins Press, 1969), 147.

52  Deborah Bright, "The Machine in the Garden Revisited: American Environmentalism and Photographic Aesethics," *Art Journal* 51, no. 2 (Summer 1992), 62.

53  Adams and Weston first met in 1927. They formed Group f/64 with Willard Van Dyke and others to further explore the precise and sharp presentation of the psychological experience of natural beauty.

54  Bright, 62.

55  Robert Adams, "The New American Frontier," in Jonathan Green. *American Photography: A Critical History 1945 to the Present.* (New York: Harry N. Abrams, 1984), 164.

56  Kelly Dennis, "Landscape and the West, Irony and Critique in New Topographic Photography" (Paper Presented at the Forum UNESCO University and Heritage 10th International Seminar "Cultural Landscapes in the 21st Century" Newcastle-upon-Tyne, April 11–16, 2005), 1.

57  I avoid using the term "new sublime" here, because that distinction is identified more closely with theoretical associations of the sublime in everything from the readymades of Duchamp and the abstractions of Barnett Newman to the shock factor in the installations of Damien Hirst and the explosive installations of Cornelia Parker. Jean-François Lyotard's notion of the postmodern sublime is identified in terms of a "negative presentation" of the "unpresentable." See Jerome Carroll, "The Limits of the Sublime, the Sublime of Limits: Hermeneutics as a Critique of the Postmodern Sublime," *The Journal of Aesthetics and Art Criticism* 66, no. 2 (Spring 2008), 172; See Paul Crowther, ed., "The Contemporary Sublime: Sensibilities of Transcendence and Shock," Special issue. Art and Design 10, no.5 (London: Academy Editions), 1995.

58  Thomas Ruff, quoted in Thomas Wulffen, "Reality So Real It's Unrecognizable," interview, *Flash Art International,* no. 168 (January/February, 1993), 66.

59  Terry Eagleton, *Sweet Violence: The Idea of the Tragic* (Malden, MA: Blackwell Publishing, 2003), 1.

60  Gene Ray, *Terror and the Sublime in Art and Critical Theory: From Auschwitz to Hiroshima to September 11* (New York: Palgrave MacMillan, 2005), 29.

61  Sigmund Freud, *The Future of an Illusion*, trans., W.D. Robson-Scott (New York: Doubleday, 1957), 23.

62  Frank Furedi, "The Changing Meaning of Disaster," *Area* 39, No. 4 (2007), 484.

63  These artists represent a shift in documentary style photography in the 1970s when its efficacy as spontaneous witness was due to the printed page in large-circulation magazines. When such magazines as *Life* and *Look* folded in the early 1970s, photo-journalists turned to publishing books of their own photographs, which removed the immediate impact of the photographs to one of aesthetic enjoyment in coffee table books. See Gretchen Garner, *Disappearing Witness: Change in Twentieth-Century American Photography* (Baltimore: Johns Hopkins University Press, 2003), 69.

64  Jill Bennett, *Empathic Vision: Affect, Trauma, and Contemporary Art* (Stanford: Stanford University Press, 2005), 5.

65  Jeremy Strick, "*Susan Crile: The Fires of War.*" *Currents* 58, St. Louis Art Museum (April 12–June 5, 1994).

66  Frances Guerin and Roger Hallas, *The Image and the Witness: Trauma, Memory, and Visual Culture* (New York: Wallflower Press, 2007), 4.

67  One important exception can be seen in the exhibition *Beautiful Suffering: Photography and the Traffic in Pain*, presented at Williams College Museum of Art in 2006. See Mark Reinhardt, et al., *Beautiful Suffering: Photography and the Traffic in Pain* (Chicago: University of Chicago Press, 2006).

68  Fiona Bradley, Katrina Brown, and Andrew Nairne, *Trauma* (London: Hayward Gallery, 2001), 9.

69  Susan Sontag, *On Photography* (New York: Farrar, Straus, and Giroux, 1977), 109.

70  Walter Benjamin, "The Author as Producer," in *Walter Benjamin: Selected Writings,* vol. 2 1927–1934, trans. Rodney Livingstone et al (Cambridge, MA: Harvard University Press, 1999), 775.

71  Ibid.

72  Davide Deriu, "Picturing Ruinscapes: The Aerial Photograph as Image of Historical Trauma," in Guerin, 191.

73  Roland Barthes, "The Eiffel Tower," in *The Eiffel Tower and Other Mythologies* (Berkeley: University of California Press, 1979), 9.

74  In fact, by World War II, aerial photographers inflected their work with aesthetic considerations and were often included in popular photography magazines of the time. Deriu, 193.

75  Sigmund Freud, "Jokes and their Relation to the Unconscious," in *The Standard Edition of the Complete Psychological Works of Sigmund Freud,* trans. James Strachey in collaboration with Anna Freud, vol. VIII (1905), (London: the Hogarth Press, 1973), 233.

76  Heike Munder, "Humour: The Secret of Aesthetic Sublimation," in Jennifer Higgie, ed., *The Artist's Joke: Documents of Contemporary Art* (Cambridge, MA: MIT Press, 2007), 212.

77  Friedman, "As Far as the Eye Can See," in Freidman, et al, 14.

78  Kirk Pillow, *Sublime Understanding: Aesthetic Reflection in Kant and Hegel* (Cambridge, MA: MIT Press, 2000), 266.

79  Eagleton, 74.

80  William James echoes William Wordsworth's observations on poetic composition here. See Bennett, 23.

81  Hal Foster, "Obscene, Abject, Traumatic," *October* 78 (Autumn, 1996), 124.

82  Max Kozloff, "Ghastly News from Epic Landscapes," *American Art* 5, no. .5 (Winter/Spring, 1991), 122.

## THE ARTISTS AND THEIR WORK

KIM ABELES

LUIS CRUZ AZACETA

SASHA BEZZUBOV

RANDY BOLTON

SONJA BRAAS

ALICE LEORA BRIGGS

DIANE BURKO

EDWARD BURTYNSKY

CORWIN "CORKY" CLAIRMONT

ROBERT D. COCKE

ANNE COE

SUE COE

DAN COLLINS

JAMES P. COOK

SUSAN CRILE

JOHANN RYNO DE WET

MARK DION

MITCH EPSTEIN

VERNON FISHER

PAUL FUSCO

FRANCESCA GABBIANI

SUSAN GRAHAM

HEATHER GREEN

EMILIE HALPERN

JULIE HEFFERNAN

RODERIK HENDERSON

TRACY HICKS

DODO JIN MING

KIM KEEVER

ISABELLA KIRKLAND

DIMITRI KOZYREV

NEVAN LAHART

ROSEMARY LAING

DAVID MAISEL

MARY MATTINGLY

RICHARD MISRACH

MATTHEW MOORE

MICHAEL NAJJAR

JOE NOVAK

LEAH OATES

ROBYN O'NEIL

TOM PALMORE

ROBERT AND SHANA PARKEHARRISON

ANTHONY PESSLER

ROBERT POLIDORI

ALEXIS ROCKMAN

BARBARA ROGERS

THOMAS RUFF

CHRIS RUSH

SUSAN SHATTER

JEFF SMITH

MIKHAEL SUBOTZKY

TOM UTTECH

ELLEN WAGENER

WILLIAM T. WILEY

A. T. WILLETT

JOEL-PETER WITKIN

# KIM ABELES

**K**im Abeles' work from the past two decades concentrates on the urban experience and the environment by chronicling historical and contemporary issues in sculptural form and installations. Abeles gathers data from library research and experiments with unconventional materials to create works that address both personal and broader social issues. Abeles also examines such themes as feminism, aging, HIV/AIDS, and labor.

Abeles' childhood was spent in the industrial steel town of Pittsburgh. As an American Field Service student in Japan in the late 1960s, she met a Shingon Buddhist priest, Kosai Kobari, who became her mentor and taught her about traditional Japanese arts. She returned to the United States to create a rural existence in southeastern Ohio in the mid-1970s, where she lived in a converted grain silo and wrote the book *Crafts, Cookery, and Country Living* (1976). In an abrupt change from her bucolic life she had fashioned in Ohio, Abeles moved to Los Angeles in 1978, where she was affected by the smog and congestion of the area. Establishing a studio near the sweatshops and harsh street life of inner Los Angeles, she directed her work away from ethereal themes to explore the harsh realities of the city.

In the mid-1980s, Abeles invented a method to create images from smog by collecting particulate matter onto stencils. The resulting work, "The Smog Collector" series, garnered international attention. Most notable among them is *Presidential Commemorative Smog Plates* depicting American presidents from McKinley to the elder Bush, which she created in the early 1990s. After cutting stencils and placing them on dinner plates, Abeles exposed them to the smoggy Los Angeles air on her rooftop for varying lengths of time, depending on the extent of each president's violation or apathy toward the distressed environment.[1] To create *Thomas Hart Benton's "Island Hay" in Thirty Days of Smog*, 2000, Abeles laid a stencil of the famous Midwestern artist's reverie of the rural experience onto black Plexiglas; she then exposed it to the smog-laden air of Los Angeles. The resulting gritty likeness makes a sharp statement about the dichotomy between rural and urban life and the limits of our tolerance to the deplorable quality of the air we breathe.

In addition to her artistic pursuits, Abeles completed the *Environmental Activity Book* in 1997, which was partially funded by the Los Angeles Cultural Affairs Department. The book translates several of her environmentally based installations into projects for the classroom and the home. She also developed projects about air pollution in conjunction with the California Bureau of Automotive Repair and the Environmental Studies Department at Oberlin College. Today, Abeles serves as a participant in think tanks and panel discussions for urban agencies, botanical gardens, and environmental conferences.
—JS

1   Kim Abeles, "Presidential Commemorative Smog Plates," exhibition brochure for *Feeling the Heat: Art, Science and Climate Change* (New York: Deutsche Bank Gallery, 2008).

**Thomas Hart Benton's "Island Hay" in Thirty Days of Smog**, 2000. Particulate matter (smog) on black Plexiglas. 12 x 16 in. Collection of Arizona State University Art Museum; Partial donation by artist and purchased with funds provided by the FUNd at Arizona State University Art Museum

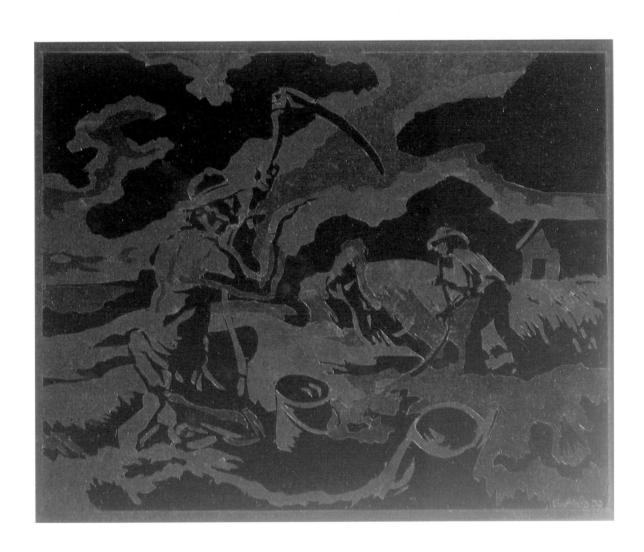

# LUIS CRUZ AZACETA

**T**he paintings and drawings of Cuban-born Luis Cruz Azaceta have long addressed themes of urban violence, personal isolation, homelessness, and displacement in overcrowded cities due to mismanaged government, the oppression of dictatorships, and the ravages of the AIDS epidemic. Working in a bold style that blends the immediacy of cartoon and graffiti art in grid-like fashion since the late 1970s, Cruz Azaceta makes statements of "social protest and sardonic commentary."[1] In his paintings of the late 1990s, however, he stripped down the baroque elements of his compositions and shifted his palette from vibrant colors to meditative, monochromatic tones. These new series more profoundly assert universal statements rather than individual dilemmas of human existence.

Since his move to New Orleans in 1992, Cruz Azaceta has expanded his use of materials to include nails, wood, photographs, and metal. At first, he photographed his neighborhood to familiarize himself with the area, and eventually he integrated photographs into his art. *At the Bottom of the Pot*, 2007, is an emotional reflection of the devastation caused by Hurricane Katrina. This large-scale installation is comprised of cooking pots found in the flood debris with photographs of anguished victims affixed to their bottoms. The faces show the range of the people who could not or did not evacuate: the overlooked, the poor, the elderly, and the infirm. Apocalyptic in its nightmarish vision of reality, the work exhibits a sense of emotional candor and compassion for humankind.[2]

*—JS*

1 Edward J. Sullivan, "Darker Visions: Recent Paintings by Luis Cruz Azaceta," in *Luis Cruz Azaceta: Bound* (New York: Mary-Anne Martin/Fine Art, 1998), 3.
2 John R. Kemp, "Luis Cruz Azaceta," *Artnews* 107, no. 5 (May 2008).

**At the Bottom of the Pot**, 2007. Photographs mounted to found pots and pans. 96 x 108 x 10 in.
*Courtesy of the artist and Arthur Roger Gallery, New Orleans, LA*

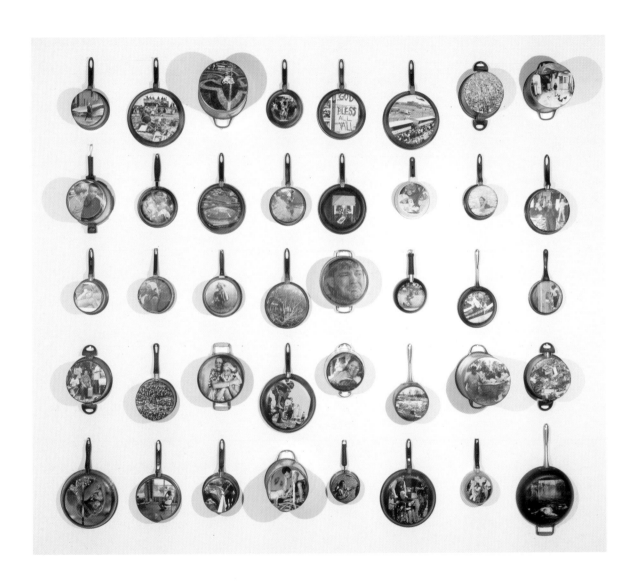

## SASHA BEZZUBOV

Since 2001, Sasha Bezzubov has worked on "Things Fall Apart," a series of photographs that capture the moment of eerie calm that occurs just after a natural disaster strikes. Devoid of human presence, the aftermath of such events as an earthquake in India, a wildfire in California, or a tornado in the American Midwest reveal the "humbling period of resignation when the traumatic event has passed, when harmony and unity once more abound."[1]

In *Tsunami #7, Thailand*, 2005, Bezzubov documents the wreckage of a devastated resort after the immense tidal wave that killed 225,000 people. Here the remnants of a resort's swimming pool, evidenced by the half-submerged tile wall, stands as mute testimony to the once thriving vacation spot. The worldwide live news broadcasts showed many more vivid depictions of human suffering from this cataclysm, but Bezzubov's solitary focus on what was once a Shangri-la, now leveled bare, is a chilling reminder of the power of nature and its implications for society. His muted palette and panoramic views remind the viewer that all things are equal in nature, the beautiful and the ugly.

Aestheticizing disaster is not Bezzubov's aim, however beautiful the damaged terrain may appear. Rather, his photographs speak of the cycle of life, death, and regeneration beyond the realm of human control. To Bezzubov, his apocalyptic photographs are a form of witnessing that becomes a kind of guilty pleasure. The artist derives satisfaction from capturing a moment of truth about the fragility and impermanence of all things.

—EH

1   Mary Hrbacek, "Sasha Bezzubov: The Front Room Gallery," *M Magazine* (May 2007).

**Tsunami #7, Thailand**, 2005. C- print, 40 x 50 in. *Courtesy of Taylor De Cordoba Gallery, Los Angeles, and The Front Room Gallery, New York*

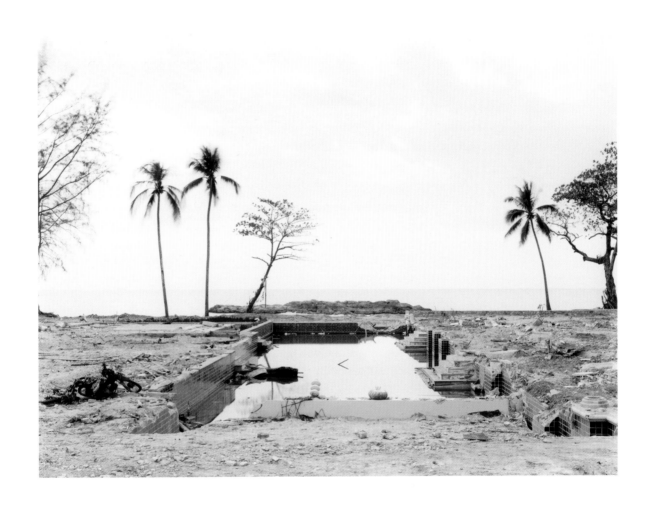

## RANDY BOLTON

Subversive storytelling through graphic characters, seemingly lifted from antique children's primers and science texts, is the hallmark of Randy Bolton's dark humor. Working with banner vinyl and other textiles and surfaces, he defies the canons of printmaking to take the medium to installation scale and format. Approachable in his lively colors and parable format, Bolton's insightful narratives appear at first to be lessons for the young, but once drawn in by his adorable creatures and circus banner presentation, viewers of all ages are hit hard with his serious messages. Bolton punctuates his pseudo-naive stories with slogans, often in a display of blatant sarcasm. Such devices imply that we are still children in need of a reminder of obvious lessons. As critic Robert Fallon asserted, "For an artist like Bolton, it's about liberating and re-using, re-cycling and re-vivifying old material for a new audience. Call him a one-man Dick and Jane liberation army."[1] Thus, images originally intended to reflect childhood security and innocence become ironic metaphors of a chaotic world that is threatened by forces beyond our comprehension and control.

Bolton reveals the power such illustrations have to shape our view of the world as children, followed by the disillusionment that occurs when these images fail us as adults. In *Never Take More Than You Need*, 2004, a large, colorful banner illustrates an anthropomorphized beaver with an axe at his side, looking perplexed as it realizes it has just chopped down the last of the trees in the forest that sustains it. The cautionary words, "Never take more than you need," are emblazoned on a nearby tree stump. The beaver is commonly known to voraciously chew the trees of his environment, damming up the water to construct lodges and to create deep, still ponds. While such activity creates wetlands for other wildlife, it drastically alters the ecosystem and can affect the spawning grounds of fish as it floods the surrounding terrain. Just as the beaver is capable of changing the environment for the good, it is also capable of causing significant disaster—the warning to the beaver is a warning to us all not to place immediate gratification over long-term stewardship of the earth.

—JS

1 Roberta Fallon, *Randy Bolton, The Cranbrook Monographs* (Brighton, England: Telos Art Publishing, 2006).

**Never Take More Than You Need**, 2004. Digital print on canvas with free-standing 3-dimensional element, 111 x 122 x 13 in.
*Courtesy of the artist and Littlejohn Contemporary, New York*

## SONJA BRAAS

German artist Sonja Braas explores the boundaries between nature and culture, chaos and control in her photographic works. Like many of the artists in this exhibition, Brass believes that the natural world and civilization are in constant conflict. As history has progressed and technology advances, we often view nature not as a dangerous enemy, but as a controllable entity. Yet, even as we seek to tame nature, we also revere its sublimity; we romanticize the very wilderness that we are systematically destroying. In 2003, the artist created "Forces," a series of photographs of both real and studio-constructed primeval forces of nature revealing dark fog, deep snow on dark, craggy mountains, and crashing waves.[1] Horizonless and violent in their tenor, these photographs touch upon the instinctual response of the viewer and comment on the ambiguity of the mediated message.

In her 2005 series, "The Quiet of Dissolution," Braas photographs natural disasters. For her, these sudden events symbolize the tension between nature and culture. Braas captures the whirling winds of a tornado, fiery rivers of lava, and engulfing smoke of wildfires in impossibly minute detail. However, while the storms, eruptions, and fires seem at first glance to be authentic, the natural disasters Brass depicts are not, in fact, natural. Rather, Braas painstakingly constructs models of these earthly forces and carefully photographs them, complete with added lighting and atmospheric effects. The resulting images tread the line between truth and fiction; they depict an artistically created hyper-reality where nature is both awesome in its strength and robbed of its power. This juxtaposition of the man-made and the cataclysmic calls into question our perceived control over and mastery of nature.

—EH

1   Neven Aufwahmen Von, "Welcome," in Susanne Pfleger, Barbara Auer, and Ulrich Ptak, *Sonja Braas: Forces* (Bielefeld, Germany: Städtischen Galerie Wolfsburg, Kuntshalle Rostock, 2003), 5.

**Lava Flow**, 2005, from the series "The Quiet of Dissolution." C-print, Diasec, 73 x 59 in. Private Collection, New Jersey.
*Courtesy of Galerie Tanit, Munich, Germany*

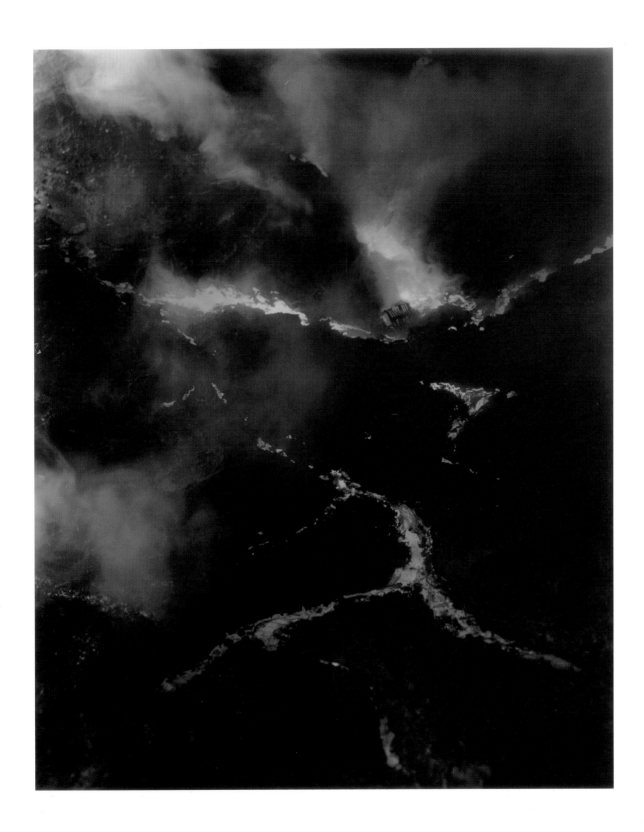

## ALICE LEORA BRIGGS

Alice Leora Briggs distills images from a range of sources, including newspapers and the Internet, reconstructing them into a new kind of truth. Combining stylistic influences and appropriated images from Roger van der Weyden, Albrecht Dürer, and Pieter Brueghel the Elder, she fuses contemporary and historical realities with tensions triggered by clashes between social and cultural ideals. Called a voyeur, a journalist, and a history painter, Briggs works primarily in sgraffito, a drawing method that originated in thirteenth-century German wall decoration. To create her complex works layered with detailed imagery, Briggs cuts into India-inked surfaces of kaolin-covered boards. Fine white lines emerge and give her works the haunting effect of a negative.

*Garden of Ruins: Eve*, 2005, a dark city scene of a charred, crowded street, echoes the aftermath of the San Francisco earthquake of 1906. Briggs's image borders on the gruesome: anguished and dying draft horses lie in the crowded street while people mill about in disbelief. To the right, a woman in medieval garb clasps her hands in awe of the devastating scene behind her. At her side, a mechanical contraption transforms itself into a futuristic instrument of destruction. By creating such an enigmatic narrative of appropriation and invention, Briggs examines the collective memory and its mediated historicism.

Recently, Briggs has been living at the Border Art Residency, thirty minutes from the border between El Paso and Ciudad Juarez. She visits places where conflict and valor barely keep pace with the uneasy amalgam of unfolding history and current events. As the artist explains, "In Ciudad Juarez one sees fiction in action; even an hour in this city is time enough to blend truth with myth. Days spent here provide me with the sensation of light and dark, anxiety and odor that I could never imagine. I require this reality, this laboratory for my work."[1] From this experience, a new body of powerful work is underway called "Dreamland."

—JS

1   Alice Leora Briggs, artist statement, 2008.

**Garden of Ruins: Eve**, 2005. Sgraffito on panel, 24 x 36 in. Diane and Sandy Besser Collection. *Photo: Wendy McEahern Photography*

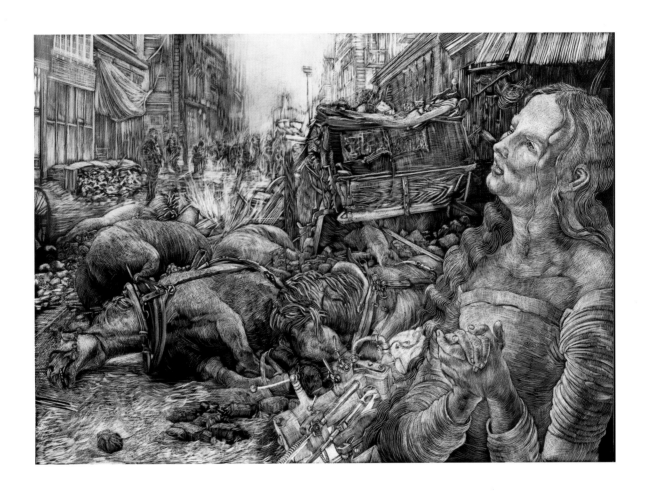

# DIANE BURKO

Since the early 1980s, Philadelphia artist Diane Burko has been known for her aerial-view paintings of such exotic places as the Himalayas, the French and Swiss Alps, the Pacific Northwest, Hawaii, the Grand Canyon, and volcanoes of the world. She began to photograph the landscape from this vantage in 1977, when she first flew over the Grand Canyon with noted light and space artist James Turrell. Studying the geology and the history of the earth, she captures the sense of grandeur and spirituality of a place. These works reveal Burko's fascination with spatial and temporal natural transformation and the fluid boundary between representation and abstraction.

Recently, Burko reviewed her archive of collected photographs from the 1970s, only to realize that human intervention had accelerated the disintegration of the spectacular snow-covered mountains she admired more than thirty years ago. Fearing for the survival of such important icons, she developed a strategy to address global warming. The resulting ongoing project, "Politics of Snow," highlights such landmarks as the Matterhorn and the Alaskan Arctic National Wildlife Reserve, and documents the rapidity of change of glaciers in America, Iceland, and other parts of the globe.

*Disappearing Series 2a, 2b,* 2007, focuses on the Matterhorn, with the bottom panel implying the impermanence of our environment. Realized through thick and thin layers of primarily black and white paint in diptych format, Burko contemplates past and present natural phenomena and her changing personal awareness through contrast and contradiction.

Burko's view of the world has changed as a result of this realization. Perceiving the beauty and majesty of this landscape differently, she reveals, "I have lost my innocence. I am compelled to revisit the sublime landscape with more than an aesthetic impulse. I wish to use my practice to contribute to the urgent dialogue about our planet, to bring attention to future perils that may await us if we do not act."[1] Still deft in seducing the viewer with her lush surfaces and formal qualities, the artist, who has recently added digital photography to her working practice, now encourages the viewer to contemplate the survival of the planet. To Burko, beauty and desolation, life and death, all conflate into a concept of mortality on both a personal and global level, dominating her creative impulse.

—JS

1   Diane Burko, artist statement, 2008.

*Disappearing Series 2a, 2b*, 2007, from the series "Politics of Snow." Oil on canvas, diptych, 48 x 24 in.
*Courtesy of the artist and Locks Gallery, Philadelphia, PA*

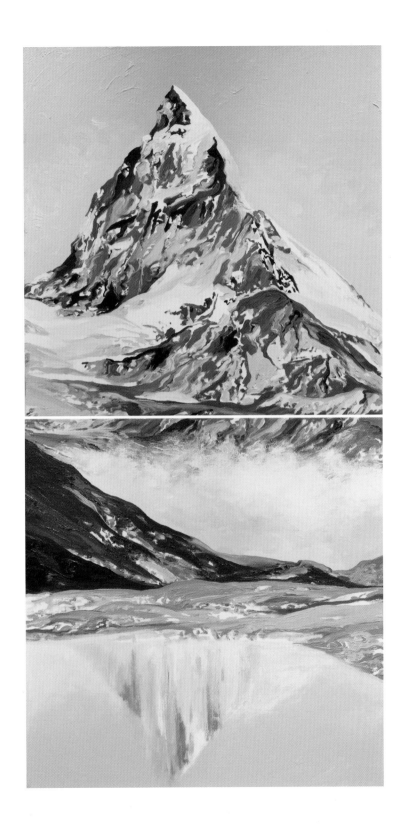

# EDWARD BURTYNSKY

**E**dward Burtynsky traces the development of his photographic work to his early experiences of the General Motors plant in his hometown of St. Catharine's, Ontario, Canada. In his images of railroads, mines, quarries, oil fields, and refineries, Burtynsky documents nature transformed through industry. His works draw attention to what he sees as a fundamental dilemma of modern existence: while mine tailings, recycling yards, and other industrial sites are places that few people think about, without their output, our daily lives would be unthinkable. Yet, Burtynsky's large-scale and lushly colored photographs transform even the most horrific instances of despoiled nature into appealing works of art. By uniting provocative subject matter with aesthetically striking images, Burtynsky creates, as he explains, "a dialogue between attraction and repulsion, seduction and fear. We are drawn by desire … yet we are consciously or unconsciously aware that the world is suffering for our success."[1]

Beginning in 1995, Burtynsky photographed the byproducts of nickel and uranium mining in his native Ontario. In *Uranium Tailings #12, Elliot Lake, Ontario*, 2004, the wooded Canadian landscape becomes a barren desert of radioactive sand. The Oxford tire pile, the subject of *Oxford Tire Pile No. 8, Westley, California*, 1999, is the world's largest pile of discarded rubber tires. These are not randomly rejected objects, but the remnants of wear and the plentitude of discard, "gathered together here, concentrated in a landscape of depletion and rejection."[2] Burtynsky's photograph emphasizes the monumentality and the grandeur of these mountains of tires, while the glimpse of a green field in the background suggests the environmental casualties of such waste.

*—EH*

1 Edward Burtynsky, artist statement, <www.edwardburtynsky.com> (10 October 2008).
2 Marc Mayer, "Burtynsky in China," in Edward Burtynsky, *China: The Photographs of Edward Burtynsky* (Göttingen, Germany: Steidl, 2005), 8.

**Oxford Tire Pile #8, Westley, California**, 1999. Chromogenic print, edition AP 1, 40 x 50 in. ©Edward Burtynsky
*Courtesy of Charles Cowles Gallery, New York*

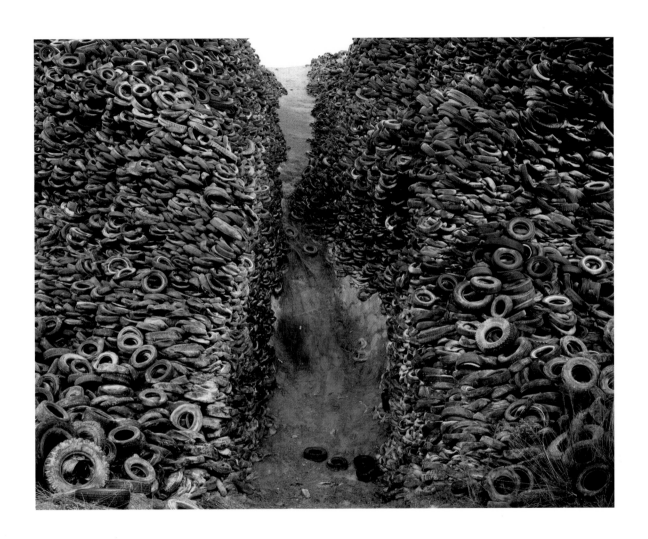

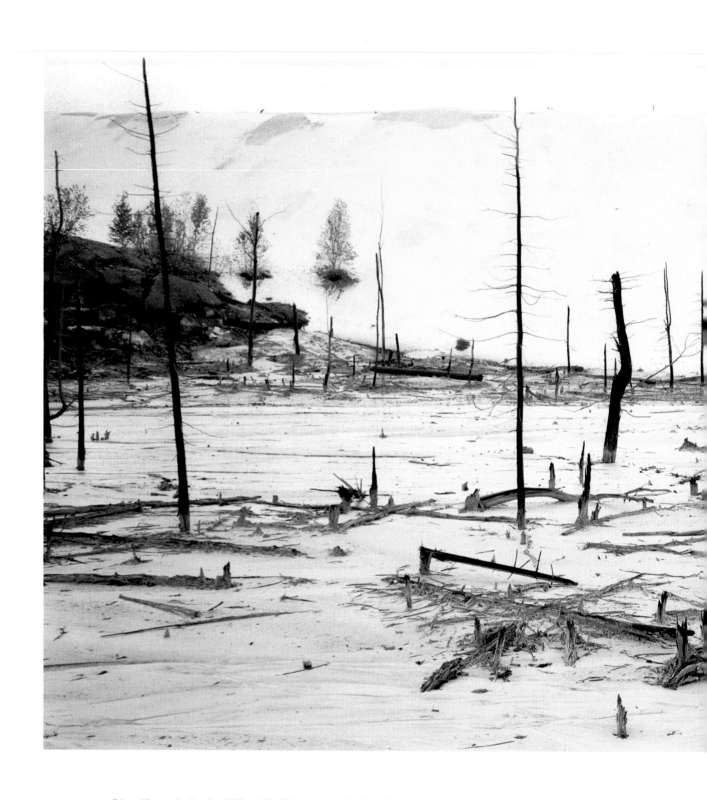

Edward Burtynsky, **Uranium Tailings #12**, Elliot Lake, Ontario, 2004. Chromogenic color print, 10/10, 22 x 45 in.
© Edward Burtynsky, Private Collection. *Courtesy of Charles Cowles Gallery, New York*

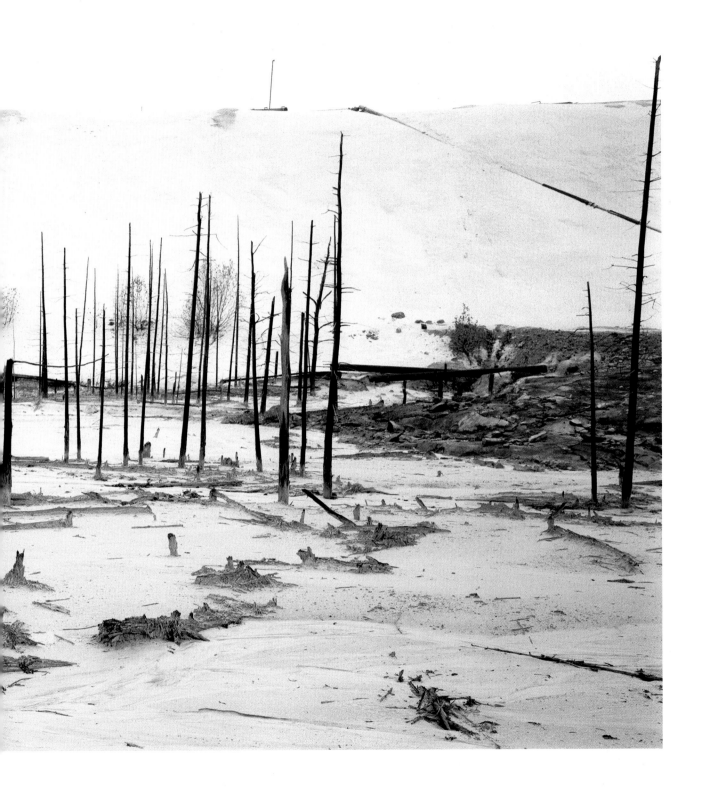

## CORWIN "CORKY" CLAIRMONT

Artist, teacher, and community activist Corwin Clairmont grew up on the Flathead Reservation in Montana where he has contributed significantly to the cultural fabric of his community. Called a "visionary artist," Clairmont works within a post-modernist perspective while addressing issues that concern contemporary life of both non-native peoples and Native Americans alike. Using traditional and non-traditional materials and concepts, the artist often imbues his work with irony, humor, and political innuendo.

Clairmont obtained a Master of Arts degree from California State University Los Angeles, where he concentrated on printmaking and was influenced by the issue-related works of John Baldessari and Joseph Beuys. After he received a grant from the Ford Foundation, he began to explore the intricacies of rural and urban relationships, culminating in the series "Torn Paper, California Beaches," 1979, created in collaboration with his friend and colleague, Leonard Edmondson. Together, they photographed the features and conditions of several beaches along the coast of southern California. On each resulting litho print, they tore off a small corner, leaving it to become part of the beach as a statement about the ephemeral health of the environment.

Included in this exhibition, one print from this series reveals a dead sea bird decaying in the sand. Ironically, the very places where people go in order to be close to nature become fragile environments because of the resulting heavy traffic.[1] On their walks, Clairmont also noticed that the shore was littered with hundreds of dead sea birds at Gregorio State Beach and asked one of the park employees why there were so many. The employee said that the birds were molting and possibly drowned as a result—but Clairmont couldn't help but notice the oil drilling platforms near the California coastline and the globs of raw crude oil imbedded in the sand.[2] The observation of nature and humankind's impact on it continues to be a central theme in the artist's work. After his time in Los Angeles, Clairmont returned to the reservation where he is now the director of the art department at Salish Kootenai College in Pablo, Montana. His interests have expanded to address issues relating to his people and the compromised environment.

—JS

1   Gail Trembly, "The Art of Corwin Clairmont: Speaking with a Clear Voice" in Gail Trembly, *Halfway Between Here and There: The Art of Corwin Clairmont* (Missoula, MT: Art Museum of Missoula, 2001), 6.
2   Corwin Clairmont, electronic correspondence with the author, 13 March 2008.

**Gregorio State Beach**, 1979, from the series "Torn Paper, California Beaches." Photo litho prints, 30 x 14 in. *Courtesy of the artists*

## ROBERT D. COCKE

Over the last twenty years, Robert D. Cocke has reacted to the changing world around him by creating oil paintings that reveal dramatic changes in style and subject matter. Yet throughout his shifts in style and palette, Cocke asserts a consistent desire to address not only human relationships, but also the relationships between humankind and the natural world. In the 1980s, he filled his brilliantly colored canvases with figures, architectonic forms, images from nature, and the detritus of civilization as a way to express his frustration with the state of the world, political corruption, and the destruction of nature. Energetically intense and emotionally charged in bold, underground comic book style, Cocke envisions a collapsing urban nightmare.

*The Quest for Knowledge*, 1989, is a chilling example of this threatening world, where a cacophonous, polluted city spews a freeway of cars driving directly into what appears to be a crematorium. In front of this ominous scene, two male figures struggle to prop up the architectural remnants of a past civilization left abandoned in a ravaged landscape, which is strewn about with fragments of sculpture, jewelry, and other artifacts. When this series was first exhibited, critic Robert S. Cauthorn remarked, "Before, his maddeningly aggressive cities afflicted his people. Now he raises the alert possibility that the cities may be merely the symptom. Rather than blaming someone else, he insists we should look into ourselves."[1]

In the 1990s and 2000s, Cocke's paintings began to change, and his attention turned away from the figure and toward serene landscapes, panoramic vistas, and arrangements of objects that were constructions synthesized from memories rather than derived from observation. Reflecting a change in the artist's world view, the resulting luminous works act as parallel worlds that articulate his thoughts and experiences. "The world is incredibly complex and ever changing," Cocke remarks, "but the world, our place in it, and our position in the universe are ultimately enigmas. I want my work to serve as a reminder that there is a bigger, deeper, and more mysterious realm out there beyond the urban, technological world that most of us inhabit day-to-day."[2] Thus, the artist turns the fear and anger inherent in his work from thirty years ago into an utopian Eden in an attempt to convey a longed-for return to paradise.

—JS

1   Robert S. Cauthorn, "Cocke Clutches Heart of Powerful Show," *The Arizona Daily Star* (15 September 1989), 7.
2   Robert D. Cocke, artist statement, 2008.

**The Quest for Knowledge**, 1989. Oil on canvas, 62 x 50 in. Collection of Tucson Museum of Art. Gift of Terry Etherton, 2000.40.1

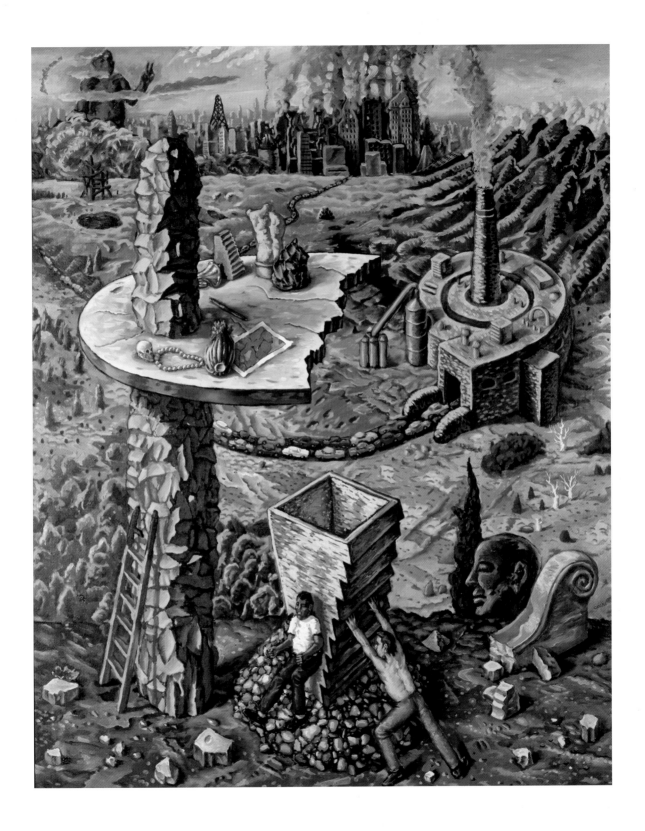

# ANNE COE

A passionate conservationist, Anne Coe creates richly colored representational paintings that involve whimsical animals wreaking havoc on domestic interiors. Coe makes statements about society's disregard of other species and humankind's relations to the natural world using humor and irony in imaginative narratives. Often the absurdity of these scenes is energized by architectural details, Renaissance painting perspectives, and eerie atmospheric conditions.[1] Such devices entice viewers to contemplate the narrative and its metaphoric content as they enjoy the humor of the moment and the intriguing story that unfolds.

A fourth generation Arizonan, Coe was raised on a ranch in a remote part of the state where she developed a close affinity for the land. She has been a major force in over seven regional and national environmental groups, focusing on everything from helping to re-introduce the Mexican wolf to its original Arizona habitat to protecting the future of thousands of acres of state trust land. Coe is also founder and president of the Superstition Area Land Trust. The artist's early paintings were in the style of comic books. Over the years, her paintings evolved from lighthearted whimsy (such as radioactive, mutant Gila monsters destroying the world in retaliatory rage) to more mature works with a confidence of message and style.

*Life Examined*, 1998, is one of Coe's more somber allegories about the conflict between society and the natural world. In this tableau, a scientist in a white coat pours a glowing green elixir into a beaker while laboratory monkeys anxiously await their fate; an apocalyptic landscape further reinforces the ominous tone of the composition.[2] Wearing a blue ribbon reminiscent of a state fair prize, a large sheep, emblematic of the famed clone "Dolly," peers anxiously out at the viewer. Allegorically, this painting tells the story of our technological world and how close we are to an experimental edge without knowing its consequences. Metaphorically, the sheep can be seen as representative of ourselves, sacrificial lambs to power and advancement.

—JS

1  Julie Sasse, "Afterword," in J. Gray Sweeney, *Anne Coe: Life Examined* (Tucson, AZ: Joseph Gross Gallery), 12.
2  Ibid., 3.

**Life Examined**, 1998. Acrylic on canvas, 60 x 100 in. Collection of Tucson Museum of Art. Gift of Vanier Galleries, 2001.20.1

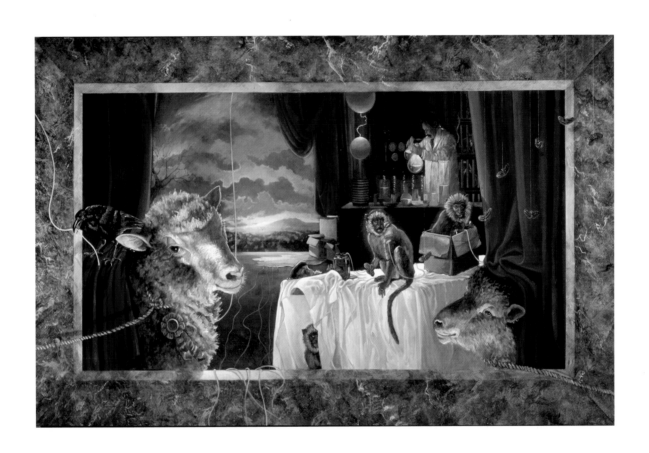

# SUE COE

Confronting the viewer with the harsh realities of societal injustice and political corruption, Sue Coe makes sobering statements about street life, sweat shops, slaughterhouses, and AIDS wards. She purposefully creates uneasy spaces and bares her contempt for cruelty and moral bankruptcy through dark narratives and figurative works that recall the mid-twentieth century German artists Otto Dix and George Grosz, who reacted against the inhumanity and avarice of the Weimar Republic. Among the many topics that Coe uses to challenge the viewer's personal space are racism in South Africa, animal rights, and the George W. Bush administration. A living witness to atrocities that are often hidden or ignored, Coe initiated her distinctive form of socio-political commentary after moving from London to New York in 1972. There she became involved with the Workshop for People's Art, a voluntary association of artists who produced posters and pamphlets for community groups. By 1974, she had also investigated topics of her own choosing, inspired by the holdings of the nearby Marxist library.[1]

Two of Coe's graphite paper works from the "Hurricane Series," created after the devastation from Hurricane Katrina, are indicative of her bold, socio-political commentary style. In *Neptune is Angry,* 2006, blade-like waves chop and slash in a raging tempest while oil wells stand like precarious sentinels in the distance. Neptune, with trident high in hand, charges toward the viewer in a chariot pulled by three powerful horses, while a walrus and a whale hold up a large red banner with the word "Hurricane" emblazoned on it. While her earlier works perhaps lift a veil of secrecy or ignorance, her protest against the political corruption and mismanagement of the catastrophe, not to mention the global warming and the political forces that have allowed it to go unchecked, echo the sentiments of an increasingly discontented society.

Coe's dark, graphic style is reminiscent of satirical political cartoons. However, her outrage at the condition of our world allows little room for humor. In *We Are All In the Same Boat*, 2006, an equally dire and humane scene is depicted. Here, a sailboat crowded with terrified passengers of all races tosses on a stormy sea. While the clouds open up to a glow of light, one lone bird dares to brave the open sky. Although some of the huddled masses cower at the spectacle of death, others reach into the open water in an attempt to save the people and animals floundering there. At once reminiscent of Théodore Géricault's *Raft of the Medusa,* 1819 (p. 22), and a dramatic version of the story of Noah's Ark, Coe reminds the viewer that our earth concerns all of us, and together we can change the destructive path we are on.

*—JS*

1   Judith Brody, "Sue Coe and the Press: Speaking Out," <www.flashpointmag.com/suecoe.html>

*Top:* **Neptune is Angry**, 2006, from the series "Hurricane." Graphite on white Strathmore Bristol board, 29 x 23 in. paper; 21 x 21 in. image ©Sue Coe. Collection of Tucson Museum of Art Museum purchase, anonymous funds, 2007.28.2. *Courtesy of Galerie St. Etienne, New York*
*Bottom:* **We Are All In the Same Boat**, 2006, from the series "Hurricane." Graphite on white Strathmore Bristol board, 29 x 23 in. paper; 13 x 13 in. image ©Sue Coe.  Collection of Tucson Museum of Art. Museum purchase, anonymous funds, 2007.28.1. *Courtesy of St. Etienne, New York*

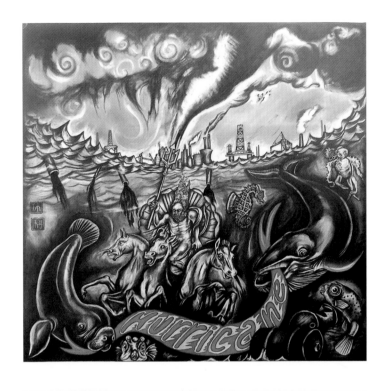

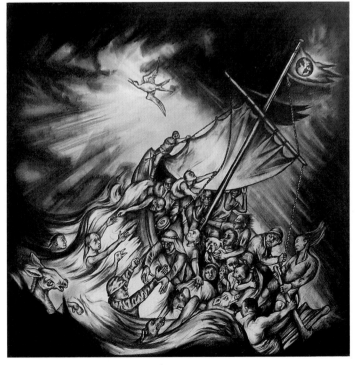

## DAN COLLINS

Flood, 2008-2009, is a video sculpture that brings to life a hypothetical flood event of epic proportions. To create the effect of a flood, Collins projects an animation of an exaggerated flood onto a topographic model of the greater Phoenix metropolitan region. The approximately eight-minute animation depicts the rise of flood waters which completely submerge areas of Phoenix and the gradual return of the landscape to an arid plain. The plausibility of this catastrophe is visualized with the aid of real-world maps, 100-year event probabilities, and data accessed from FEMA and the Flood Control District of Maricopa County.

In Arizona, dry river beds are inundated by flash floods, catchment basins overflow, and low lying areas of the Phoenix Valley are submerged. "Following predictions for a 100-year event, neighborhoods immediately adjacent to major water ways could become flooded," explains Collins. "Beyond short-term cycles, change in the global sea level resulting from melting ice caps leads one to speculate about the possibility of a flood of truly biblical proportions. Imagine all of Maricopa County—over 9,000 square miles—submerged under an inland sea."[1] While the desert terrain is far from major sources of water, such a flood could submerge the fifth largest city in the United States in minutes. Such data alters our basic perceptions of life in the Sonoran Desert and reveals the subtle, if not fragile, features of the desert Southwest.

Collins was a student of noted performance artist Chris Burden when he was a MFA student at UCLA in early 1980s and is currently a professor of Intermedia and Foundations at Arizona State University. He uses scientific advances in digital and video technology to meld aesthetic concerns with philosophic inquiry. Collins's works on paper, virtual sculptures, and fully realized, three-dimensional sculptures and installations reveal his interest in how we experience and perceive art and the world at large through semiotic cues, contextual factors, and technology. Underscoring much of his work is the focus on anamorphic form, a fifteenth-century device where images are distorted from one vantage point, but are reconstituted when seen from a different angle. Juxtaposing real phenomenology with the intangible, Collins manipulates our perception by using objects and optical devices. At the forefront of artistic exploration, he delves deeply into the understanding of such topics as code, language, morphing, and transubstantiation. —JS

1   Dan Collins, artist statement, 2008.

Flood, 2008-2009. Video installation: digital animation projected on relief sculpture comprised of computer routed gridded frame and bonded sea salt; includes 6 framed digital prints, dimensions variable.
Courtesy of the artist and Lisa Sette Gallery, Scottsdale, AZ. Technical assistance provided by Skynsay

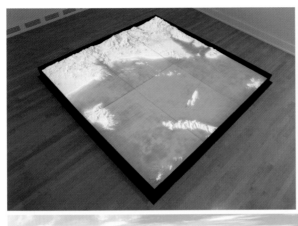

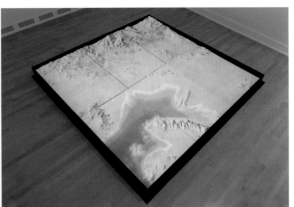

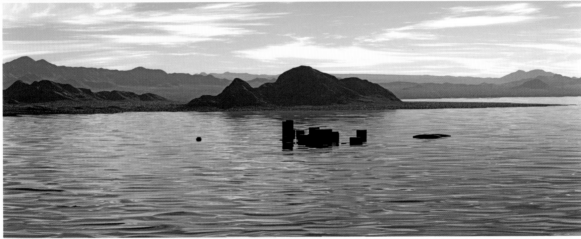

## JAMES P. COOK

Working in the American landscape tradition of the nineteenth-century Hudson River School painters who immersed themselves in the sublime aspects of nature, Arizona artist James P. Cook relies on direct observation and a deeply felt commitment to the land. Cook focuses on nocturnal industrial landscapes, intimate views of the dense foliage of woodland scenes, dramatic seascapes, and majestic vistas of the rock formations of the American West. Eschewing the then-dominant minimalist style as an art student in Kansas in the late 1960s, he opted instead to pursue a "new realist" approach to the world around him. Thick layers of luscious paint applied with wide brushes and mason's trowels mark his painting technique, while the attention to the dramatic effects of reflective light hallmark his bold style. Cook sees his method of plein air painting as less of a spontaneous act of intuitively applied pigment to canvas than a "choreographed" system of the interaction of one layer over another in observant mark making.

*Trinity Bay-Reflections*, 2007, is a seductive nocturnal scene of a Texas oil refinery. While Cook is more interested in finding the "truth" in the formal qualities of his subject matter than making comments about the land, he acknowledges the irony of it. While the region depicted in this work is considered one of the most toxic places in the world, Cook renders the place beautiful, insisting that his intent is not to glorify something that causes harm, but to be faithful to what he has seen. To Cook, his paintings attempt to address the philosophical question of how Americans understand and connect with the land. His works do not bemoan the passing of a pristine past, because he acknowledges the reality of change. Indeed, he is also aware of the conundrum faced in an era hungry for energy. As Cook observes, "We thrive because of the certain mastery of nature."[1]

—JS

1   James P. Cook, interview with Fred See and James P. Cook in *James P. Cook* (Tucson, AZ: Davis Dominguez Gallery, 2008), 14.

**Trinity Bay-Reflections,** 2007. Oil on linen, 60 x 40 in. *Courtesy of the artist and Davis Dominguez Gallery, Tucson, AZ*

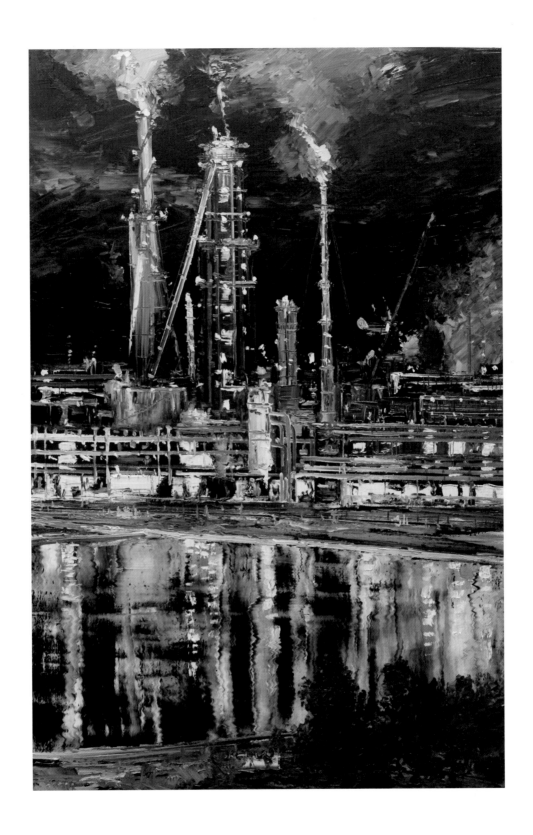

## SUSAN CRILE

Inspired by such artists as Francisco de Goya, George Grosz, Otto Dix, and Anselm Kiefer, whose paintings address the horrors of war, New York artist Susan Crile employs formal mastery of color and space to create powerful works about human atrocities and their effect on the environment and humankind. Crile was known in the 1970s and 1980s for her complex abstractions marked by radiant color and intricate patterning, but in the 1990s, she took an abrupt turn. Outraged over aggressive actions in the Middle East and the media's packaging of it as indifferent entertainment, she embarked on a series of emotionally charged landscapes.

*Encrusted Tar*, 1994, documents the aftermath of the 1990–91 Gulf War when defeated Iraqi forces detonated over 600 oil wells, igniting what is considered the greatest deliberately engineered ecological disaster in human history. At the encouragement of her brother, a noted CBS news reporter, she organized a ten-day trip to the al Ahmadi and Burgan oil fields of Southern Kuwait to witness the burning of the oil fields firsthand. Crile sketched and photographed the apocalyptic scene as part of an artistic strategy to depict the media-saturated disaster in a new way in an attempt to reinvigorate viewers who had become disassociated with it.[1]

In this painting, compositional framing strategies work to convey the physical sensation of being enveloped by fire and engulfed by choking black smoke. Reminiscent of the dramatic nocturnal scenes of British landscape painter J.M.W. Turner, this work is a vivid expression of intense heat from the raging yellow, orange, and red fire. Bifurcating the composition, the awesome inferno is juxtaposed against the dark tarry slick of the oil that covers the land. Her paintings from this time period document the environmental atrocity with a visceral quality and an emotional commentary on a crisis of place. In a shift from the landscape to figurative works, Crile's subsequent series of drawings in the mid-2000s focus on the well-documented torture of prisoners at Abu Ghraib in spare, yet riveting works inspired by the notorious photographs taken by their captors. —JS

1   Jeremy Strick, "Susan Crile: *The Fires of War.*" *Currents* 58, St. Louis Art Museum (April 12–June 5, 1994).

**Encrusted Tar**, 1994. Oil on canvas, 60 x 60 in. *Courtesy of the artist*

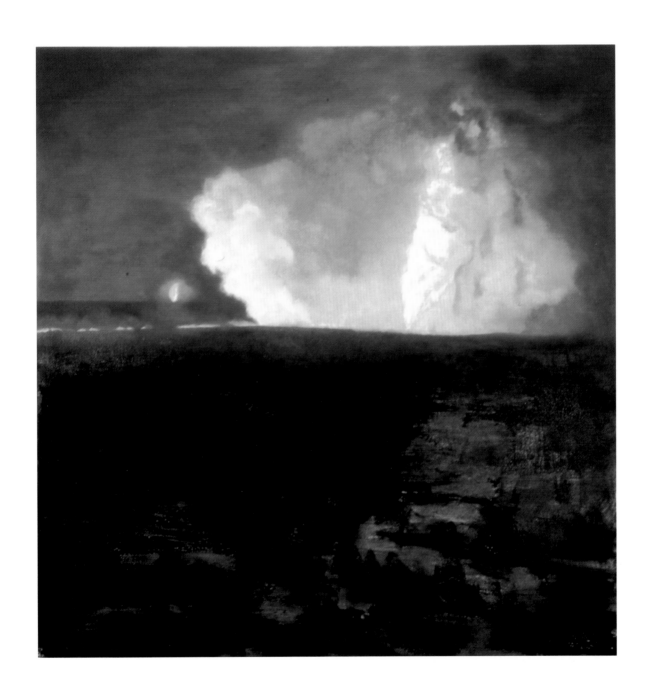

## JOHANN RYNO DE WET

South African-born photographer Johann Ryno de Wet's images tread the line between the real and the surreal. He creates dystopic environments that are imbued with a cinematographic other-worldliness. The artist begins with a digital color photograph as a point of departure, subtly transforming the mundane reality captured in the image into landscapes that are simultaneously banal and menacing, beautiful and terrifying, which recall Freud's notion of the "uncanny." In 2005, de Wet was chosen by Aperture Foundation for participation in *reGeneration* at the Musée de L'Elysée in Lausanne, Switzerland, an exhibition highlighting talented young photographers from around the world. The artists chosen for the exhibition were selected because they did not seek to rediscover the world, but to comment on it.[1]

In *Thirst,* 2006, storm clouds hover over a vast desert that stretches, empty and sun-scorched, to the dark horizon in the background. The photograph is a nightmarish view of a post-apocalyptic landscape devoid of human presence. While the scene is one as much from a distant place as it is from his imagination, viewers familiar with the desert Southwest can find familiar ground with its sublime qualities of awe and terror. The threatening storm clouds also reveal the conundrum that such arid land faces. What hovers above so often never reaches the ground so in need of the life-giving moisture. Yet when rain finally arrives, it often comes with a price—life threatening flooding and runoff that never reaches the depleted aquifer. While de Wet does not assume the role of environmental activist, his mysterious photographs nevertheless have been called a dystopic "overdose of mystery, panic, and disturbance."[2]

—EH

1   <www.galerie-poller.com/artists/Wet/deWet>
2   <www.nyartbeat.com/event/20008/08C7>

**Thirst,** 2006. Digital inkjet, 1/5. 12 $^{11}/_{16}$ x 23 $^{3}/_{8}$ in. *Courtesy of Galerie Poller, New York*

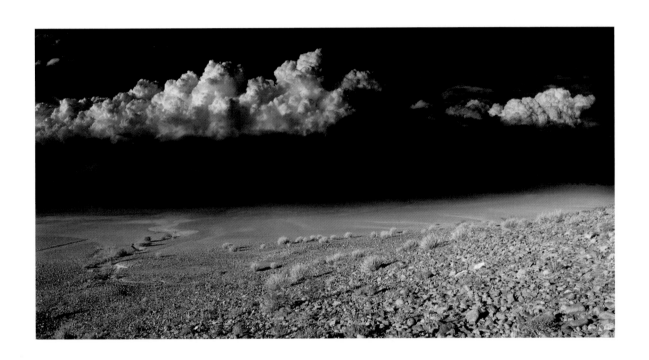

## MARK DION

Mark Dion examines how knowledge is produced by playfully probing and questioning the trappings of authority. His versions of the simulated worlds of dioramas, sculptural works, and photographic installations address environmental crises. Fascinated with the taxonomic strategies and the dioramas of natural history museums, he assumes the persona of a "dilettante scientist," adventurer, and historian in order to observe how we attempt to order the world around us. Dion has created dioramas of landfills, dug for ancient and contemporary artifacts in the banks of London's Thames River, staged fishing and entomological expeditions in the jungles of Guyana, and created cabinets of curiosities to illustrate the antiquated hierarchies of creatures and scientific learning. His museum-based interventions and fieldwork projects have garnered him an international reputation as a surrealist posing as a Victorian empiricist who addresses modern-day scientific and environmental issues.

In *The Bureau of Remote Wildlife Surveillance*, 1999–2007, Dion humorously critiques our myopic and often misguided understanding of nature. To create this piece, he first set up a number of heat-sensitive "trap-cameras" on his property in Pennsylvania to capture the movement of forest life living in the area. The resulting color photographs, organized in a tightly formatted grid, act as "data" to be studied by a fictional surveillance office. The various perspectives of the animals and the surprise aspect of the flash of the camera in the night recalls the reality of increasing surveillance in a post 9/11 world and governmental agencies' zeal to track the "enemy," even it if is only a curious white-tailed deer.[1] Thus, his interest in the study of animals and their movement is only a launching point for an examination of broader social and political issues in a "Big Brother" world.

—JS

1   Ingrid Dudek, "Mark Dion" in Brian Wallis, et. al., *Ecotopia: The Second ICP Triennial of Photography and Video* (New York: International Center of Photography, 2006), 34.

**Bureau of Remote Wildlife Surveillance**, 1999-2007. 20 unique color photographs, each: 13$\frac{1}{2}$ x 15 in. installed: 58$\frac{1}{2}$ x 81 in.
*Courtesy of the artist and Tanya Bonakdar Gallery, New York*

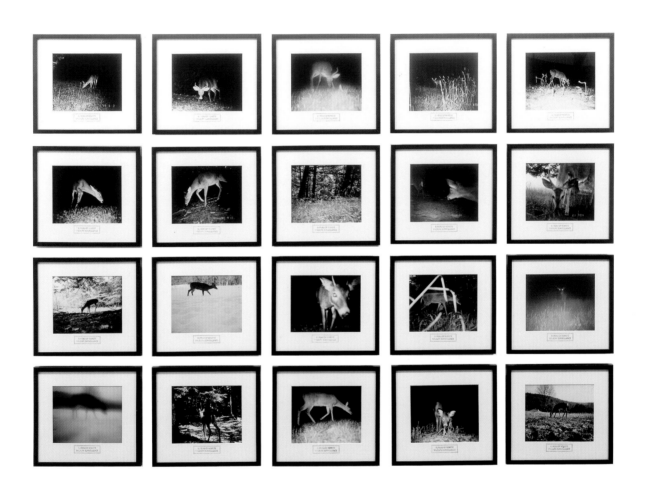

# MITCH EPSTEIN

In a career spanning nearly three decades, Mitch Epstein has created numerous bodies of work that explore often unobserved, everyday subjects. Epstein's "American Power" series resulted from what he has called an "energy tourism" journey along the Gulf Coast from Mobile, Alabama, to New Orleans, Louisiana, an area that accounts for nearly thirty percent of the United States' oil production and refining capacity.[1]

His blend of photo-conceptualism and documentary photography captures the people and communities that exist alongside nuclear power plants, oil-drilling operations, and wind turbines. These images not only document the consequences of energy production in the United States, but they also explore the complex network of economic, social, environmental, and aesthetic politics that define America both as a concept and as a culture today. In particular, Epstein is interested in how government, corporations, and the consuming public alter the landscape.

However, the landscape in *Biloxi, Mississippi, 2005,* displays not the collateral environmental costs of America's reliance on power, but the destruction wrought by Hurricane Katrina. Epstein captured this image six weeks after the hurricane struck. Although cleanup was well underway, the landscape still bore the traces of Katrina's devastation. Set against the backdrop of a picture-perfect blue sky is a tree strewn with tattered clothing. A mattress hangs precariously from a broken branch, while, in the background, an upended car spins its tires in the air. Indeed, in *Biloxi Mississippi,* Epstein captures a world turned upside down, a surreal collision of nature and culture brought about by a natural catastrophe of unimaginable proportions. Rather than a testament to American power, this image speaks of the ultimate vulnerability of the energy-producing coastline. It is a stark reminder that, although powerful, America is not omnipotent.

—EH

1   Mitch Epstein, <www.americanacademy.de/home/program/on-the-waterfront/blog/2008/01/30/american_power_what_s really_at risk/233/detail/>

**Biloxi, Mississippi**, 2005, from the series "American Power." C-print, edition of 6, 45 x 58 in.
*Courtesy of the artist & Sikkema Jenkins and Co., New York.* Used with permission. All rights reserved.

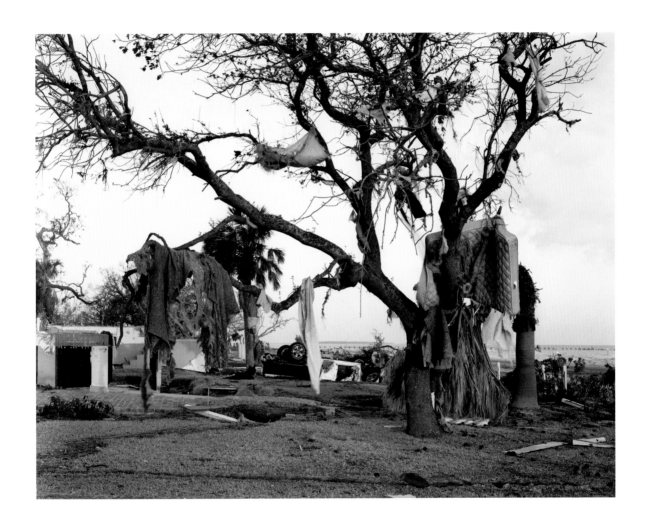

## VERNON FISHER

Texas artist Vernon Fisher combines text, painting, photography, sculpture, and drawing with found objects in his work that addresses life's experiences, reconciling the extraordinary with the mundane. Exploring the nature of perception, Fisher assembles a network of artificial signs such as written language, maps, standards of measurement, and color scales that urge the viewer to read and interpret them like "intermediaries between ourselves and the world."[1]

Metaphoric content is a strong component in Fisher's *Inscribing the World with Water,* 1994. One work from his well-known "blackboard" series, this painting resembles the dark charcoal of an old-school slate board. A wooden shelf that holds an eraser and white chalk bifurcates the canvas into upper and lower sections (in itself symbolic of landscape and of heaven and hell). The predominant image of this painting is a linear drawing of the earth; dotted lines delineate polar caps and current flows. Erased and redrawn in palimpsest fashion, the diagram stands as a symbol of the earth under constant natural change and imposed revision.

Superimposed on the earth are fragile, leafless saplings, while above them, a blood-red drawing of a hand pours liquid from a glass beaker that extends down the full length of the canvas, as if offering the saplings a much needed drink. In three of the quadrants that result from the intersection of chalk shelf and downpour of water, thick tree trunk logs reveal deeply scarred wounds. This work recalls not only how reliant we are on water to sustain life, but also that this very same element could be our downfall in the way of flooding as a result of global warming. The hand pouring the water recalls our society's impact on the environmental problems we face today, and that we also have the power to affect change for the better. Thus, Fisher's work is rich with metaphoric content, from the didactic connotations of the blackboard to the detailed diagrams explaining the earth's fragility and dependence on water.
—JS

1   Madeleine Grynsztejn, "Telltale Signs: The Art of Vernon Fisher," in *Vernon Fisher* (La Jolla: La Jolla Museum of Contemporary Art, 1989), 8.

**Inscribing the World with Water**, 1994. Oil, blackboard slating on wood, chalk, erasers, 71 x 76 1/2 x 6 in. Collection of Tucson Museum of Art Gift of the Contemporary Art Society in memory of Jules Litvack 2005.11.1

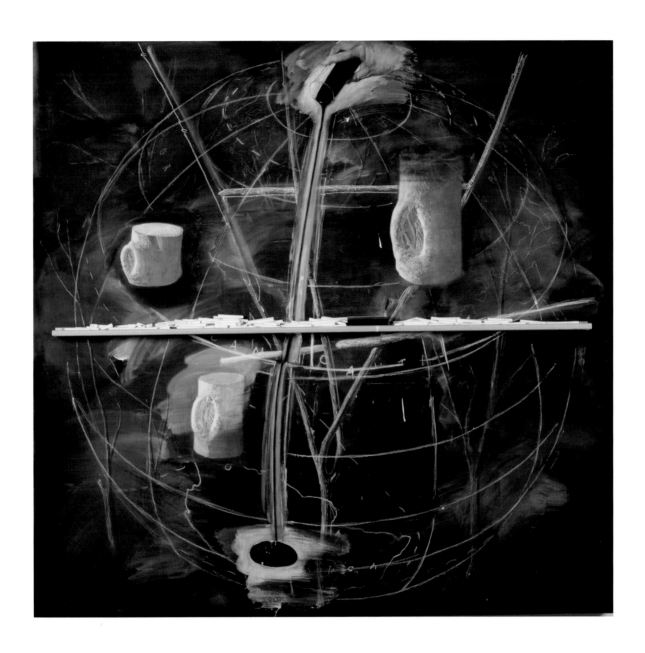

# PAUL FUSCO

For more than fifty years, photojournalist Paul Fusco has produced important photo-essays on social issues in the United States and abroad. Fusco first worked as a photographer with the United States Army Signal Corps in Korea in the early 1950s. As a staff photographer for *Look* magazine in the 1960s and member of the Magnum Photography Agency from 1974 to the present, Fusco has focused his lenses on subjects ranging from miners in Kentucky to the Zapatista uprising in the Mexican state of Chiapas.

In 1997, Fusco traveled to Ukraine and Belarus to document the human and environmental casualties of the 1986 Chernobyl nuclear power plant disaster. Described by the United Nations as "the greatest environmental catastrophe in the history of humanity," the explosion released 200 times the radioactive fallout of the two nuclear weapons detonated at the end of World War II. Large areas in Ukraine, Belarus, and Russia were badly contaminated, resulting in the evacuation and resettlement of more than 336,000 people. *Ukraine, Prypiat*, 1997, depicts abandoned housing that was built to service Chernobyl stations. Because of the dangerous levels of radiation, all 50,000 residents were evacuated from the city the day after the disaster.

The explosion has been linked to a drastic increase in birth defects and cancer rates. After the disaster, four square kilometers of pine forest in the immediate vicinity of the nuclear reactor turned brown and died. Although these "red forests" are now thriving, the long-term effects of radioactive contaminants on the various affected habitats remain unknown. Fusco's images capture the places and people who—a generation after the explosion—still bear the horrific burden of Chernobyl's legacy.[1]

*—EH*

1    <http://www.magnumphotos.com/Archive/C.aspx?VP=XSpecific_mag.BookDetail_VPPage&pid=21c703r18zxl8>

**UKRAINE. Prypiat,** 1997. Gelatin silver print, 16 x 20 in. *Courtesy of Magnum Photos*

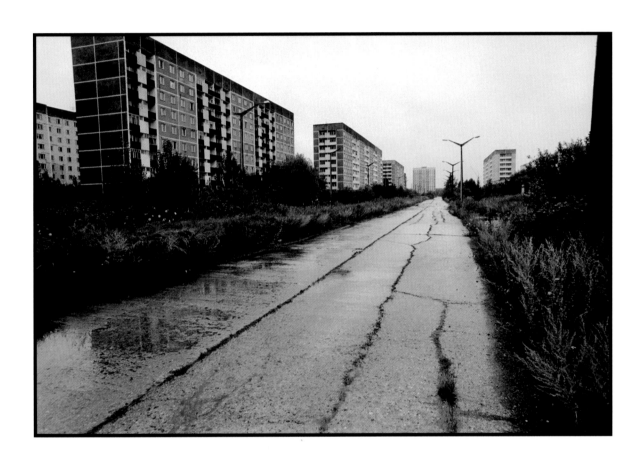

# FRANCESCA GABBIANI

An uncanny threat of violence hangs over Los Angeles-based artist Francesca Gabbiani's theatrical interior scenes made through her signature technique of cut and collaged colored paper and gouache. Eerily vacant rooms reveal blank mirrors in antique frames, candelabras with cool, glowing flames, and ornate fireplaces with less-than-cozy fires in them; outdoor scenes of raging forest fires are placed in elaborate, pointy-edged Art Deco frames. Her work leaves the viewer with a sense of the dark and the haunting—macabre without any sign of the danger that is implied by the harsh, raking light and extreme opposition of dark and light tones. "There is a way in which these blank mirrors, these evacuated rooms, these candles which appear to have lit themselves, are conspiring against you," observes author Benjamin Weissman, "grinning in an unseemly manner with the hungry leer of something lying in wait, a knowing presence, which casts the viewer as prey, the missing figure the Rococo molding was waiting for."[1]

In *Rise*, 2007, Gabbiani depicts an inferno rising up through tall trees—the scorched trees standing in stark silhouette to the raging fire that smokes and glows with fierce yellow and Halloween orange. Barely discernable at first, a fleet of witches with pointy hats ride on broomsticks that emanate from the dark branches of the pine trees into the searing air. In this terrifying scene, the viewer is at once mesmerized and repelled by the powerful fire. In many ways, the spectacle of the fire recalls the media's fascination with natural disasters and thus our own psychological compulsion to witness disaster—like moths to a flame, we get ever closer to potential disaster only to get burned by our own greed and curiosity.

—JS

1   Benjamin Weissman, "Black Rooms that Smell Like Anise" in *Francesca Gabbiani: Soul Keepers* (Santa Monica, CA: Patrick Painter Inc., 2007), 3.

**Rise**, 2007. Colored paper and gouache on paper, 69 x 57 in. Collection of David Burtka. *Courtesy of Patrick Painter Gallery, Santa Monica, CA*
Photo: Fedrik Nilsen

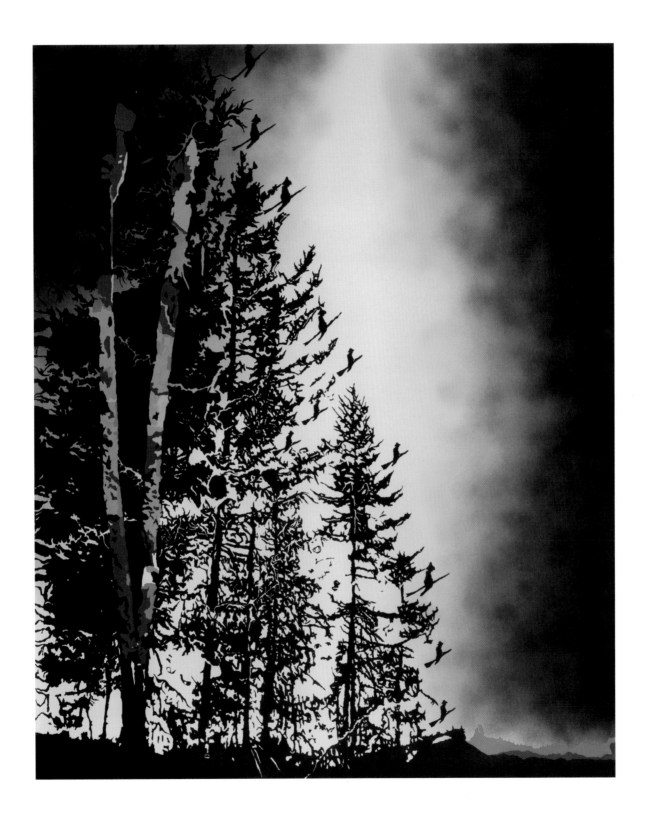

## SUSAN GRAHAM

New York artist Susan Graham works with photographs, sculpture, video, and drawings to create uneasy objects and situations that reinforce the pervasive sense of anxiety in the world. Her sources come not only from the news media but also from her extended family of charismatic, fundamentalist Christians who talked endlessly about the second coming, holy wars, and the apocalypse when she was a child. Fascinated by, yet skeptical of this apocalyptic outlook, Graham expresses the fear and optimism of her upbringing. Growing up in Dayton, Ohio, she also witnessed, firsthand, the devastation of a tornado that virtually wiped out the nearby town of Xenia, Ohio, in the 1970s. Soon after, her teachers talked endlessly about tornadoes, showed films about them, and held tornado drills, which further instilled a sense of apprehension and anxiety. Her interest in natural disasters and the fear they spawn was reinvigorated after Hurricane Katrina wreaked havoc in the South. Thus, childhood fears and adult dreams of the apocalypse are encapsulated in her eerie depictions of the bucolic gone bad. As Graham explains, "As a kid it was the nuclear bomb and the tornadoes in our region, but now it is about the world becoming uninhabitable."[1]

*Big Storm 2*, 2006, depicts a disturbing dream-like landscape within a dark gloomy sky. A large oil derrick lords over a cluster of pitched-roof houses and other ornate structures. Splitting the composition, an ominous tornado approaches the domestic setting. Graham affected the soft-focus, nightmarish atmosphere of the scene by first making a pinhole photograph created from a simple camera with no lens, small aperture, and manually operated shutter. She later scanned and enlarged the photograph into a digital print, further reinforcing the surreal quality of the composition in the scene itself. This is not a photographic capture of a real moment, but miniature sculptures made of cast sugar and fabricated tornado and derrick. Graham began to use sugar as a medium several years ago when she experimented with super eight film.

In recent photographs and video work, she relates the experience of one woman's attempt to live in a situation of relative safety and comfort as she tries to prepare for such calamities as a natural disaster, war, or an out-of-control government. Addressing foreboding threat, paranoia, and survivalist ideology, her female protagonist tries to hide from disastrous skies looming outside, while reciting a detailed list of things needed to survive in a post-apocalyptic world.[2]

—JS

1  Susan Graham, telephone conversation with the author, 23 October 2008.
2  Susan Graham exhibition press release, Schroeder Romero, New York, NY, 2007.

**Big Storm 2**, 2006. Lambda print, 1/2, 30 x 40 in. *Courtesy of the artist and Schroeder Romero Gallery, New York*

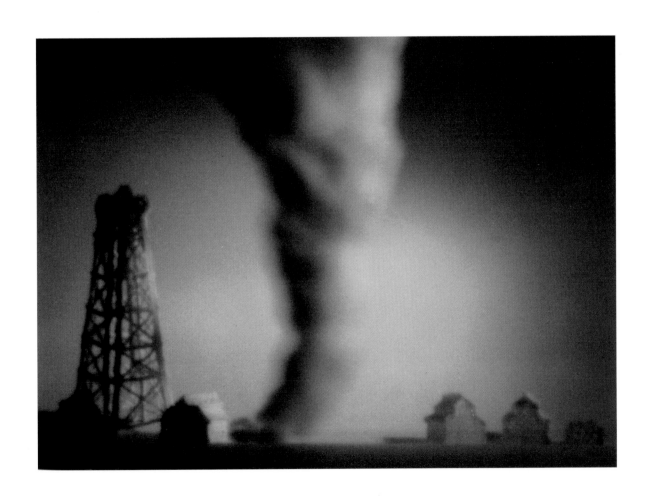

## HEATHER GREEN

Arizona artist Heather Green's work is informed by her life-long relationship with the headland of La Cholla near Puerto Peñasco, Mexico, which has one of the largest tides in North America. Green combines traditional oil paints with letterpress, carved topographical maps, etched glass, and oxidized metal to create cerebral, yet romantic installations that reflect her experiences in this desert coastal region. Intent upon educating a wide audience about the importance of biodiversity and ecology, she has worked with poets, scientists, and fisherman on a variety of nature-based projects. Her investigations and projects have yielded poetic works that reveal the nuances of place, memory, and natural phenomena. Green has worked extensively with the Intercultural Center for the Study of Deserts and Oceans (CEDO), collaborated on projects with the astronomy department at the University of Arizona, and worked on the international project, PANGAS, that strives to connect Mexican fishermen with science, policy, and ecology in order to sustain their fisheries.[1]

*Tide Cycle—An Act Against Erasure*, 2008, is comprised of oil paintings, linotype on steel shelves, letterpress cards, and two mutoscopes that depict the Cholla tide going in and out from dawn to dusk.[2] The paintings focus on a red chair being sucked out by the tide. Accompanying each painting is a rusted shelf with a stack of weathered linotype slugs that reference the problems with development and over-fishing in La Cholla. As the artist explains:

The chairs allude to the fable of the British King Canute, so besotted with his own power that he boasted he could control the tides.... To demonstrate this, he ordered his throne to be placed on the shore at low tide where it was consequently overwhelmed by the incoming water. Though a story over a thousand years old, its point is apt: one cannot control the natural cycles of the world, nor demand that they bend to one's will.[3]

Cast into the linotype slugs are many common and scientific names of species that are threatened by the aggressive fishing and development in the headland. The artist uses the installation as an opportunity to bring about awareness of the environmental problem. Take-away cards, created from the linotype slugs, direct the viewer to a website to learn more about La Cholla and a virtual museum in the making called *La Cholla Museum of Nature and Cultural History*, a project that seeks to illuminate the hidden facts and history of this irreplaceable ecosystem.

—JS

1  Heather Green, artist statement, 2008.
2  Mutoscopes are an early motion-picture device based on the concept of the flipbook. Hundreds of individual photographs on flexible paper are attached to a central core, activated by a hand crank for personal viewing. Such devices were popular at the turn of the twentieth century in amusement parks and arcades.
3  Heather Green, "Tide Cycle—an Act Against Erasure," exhibition statement, The University of Arizona Museum of Art, April 2008.

**Tide Cycle—An Act Against Erasure**, 2008. Oil on panel, linotype on steel shelves, letterpress cards, mixed media mutoscopes, dimensions variable. *Courtesy of the artist*

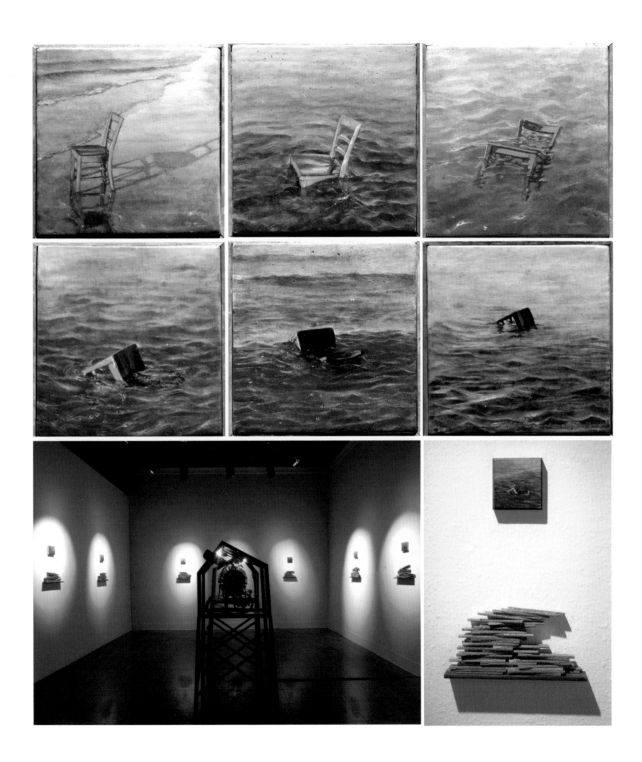

## EMILIE HALPERN

French-born artist Emilie Halpern creates photographs, videos, and sculptures inspired by nature, scientific magic, and the romantic. Relying on careful research into such phenomena as moths that feed on human tears, deceptive orchids, dying stars, the far side of the moon, and lightning bolts, she creates haunting metaphors for the pain and thrill of the human heart. Like a magician unafraid of revealing her secrets, Halpern employs optical fakery to entice the viewer. As one critic comments, "The artist offers glimpses of fantastic possibilities while simultaneously alerting us to the harsh limitations of our shared perception."[1] The natural wonders she conjures elicit the emotions of awe and resignation as we marvel in joyful abandon at that which we know to be filled with disillusionment.

*Lightning #5*, 2006, is a formally elegant sculpture made of thermoplastic and aluminum wire that hangs from the ceiling. Recalling elementary school science fairs, where science was made visible through such projects as ant farms, baking-soda volcanoes, and other home-made displays, Halpern expresses our need to articulate the natural world in commonplace terms. In particular, she depicts the powerful and emotionally charged forces of nature that become archetypes of sublime moments as a way of expressing deeper themes of light and darkness, life and death, and the body and its absence.[2]
—JS

1  Brendan Threadgill, "Emilie Halpern," *Art US*, issue 14 (July–September 2006), 5.
2  Holly Myers, "Unfathomable Acts Evoke a Sense of Awe," *Los Angeles Times* (28 April 2006).

**Lightning #5**, 2006. Thermoplastic, aluminum wire, 50 x 33 x 74 in. *Courtesy of the artist. Photo: Brian Forrest*

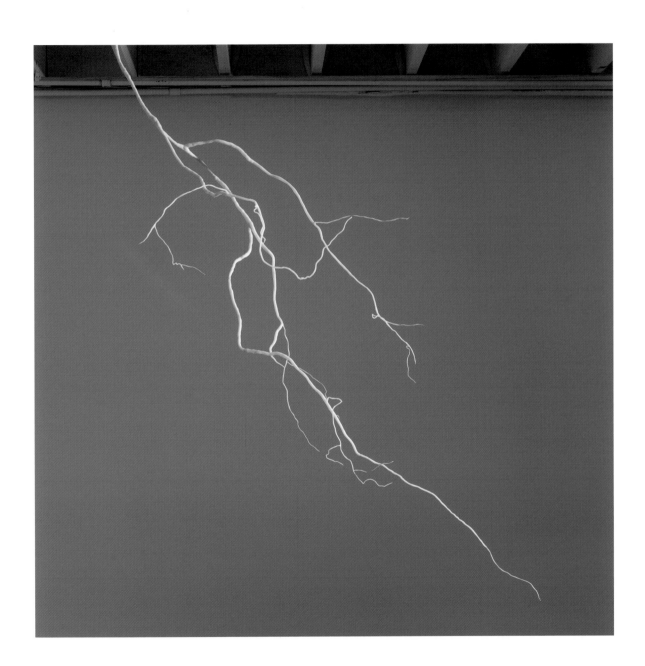

## JULIE HEFFERNAN

**N**ew York artist Julie Heffernan creates allegorical tableaux that insinuate impending disaster in otherwise paradisiacal settings. These epic dramas of people, lush foliage, and such atmospheric theatrics as ominous tornadoes, smoke trails, and bursts of flame are painted in the rich oil tradition of Baroque and Rococo masters. By blending the genres of still life, portraiture, and landscape in her monumental canvases, Heffernan creates a kind of operatic grandeur and makes timeless statements about the human condition.[1]

Typically, Heffernan paints herself in the center of an opulent composition as a serene milk-skinned, red-haired little girl or twins in the nude or dressed in elaborate costumes. In this way, the artist combines enticing sexuality with threatening magic. Other times, she melds her likeness with noted figures in art history to further weave a mythical tale as mysterious and metaphorically laden as the sublime setting in which she places herself.

In *Self Portrait as Astyanax*, 1997, Heffernan portrays herself as an archetypal figure in an opulent forest of ripe fruit against a backdrop of a mythical battle and impeding natural disaster. Astyanax, known as the "Lord of the City" of Troy, has alternately been known as the son of the Trojan hero Hector and Andromache and the son of Heracles and Epilais, both prominent figures in Greek mythology. As a young Astyanax, Heffernan stands before the viewer bald and nude with the image of a storm emblazoned on her forehead. She playfully holds a writhing oroborus, a mythic snake that eats its own tail. She gazes out at the viewer with a wry, almost sinister smile as if a harbinger of the destruction to come—a smoking volcano in the distance that threatens to erupt. Behind her, a cacophonous assembly of toga-clad Lilliputian-sized warriors battle each other, oblivious to the spectacle standing before them.

To the artist, the child is not an innocent, but implicated in the blood bath behind her. The oroborus suggests that things continue in a circular way, just as violence seems never ending. Equally important is the storm symbol on Astyanax's head. It suggests the storms in the minds and hearts of the warriors.[2] In such a scenario, Heffernan does not portray an idyllic Eden or an unwitting Eve, she represents one who is consciously aware of what her actions will summon— her own expulsion from the garden and therefore her own demise.

—*JS*

1   Janet Riker, "Introduction," *Julie Heffernan: Everything that Rises* (Albany: University Art Museum, 2006), 7.
2   Julie Heffernan, email correspondence with the author, 28 July 2008.

**Self Portrait as Astyanax**, 1997. Oil on canvas, 66 x 89 in. *Courtesy of Lisa Sette Gallery, Scottsdale, AZ*

## RODERIK HENDERSON

For years, Dutch photographer Roderik Henderson, along with his wife and daughter, traveled through the deserts of Nevada, California, Utah, New Mexico, Arizona, and West Texas. Like modern-day nomads, the family wandered through and photographed barren landscapes. It was, Henderson has written, "a trip through the world's ultimate void, [a search] for the lucidity of naked rock and burning sand. No thoughts, no dreams, no ambitions—only absolute, sublime nothingness."[1] However, the photographer soon found that this "sublime nothingness" was full of the traces of human activity—the untouched desert of his dreams no longer existed.

Henderson's "Badlands" series was photographed in the deserts around Caineville, Utah. One of the most desolate areas in the world, its extreme topography and steeply eroded hills make it a popular site for motorcyclists and off-road vehicle enthusiasts. Studies have indicated that the lands disturbed by motorcycles and ORVs are eroding the land 300 percent faster than the natural rate. In Henderson's images, tire tracks, which can remain visible for nearly a decade, cut across the smooth contours of the desert landscape like scars. In *Badlands #14*, 2001, a sublime landscape in black and white captures dramatic storm clouds that open with a cascade of regal sunlight onto a majestic mountain panorama. Undulating and swirling incisions caused by recreational vehicles stretch like veins across the land, reminding us of the cost of human presence. Henderson's surreal photographs capture a habitat irreparably altered and damaged by human activity. —*EH*

1   Roderik Henderson, artist statement, 2008.

**Badlands #14**, 2001. Gelatin silver print, 24 x 35 in. *Courtesy of the artist*

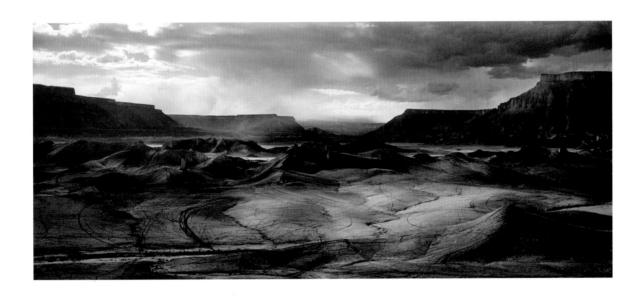

## TRACY HICKS

Incorporating glass shelving, translucent cast rubber scientific containers, plant life, thermometers, small hydraulic systems, and video in pseudo-scientific installations, Tracy Hicks takes a unique approach to the examination of the precarious balance of our shared global ecosystem. Hicks is an avid breeder of endangered and non-endangered species of frogs and references these creatures to make urgent statements about global warming and species decimation.[1] A self-professed obsessive interpreter of collection, he has long been interested in the idea that everything is within a subset of collection, and that everyone interprets the world on an individual basis, furthering our general knowledge.[2]

In 2005, Hicks was invited to work with scientists at the University of Kansas Natural History Biodiversity Museum and Chicago's Field Museum, which hold two of the world's most comprehensive collections of amphibians. The resulting exhibition, *still/*LIFE was shown in Dallas in 2008, which later expanded to a two-room installation, *Global/ Warning.* Together they suggest a science laboratory complete with a specimen collection teeming with clear jars filled with cast translucent urethane and silicone replicas of endangered tropical frogs and toads. Infused with brilliant pigments and fluorescent and phosphorescent dyes, these casts of extinct or endangered species glow in the dark with a toxic hue. In such works, Hicks presents the idea that, while nature is intently studied, it is also manipulated to the breaking point.

*Canaries/Frogs/Silence,* 2009, is an installation created specifically for *Trouble in Paradise.* In this piece, Hicks continues his inquiry about what we find precious enough to preserve and the boundaries between art and science. His representations of life's diversity recall contemporary scientific environments, eighteenth-century empirical studies, and alchemy of the Middle Ages. Regarding the unusual presentation of these unique beings, Hicks remarks, "By turns ethereal, somber, vibrant, and insistent, they whisper life's fragility and shout its resilience."[3]

—*JS*

1. Charissa N. Terranova, "Enlightenment Awaits Those Who Leap into Tracy Hicks' Endangered-frogs Installation at McKinney Avenue Contemporary," *Dallas Morning News* (12 July 2008): E1.
2. Tracy Hicks, email correspondence with the author, 1 October 2008.
3. Tracy Hicks, artist statement, 2008.

**Canaries/Frogs/Silence**, 2009. Detail of mixed media installation, dimensions variable. *Courtesy of the artist. Frog photos courtesy of Tim Paine*

## DODO JIN MING

In her series of seascapes entitled "Free Element," Chinese born photographer DoDo Jin Ming captures the awesome power and drama of the sea. She photographs the treacherous coasts of Maine, Nova Scotia, and Hong Kong. Jin Ming, like pioneering nineteenth-century explorer-photographers, captures her images at great personal risk.[1] In *Free Element, Plate XXX*, 2002, an eerie light emanates from a darkened sky as the terrifying force of turgid water cascades toward the viewer. Jin Ming forces her audience to share her death-defying experience: standing before the photographs, the viewer balances on a precipice about to be submerged under surging waves.

The solidity of land becomes replaced by the turbulence of the sea and the sky. Often, it is difficult to tell where one begins and the other ends. This merger of elements occurs as a result of Jin Ming's photographic practice, which often involves printing an image from a combination of two negatives. In this way, Jin Ming's photographs hark back to the nineteenth-century photographer Gustav LeGray's composite seascapes.[2] Yet, in its vertiginous exploration of nature's wildness, the "Free Element" series recalls the paintings of J.M.W. Turner and Winslow Homer, for whom, like Jin Ming, the sea was both sublimely beautiful and terrifying—a powerful force in its own right and a metaphor for the artist's more elusive, and more personal, emotional landscape. —EH

1  Margaret Loke, "Art in Review: DoDo Jin Ming 'Seascapes'," *New York Times* (7 June 2002).
2  Press release, Laurence Miller Gallery (April 18–June 15, 2002).

**Free Element, Plate XXX**, 2002. C-print, 7/10, 42 x 51 in. © DoDo Jin Ming. *Courtesy of Laurence Miller Gallery, New York*

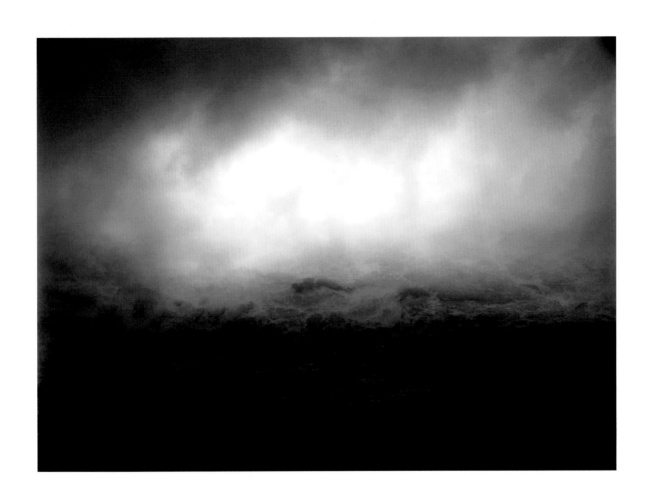

# KIM KEEVER

At first glance, Kim Keever's large-scale photographs of dystopic environments recall the sublime atmospherics inherent in the landscape traditions of Romanticism, the Hudson River School, and Luminism. Upon closer inspection, however, something appears to be too surreal to be an actual environment. Keever, who was first trained as a painter, constructs miniature topographies by hand from paper, plaster, reflective mylar, and other materials in a 200-gallon tank and fills it with water. He further manipulates the other-worldliness of his dioramas with colored lights and pigments to produce ephemeral atmospheres and cloud formations.[1] His subversion of historic canons through contemporary contrivance and conceptual artifice emphasizes the dichotomy between reality and perception and our assumptions about the concept of the landscape.

*Summer: Blue, Yellow and Gray*, 2004, is a large-scale color photograph that depicts withering trees within a rocky, swampy landscape engulfed in a toxic cloud of acrid yellows, oranges, and greenish sky. The floating debris within the tank that holds his diorama translates to film like the flaws of an early printing technique or the weathered surface of an ancient fresco. The overarching theme of his work is thus a deep veneration of natural forces and an inherent warning about our effect on the land. As Mel Watkin explains, "Keever, who grew up on the Eastern shore of Virginia, watched nature go through its paces often as a child. He is especially aware of the brute force of major storm systems, the sheer muscle of wind and water erosion and the monstrous ability of microbes, bacteria, algae and other flora to multiply and accrue."[2] Just as Keever manipulates his "landscapes" with artifice for aesthetic effects, so too does humankind intervene in nature's systems, often with similarly disconcerting results but with much graver consequences.

—JS

1   Lisa Umberger, *Kim Keever: Suspended States* (Sheboygan, WI: John Michael Kohler Arts Center, 2005).
2   Mel Watkin, "Kim Keever," *Unreal Exhibition* (St. Louis: Contemporary Art Museum, 2002).

**Summer: Blue, Yellow and Gray**, 2004. C-print, edition of 3, 51 1/8 x 68 1/8 in. *Courtesy of Kinz + Tillou Fine Art, New York*

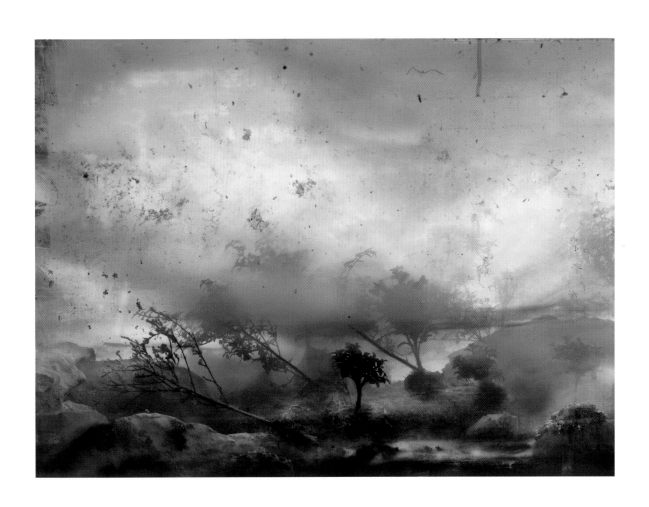

## ISABELLA KIRKLAND

Inspired by seventeenth-century botanical painters Georg Dionysus Ehret, Jan Davidzson de Heem, and Rachael Ruysch, California artist Isabella Kirkland examines humankind's relationship to the natural world. Interested in science from an early age, she worked for a time as a bird taxidermist and developed a keen awareness about the fragility and interconnectedness of life. Currently, she serves as a research associate of the Library and Department of Aquatic Biology at the California Academy of Sciences. Her meticulously researched and precisely rendered drawings and oil paintings attest to her keen desire to create a dialogue about environmental issues through her art.

Kirkland's *Gone*, 2008, is an inkjet print based on her original oil painting of the same name—part of a series entitled "TAXA." Created in the opulent style of seventeenth-century Dutch still life painters, *Gone* focuses on sixty-three species that are now extinct. Within this series, she also created *Descendant*, which depicts plants and animals that are listed on federal endangered species lists and presumed extinct in the mainland United States, Hawaii, or Central America; *Trade*, which highlights species whose wild populations have been depleted by collectors for both legal and illegal markets; and *Ascendant*, which pictures non-native species that have been introduced to the United States (or its trust territories) and are on the increase, as they successfully out-compete native residents. The series also includes *Back*, a more optimistic painting that depicts species that have been rediscovered or brought back from the brink of extinction. Finally, she painted *Collection*, an exploration of our desire to possess plants and animals that we want to study in depth, to exhibit, or simply to admire at leisure.

Before embarking on a painting, Kirkland conducts thorough research into a particular subject such as endangerment, invasiveness, and trade value. After compiling a detailed list of species of flora and fauna within those categories, she exhaustively researches her subjects, and measures and photographs specimens. Before Kirkland begins painting, she makes hundreds of preliminary drawings in order to get each plant and animal rendered as accurately as possible. Then she paints from her drawings for several months to depict her subjects in life size. Kirkland not only sends ecological messages through her art, but she often lends her images to organizations such as the UN Conference on Biodiversity, the Missouri Botanic Gardens, and the All Species group for fundraising and awareness-building projects.[1]

—*JS*

1   Isabella Kirkland, interview at Feature Inc. Gallery, New York, NY, <http://www.featureinc.com/artist_bios-texts/kirkland-texts.html> (30 May 2002).

**Gone,** 2008. From "TAXA," a suite of six inkjet prints, edition of 50, printed by Trillium Press on Moab Entrada natural white, 35 x 26 in. *Courtesy of the artist and Feature Inc., New York.* Photo: Electric Works

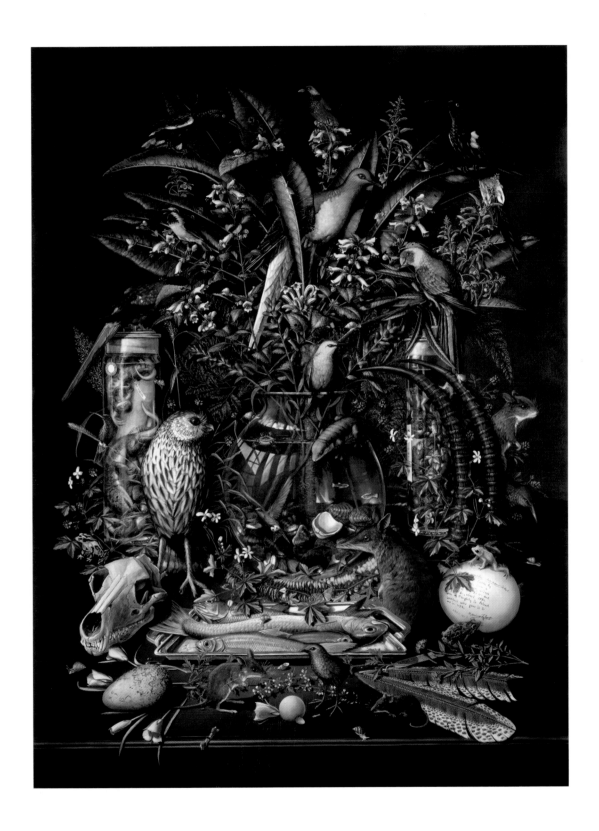

# DIMITRI KOZYREV

Russian artist Dimitri Kozyrev explores the abject qualities of nature through his landscapes that are imbued with a surreal sense of perspective and sparse articulation of subject matter that one writer calls "autopian" topography.[1] Through deft juxtapositions of overlapping planes of color, Kozyrev creates an uneasy dimensionality in his investigation of the relationship between time, space, and distance. Derived from photographs taken on road trips throughout the country, and informed by analytic cubism and constructivist tenets of angularity and material/spatial concerns, Kozyrev's paintings are highly nuanced landscapes charged with intense psychological content.

*Teenage Dream*, 2002, is oil and acrylic on linen in muted tones that recall the long stretches of desert and uninhabited land that define much of the eastern edge of the California coastline. The expanse of what could be sand is reinforced by the regular patterning of wide lines, reminiscent of the texture created when machines grade the beach of seaweed and debris. The articulation of structures that resemble freeway overpasses, roadways, the staccato pattern of upright poles, and other subtle marks that allude to built structures are devoid of human presence. Only the sky dominates the eerie quiet of his draftsman-like rendering of a stark landscape seen from a speeding car. Not quite thunder clouds, not quite acrid smog, the atmosphere appears nonetheless claustrophobic, hovering over the land that stretches out into the distant horizon. Such is the tenor of so much abused land throughout the world—scored, scarred, bladed, and left for waste—neither utilitarian space nor wilderness.

—*JS*

1   Colin Gardner, Wall Notes, "Space/Vision/Perception," 2006.

**Teenage Dream**, 2002. Oil, acrylic on linen, 36 x 36 in. *Courtesy of the artist and Mark Moore Gallery, Santa Monica, CA*

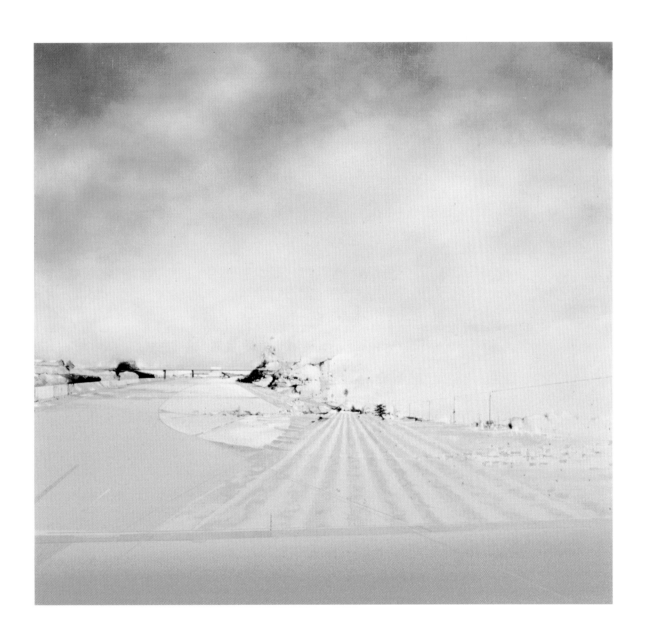

# NEVAN LAHART

Considered by some to be a satirical jokester known for "toying with art history from Dürer to Duchamp via Van Gogh," Irish artist Nevan Lahart plays with words, emotions, politics, popular culture, materials, and the viewer's expectations.[1] But while Lahart employs humor, it is not at the expense of sadness and poetry. As the artist explains, "A lot of my work is within the happy/sad, comic/tragic tradition—a kind of "grey humor" that has an affinity with loss—a sort of contemporary nostalgia."[2] His work takes the form of paintings, drawings, animation, computer programming, video, and installation projects, while his irreverent social commentaries are at once hilarious and sobering. We laugh at ourselves and the world's situation for a suspended moment—then the reality of his farcical message sinks in. Issues such as the exploitation of migrant workers in the Republic of Ireland, Bush administration politics, and the environment have all come under Lahart's comical scrutiny. Garnering the attention of his peers for his politically charged work, he won acclaim in 2004 at the prestigious Eurojet Futures show at the Royal Hibernian Academy in Dublin.

*Ch. 91: The Sun Sets on Santa's North Pole Operation*, 2007, emulates Géricault's *Raft of the Medusa* (p. 22). In this dark-humored work, Lahart presents a crudely rendered old-style television with a black-and-white image of a shocking scenario. Floating among choppy waves with a turbulent sky overhead, a large white polar bear sits on his haunches on a small ice flow and licks his paw. A dead, denuded and bloodied Santa Claus, wearing only white fur-edged boots and his signature stocking cap, lies spread across its lap like a pietà. Santa is the last great victim of global warming and the melting of the polar ice cap. Lahart intends no moral message in the image, nor does he see it as a catalyst to make us react. To him, it is simply a way of documenting the present as we find it. Still, the viewer cannot help but reflect on the work as a parody of the ubiquitous reports about global warming that swirl in the media like so much casual entertainment. It would be a depressing scene if it wasn't so absurd—Santa Claus is a myth (although not to Lahart, who believes Santa is "as real as any of the ideas we find cluttered around us"), but Santa's plight reminds us that foolish people think that global warming is a myth too.

—JS

1   Cristin Leach, "Nevan Lahart is the Joker in the RHA Pack of Young Irish Artists," *The Sunday Times,* Irish Edition (28 November 2004), Culture Supplement, p. 8.
2   Nevan Lahart, email correspondence with the author, 18 November 2008.

**Ch. 91: The Sun Sets on Santa's North Pole Operation**, 2007. Oil and acrylic on MDF, 18 x 24 in. *Courtesy of Kevin Kavanagh Gallery, Dublin, Ireland*

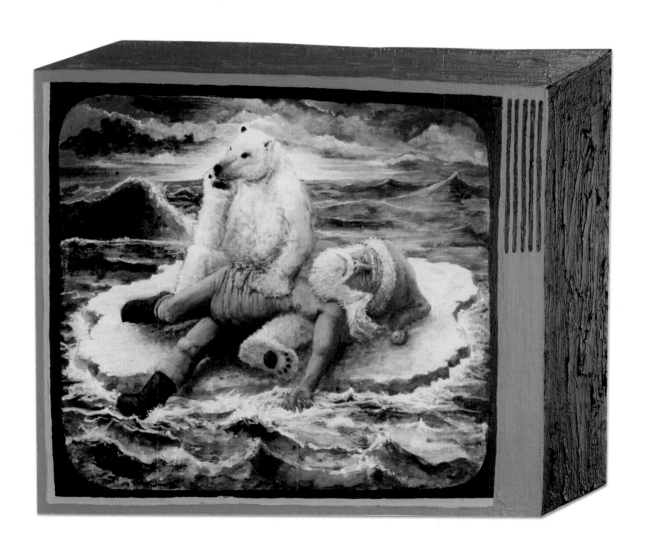

## ROSEMARY LAING

**W**orking in photography since the late 1980s, Australian Rosemary Laing creates large-scale photographic scenes within which conditions of contemporary experience and cultural history are dramatized in the form of human interaction with the natural world. For her series "brownwork," 1996–1997, "airport," 1997, "flight research," 1998–2000, "bulletproof glass," 2002, and "weather," 2006, Laing photographed scenarios that involved extraordinary performances for the camera. For *groundspeed,* 2001, and *brumby mound, burning Ayer, scrub,* and *remembering Babylon,* works from "one dozen unnatural disasters in the Australian landscape," 2003, she sets products of human activity in evocative landscapes. Other works depict sites in which the transformative traces of human intervention already exist. In 2005, the Museum of Contemporary Art, Sydney, mounted a major survey exhibition of Laing's works. This exhibition focused on her picturing of place, set in the contexts of the history of landscape representation and the central importance of land to very different experiences and conceptions of indigenous, colonial, and present-day Australian identity.[1]

In *weather #4,* 2006, a woman with long flowing hair wearing a light gray gown appears to be caught in a maelstrom in a non-specific void. She falls head over heels in a whirlwind of news scrap detritus, eerily conjuring up images of victims during the 2001 terrorist attack on the World Trade Center. The powerlessness that pervades the atmosphere in this image is belied by the sense of liberation amidst a sky that appears at once non-threatening and violent. As author Rex Butler comments, "Appropriately enough for work about location and its loss, the work itself is subject to a certain loss of location."[2] Laing's sense of cinematic scale and narrative suggestion add to the uncanny nature of her highly-charged photographs. —JS

1   Information concerning the general work of Rosemary Laing taken from Blair French, "Rosemary Laing," in *Twelve Australian Photo Artists* (Australia: Piper Press, 2008).
2   Rex Butler, "The Art of Rosemary Laing," *Art & Australia* 44, no. 4 (2007), 562.

**weather #4**, 2006. C type photograph, 2/8, 43 $^5/_{16}$ x 72 $^7/_{16}$ in. ©Rosemary Laing. *Courtesy of the artist and Galerie Lelong, New York*

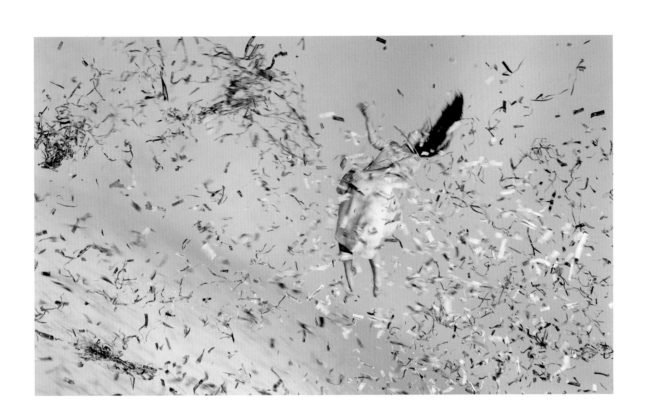

# DAVID MAISEL

**D**avid Maisel's photographic practice focuses on sites impacted by industrial efforts that range from mining to military testing, making him one of the "new global topographers" who document the changing planet.[1] In 1983, during his student days at Princeton, Maisel honed his craft when he accompanied noted photographer Emmet Gowin in capturing the aftermath of the eruption of Mount Saint Helens. For his own work, Maisel took aerial photographs of the Owens Valley in southeastern California, which became "The Lake Project" series.

In 1913, the city of Los Angeles began diverting water from the valley to the Los Angeles Aqueduct. By 1926, the lower Owens River and Owens Lake had been depleted, leaving a toxic salt flat encrusted with mineral deposits. Today, winds sweeping through the valley dislodge carcinogenic particles from the lakebed and blow clouds of poisonous dust over nearby towns and farmlands, making the Owens lake region the largest source of particulate matter pollution in the United States. For Maisel, the wounded remains of such sites are other-worldly reminders of an estranged earth—they are "landscapes undone."[2]

With their vibrant colors and play of geometrical shapes and sinuous lines, Maisel's photographs resemble abstract paintings. By photographing the land from an aerial perspective, he moves back and forth between the content and the process of abstraction. Yet, while these colors and topographical forms make the photographs pleasing to the eye, they are also evidence of a poisoned landscape. In *Lake Project #11,* 2001, the deep gash of reds and variegated pinks and grays are the result of bacteria that thrive in the mineral-rich environment of the valley and the swirls and grooves of the terrain from the disappearance of groundwater. Maisel's photographs therefore blend visual pleasure and repulsion—through his lens the landscape becomes bruised and bloody, cut through with open wounds.

—*EH*

1 Lyle Rexer, "The New Global Topographers: A Generation of Photographers Documents a Changing Planet," *Art on Paper* (March–April 2006), 54.
2 David Maisel, quoted in Geoff Manaugh, "Human Ash Reactions: Geoff Manaugh on David Maisel," *Contemporary* magazine 86 (2006), 51.

**Lake Project #11**, 2001. C print, edition of 5, 48 x 48 in. *Courtesy of the artist and Evo Gallery, Santa Fe, NM*

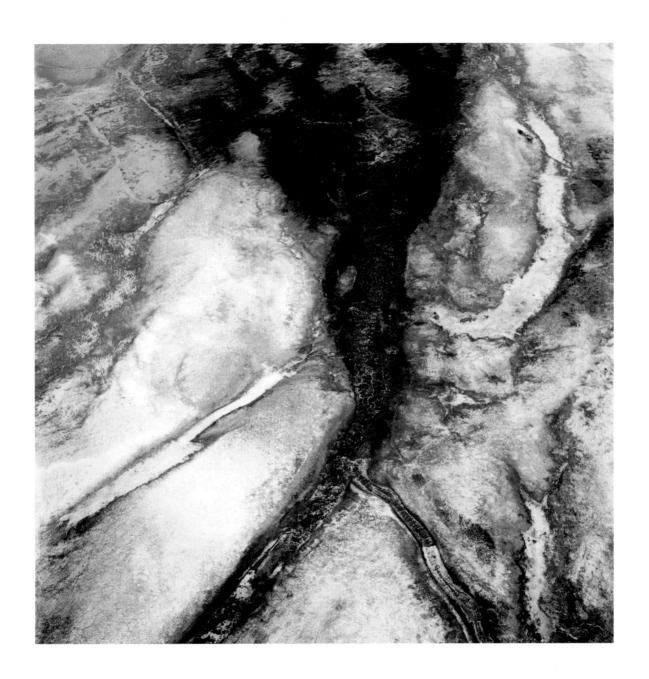

# MARY MATTINGLY

**M**ary Mattingly's photographs are not pictures of our world. They are projections into the future, prognostications of a world that she believes humans will one day inhabit, in which nomads roam the earth and survive by inventing and utilizing adaptive technologies. Based on her extensive investigations into the anthropology of fashion and architecture, Mattingly's "navigators" wear "wearable homes" made from temperature-adjusting, weatherproof fabric. They also carry "elements," tools which help mitigate the physical and psychological stress caused by their rootless existence.[1] Her examination of the evolving relationship between humans and technology is inspired by current scientific research and the works of contemporary theorists.

To create these glimpses of an utopian (or dystopian) tomorrow, Mattingly merges pictures created with three-dimensional imaging programs, topographical photographs taken in different parts of the world, and digital photographs of posed models. The composite images, with their dramatic landscapes and garish, picture-postcard sunsets, do not hide their artifice. Yet, at the same time, the world Mattingly constructs is too perfectly imagined, too fully formed, and too convincing to be dismissed as pure fiction.

In *Silent Engineers*, 2005, a beautiful female figure dressed in a white garment that seems part scientific jumpsuit, part religious robe, focuses intently on a project in front of her. Behind her, similarly clad figures wander through a barren desert landscape that stretches unbroken to the horizon, save for a solitary dead tree. In the distance, a black plume of smoke rises from a fire. What appears to be an oil refinery lends an ominous tone to the enigmatic photograph. In many ways, this photograph recalls the Kuwait War oil field fires, the need to address our dependence on oil, and the toll such drilling takes on the land. The world envisioned in *Silent Engineers* is a literal "virtual reality"—it hovers somewhere between the real and the unreal, the present and the future.

—EH

1   Joanna Lehan, "Mary Mattingly," in Brian Wallis, et al, *Ecotopia* (New York: International Center of Photography, 2006), 166.

**Silent Engineers**, 2005. Chromogenic dye coupler print, edition of 5 + 2 AP, 40 x 40 in. ©Mary Mattingly
*Courtesy of Robert Mann Gallery, New York*

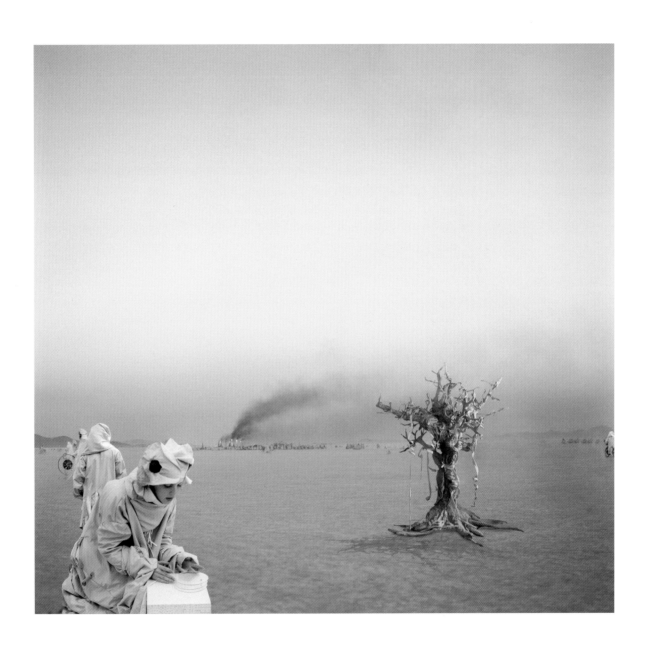

## RICHARD MISRACH

At first glance, Richard Misrach's images of the Western landscape seem firmly rooted in the documentary landscape tradition and far removed from the social-documentary work with which he began his career. However, Misrach's "Desert Cantos," 1981–present, the enormous body of work that has been his primary project for nearly thirty years, synthesizes aesthetic and social concerns.

Misrach, who was born in California in 1949, took up photography with the intent of fostering social change. When he began photographing the Southwest in the late 1970s, he soon realized that the desert, which had long been feared, forgotten, or ignored, was a fertile source for both striking imagery and social commentary. "Desert Cantos" contains individual series, each of which explores a specific idea, event, or topographic feature of the desert. While each "Canto" varies in terms of subject matter, number of images included, and duration of time represented, they all share a common theme: man's intervention in the landscape.

*Dead Animals #327, Nevada*, 1987, is from the series "Canto VI: The Pit," which documents the mass burial pits common in the West. Misrach introduces his sixth Canto with a text describing the deaths of thousands of animals following atomic tests that were performed in the desert in 1953. "I felt," Misrach said, "that combining the earlier account with the graphic images would be a viable way of creating a generic protest of our military and government contamination of the environment and the inevitable cover-ups."[1] *Desert Fire [#699-84]*, 1984, is a large-scale work photographed in 1984 and printed specifically for this exhibition. It recalls the awesome devastation of the fires that swept through much of Southern California in the spring of 2008.

—EH

1  Richard Misrach, quoted in Anne Wilkes Tucker, *Crimes and Splendors: The Desert Cantos of Richard Misrach* (Houston: Houston Museum of Fine Arts, 1996), 27.

**Dead Animals #327, Nevada**, 1987. Digitally remastered 2008. Digital chromogenic print, 1/10, 30 x 37 in.
*Courtesy of Fraenkel Gallery, San Francisco, Marc Selwyn Fine Art, Los Angeles and Pace/MacGill Gallery, New York.*
Collection of Tucson Museum of Art. Gift of Ceta Scott and Harry George, 2007.23.1

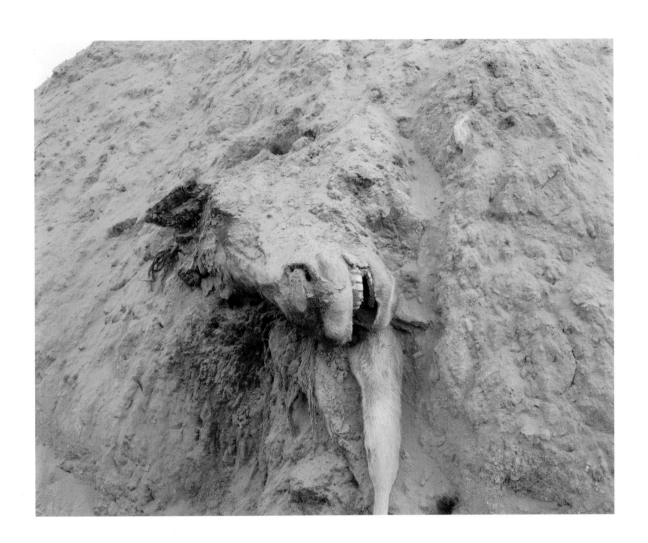

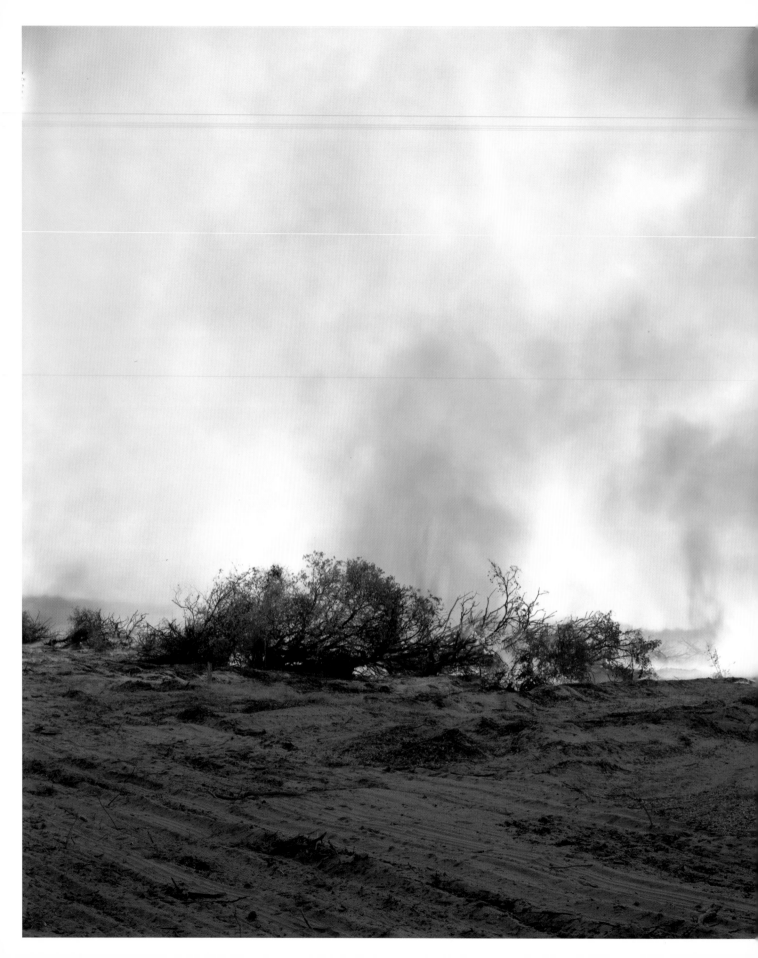

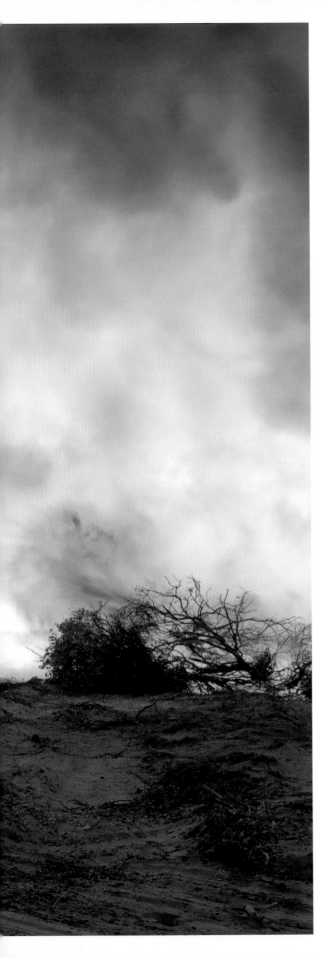

Richard Misrach, **Desert Fire [#699-84]**, 1984. Archival pigment print, 1/3, 60 x 72 in.
*Courtesy of Fraenkel Gallery, San Francisco, Marc Selwyn Fine Art, Los Angeles and Pace/MacGill Gallery, New York*

# MATTHEW MOORE

Farming with his family in the fertile plains just west of Phoenix, Arizona, Matthew Moore knows first-hand the demands placed on the land and the pressures of urban sprawl. His family has been farming there for four generations, first by growing citrus and alfalfa and, later, cotton, which they cultivated for forty-five years. Recently, the Moore family has grown everything from watermelons to carrots, sorghum, barley, and wheat. Moore returned to the family farm after receiving his Master of Fine Arts degree from San Francisco State University. The eventual loss of the farm to development is a concern that he addresses through video installations and land art projects using the very crops that are in jeopardy.[1]

*Rotations: Single Family Residence*, 2006, is a photographic aerial view of a land art project that encompasses a twenty-acre barley field. After Moore's family sold several acres of farmland, Moore obtained the plans for a single family residence. On land nearby the family farm, he planted a field of barley. When the golden crop was ripe, he cut a replica of the floor plan into the field. While the artist insists that he is not against development and that the land has been good to his family, he admits to a personal sense of loss over a vanishing way of life. At the conclusion of the project, Moore harvested the crop for resale as feed. By planting crops and cutting into the resulting bounty, he offers a thoughtful reverie about the technological feats needed to farm in the desert and the concept of change.

—*JS*

1   John D. Spiak, "Matthew Moore," in *New American City: Artists Look Forward* (Tempe: Arizona State Art Museum, 2006), 34.

**Rotations: Single Family Residence**, 2006. Twenty-acre barley field. C-print, 1/7 44¹/₂ x 60¹/₂ in. Private Collection, *Courtesy of Lisa Sette Gallery, Scottsdale, AZ*

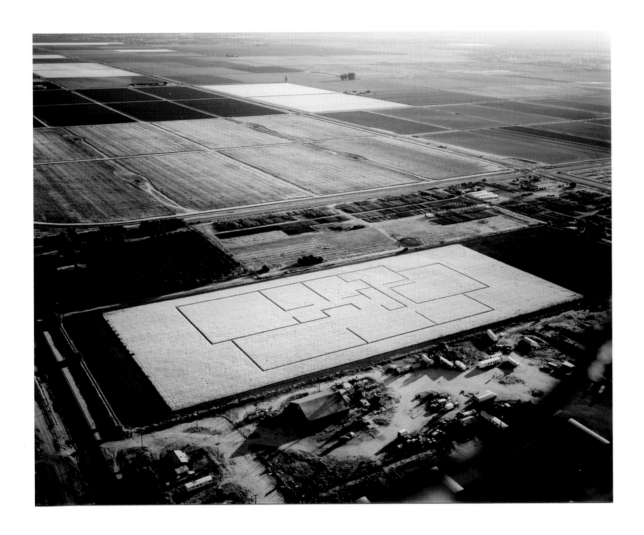

## MICHAEL NAJJAR

**G**erman photographer and visual artist Michael Najjar is a pioneer of digital manipulation of photographic images. He works with a hybrid of analog and digital techniques and conceptual investigations that range from life in Ancient Greece to an imaginary future in which fact, fiction, and pure fantasy interweave. Najjar posits a critical approach to truth and the authenticity of images in a media-controlled world. In recent series, he explores his fascination of scenarios for the future of humankind. In these works, he depicts bionic beings with brain expansion implants and eyes like data scanners. Najjar's recent work focuses on photographic portraits of heavily made-up models in theatrical poses that are altered in the digital imaging process. As Wim van Sinderen points out, the result is "arresting portrayals as ethereal as Meissen porcelain figurines."[1]

*invisible city,* 2004, is the video component of a larger installation of video, photography, and sculpture from *netropolis*. For this piece, Najjar photographed twelve megacities including Tokyo, New York, Dallas, Mexico City, Dubai, Hong Kong, and Shanghai from the tops of their highest buildings and from each of the four compass points. Using a complex logarithmic program to superimpose the pictures on each other, Najjar sets up an optical illusion that depicts the increasing complexity of our urban infrastructure. This metamorphosis expresses not only the high energy buzz of the urban experience, but also the technology-driven transformation that is occurring within individuals and society. As Najjar explains, "The city as an artificial construct can only be experienced in terms of a dialectical interplay between microcosm and macrocosm, between reality and simulation."[2] Recalling the dark social complexity depicted in the 1982 Ridley Scott film *Blade Runner,* where technology and the density of human life intersect, Najjar's not-so-fictional world has long abandoned nature for a cyberspace of global information network flows.

—JS

1   Wim van Sinderen, "Introduction," in *Augmented Realities: Michael Najjar Works 1997–2008* (Rotterdam: Veenman, 2008).
2   Michael Najjar, "Netropolis—Imaging the City in the Age of Electronic Communication," in *Netropolis: 2003–2006* (New York: bitforms gallery, 2006), 5.

**invisible city**, 2004. Video, 15 minutes, edition of 10. *Courtesy of the artist and bitforms gallery nyc*

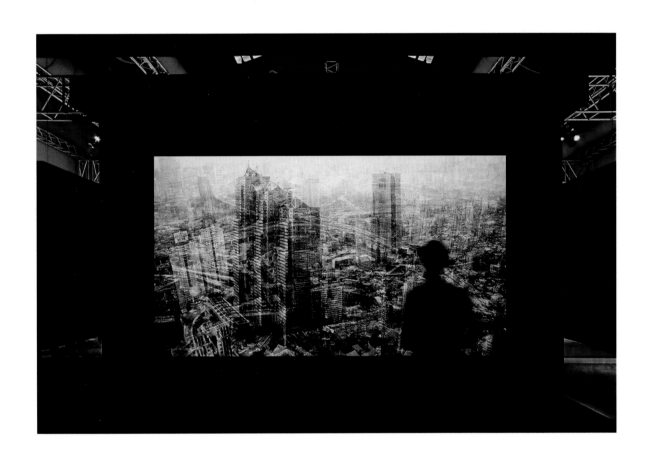

## JOE NOVAK

Primarily interested in large-scale painterly abstractions on canvas that focus on the nuances of light and color, California artist Joe Novak infuses his tonal gradations with a meditative quality. To heighten the effect of his glowing surfaces, Novak often manipulates the light cast on his paintings as an integral aspect of the work, even to the point of creating programmed sequences of variable light movements and configurations. Such works broaden the visual experience to encompass elements of time, movement, and change. In the early 2000s, Novak continued his investigations into color and light, but shifted the scale of his work to concentrate on drawings, small paintings, assemblages, mixed media prints, and multi-plate color aquatint etchings and monoprints.[1]

*Phoenix III*, 2003, is a work in "fumage," a surrealist technique invented by Wolfgang Paalen (later called "sfumato" by Salvador Dalí, who also used the technique) in which impressions are made by the smoke of a candle or a kerosene lamp on paper. Although the Surrealists used the technique to produce soft, wavy patterns that articulated figurative form, Novak uses the process to produce ethereal shapes reminiscent of the swirling motion of the swarming of birds, billowing smoke from fire, or the funnel clouds of tornadoes. Such swirling and conical forms belie the serenity of his glowing, meditative color works, yet they speak of powerful natural forces. The hypnotic motion of the smoky mass conjures the captivating eeriness of an atmosphere churning with particulate matter. While the original intention of the artist was not to create a commentary on the environment, by the work's creation from a petroleum-based product, it recalls society's reliance on fuel which creates a similar chain reaction of natural upset. —JS

1   Joe Novak, "Artist Statement," in Peter Frank, *Joe Novak: Colors, Paintings on Panel 2006-2008* (Los Angeles: Bert Green Fine Art, 2008), 5.

**Phoenix III,** 2003. Fumage on paper, 25¼ x 19½ in. Collection of Tucson Museum of Art
Gift of David Frank and Kuzukuni Sugiyama in memory of Jules Litvack, 2005.19.1. Photo: Wilson Graham

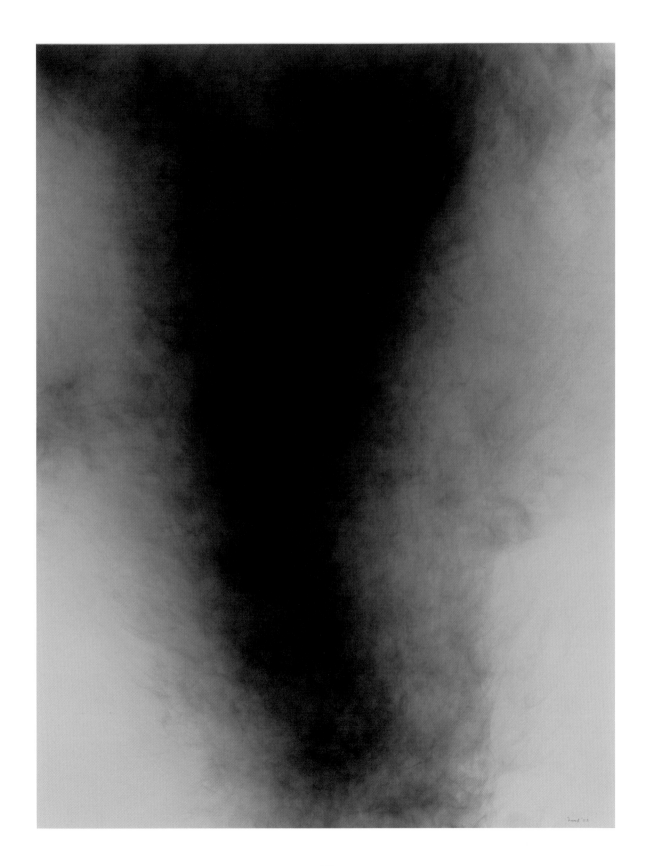

## LEAH OATES

Photographing the abandoned locales of industry, institutions, and urban environments, Leah Oates captures the aura of a place rather than a pure document of its utility. She believes that each object she fixes on film becomes an artifact of lost knowledge rather than simply a record of its being. As writer David Gibson notes, "In our culture, the relic has an especially short half-life. But the photograph reanimates the essential significance of experience itself, creating a form of discursive archaeology in which the artist pursues hidden truths in seemingly useless and random effects."[1] Oates isolates her subjects from any vestige of narrative, encouraging the viewer to discover the temporality of the photographic image.

Oates has traveled to such regions as Taiwan, Newfoundland, Finland, and Chicago to reveal the structures and rituals that form cultural and social life through the detritus left behind. Photographing such places, she portrays the hidden corners of a city and the lost and forgotten alleyways and plots of land. In 2004, she concentrated on urban environments to address the transitory nature of life and the constant ebb and flow of human existence.

In recent series, the artist photographed deserted factories sealed off from human habitation by chain link fences. Signs of human presence can be seen by the appearance of food and clothing strewn about and the ubiquitous graffiti that covers every surface. In *Transitory Space, Chicago (double electric 3)*, 2007, an abandoned electric power plant is diffused by double exposure. No longer a fixed object, the mutable image against a clear blue sky echoes the changing nature of the facility's lost utility. Preferring traditional photographic practices to digital techniques, Oates is interested in how the photographic image embodies visual knowledge while captivating the viewer with the moment of recognition. We recognize the power plant and make associations with energy, industry, and our own need for such resources. But the abandoned appearance of the plant reminds us of the finality of its function and alludes to how the current technology of power generation is becoming obsolete.

—JS

1   David Gibson, "The Discursive Archaeology of Space: The Photography of Leah Oates," in *Leah Oates: New Photographic Work: 2004–2007* (self-published catalogue, 2007).

**Transitory Space, Chicago (double electric 3)**, 2007. C-print, edition of 10, 24 x 30 in. *Courtesy of the artist*

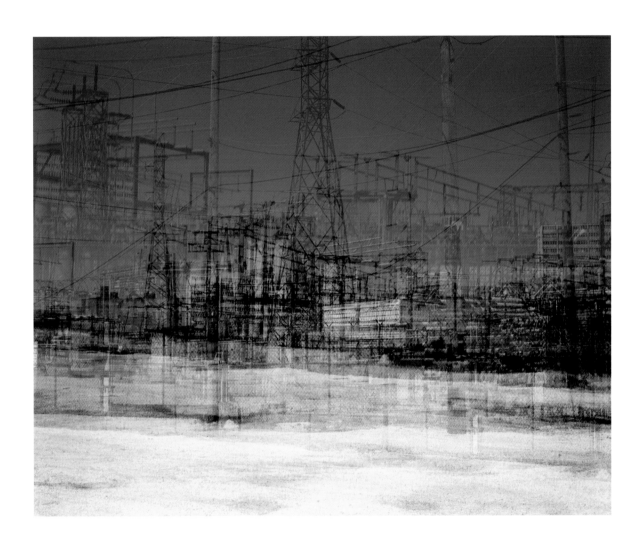

# ROBYN O'NEIL

Stark and foreboding, the large-scale graphite drawings by Texas artist Robyn O'Neil explore the human condition within a bleak landscape. Their black-on-white austerity creates the effect of desolate snow in winter or ash-covered land after a devastating forest fire. Dark, denuded trees emphasize the sense of hopelessness and melancholy. O'Neil's drawings are either devoid of human presence or scattered with tiny men who pray, stare off into space, cavort in the snow, or play in mock combat. Women are not present, reinforcing the notion of an infertile environment. The artist sees her figures as representing "the anxiety of not really seeing the point of anything and yet feeling an unfulfilled need to be a productive human."[1] O'Neil borrows from film noir, fourteenth- and fifteenth-century formal devices, and such artists as Winslow Homer and Henry Darger to create her angst-ridden allegories of environmental despair.

The apocalyptic *Our Earth, Our Bodies, Our Decline*, 2006, deftly portrays the complacent acceptance of a dystopic world. In this drawing, O'Neil presents a large expanse of bladed earth covered in a blanket of oppressively dark clouds and sparsely dotted with small evergreens and spindly, leafless trees. Below this stark land, a flat-bottomed pit, reminiscent of a strip mine with eroded earthen walls, becomes the snowy playground of assorted middle-age men who, lying prone or arched on "all fours" intently engage in what appears to be a sledding activity. The intensity of their sport and the animalistic nature of their posture allude to humankind's refusal to take the environment seriously, preferring instead to ignore their surroundings in favor of mindless preoccupations. This piece was inspired in part by the devastation of Hurricane Katrina. It also recalls the 1900 storm in Galveston. O'Neil visited the Funeral Museum in Houston where she viewed hundreds of photographs taken after the storm. She was greatly moved by the jarring images of "humans on top of humans, all thrown into mass graves that were huge holes dug in the ground."[2] To O'Neil, the human suffering of the Galveston disaster of a century ago and the Katrina disaster have sobering similarities.

—JS

1   Robyn O'Neil quoted in Regine Basha, "Robyn O'Neil," *Arthouse Texas Prize* (catalogue), 2005.
2   Robyn O'Neil, email correspondence with the author, 4 June 2008.

**Our Earth, Our Bodies, Our Decline**, 2006. Graphite on paper, 66 x 66 in. Collection of Jason and Leigh Taylor
*Courtesy of Dunn and Brown Contemporary, Dallas, TX*

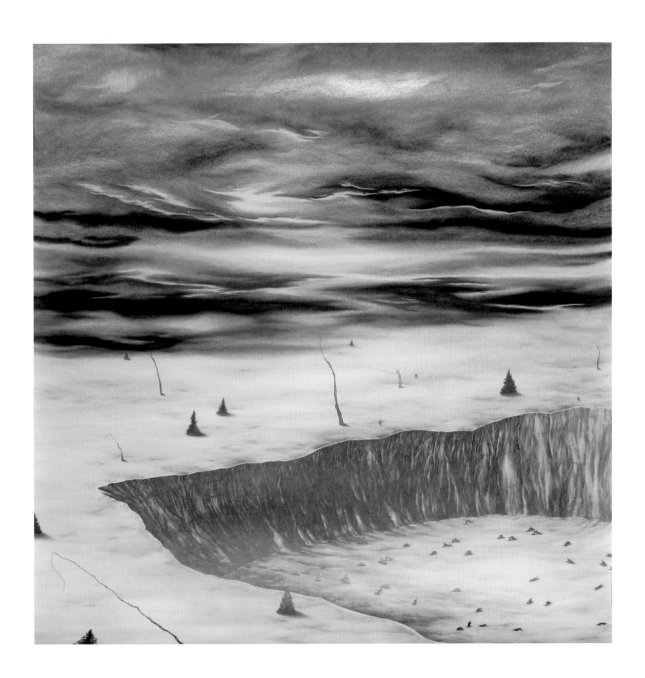

# TOM PALMORE

Tom Palmore's hyper-realist style is rooted in the academic principles set forth by the Pennsylvania Academy of the Fine Arts where he was trained in the late 1960s. Painting in Philadelphia in the early 1970s, Palmore poked fun of the canons of classical art with Ingres-inspired compositions, such as a gorilla seductively lounging on an elaborate oriental carpet in the style of a nineteenth-century reclining odalisque. Later in the decade, he moved to New Mexico and expanded his subject matter to include animals of the American Southwest like stoic prize bulls, frisky jackrabbits, and regal bighorn sheep. Eventually, he included house pets, such as dogs, cats, and birds in his repertoire, each theatrically posed against unlikely backdrops such as Navajo rugs, Victorian wall paper, and paint-by-numbers diagrams. Exacting brushstrokes articulate the fine details of animals' coats and birds' colorful plumage. Palmore paints formal "portraits" of the creatures, posed proudly as if to appear like they might have commissioned the paintings themselves. In this manner, the artist retains the dignity of the animals while anthropomorphizing them—the humor of his works lie not in imposing human characteristics on his subjects, but in the unlikely environments in which they are placed. Through humor, he invites the viewer to contemplate the notion that animals indeed have souls.

Relocating to his Oklahoma roots in the mid-1990s, Palmore opened up his backdrops to include the landscape, often incorporating an iconic tornado funnel cloud for a dramatic effect and identification with place. In *Run, Sparky, Run!*, 2004, a nervous terrier, reminiscent of Toto in *The Wizard of Oz,* stands frozen in anticipation while a funnel cloud swiftly advances toward it. The artist, an ardent environmentalist and animal lover who has raised horses, llamas, dogs, and birds throughout his life, wants to believe that all will work out for the terrified pet. Palmore explains, "Don't worry, nothing will happen to Sparky. What you don't know is that his master is just out of range calling for him—he's going to be rescued and taken to a shelter."[1] But this magic realist scene is a telling reminder of our own complacency regarding the environment and our ambivalence toward the increasing number of turbulent weather occurrences exacerbated by global warming. The underlying question we might ask ourselves is this: Will we really be rescued, like the scruffy little dog, by scientists and the government, or should we attempt to do something ourselves about our rapidly deteriorating earth?
—JS

1   Tom Palmore, conversation with the author, 5 September 2008.

**Run, Sparky, Run!**, 2004. Oil and acrylic on canvas, 30 x 46 in. Private collection, Pennsylvania, PA

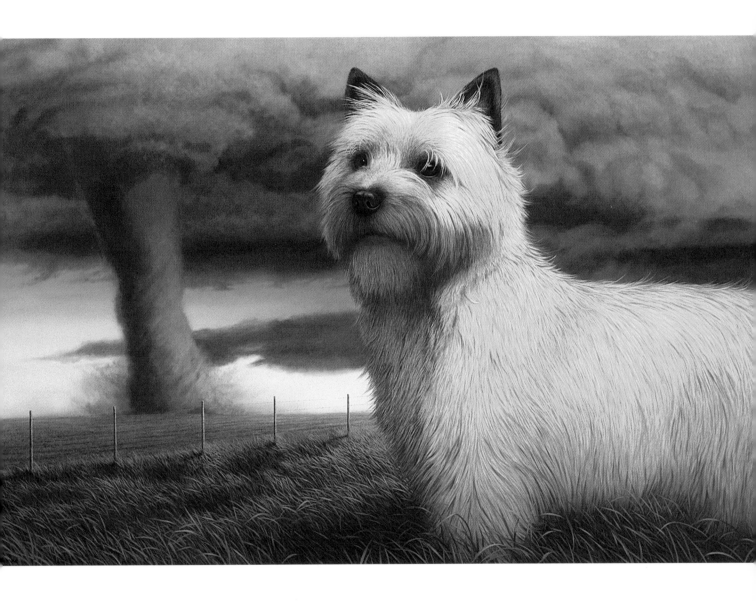

# ROBERT AND SHANA PARKEHARRISON

**B**eautiful and haunting, the black-and-white photographs of Robert and Shana ParkeHarrison from the 1990s are psychological narratives that address issues connected with humankind's responsibility to heal the damaged earth. At times, the husband and wife collaborative employ elaborate set constructions to create their surreal tableaux. Atmospheric in tenor, their poetic photographs are often defined by spirals of smoke, blankets of steam, or brooding skies, which have been interpreted as a kind of evanescence and loss.[1] Ultimately, these works investigate the concept of loss and detachment from nature and the earth.

*Burn Season*, 2005, is an example of the ParkeHarrisons' focus on the eroding relationship between humankind, technology, and nature. In this sepia-toned image, a dark-suited man with his back to the viewer stands before a raging fire along a flat denuded stretch of earth. Nothing is visible but the line of fire that licks the dense, smoke-filled sky. Standing as if bearing witness rather than in terror, the man offers bags of water attached to his suit as humble offerings to a fire that is beyond his control. This photograph brings to mind the overwhelming catastrophic forces that nature can exert and our often meager attempts to control them.

After many years of working in this dark-hued, melancholy style, the ParkHarrisons have recently incorporated color and blurred focus into their works, a continuation of their interest in the failed promise of technology. Now strange scenes of hybridizing forces, swarming elements, and "bleeding overabundance" portray nature unleashed by technology and revisit the notion that our situation is uncontrollable.
—*JS*

1   Jan Adlemann and Barbara McIntyre, *Contemporary Art in New Mexico* (Roseville East, Australia: Craftsmanhouse, 1996), 98.

**Burn Season**, 2005. Photogravure, AP 4/5 from an edition of 50 + 5 AP, 26 x 30 in. *Courtesy of the artists and Jack Shainman Gallery, New York*

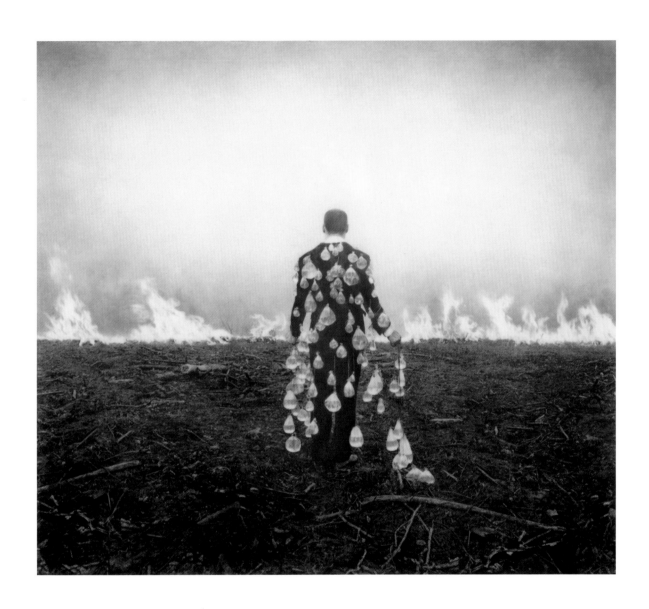

## ANTHONY PESSLER

Serving as metaphors for the artist's life, the meticulously painted, small-scale works by Anthony Pessler are jewel-like icons of nature. His intimate works are intrinsically connected to the rustic landscape of his rural North Dakota homeland and the Wisconsin woods where he lived before moving to the desert region of Phoenix in the early 1990s. An avid hunter and outdoorsman, Pessler shows a reverence for nature while asserting his presence in it. The details of his scenes are personal to the artist, who is there in spirit and imagination if not physically. While the artist does not depict himself in such scenes, animals often act as his body double. For example, birds in Pessler's paintings represent ideal "states of being," soaring through the air in search of meaning.[1] Lightning, raindrops, antlers, and the patterns of stars also become metaphoric and allegorical symbols, while serving as formal constructs in the pure act of painting.

*Sturm und Drang,* 2008, is a dark graphite work depicting the swirling motion of a tornado. This imagery comes from two recurring apocalyptic dreams that Pessler recalls from his childhood—tornadoes and nuclear war. Growing up in an area where the threat of tornadoes is common, Pessler lived in the middle of one of the largest deployments of ICBMs in the world. "These dreams were almost never frightening, but rather awe-inspiring," recalls Pessler, "and I remember thinking how beautiful the mushroom clouds and tornadoes were."[2] He was also powerfully affected by *The Wizard of OZ* as a child.

While the depiction of the destructive force of a tornado speaks for itself, and Pessler's associations reflect his physical and cultural environment, the title of this piece refers to the name of a German literary movement from the late eighteenth century. Literally translated as "storm" and "stress," the word "drang" can also refer to impulse and longing. Thus, Pessler's dramatic depiction of violent winds acts as a metaphor for the human condition as it succumbs to extremes in today's fast-paced society. Pessler is interested in the idea of the anthropomorphized natural force driven, not by the common association with malice, but by longing.[3]

—JS

1   David S. Rubin, "A Bird Tapestry," in *Birdspace: A Post-Audubon Aviary* (New Orleans: Contemporary Arts Center, 2004), 38.
2   Anthony Pessler, email correspondence with the author, 16 October 2008.
3   Anthony Pessler, email correspondence with the author, 13 June 2008.

**Sturm und Drang**, 2008. Graphite on panel, 21 x 21 in. *Courtesy of the artist and Circa Gallery, Minneapolis, MN*
Photo: Michael Lundgren

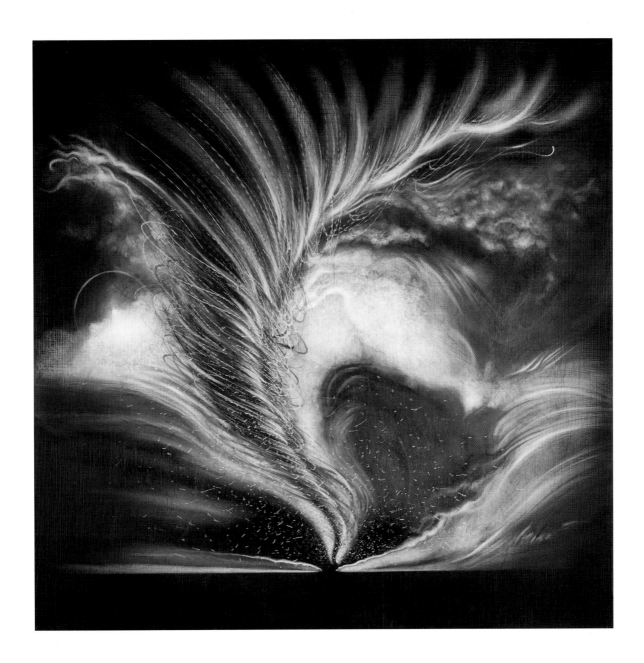

## ROBERT POLIDORI

When photographer Robert Polidori traveled to New Orleans a month after Hurricane Katrina, he found a modern-day Pompeii, a city that, although destroyed and largely abandoned, still contained the traces of its inhabitants. Over four extended trips, Polidori, who is best known for his architectural photography, painstakingly documented the ruins, street by street and house by house. In 2006, he published his photographs in the book *After the Flood* (Göttingen: Steidl). Polidori's work is not an exposé: the book makes no attempt to assign blame or to uncover what exactly went wrong during the hurricane and its aftermath. Instead, he takes on the role of psychological witness, photographing the absent and deceased through what remains of their belongings and their homes.

*6328 North Miro Street*, 2005, reveals the dark remains of a well-appointed bedroom from a devastated low-lying area of New Orleans. The pervasive mold that quickly grew from the moisture-laden buildings casts an eerie pall over the room, while the soft glow from the window indicates only a small glimmer of hope. While none of Polidori's interiors include people and all are titled only by their street address, each is as personal, individual, and revealing as a portrait. As Polidori explains, "One can see the fibers of people's lives that no longer are. Most people lived through the storm, they were either pre- or post-evacuated ... what you're looking at is a sort of curious mortuary, not of an individual that's dead, but of a life that's dead." Polidori's silent but eloquent photographs eulogize "a city that care forgot."[1] While these works do not propose solutions, the artist intends for them to spark discussion about environmental protection and the effects of global climate change. In so doing, Polidori underscores the essential role of the camera in modern society.

—EH

1  Robert Polidori, quoted in <http://wwww.thedrawbridge.org.uk/issue3/aftertheflood/> (20 August 2008).

**6328 North Miro Street**, 2005, from the series "After the Flood." Fujicolor Crystal Archive print, mounted to Dibond, edition AP 1
40 x 54 in. *Courtesy of the artist and Arthur Roger Gallery, New Orleans, LA*

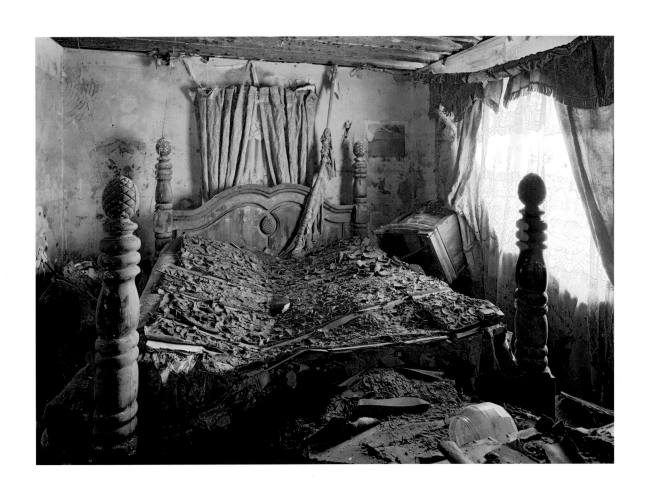

## ALEXIS ROCKMAN

**A**lexis Rockman explores the precarious relationship between humankind and nature through meticulously detailed paintings of exotic flora and fauna. He is inspired by his travels to the far reaches of the world. Fear and exhilarating wonder lie at the core of Rockman's works, derived from his childhood visits to the Museum of Natural History in New York. The artist confronts our fears by offering new ways to view the living world while relying firmly on science and intimate observation. His style blends the visual techniques of science fiction films, historical landscape and genre paintings, biology illustrations, and museum dioramas. "We are enmeshed in a food chain of ruthless complexity, confronted with the brutal liveliness of destruction and decay," explains Katherine Dunn about Rockman's world. "Ravenous for information, Rockman's lens focuses on every level, zooming in to depict the microscopic denizens of a single drop of river water and going airborne for a wide-angle sweep of the big picture."[1]

*Untitled*, 1997, is a work on paper created as part of a series based on Rockman's 1994 six-week expedition into the dense tropical rain forest of Guyana with noted environmental artists Mark Dion and Bob Braine. This jungle setting is a place where extensive field research is conducted by scientists and naturalists, often under strenuous circumstances. Their trip was modeled after such pioneer naturalists as Charles Darwin, Alfred Russell Wallace, and others who once worked in the same general vicinity. Painting the plants and animals native to the area strictly from observation (rather than working from his imagination), the artist created several large-scale watercolors and oil on wood paintings. Unique among the brilliantly colored and highly detailed paintings from this series, this work is one of a few anomalies. Created from actual mud, raw sewage, and river water on paper in a Japanese Sumiye ink technique, it is a reminder of the fecundity of the earth and our emphatic mark upon it. In fact, shortly after his visit to Guyana, an accident at a jungle gold mining operation spilled many millions of gallons of cyanide solution into the river system he had explored, destroying much of what he had seen and was in the process of painting.

*—JS*

1    Katherine Dunn, "Alexis Rockman: Alive in Guyana," in *Guyana: Alexis Rockman* (Santa Fe, NM: Twin Palms Press, 1996).

**Untitled**, 1997. Mud, raw sewage, and river water on paper, 10 x 7 in. Collection of Adam Weinstein and Kira Dixon-Weinstein, Tucson, AZ
©2007 Alexis Rockman / Artists Rights Society (ARS), New York. Photo: Wilson Graham

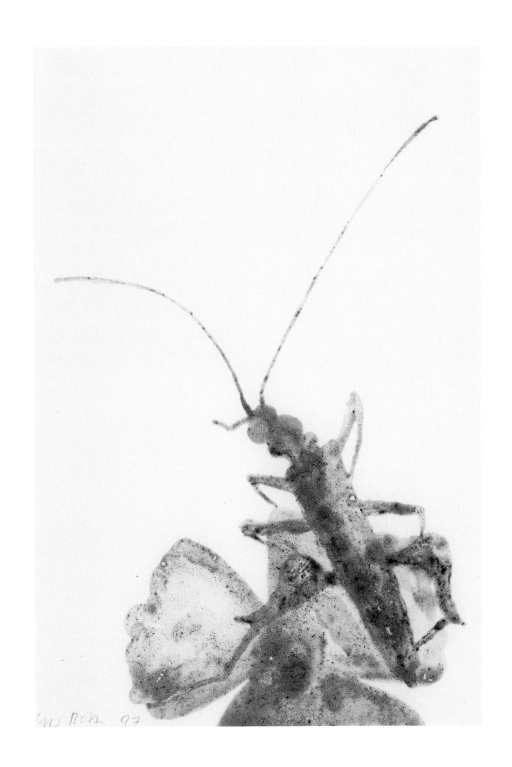

## BARBARA ROGERS

For more than thirty years, Arizona artist Barbara Rogers has worked with themes about nature in its manipulated, raw, and sublime states. In that time, she has also explored the garden as a personal and symbolic Eden. In the 1970s, she worked with an airbrush and acrylics to create hyper-realist scenes of colorful birds, theatrical props, nudes, and costumed couples in lush, albeit artificial, jungle settings. Attempting to transform the "ugly and the ordinary" into the "beautiful and the gorgeous,"[1] her fictional world was an erotically charged wonderland of romance and exoticism.

In 1982, on a visit to Oahu, Hawaii, to gather visual material and ideas for her paintings, her work took an abrupt turn. She arrived just before the force of Hurricane Iwa slammed into the island, destroying homes, businesses, and lives. The awesome force of nature upon this lush, peaceful paradise deeply affected the artist as well as her thinking about nature and what it represented in her work. After seeing the tropical detritus all around her—the ravished jungles, beaches, and gardens—she changed her style and content to express the sensations and emotions associated with the terrifying chaos of the storm. At that time, Rogers worked in oils and acrylics and used photography as a tool to record tropical environments for her paintings. In the late 1980s, she incorporated collaged photographic elements, which she adhered to the paper with beeswax, a precursor to the encaustic paintings she would develop later on. She also included the actual detritus found in the nature—embedding unusual dried plant forms and seed pods into the surface of the composition.

The Price for the Prize, 2007, is created with this mixture of photographs, encaustic, and dried cactus segments in a colorful grid construction. In this piece, Rogers comments on the rampant development in unspoiled desert regions. Attempting to build homes nestled among the regal saguaros growing in the desert, developers find that these precious cacti soon die, because the drainage is interrupted due to the invasive acts on the land. Therefore, the ultimate cost of a beautiful view and desert location is the destruction of the very flora that entices people to settle there.

—JS

1   Donald Miller, "New Exotic Realism at the Berger Gallery," *Pittsburg Post Gazette*, November 1978.

**The Price for the Prize**, 2007. Mixed media, 65 x 48 in. *Courtesy of the artist and Gebert Contemporary, Santa Fe, NM; Scottsdale, AZ; Venice, CA*
Photo: Steve Stayton, Light Mechanics

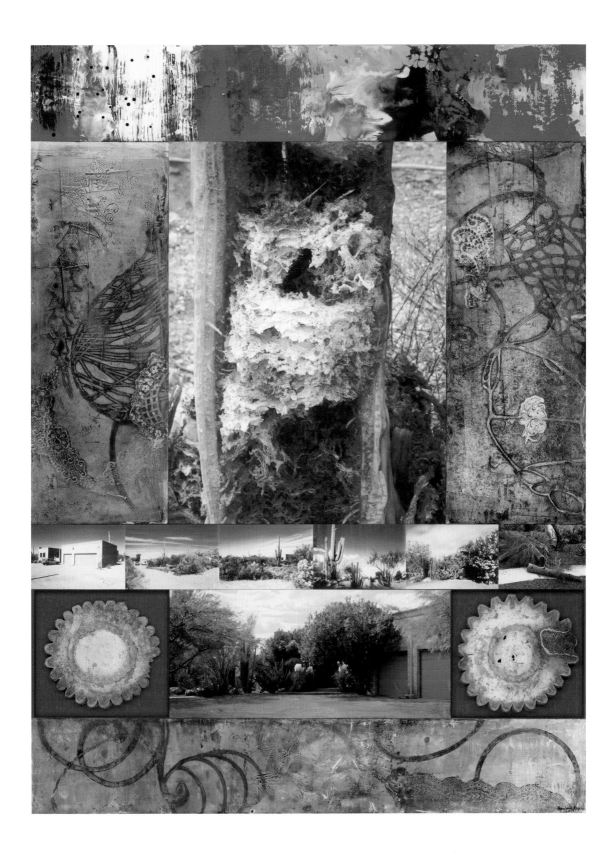

## THOMAS RUFF

German artist Thomas Ruff examines the theoretical notion of the mediated message and the efficacy of the pairing of text and image. To Ruff, when text and image are separated, the veracity of information is often incomplete, yet other images separated from their text can take on a unique visual aesthetic. Ruff's interest in appropriated, digitized images marks a shift from his earlier work. Between 1977 and 1985, Ruff studied with famed photographers Bernd and Hilla Becher at the Kunstacademie in Düsseldorf. Soon after graduating, Ruff garnered international attention and acclaim for his monumental color portraits.

In the late 1980s, Ruff began creating work based on photographs appropriated from newspapers, magazines, and the Internet. In his "Jpeg" series, Ruff mined the World Wide Web for images of subjects ranging from landscapes to the World Trade Center after the 2001 attack and assembled them into a visual encyclopedia of the modern world. Yet, as he translates the photographs from the Web to the gallery wall, by isolating them from their original contexts, and enlarging and digitally manipulating them, Ruff transforms the images.

In *Jpegs*, 2006, the violent eruption of Mount St. Helens is overlaid with pixel lines. This juxtaposition of the organic forms of the volcano's smoke and the pixilated grid suggests the imposition of technology on the natural world. However, Ruff's "Jpeg" images also explore the ways in which technology, which has made information universally accessible, has lead to the devaluation and homogenization of that information. As Ruff states, "Maybe in our society we are not only consuming products and nature but [also] doing the same thing with information….We are consuming information, we swallow it and it is gone, it doesn't reach our brain."[1]

—EH

1  Thomas Ruff, artist statement, 2008.

**Jpegs**, 2006. Digital pigment print (Ditone) on photo paper, edition of 45, 48 x 36 in.
©2007 Artists Rights Society (ARS), New York/VG Bild - Kunst, Bonn. *Courtesy of Richard Levy Gallery, Albuquerque, NM*

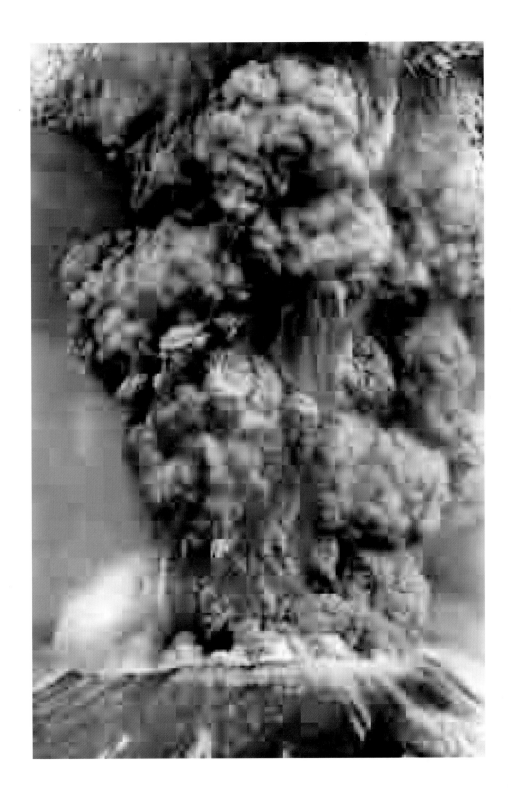

## CHRIS RUSH

Largely known for his masterful portraits of people with disabilities, Arizona artist Chris Rush explores the "unknowability of another person." Driven by the mystery of one's being in a solitary body, Rush imbues his subjects with a sense of dignity that underscores their physical limitations. He achieves this transformation from pathology to beauty by placing his subjects, invented and real, in non-confrontational poses and bathing them in soft, glowing light. In recent years, his work has expanded to include objects and images from eighteenth-century cabinets of curiosity. In these works, the artist explores the fear and fascination of nature and how our preconceived notions guide our understanding of the world around us.

Rush began his career launching guerrilla art campaigns on the streets of Tucson. His experiences during the 1980s rooted him in the pop art tradition of representation in which everything is reduced to its most immediate and elemental form. Upon moving to Arizona, however, he became concerned with the heroic nineteenth-century view of the "inhuman muscularity of nature."[1] Seeking to bridge a pop sensibility with his own aesthetic, he created *Fire Water Moon*, 1994. In this aerial view, a raging fire emitting dark clouds of ominous smoke engulfs the land, its flames licking the coastline. Simultaneously, a rising moon casts a serene glow on calm turquoise waters. At first glance, this work brings to mind a tropical island with hot lava traveling to the sea, yet this interpretation is uncertain. In fact, this landscape/seascape was painted after the first Gulf War from impressions that remained with the artist of media coverage of the conflict. To Rush, this painting was like a "sweet advertisement for disaster"—fire meeting water in a sublime moment of tranquility and terror.

—JS

1    Chris Rush, interview with the author, 30 September 2008.

**Fire Water Moon**, 1994. Gouache on board, 30 x 36 in. *Courtesy of the artist and Etherton Gallery, Tucson, AZ*

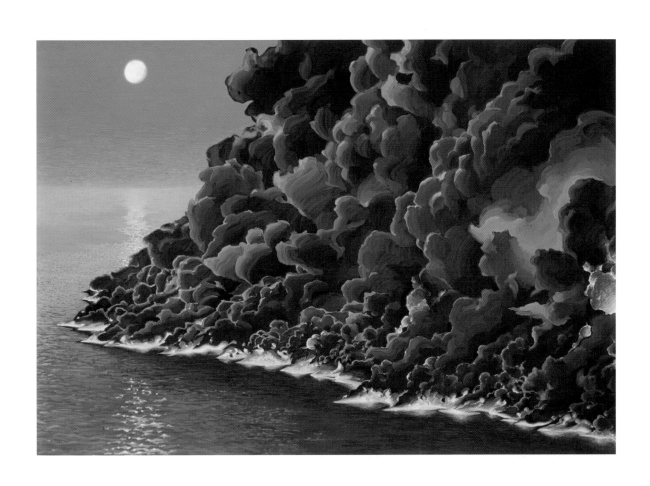

## SUSAN SHATTER

A sense of apprehension and urgency exudes from Susan Shatter's egg tempera, watercolor, and oil paintings of sublime landscapes in rich, vivid colors. Streaming majestic sunsets, glowing skies set ablaze by lightning strikes, and Turneresque skies dominate her oeuvre. In her works from the 1990s, the idea of danger as an integral aspect of nature looms large. The forbidding qualities in nature are ever present, hallmarked by sharp contrasts of deep blues and purples juxtaposed by glowing oranges and yellows.

Shatter's panoramas and aerial views created over the last twenty-five years are not metaphors for refuge and solace, but displays of the eternal physicality of matter and force. Known as a realist, she neither mythologizes nor de-mythologizes her subject. Her landscapes are simply the "dizzying objectivity of nature."[1] The many sites Shatter chooses for such majestic interpretations include the Irish Sea, the desert Southwest, and the Maine coastline. Her attention to the geologic structure of the land in concert with the fluidity of water and atmospheric theatrics of the sky place her in the realm of Hudson River School artists Thomas Cole, Asher Durand, and Frederick Church.

*Volcano*, 1992, for instance, reveals a close-up view of a violent eruption—a powerful burst of hot molten lava and belching steam thrusting up from a darkened mountain. The heat and force of the red, orange, and glowing yellow of the lava seems to come alive as it streams down the ragged slopes. A supreme homage to raw nature, the scene is at once beautiful and unforgiving.

—JS

1   Donald Kuspit, *Susan Shatter: Tracking the Terrain* (Stony Brook, NY: Stony Brook University, 2003).

**Volcano**, 1992. Egg tempera on wood panel, 8 x 10 in. *Courtesy of the artist and DFN Gallery, New York*

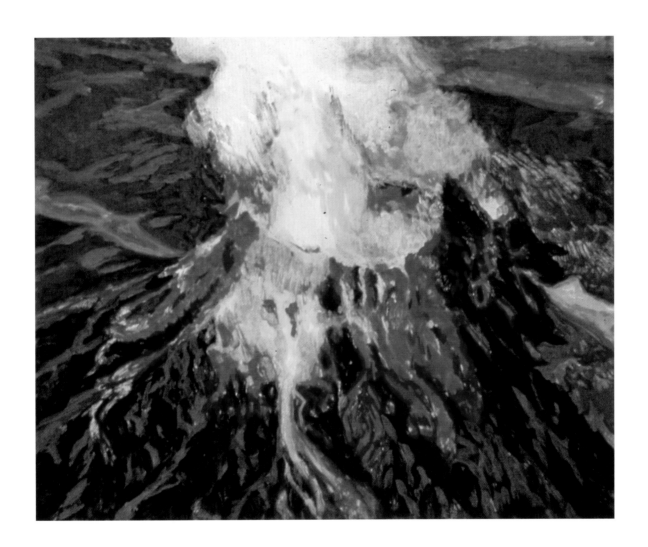

## JEFF SMITH

Known as a "storm-chasing adrenaline junkie," Arizona photographer Jeff Smith has collaborated with fellow photographer A. T. Willett for twenty-five years in the pursuit of violent lightning storms, hurricanes, and tornadoes. The two place themselves at risk to capture sublime moments during Arizona's lively monsoon season for a visceral thrill and for the unique photographic results. Primarily interested in nightscapes with lightning, Smith explains, "These images serve as a remembrance of that moment, and without proof for other people, some of the storms you experience would just sound like a big fish story."[1] The artist is also interested in the subculture of those who seek out the physical experience of storms. Often the trace of their presence can be seen in his photographs through the low glow of their headlights or faint movement of their bodies.

*Red Rock Power Station, Arizona*, 2003, is a large-scale digital print that reveals the awesome majesty and force of nature unleashed in the form of a major lightning strike near the Red Rock Power Station in Arizona. In this powerful work, the nocturnal sky is a brilliant violet color lit up by a large white bolt of lightning that slams to earth, sending spidery veins of electricity crackling off into the sky. Soft lights from structures in the background produce an eerie green glow, which reflects in the standing water of the foreground. The dichotomy of the force of nature and the black silhouette of the power lines and towers of the station is palpable. Here the viewer encounters the energy we so desperately rely on, and the seemingly archaic methods we use to try and harness it.
—*JS*

1   Jeff Smith, artist statement, 2007.

*Red Rock Power Station, Arizona*, 2003. Archival pigment inkjet print, 1/15, 40 x 40 in. ©Jeff Smith 2003, www.jeffsmith.com
*Courtesy of Etherton Gallery, Tucson, AZ*

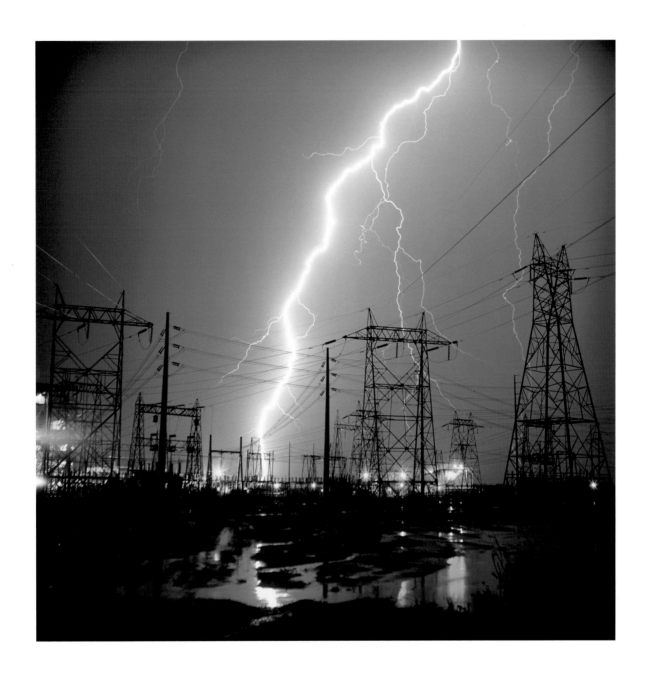

# MIKHAEL SUBOTZKY

**S**outh African photographer Mikhael Subotzky became committed to social democracy at an early age, in part due to his exposure to the activist work of his uncle, Gideon Mendel, a noted "struggle photographer." In his images, Subotzky explores the social landscapes of contemporary South Africa in an attempt to make sense of his homeland's strained post-apartheid condition. His student thesis project, completed in 2004, focuses on the infamous Pollsmoor Maximum Security Prison where Nelson Mandela spent several years of his political imprisonment. There Subotzky created a series of panoramic photographs of the prisoners, his first inquiry into this critical issue of South African history.

Subotzky's most recent photographic project focuses on Beaufort West, a small town in the Karoo Desert, described by the South African Human Rights Commission as "an isolated town that has not broken away from the shackles of South Africa's apartheid past, [where] economic and social integration is severely limited."[1] Beaufort West has one of the highest rates of unemployment in South Africa, as well as high rates of crime, alcoholism, and prostitution. For *SOUTH AFRICA. Beaufort West,* 2006, Subotzky photographed people at Beaufort West's landfill as they search for food in a pile of newly-dumped garbage. For Subotzky, Beaufort West is far from an aberrant backwater on the fringes of civilization. Rather, it is a site where the underlying social problems of South Africa converge and reveal themselves.

—*EH*

1    <http://www.magnumphotos.com/Archive (29)> (September 2008).

**SOUTH AFRICA. Beaufort West**, 2006. Beaufort West rubbish dump, photograph. 30 x 40 in. *Courtesy of Magnum Photos*

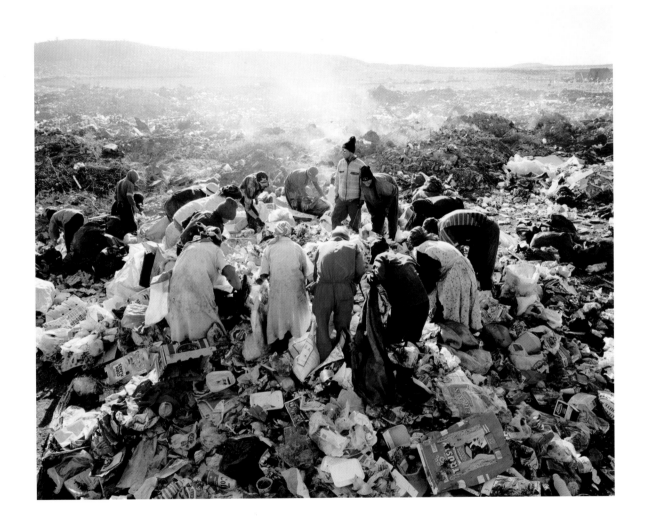

# TOM UTTECH

Hauntingly desolate, the large-scale landscapes of Wisconsin painter Tom Uttech turn away from the idyllic visions of paradise for a frankly austere and visually honest depiction of nature, however dreamlike in quality. Uttech is motivated by ethical concerns for the bounty of the wilderness and the beauty of the forest. He conveys his fascination with ecosystems by paying particular attention to the earth, sunlight, water, and atmosphere, as well as details in the many elements and textures found in nature. Working strictly from observation, the artist divides his paintings into two horizontal, sharply tilting planes of sky and land, creating a clear foreground and deep, vast space. Uttech often depicts a lone animal (such as a bear, moose, or wolf) that stands before a winter sunset and looks out toward the viewer. In many paintings, he fills the sky with dark birds that seem to serve as a portent of trouble to come. Such imagery conveys an unsettling feeling. Noted critic John Yau ponders, "We are stuck with the disquieting sense that these animals are determined to get away from what lies up ahead, in their future and, no doubt, ours."[1]

Uttech bases his scenes on the verdant woods of Quetico Provincial Park in Ontario, Canada, and the Puchyan Marsh near his home in Saukville, Wisconsin. In his surreal scenes, the landscape is energized with activity, and sights emerge that confound the viewer as rocks, animals, and plants take on lives of their own.[2] *Nin Maminawendam*, 2006, is an example of Uttech's visionary landscapes depicting a denuded pine forest dotted with charred trunks and dark stumps, as if the victims of a forest fire. In this sublime landscape, the brilliant sky teems with hawks, swallows, woodpeckers, and owls, while wolves race through the barren ground. The glowing embers of a radiant sunset reflecting off the marsh waters further heightens the dramatic scene of devastation that at once recalls an apocalyptic nightmare and a hope for redemption.

—*JS*

1  John Yau, "Tom Uttech," in *Tom Uttech: New Paintings* (New York: Alexandre Gallery, 2004).
2  Lucy Lippard, "Magnetic North," in *Magnetic North: The Landscapes of Tom Uttech* (Milwaukee: Milwaukee Art Museum, 2004), 15.

**Nin Maminawendam**, 2006. Oil on linen, 73 x 78 in. *Courtesy of Alexandre Gallery, New York*

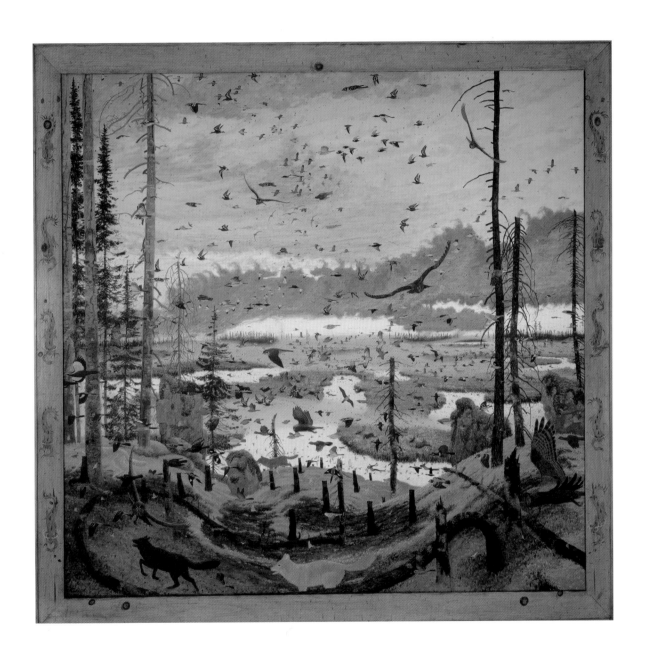

## ELLEN WAGENER

Inspired by the landscape traditions of the Hudson River School, American Luminism, and twentieth-century Iowa artists such as Grant Wood and Marvin Cone, among others, Phoenix-based artist Ellen Wagener is a keen observer of the atmospheric and tactile qualities of the sky and land. Wagener is a self-described regionalist who draws ideas from her Iowa homeland and a deeply felt connection to the desert Southwest. Creating agrarian landscapes in pastels and charcoal, she builds her landscapes as composites from sketches, memory, and photographs. Often the artist revisits sites to observe the changes in crop rotation, weather, and time of day and season.

Known for her stormy clouds, burning fields, dust storms, and tornadoes moving across prairies and fields, Wagener took a new approach after her move to the West in 2001. To the artist, the Arizona landscape embodies a sense of place with emotional and metaphoric content rather than the specificities of a particular landmark—a sharp contrast to the ubiquitous stereotypes depicted about the region. In 2005, for instance, Wagener created the series "The Cultivated Desert," where she juxtaposed vibrantly colored urban landscapes with black and white drawings of the open stretches of pristine desert evocative of luminous silver-gelatin photographs. Such natural phenomena as dust storms, monsoons, and forest fires became unsettling metaphors for her own emotional state as she made the transition from Midwesterner to desert transplant.

*Koyaanisqatsi*, 2008, from the "Life Out of Balance" series encourages viewer introspection about humankind's effect on nature and gives a sense of Wagener's own tentative state of personal balance. In this work, the billowing clouds of her former Iowa prairie scenes give way to a powerful nuclear mushroom cloud, inspired by the iconic photographs of this phenomenon obtained from media sources. This dramatic large-scale drawing reminds the viewer that Arizona has one of the largest nuclear plants in the country, not far from the high-density population of Phoenix.

—*JS*

1  Jane Milosch, *On the Lands: Drawing the Cycles of Nature* (Cedar Rapids, IA: Cedar Rapids Museum of Art, 2003),1.

**Koyaanisqatsi**, 2008, from the series "Life Out of Balance." Pastel on paper mounted on board, 40 x 60 in. Collection of Tucson Museum of Art. Museum Purchase, funds provided by Robert Greenberg, 2008.9.1

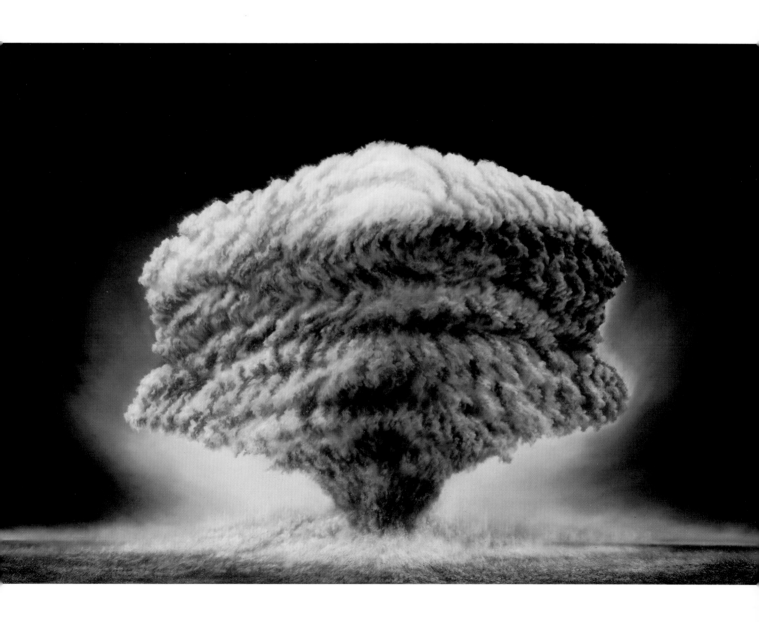

## WILLIAM T. WILEY

California artist William T. Wiley makes acerbic socio-political statements by combining playful doodles, illustrative figures, representational images, and scrawling text in freeform language. Commenting on contemporary life, Wiley has an expansive command of current events and history culled from NPR broadcasts, history books, and the Internet. Although his sensuous drawings recall Old Masters, Wiley's witty and engaging visual and verbal puns point directly to the events and concerns of today. He is known for his figurative style developed in the early 1960s that differed from minimalism, popular at the time, and for being one of the originators of the "Bay Area Funk" movement. Wiley creates work that is uniquely his own. He blends the thoughtful philosophical wisdom of Zen Buddhism with humor to create a satirical commentary on the grave condition of politics, the environment, and global conflicts.[1]

*#1 Polar Plight*, 2006, is a small watercolor that appears at first to be a children's book illustration. But the story is not the happy one of children's fantasies. Instead, it tells the story of the very real possibility of global warming consuming the polar ice caps. In this work, there is barely a division between the washy blues and greens articulating the sea and the sky. Gasping for breath, a polar bear with large gaping mouth and sharp white fangs struggles in vain within a great expanse of water. Overlaying the chilly depths of the sea, a visual parable warns, "And so through the cold blue water the polar bear swam and swam ... (but it wasn't cold enough) he was looking for hard water land ... swimming so long now the great strength was ebbing and despite all its effort ... was slipping through the webbing ... of Indra's Net ... into oblivion the gracious void the maw the yawn ... The big black hole where light has gone. And where all will go sooner or later ... Like the polar bear or the alligator. But not you or me here safe on land ... the way its spose to be safe ... and at our command."

—*JS*

1   Betti-Sue Hertz, "Recent Paintings by William Wiley: Place is the Inquiry, Words are the Commentary," in *The Word According 2 William T. Wiley* (Fullerton: California State University Main Art Gallery, 2003).

**#1 Polar Plight**, 2006. Watercolor, ink on paper, 12 1/4 x 9 in. *Courtesy of the artist and Charles Cowles Gallery, New York*

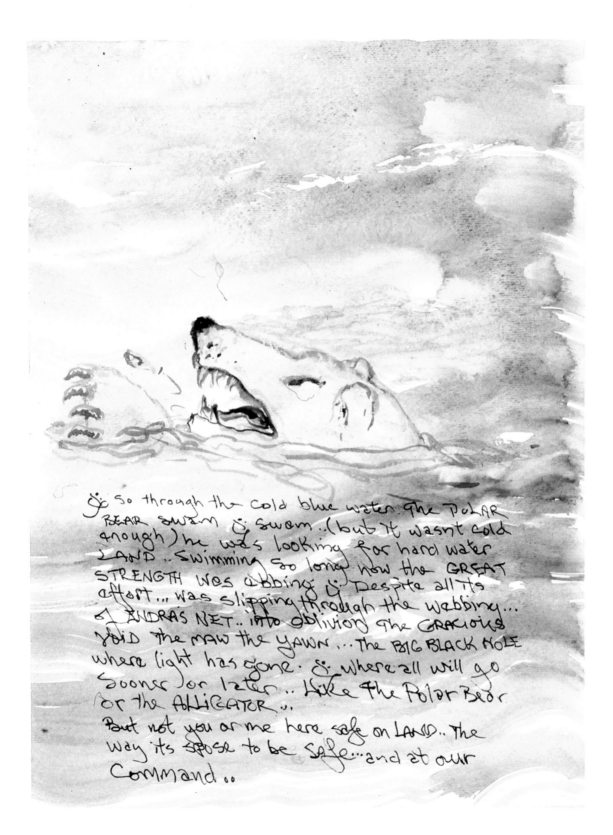

So through the cold blue water the POLAR BEAR swam swam..(but it wasn't cold enough) he was looking for hard water LAND..swimming so long now the GREAT STRENGTH was ebbing Despite all its effort...was slipping through the webbing... of INDRAS NET..into oblivion the GRACIOUS void the maw the YAWN...THE BIG BLACK HOLE where light has gone. where all will go sooner or later... like the Polar Bear or the ALLIGATOR...

But not you or me here safe on LAND..The way its spose to be SAFE...and at our command..

## A. T. WILLETT

Chasing active storms with fellow photographer Jeff Smith, A. T. Willett is captivated by the setting sun and the raw power of tornadoes and lightning storms in the Southwest. These two "Lightningsmiths" brave deadly conditions to capture the perfect moment of a storm—when moisture, wind, and heat combine. Willett's life-long fascination with dangerous storms developed when he witnessed the power of a tornado that damaged his family's house in a suburban Chicago neighborhood. As a young boy, he often had to seek shelter under the stairs in the middle of the night, ear pressed to the radio for tornado warning updates. When he moved to Arizona at eight years old, Willett became enthralled by the summer monsoon thunderstorms that are unique to the area.[1]

*Gruver, Texas, Tornado*, 1995, is a large-scale archival inkjet print that captures the moment when a tornado touches down. Directly centered in the composition within a dark grey sky, the powerful funnel cloud emanates from the heavens and reaches to the flat green earth; a lone windmill stands to the left as a miniature testament to the tornado's awesome scale. To reinforce the presence of the photographer, Willett includes the brackets from the Fuji film strip and the number of the frame. In such works, the photographer acts as a witness to the terrifying forces of nature, capturing the exhilarating moment when the storm unleashes its fury. For a suspended moment, all thoughts are focused on the awesome phenomenon, rather than the reality of the ensuing destruction and devastation.

—JS

1   A. T. Willett, artist statement, 2007.

**Gruver, Texas Tornado**, 1995. Archival pigment inkjet print, 1/15, 37 x 39 in. © 1995 A.T. Willett. *Courtesy of Etherton Gallery, Tucson*

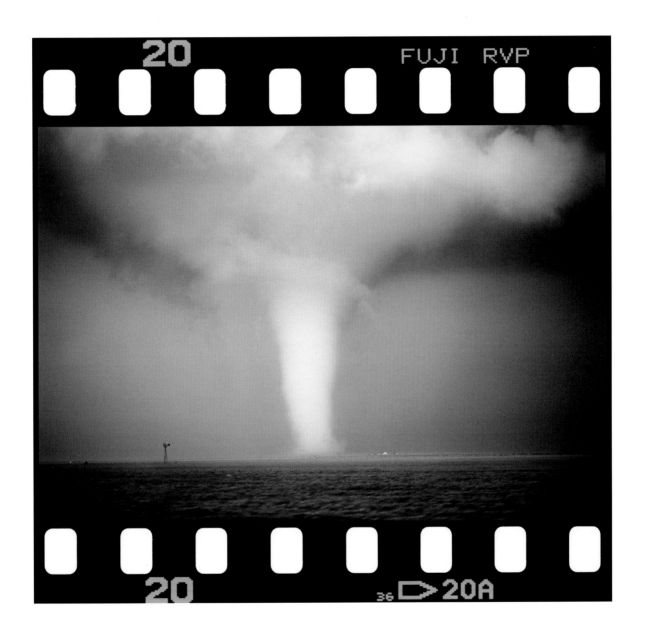

## JOEL-PETER WITKIN

**A**merican photographer Joel-Peter Witkin's images are simultaneously violent and sensuous, repulsive, and gorgeous. They are informed by the artist's vast knowledge of art history, yet firmly rooted in the present. Witkin claims that his unique aesthetic sensibility stems from a single, traumatic event: as a child, he witnessed a horrific car accident in which a young girl was decapitated. He vividly recalls the girl's dead eyes staring up at him. It is this juxtaposition of life and death, the grotesque and the beautiful that Witkin captures in his photographic works.

Trained as a painter and a sculptor, Witkin stages elaborate tableaus. His otherworldly images (which often reference the works of Bosch, Goya, Velasquez, Miro, Botticelli and Picasso), are populated by untraditional models: dwarfs, hermaphrodites, androgynes, people with odd physical qualities, or, as Witkin has written, "any living myth ... anyone bearing the wounds of Christ."[1] Through his photographs of people cast aside by society, Witkin challenges his audience's sense of normalcy and morality.

In *The Raft of George W. Bush*, 2006, Witkin takes French artist Théodore Géricault's 1819 painting *The Raft of the Medusa* (p. 22) as his model. Géricault's work depicts the wreck of the frigate Medusa and its survivors' desperate struggle. Witkin recreates the painting in minute detail, capturing Géricault's dramatic lighting, theatrical composition, and baroque play of contorted bodies in rich tones of black and white. According to Witkin, the events surrounding the tragic shipwreck also resonate with the contemporary political scene. Just as Medusa's captain was inexperienced and incompetent, Witkin notes, "George W. Bush is also incompetent....The people on *The Raft of George W. Bush*—his party and regime—are the victims of their own rationale, their conservative elitism, their hunger for political and social power, and their unilateral military ambitions."[2] *The Raft of George W. Bush* therefore blends shocking visuals with incisive political commentary.

—EH

1   Joel-Peter Witkin, "Revolt Against the Mystical," in Germano Celant and Joel-Peter Witkin, *Witkin* (New York: Sabo, 1995), 249.
2   Joel-Peter Witkin, artist statement, <www.edelmangallery.com/witkin33.htm> (5 October 2008).

**The Raft of G.W. Bush**, 2006. Toned gelatin silver print, 11/12, 29 $^3/_8$ x 35 in. *Courtesy of Joel-Peter Witkin and Etherton Gallery, Tucson, AZ*

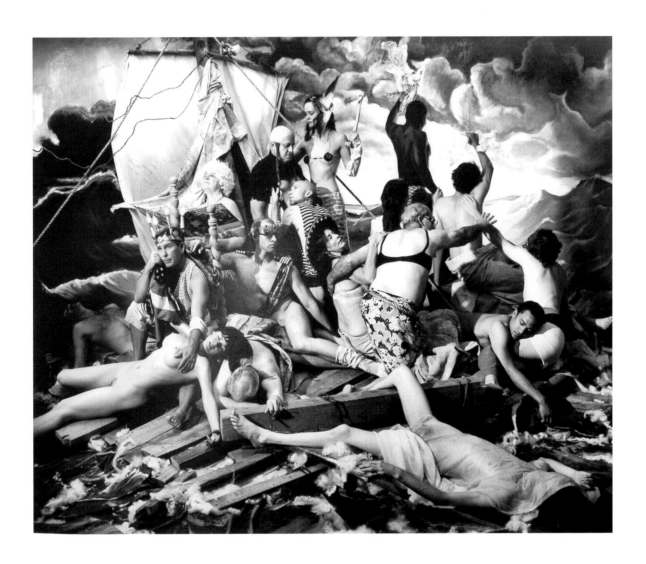

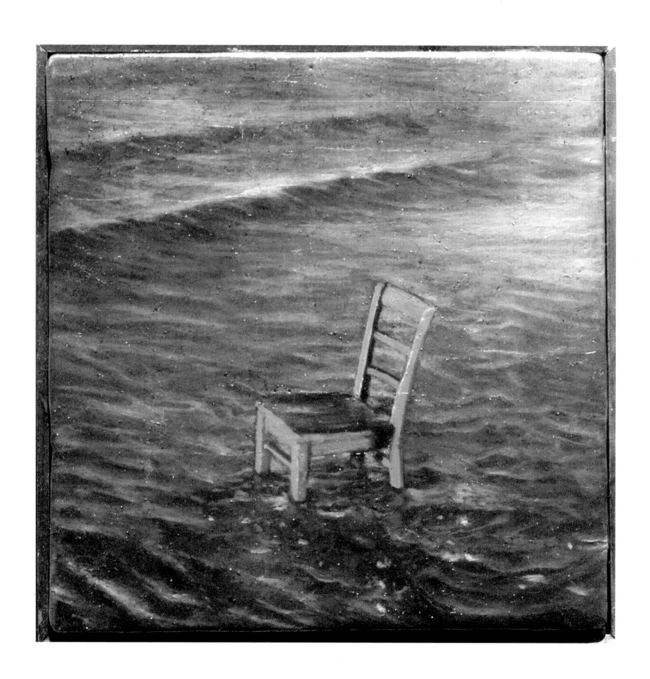

*Detail:* Heather Green, **Tide Cycle—An Act Against Erasure**, 2008.

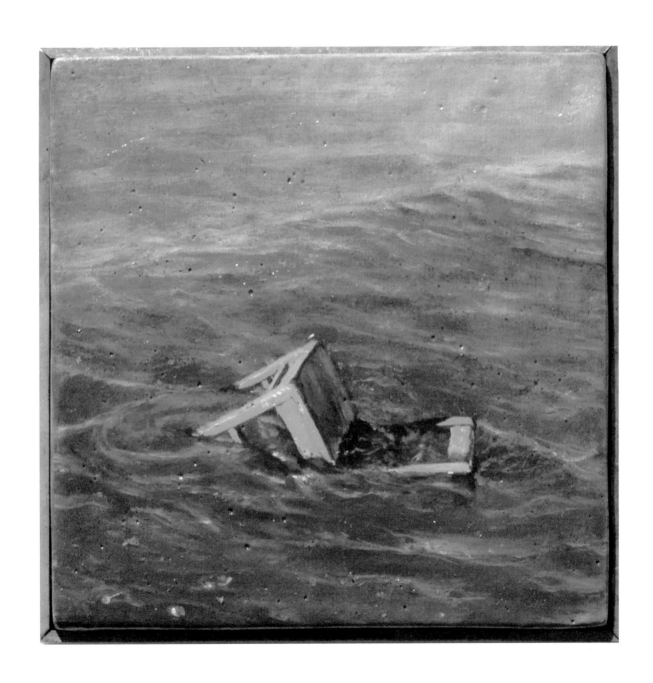

*Detail:* Heather Green, **Tide Cycle—An Act Against Erasure**, 2008.

# EXHIBITION CHECKLIST

**KIM ABELES**
**Thomas Hart Benton's "Island Hay" in Thirty Days of Smog**, 2000
particulate matter (smog) on Plexiglas
12 x 16 in.
Collection of Arizona State University Art Museum; Partial donation by artist and purchased with funds provided by the FUNd at Arizona State University Art Museum

**LUIS CRUZ AZACETA**
**At the Bottom of the Pot**, 2007
photographs mounted to found pots and pans
96 x 108 x 10 in.
*Courtesy of Arthur Roger Gallery, New Orleans, LA*

**SASHA BEZZUBOV**
**Tsunami #7, Thailand**, 2005
C- print
40 x 50 in.
*Courtesy of Taylor De Cordoba Gallery, Los Angeles, and The Front Room Gallery, New York*

**RANDY BOLTON**
**Never Take More Than You Need**, 2004
digital print on canvas with free-standing 3-dimensional element
111 x 122 x 13 in.
*Courtesy of the artist and Littlejohn Contemporary, New York*

**SONJA BRAAS**
**Lava Flow**, 2005, from the series "The Quiet of Dissolution"
C-print, Diasec
73 x 59 in.
Private Collection, New Jersey
*Courtesy of Galerie Tanit, Munich, Germany*

**ALICE LEORA BRIGGS**
**Garden of Ruins: Eve**, 2005
sgraffito on panel
24 x 36 in.
Diane and Sandy Besser Collection

**DIANE BURKO**
**Disappearing Series 2a, 2b**, 2007
from the series "Politics of Snow"
oil on canvas, diptych
48 x 24 in.
*Courtesy of the artist and Locks Gallery, Philadelphia, PA*

**EDWARD BURTYNSKY**
**Oxford Tire Pile #8, Westley, California**, 1999
C-print, edition AP 1
40 x 50 in.
© Edward Burtynsky
*Courtesy of the artist and Charles Cowles Gallery, New York*

**EDWARD BURTYNSKY**
**Uranium Tailings No. 12, Elliot Lake, Ontario**, 2004
chromogenic color print, 10/10
22 x 45 in.
© Edward Burtynsky
Private Collection

**CORWIN "CORKY" CLAIRMONT AND LEONARD EDMONDSON**
**Gregorio State Beach**, 1979
from the series "Torn Paper, California Beaches"
photo litho prints
30 x 14 in.
*Courtesy of the artists*

**ROBERT D. COCKE**
**The Quest for Knowledge**, 1989
oil on canvas
62 x 50 in.
Collection of Tucson Museum of Art
Gift of Terry Etherton, 2000.40.1

**ANNE COE**
**Life Examined**, 1998
acrylic on canvas
60 x 100 in.
Collection of Tucson Museum of Art
Gift of Vanier Galleries, 2001.20.1

**SUE COE**
**Neptune is Angry**, 2006
from the series "Hurricane"
graphite on white Strathmore Bristol board
29 x 23 in. sheet;
29 $^3/_4$ in. x 21 $^3/_4$ in. image
©Sue Coe
Collection of Tucson Museum of Art Museum purchase, anonymous funds, 2007.28.2

**SUE COE**
**We Are All In the Same Boat**, 2006
from the series "Hurricane"
graphite on white Strathmore Bristol board
29 x 23 in. sheet; 13 x 13 in. image
©Sue Coe
Collection of Tucson Museum of Art Museum purchase, anonymous funds, 2007.28.1

**DAN COLLINS**
**Flood**, 2008-2009
Video installation: digital animation projected on relief sculpture comprised of computer routed gridded frame and bonded sea salt; includes 6 framed digital prints
dimensions variable
*Courtesy of the artist and Lisa Sette Gallery, Scottsdale, AZ*

**JAMES P. COOK**
**Trinity Bay-Reflections**, 2007
oil on linen
60 x 40 in.
*Courtesy of the artist and Davis Dominguez Gallery, Tucson, AZ*

**SUSAN CRILE**
**Encrusted Tar**, 1994
oil on canvas
60 x 60 in.
*Courtesy of the artist*

**JOHANN RYNO DE WET**
**Thirst**, 2006
digital inkjet print, edition of 5
12 $^{11}/_{16}$ x 23 $^3/_8$ in.
*Courtesy of Galerie Poller, New York*

**MARK DION**
**Bureau of Remote Wildlife Surveillance**, 1999-2007
20 unique color photographs
each: 13 $^1/_2$ x 15 in.
as installed: 58 $^1/_2$ x 81 in.
*Courtesy of the artist and Tanya Bonakdar Gallery, New York*

**MITCH EPSTEIN**
**Biloxi, Mississippi**, 2005
from the series "American Power"
C-print, edition of 6
45 x 58 in.
*Courtesy of the artist and Sikkema Jenkins & Co., New York*

**VERNON FISHER**
Inscribing the World with Water, 1994
oil, blackboard slating on
wood, chalk, erasers
71 x 76 1/2 x 6 in.
Collection of Tucson Museum of Art
Gift of the Contemporary Art Society
in memory of Jules Litvack
2005.11.1

**PAUL FUSCO**
UKRAINE. Prypiat, 1997
gelatin silver print
16 x 20 in.
*Courtesy of Magnum Photos*

**FRANCESCA GABBIANI**
Rise, 2007
colored paper and gouache on paper
69 x 57 in.
Collection of David Burtka
*Courtesy of Patrick Painter Gallery,*
*Santa Monica, CA*

**SUSAN GRAHAM**
Big Storm 2, 2006
lambda print, 1/2
30 x 40 in.
*Courtesy of the artist and Schroeder*
*Romero Gallery, New York*

**HEATHER GREEN**
Tide Cycle-An Act Against
Erasure, 2008
oil on panel, linotype on steel shelves,
letterpress cards,
mixed media mutoscopes
dimensions variable
*Courtesy of the artist*

**EMILIE HALPERN**
Lightning #5, 2006
thermoplastic, aluminum wire
50 x 33 x 74 in.
*Courtesy of the artist*

**JULIE HEFFERNAN**
Self Portrait as Astyanax, 1997
oil on canvas
66 x 89 in.
*Courtesy of Lisa Sette Gallery,*
*Scottsdale, AZ*

**RODERIK HENDERSON**
Badlands #14, 2001
gelatin silver print
24 x 35 in.
*Courtesy of the artist*

**TRACY HICKS**
Canaries/Frogs/Silence, 2009
mixed media installation
dimensions variable
*Courtesy of the artist*

**DODO JIN MING**
Free Element, Plate XXX, 2002
C-print, 7/10
42 x 51 in.
© DoDo Jin Ming
*Courtesy of Laurence Miller Gallery,*
*New York*

**KIM KEEVER**
Summer: Blue, Yellow and Gray, 2004
C-print, edition of 3
51 1/8 x 68 1/8 in.
*Courtesy of Kinz + Tillou Fine Art,*
*New York*

**ISABELLA KIRKLAND**
Gone, 2008
from "TAXA," a suite of six inkjet prints;
printed by Trillium Press on Moab
Entrada natural white, edition of 50
35 x 26 in.
*Courtesy of the artist and Feature Inc.,*
*New York*

**DIMITRI KOZYREV**
Teenage Dream, 2002
oil, acrylic on linen
36 x 36 in.
*Courtesy of the artist and Mark Moore*
*Gallery, Santa Monica, CA*

**NEVAN LAHART**
Ch. 91: The Sun Sets on Santa's North
Pole Operation, 2007
oil and acrylic on MDF
18 x 24 in.
*Courtesy of Kevin Kavanagh Gallery,*
*Dublin, Ireland*

**ROSEMARY LAING**
weather #4, 2006
C type photograph, 2/8
43 5/16 x 72 7/16 in.
Courtesy of the artist and Galerie
Lelong, New York

**DAVID MAISEL**
Lake Project #11, 2001
C-print, edition of 5
48 x 48 in.
*Courtesy of the artist and Evo Gallery,*
*Santa Fe, NM*

**MARY MATTINGLY**
Silent Engineers, 2005
chromogenic dye coupler print, edition
of 5 + 2 AP
40 x 40 in.
©Mary Mattingly
*Courtesy of Robert Mann Gallery,*
*New York*

**RICHARD MISRACH**
Dead Animals #327, 1987
digital chromogenic print, 1/10
30 x 37 in.
*Courtesy of Fraenkel Gallery,*
*San Francisco, Marc Selwyn Fine Art,*
*Los Angeles and Pace/MacGill Gallery,*
*New York*
Collection of Tucson Museum of Art
Gift of Ceta Scott and Harry George,
2007.23.1

**RICHARD MISRACH**
Desert Fire [#699-84], 1984
archival pigment print, 1/3
60 x 72 in.
*Courtesy of Fraenkel Gallery,*
*San Francisco, Marc Selwyn Fine Art,*
*Los Angeles and Pace/MacGill Gallery,*
*New* York

**MATTHEW MOORE**
Rotations: Single Family Residence, 2006
20 acre barley field
C-print, 1/7
44 1/2 x 60 1/2 in.
Private Collection
*Courtesy of Lisa Sette Gallery,*
*Scottsdale*

**MICHAEL NAJJAR**
invisible city, 2004
video, 15 minutes, edition of 10
*Courtesy of bitforms gallery, nyc*

**JOE NOVAK**
**Phoenix III**, 2003
fumage on paper
25½ x 19½ in.
Collection of Tucson Museum of Art
Gift of David Frank and
Kuzukuni Sugiyama in memory
of Jules Litvack, 2005.19.1

**LEAH OATES**
**Transitory Space, Chicago (double
electric 3)**, 2007
C-print, edition of 10
24 x 30 in.
*Courtesy of the artist*

**ROBYN O'NEIL**
**Our Earth, Our Bodies, Our Decline**,
2006
graphite on paper
66 x 66 in.
Collection of Jason and Leigh Taylor
*Courtesy of Dunn and Brown Gallery,
Dallas, TX*

**TOM PALMORE**
**Run, Sparky, Run!**, 2004
oil and acrylic on canvas
30 x 46 in.
Private collection, Pennsylvania, PA

**ROBERT AND SHANA
PARKEHARRISON**
**Burn Season**, 2005
photogravure, AP 4/5 from an edition
of 50 + 5 AP
26 x 30 in.
*Courtesy of the artists and
Jack Shainman Gallery, New York*

**ANTHONY PESSLER**
**Sturm und Drang**, 2008
graphite on panel
21 x 21 in.
*Courtesy of the artist and Circa Gallery,
Minneapolis, MN*

**ROBERT POLIDORI**
**6328 North Miro Street**, 2005
from the series "After the Flood"
Fujicolor Crystal Archive print,
mounted to Dibond, edition AP 1
40 x 54 in.
*Courtesy of Arthur Roger Gallery,
New Orleans, LA*

**ALEXIS ROCKMAN**
**Untitled**, 1997
mud, raw sewage and river
water on paper
10 x 7 in.
Collection of Kira Dixon-Weinstein
and Adam Weinstein, Tucson, AZ

**BARBARA ROGERS**
**The Price for the Prize**, 2007
mixed media
65 x 48 in.
*Courtesy of the artist and Gebert
Contemporary, Santa Fe, NM;
Scottsdale, AZ; Venice, CA*

**THOMAS RUFF**
**Jpegs**, 2006
digital pigment print (Ditone) on photo
paper, edition of 45
48 x 36 in.
*Courtesy of Richard Levy Gallery,
Albuquerque, NM*

**CHRIS RUSH**
**Fire Water Moon**, 1994
gouache on board
30 x 36 in.
*Courtesy of the artist and Etherton
Gallery, Tucson, AZ*

**SUSAN SHATTER**
**Volcano**, 1992
egg tempera on wood panel
8 x 10 in.
*Courtesy of the artist and DFN Gallery,
New York*

**JEFF SMITH**
**Red Rock Power Station,
Arizona**, 2003
archival pigmented inkjet print, 1/15
40 x 40 in.
*Courtesy of Etherton Gallery, Tucson, AZ*

**MIKHAEL SUBOTZKY**
**SOUTH AFRICA. Beaufort West**, 2006
Beaufort West rubbish dump
photograph
30 x 40 in.
*Courtesy of Magnum Photos*

**TOM UTTECH**
**Nin Maminawendam**, 2006
oil on linen
73 x 78 in.
*Courtesy of Alexandre Gallery,
New York*

**ELLEN WAGENER**
**Koyaanisqatsi**, 2008
from the series "Life Out of Balance"
pastel on paper mounted on board
40 x 60 in.
Collection of Tucson Museum of Art
Museum Purchase, funds provided by
Robert Greenberg, 2008.9.1

**WILLIAM T. WILEY**
**#1 Polar Plight**, 2006
watercolor, ink on paper
12 ¼ x 9 in.
*Courtesy of the artist and Charles
Cowles Gallery, New York*

**A. T. WILLETT**
**Gruver, Texas Tornado**, 1995
archival pigment inkjet print, 1/15
37 x 39 in.
*Courtesy of Etherton Gallery, Tucson, AZ*

**JOEL-PETER WITKIN**
**The Raft of G.W. Bush**, 2006
toned gelatin silver print, 11/12
29 ⅜ x 35 in.
*Courtesy of Etherton Gallery, Tucson, AZ*

Right: Tracy Hicks, **Canaries/Frogs/Silence**, 2009, *detail*

# BIBLIOGRAPHY

_____. "Natural Disasters." Special issue. *Life*. New York: Time Inc., 1994.

**Adams, Robert**. *Beauty in Photography: Essays in Defense of Traditional Values*. New York: Aperture, 1981.

**Adamson, Jeremy Elwell**. "Frederic Edwin Church's *Niagara: The Sublime as Transcendence*." PhD diss., vol. 1-3. The University of Michigan, 1981.

**Barthes, Roland**. *Mythologies*. Trans. Annette Lavers. New York: Hill and Wang, 1972.

**Benjamin, Walter**. "The Author as Producer." In *Walter Benjamin: Selected Writings*, vol. 2, 1927-1934. Trans. Rodney Livingstone et al. Cambridge, MA: Harvard University Press, 1999.

**Berwick, Raphael, et al**. *The Greenhouse Effect*. London: *Serpentine* Gallery, 2000.

**Blessing, Jennifer**. *True North*. New York: Guggenheim Museum, 2008.

**Boettger, Suzanne**. "Global Warnings." *Art in America,* no. 6 (June/July 2008): 154-161, 206-207.

**Bolton, Richard**. *The Contest of Meaning: Critical Histories of Photography*. Cambridge, MA: The MIT Press, 1989.

**Bradley, Fiona**, **Katrina Brown**, and **Andrew Nairne**. *Trauma*. London: Hayward Gallery, 2001.

**Bright, Deborah**. "The Machine in the Garden Revisited: American Environmentalism and Photographic Aesthetics." *Art Journal* 51, no. 2, *Art and Ecology* (Summer 1992): 60-71.

**Burke, Edmund**. *A Philosophical Enquiry into the Origin of our Ideas of the Sublime and Beautiful*. London: Robert and James Dodley, (1757; 1759); Ed. Adam Phillips. London: Oxford University Press, 1998.

**Burtynsky, Edward**. *China: The Photographs of Edward Burtynsky*. Göttingen: Steidl, 2005.

**Carey, Frances**. *The Apocalypse: And the Shape of Things to Come*. Toronto: University of Toronto Press, 1999.

**Carroll, Jerome**. "The Limits of the Sublime, the Sublime of Limits: Hermeneutics as a Critique of the Postmodern Sublime." *The Journal of Aesthics and Art Criticism* 66, no. 2 (Spring 2008): 171-181.

**Colorado Springs Fine Arts Center**. *Katrina: Catastrophe and Catharsis*. Colorado Springs, CO: Colorado Springs Fine Arts Center, 2007.

**Cooper, James F**. *Knights of the Brush: The Hudson River School and the Moral Landscape*. New York: Hudson Hills Press, 1999.

**Corbett, Rachel**, and **Adam P. Schneider**. "Gobal Warning." *Artnews* 107, no. 6 (June 2008): 110-113.

**Cronon, William**. *Uncommon Ground: Toward Reinventing Nature*. New York: W. W. Norton, 1995.

**Crowther, Paul** (ed.) "The Contemporary Sublime: Sensibilities of Transcendence and Shock." Special issue *Art and Design*. 10, no. 5. London: Academy Editions, 1995.

**Delumeau, Jean**. *History of Paradise: The Garden of Eden in Myth and Tradition*. Chicago: University of Illinois Press, 2000.

**Dennis, Kelly**. "Landscape and the West: Irony and Critique in New Topographic Photography." Paper presented at the Forum UNESCO University and Heritage 10th International Seminar "Cultural Landscapes in the 21st Century" Newcastle-upon-Tyne, 11-16 April 2005, revised, July 2006.

**Dewey, John**. *Experience and Nature*. La Salle, IL: Open Court, 1965

**Duncan, Michael**. *High Drama: Eugene Berman and the Legacy of the Melancholic Sublime*. New York: Hudson Hills Press, 2005.

**Dundee Contemporary Arts**. *Trauma*. London: Hayward Gallery, 2001.

**Eagleton, Terry**. *Sweet Violence: The Idea of the Tragic*. Malden, MA: Blackwell Publishing, 2003.

**Earenfight, Phillip** and **Nancy Siegel, ed**. *Within the Landscape: Essays on Nineteenth-Century American Art and Culture*. University Park, PA: 2003.

**Fagone, Vittoria** (ed.) *Art in Nature*. Milan: Edizioni Gabriele Mazzotta, 1996.

**Foster, Hal**. "Obscene, Abject, Traumatic." *October* 78 (Autumn 1996): 106-124.

**Freud, Sigmund**. *The Future of an Illusion*. Translated by. W.D. Robson-Scott. New York: Doubleday, 1957.

**Freud, Sigmund**. "Jokes and their Relation to the Unconscious." In *The Standard Edition of the Complete Psychological Works of Sigmund Freud*. Trans. James Strachey in collaboration with Anna Freud. Vol. VIII (1905). London: The Hogarth Press, 1973.

**Friedman, Martin, et al**. *Visions of America: Landscape as Metaphor in the Late Twentieth Century*. New York: Harry N. Abrams, 1994.

**Gamwell, Lynn**. *Exploring the Invisible: Art, Science, and the Spiritual*. Princeton: Oxford University Press, 2002

**Garner, Gretchen**. *Disappearing Witness: Change in Twentieth-Century American Photography*. Baltimore: John's Hopkins University Press, 2003.

**Gilbert-Rolfe**, **Jeremy**. *Beauty and the Contemporary Sublime*. New York: Allworth Press, 1999.

**George, Hardy** (ed.) *Tempests and Romantic Visionaries: Images of Storms in European and American Art*. Oklahoma City, Oklahoma City Museum of Art, 2006.

Goldsmith, Marcella Tarozzi. *The Future of Art: An Aesthetics of the New and the Sublime.* Albany, NY: State University of New York Press, 1999.

Green, Jonathan. *American Photography: A Critical History 1945 to the Present.* New York: Harry N. Abrams, 1984.

Guerin, Frances, and Roger Hallas. *The Image and the Witness: Trauma, Memory and Visual Culture.* London: Wallflower Press, 2007.

Guimond, James. *American Photography and the American Dream.* Chapel Hill, NC: The University of North Carolina Press, 1991.

Harding, Walter. *Henry David Thoreau As a Source for Artistic Inspiration.* Lincoln, MA: DeCordova and Dana Museum and Park, 1984.

Heartney, Eleanor. "Paradise Lost: The Garden in Art." In *After Eden: Garden Varieties in Contemporary Art.* Middlebury, VT: Middlebury College Museum of Art, 1998.

Henkel, Kathryn. *The Apocalypse.* Baltimore: The University of Maryland, 1973.

Heon, Laura. *Unnatural Science.* North Adams, MA: MASS MoCA, 2000.

Higgie, Jennifer (ed.) *The Artist's Joke: Documents of Contemporary Art.* Cambridge, MA: MIT Press, 2007.

Hylton, Robert. *Landscape Trauma in the Age of Scopophilia: an Autograph Exhibition.* London : Autograph, 2001.

Hoffman, Werner. *The Earthly Paradise: Art in the Nineteenth Century.* New York: George Braziler, 1961.

Kant, Immanuel. *Observations on the Feeling of the Beautiful and Sublime.* First published 1763. Trans. John T. Goldthwait Berkeley: University of California Press, 1960.

Kelly, Michael (ed.) *Encyclopedia of Aesthetics.* New York: Oxford University Press, 1998.

Ketner, Joseph D. II, and Michael J. Tammengra. *The Beautiful, The Sublime, and The Picturesque: British Influences on American Landscape Painting.* St. Louis, MO: Washington, 1984.

Klochko, Deborah. *Picturing Eden.* New York: George Eastman House, 2006.

Knode, Marilu. "Gardens." *Zing Magazine.* 2 (winter/spring 1996): 138-152.

Kozloff, Max. "Ghastly News from Epic Landscapes." *American Art* 5, no.5 (Winter-Spring, 1991): 109-131.

Kozlow, Francine Amy. *Henry David Thoreau As a Source for Artistic Inspiration.* Lincoln, MA: DeCordova and Dana Museum and Park, 1984.

Kusch, Gail E. *Something Coming: Apocalyptic Expectation and Mid-Nineteenth-Century American Painting.* Hanover, MA: University Press of New England, 2000.

Levine, Caroline. *Provoking Democracy: Why We Need the Arts.* Malden, MA: Blackwell Publishing, 2007.

Lineberry, Heather (ed.) *New American City: Artists Look Forward.* Tempe, AZ: Arizona State University Art Museum, 2006.

Lippard, Lucy. *The Lure of the Local: Senses of Place in a Multicentered Society.* New York: New Press, 1997.

_____. *Weather Report: Art and Climate Change.* Boulder, CO: Boulder Museum of Contemporary Art, 2007.

Lombino, Mary-Kay. "Artists in the Garden: Where Nature and Culture Collide." In *UnNaturally.* New York, NY: Independent Curators International, 2003.

Ludwig Forum für Internationale Kunst. *Natural Reality: Artistic Positions between Nature and Culture.* Stuttgart: DACO, 1999.

Matilsky, Barbara C. *Fragile Ecologies: Contemporary Artists' Interpretations and Solutions.* New York : Rizzoli International, 1992.

McShine, Kynaston (ed.) *The Natural Paradise: Painting in America 1800-1950.* New York: The Museum of Modern Art, 1976.

Merchant, Carolyn. *American Environmental History: An Introduction.* New York: Columbia University Press, 2007.

_____. *The Death of Nature: Women, Ecology and the Scientific Revolution.* San Francisco: Harper and Row, 1980.

Metzger, Charles R. *Emerson and Greenough: Transcendental Pioneers of an American Esthetic.* Westport, CT: Greenwood Press, 1954.

Murphy, Frank. *The Book of Nature: American Painters and the Natural Sublime.* Yonkers, NY: The Hudson River Museum, 1983.

Najjar, Michael. *Augmented Realities: Works 1997-2008.* Rotterdam: Veenman Publishers, The Hague Museum of Photography, 2008.

_____. *Netropolis.* New York: bitforms gallery, 2006.

Matilsky, Barbara C. "Sublime Landscape Painting in Nineteenth Century France: Alpine and Arctic Iconography and Their Relationship to Natural History." PhD diss. New York University, 1983.

Nelson, Senator Gaylord. "How the First Earth Day Came About." earthday.envirolink.org/history.html.

Newman, Michael. "From World to Earth: Richard Deacon and the End of Nature." In Stephen Bann and William Allen, ed. *Interpreting Contemporary Art.* New York: HarperCollins, 1991.

Nye, David. *American Technological Sublime.* Cambridge, MA: MIT Press, 1994.

**Oleksijczuk, Denise**. "Nature in History: A Context for Landscape Art." In *Lost Illusions: Recent Landscape Art.* Vancouver: Vancouver Art Gallery, 1991.

**Osborne, Harold**. *Aesthetics and Art Theory: An Historical Introduction.* New York: E.P. Dutton, 1970.

**Owens, Gwendolyn**. *Golden Day, Silver Night: Perceptions of Nature in American Art 1850-1910.* Ithaca, NY: Herbert F. Johnson Museum of Art, 1982.

**Paley, Morton D.** *The Apocalyptic Sublime.* New Haven: Yale University Press, 1986.

**Penny, Nicholas**. Review of *The Apocalyptic Sublime* by Mortan D. Paley. *The English Historical Review.* 104, no. 412 (July 1989): 748-749.

**Pillow, Kirk**. *Sublime Understanding: Aesthetic Reflection in Kant and Hegal.* Cambridge, MA: MIT Press, 2000.

**Polidori, Robert**. *After the Flood.* Göttingen: Steidl, 2006.

**Ray, Gene**. *Terror and the Sublime in Art and Critical Theory: From Auschwitz to Hiroshima to September 11.* New York: Palgrave Macmillan, 2005.

_____. "The Use and Abuse of the Sublime." PhD diss. Coral Gables, FL: University of Miami, 1997.

**Reinhardt, Mark** (ed.) *Beautiful Suffering: Photography and the Traffic in Pain.* Chicago: The University of Chicago Press, 2006.

**Rosenthal, Norman, et al.** *Apocalypse: Beauty and Horror in Contemporary Art.* London: Royal Academy of Arts, 2000.

**Rozelle, Lee**. *Ecosublime: Environmental Awe and Terror from New World to Oddworld.* Tuscaloosa: University of Alabama Press, 2006.

**Ruskin, John**. *Modern Painters.* New York: John W. Lovell Company, 1850.

**Santa Barbara Contemporary Arts Forum**. *Diabolical Beauty.* Santa Barbara, CA: Santa Barbara Contemporary Arts Forum, 2001.

**Santayana, Georges**. *The Sense of Beauty: Being the Outlines of Aesthetic Theory.* New York: Dover Publications, 1955.

**Schmitt, Peter J**. *Back to Nature: The Arcadian Myth in Urban America.* Baltimore: Johns Hopkins University Press, 1969.

**Sherman, Paul**. *Emerson's Angle of Vision: Man and Nature in American Experiences.* Cambridge: Harvard University Press, 1952), 97-98.

**Smith, Stephanie**. *Beyond Green: Towards a Sustainable Art.* New York, NY: Independent Curators International, 2006

**Solnit, Rebecca**. *As Eve Said to the Serpent: On Landscape, Gender, and Art Athens.* GA: The University of Georgia Press, 2001.

_____. *Storming the Gates of Paradise: Landscapes for Politics.* Berkeley: University of California Press, 2007.

**Sonfist, Alan** (ed.) *Art in the Land: A Critical Anthology of Environmental Art.* New York: E. P. Dutton, 1983.

**Sontag, Susan**. *On Photography.* New York: Farrar, Straus, and Giroux, 1977.

**Strauss, David Levi**. *Between the Eyes: Essays on Photography and Politics.* New York: Aperture Foundation, 2003.

**Strelow, Heike**. *Natural Reality: Artistic Positions between Nature and Culture.* Stuttgart: DACO, 1999.

**Strick, Jeremy**. Susan Crile: *The Fires of War. Currents* 58 April 12 – June 5, 1994. Saint Louis: The Saint Louis Art Museum, 1994.

**Sullivan, Robert** (ed.) "Nature's Fury: The Illustrated History of Wild Weather and Natural Disasters." *Life.* 8, no. 2 (14 January 2008).

**Tagg, John**. *Grounds of Dispute: Art History, Cultural Politics and the Discursive Field.* Minneapolis: University of Minnesota Press, 1992.

**Tucker, Anne Wilkes**, and **Rebecca Solnit**. *Crimes and Splendors: The Desert Cantos of Richard Misrach.* Houston: The Museum of Fine Arts, 1996.

**Veith, Gene Edward**. Painters of Faith: *The Spiritual Landscape in Nineteenth-Century America.* Washington, DC: Regnery Publishing, 2001.

**Wallis, Brian et al**. *Ecotopia: The Second ICP Triennial of Photography and Video.* New York, NY: International Center of Photography, 2006.

**Weintraub, Linda**. *Environmentalities: Twenty-two Approaches to Eco-Art.* Rhinebeck, NY: Artnow Publications, 2006.

**Weisman, Alan**. *The World Without Us.* New York: Thomas Dunne Books, 2007.

**Wilton, Andrew**, and **Tim Barringer**. *American Sublime: Landscape Painting in the United States 1820-1880.* London: Tate Publishing, 2002.

**Yard, Sally**. "The Shadow of the Bomb." *Arts.* 58, no. 8 (April 1984): 73-82.

Right: Michael Najjar, **invisible city**, 2004, *detail*

# ARTIST BIOGRAPHIES

## KIM ABELES
Born 1952, Richmond Heights, MO
Lives Los Angeles, CA

### Education
1980    University of California, Irvine, CA. M.F.A.
1974    Ohio University, OH. B.F.A.

### Selected Exhibitions
2008    *Feeling the Heat: Art, Science and Climate Change*, Deutsche Bank Gallery, New York, NY
2008    *Kim Abeles*, survey exhibition, Schneider Museum of Art, Ashland, OR
2007    *Art Since the 1960s: California Experiments*, Orange County Museum of Art, Newport Beach, CA
2007    *Nature/Culture: Artists Respond to Their Environment*, Morris Museum, Morristown, NJ
2007    *Whose Nature? What's Nature?*, Sun Valley Center for the Arts, Sun Valley, ID
2007    *Multiple Vantage Points: Southern California Women Artists, 1980-2006*, Los Angeles Municipal Gallery, Barnsdall Park, Hollywood, CA
2007    *SWARM*, Abeles in collaboration with Suzanne Lacy and Jeff Cain, Artscene:25, Los Angeles County Museum of Art, Los Angeles, CA
2007    *Weather Report: Art and Climate Change*, Boulder Museum of Contemporary Art, Boulder, CO
2004    *Certain Traces: Dialogue Los Angeles/Prague*, Museum Kampa, Prague
2004    *PAC III*, Art Centre, Silpakorn University, Bangkok, Thailand; Hanoi University of Art, Hanoi, Vietnam

### Selected Collections
Arizona State University Art Museum, Phoenix, AZ
The Banff Centre for the Arts Library Collection, Banff, Alberta, Canada
Berkeley Art Museum, Berkeley, CA
Los Angeles County Museum of Art, CA
Museum of Contemporary Art, Los Angeles, CA
Orange County Museum of Art, Newport Beach, CA
Palm Springs Desert Museum, Palm Springs, CA
San Jose Museum, San Jose, CA
Sheldon Memorial Art Gallery, University of Nebraska, Lincoln, NB

### Selected Publications
Barnes, Lucinda, ed. *Measure of Time*. Berkely: University of California Art Museum & Pacific Film Archive, 2007.
Jacobson, Karen, ed. *See/Hear: Museums and Imagination*. California Natural History Museum, 2006.
Selz, Peter. *Art of Engagement: Visual Politics in California and Beyond*. University of California Press, 2005.

## LUIS CRUZ AZACETA
Born 1942, Havana, Cuba
Lives New Orleans, LA

### Education
1966-69  School of Visual Arts, New York, NY

### Selected Awards
1991-92    National Endowment for the Arts, Washington, D.C.
1985       Guggenheim Memorial Foundation Grant, New York, NY
1985       New York Foundation for the Arts, New York, NY
1980-81    National Endowment for the Arts, Washington, D.C.

### Selected Solo Exhibitions
2008    *No Bounds*, Gertrude Herber Institute of Art, Augusta, GA
2006    *Bloom*, Museum of Contemporary Art, Jacksonville, FL
1996    *Self as Another*, San Diego State University, San Diego, CA
1996    *A Painter's Passage*, New Jersey Center for Visual Arts, Summit, NJ
1995    *Hell: Luis Cruz Azaceta, Selected Works From 1978 - 93*, The Alternative Museum, New York, NY
1993    *Biting the Edge*, Contemporary Art Center, New Orleans, LA
1992    *Fragile Crossing*, Smithsonian Institution, Washington, D.C.
1991    *Trayectoria*, Museo de Arte de Ponce, Puerto Rico
1991    *The AIDS Epidemic Series*, The Queens Museum of Art, Queens, NY

### Selected Group Exhibitions
2008    *On the Margins*, The Mildred Lane Kemper Art Museum, Washington University, St. Louis, MO
2008    *Katrina: Catastrophe & Catharsis*, Fine Arts Center of Colorado Springs, CO
2006    *Unbroken Ties: Dialogues in Cuban Art*, Museum of Latin American Art, Long Beach, CA
2005    *Dissidence: Political Social & Artistic Protest* University of Connecticut, Stanford Art Gallery, CT
2002    *Crisis Response*, Rhode Island School of Design Art Museum, Providence, RI
1993    *43rd Biennal Of Contemporary American Painting*, The Corcoran Gallery of Art, Washington, D.C.
1992    *Latin American Artists of the 20th Century*, Museum of Modern Art, New York, NY
1992    *Beyond Glory: Re-Presenting Terrorism*, Maryland Institute College of Art, Baltimore, MD
1991    *Artists Of Conscience: 16 Years Of Social & Politcal Commitment*, The Alternative Museum, New York, NY
1990    *Figuring the Body*, Museum of Fine Arts, Boston, MA
1990    *Affirmative Actions*, The School of the Art Institute of Chicago, IL
1987    *Art Of The Fantastic: Latin American Art, 1920 - 1987*, Indianapolis Museum of Art, Indianapolis, IN
1987    *Hispanic Art in the United States: Thirty Contemporary Painters & Sculptors*, the Corcoran Museum of Art, Washington, D.C.

### Selected Collections
Alternative Museum, New York, NY
Fine Arts Center of Colorado Springs, CO
The Houston Museum of Fine Arts, TX
The Metropolitan Museum of Art, New York, NY
Miami Art Museum, FL

Museo Del Barrio, New York, NY
Museo De Bellas Artes, Caracas, Venezuela
The Museum of Fine Arts, Boston, MA
The Museum of Modern Art, New York, NY
The New Orleans Museum of Art, LA
Rhode Island School of Design Museum Collection,
    Providence, RI
The Smithsonian Institution, Washington, D.C.
Whitney Museum of Art, New York, NY

## SASHA BEZZUBOV
Born 1965, Kiev, Ukraine
Lives Brooklyn, NY

### Education
1997    Yale University School of Art, New Haven, CT.
        M.F.A. Photography
1989    State University of New York, Purchase, NY. B.A.

### Fellowships, Grants, and Awards
2007    The Society of Publication Designers, Gold Medal -
        The New York Times Magazine "The Natural-
        Catastrophe Casino" Cover
2005-06 Fulbright Scholarship Award, India
2005    Bakery Photographic Collective Artist Residency,
        Portland, ME
2000-01 Fulbright Scholarship Award, Vietnam

### Selected Exhibitions
2008    *Sound the Alarm: Landscapes in Distress,* Wavehill,
        Bronx, NY
2008    *Inlandia,* Wignall Museum, Chaffey College, Rancho
        Cucamonga, CA
2007    *Act of Faith,* Noorderlicht Photography Festival XIV,
        Groningen, The Netherlands
2006    *Exploded View,* Art Engine, San Francisco, CA
2006    *Deconstruction and Reconstruction: The Family
        Experience,* Museum of Fine Arts, Tallahassee, FL
2005    *Children's Hour,* Detroit Museum of New Art
        (MONA), Detroit, MI

### Selected Collections
Metropolitan Museum of Art, New York, NY

### Selected Publications
Aletti, Vince. "The Gringo Project" (review). *The Village Voice.*
    July 6, 1999.
Bezzubov, Sasha. *Wildfires* (monograph). New York: Nazraeli
    Press, 2008.
Bibeau, Petra. "Things Fall Apart" (review). *Marginal.*
    April 2007.
Brooks, Kimberly. "The Art of Global Warming." *The
    Huffington Post.* March 22, 2008.
Hrbacek, Mary. "Things Fall Apart." (review). *The New York
    Art World.* May 2007.
Kalm, James. "Things Fall Apart" (review). *Wagmag.*
    April 2007
Neyenesch, Cassandra. "The Searchers" (review). *The
    Brooklyn Rail.* May 2008.
"Things Fall Apart." *NY Arts Magazine.* July – August 2007.

### Selected Publications Featuring Works by Bezzubov
*New York Times Magazine,* "The Natural Catastrophe Casino."
    August 2007.
*Esquire Magazine.* "World Trade Center." September 2005.
*Newsweek Magazine,* "Green Religion." Summer 2005.
*Newsweek International Magazine,* "Time Travelers."
    April 2004.
*Esquire Magazine,* "Is Something Burning." March 2004.
*Newsweek Asia Special Issue.* "Seeking the Light."
    August 2001.

## RANDY BOLTON
Born 1956, Dallas, TX
Lives Bloomfield Hills, MI

### Education
1982    Ohio State University, Columbus, OH. M.F.A.
1978    University of North Texas, Denton, TX. B.F.A.

### Selected Awards
2003    Pennsylvania Council on the Arts, Individual
        Creative Artist Special Opportunity Stipend
        (S.O.S) Program
1989    National Endowment for the Arts/Visual Artists
        Fellowship Grant (Works on Paper), Washington, D.C.
1999    The MacDowell Colony, Peterborough, NH
1996    Yaddo, Saratoga Springs, NY

### Selected Exhibitions
2007    *Inner Child: Good and Evil in the Garden of
        Memories,* Hunterdon Museum of Art, Clinton, NJ
2004    *Twice-Told Tales,* Cranbrook Art Museum,
        Bloomfield Hills, MI
2004    *New Prints 2004/Spring,* International Print Center
        New York, New York, NY
2002    *Off-Register: New Definitions of Printmaking,*
        Laramie Museum, Laramie, WY
2001    *Digital: Printmaking Now,* The Brooklyn Museum,
        Brooklyn, NY
2000    *Delaware Biennial,* Delaware Art Museum,
        Wilmington, DE
1999    *Fabled Impressions,* Georgia Museum of Art,
        Athens, GA
1999    *Between Nature and Culture: American Prints,*
        Jyvaskyla Art Museum, Jyvaskyla, Finland
1999    *Original Copies,* Allcott Gallery, University of North
        Carolina, Chapel Hill, NC
1998    *Visiting Artist Exhibition,* School of the Museum of
        Fine Arts, Boston, MA
1997    *Pervasive Impressions: Contemporary Political
        Prints,* The University of Texas at Arlington,
        Arlington, TX
1997    *Prized Impressions: Gifts from the Print Center,*
        Berman Steiglietz Gallery, The Philadelphia Museum
        of Art, Philadelphia, PA
1996    *Print Narratives and Bedtime Stories: Randy Bolton,
        Matthew Lawrence and John Schulz,* University of
        West Virginia, Morgantown, WV

| 1996 | *The Minnesota National Print Biennial,* Katherine E. Nash Gallery, University of Minnesota, Minneapolis, MN |
| 1995 | *Philadelphia Prints USA,* The Museum of Foreign Art, Riga, Latvia |
| 1994 | *Alternative Prints,* University of South Dakota, Vermillion, SD |
| 1993 | *35th North Dakota Print and Drawing Annual,* University of North Dakota, Grand Forks, ND |
| 1991 | *The Anonymous Image,* Pennsylvania School of Art and Design, Lancaster, PA |
| 1990 | *9th Annual September Competition,* Alexandria Museum of Art, Alexandria, LA |
| 1989 | *10th Annual Paper in Particular National Exhibition of Works On/Off Paper,* Columbia College, Columbia, MO |
| 1987 | *Kansas 12th National Small Painting, Drawing and Print Exhibition,* Fort Hays State University, Hays, KS |
| 1986 | *11th Colorprint USA,* Texas Tech University, Lubbock, TX |
| 1984 | *Miami International Print Biennial,* North Miami Museum and Art Center, Coral Gables, FL |
| 1984 | *14th National Print and Drawing Exhibition,* Dakota Northwestern University, Minot, ND |
| 1982 | *2nd International Exhibition of Prints and Drawings,* Wesleyan College, Macon, GA |
| 1982 | *The Lawndale Competition,* University of Houston, Houston, TX |
| 1982 | *Illinois Print Show,* Northwestern University, Evanston, IL |

## SONJA BRAAS
Born 1968, Siegen, Germany
Lives New York, NY

### Education
| 1997 | Fachhochschule Dortmund, Degree in Visual Communication, Photography and Film, Dortmund, Germany |
| 1995-96 | The School of Visual Arts, New York Photography (Fulbright Grant), New York, NY |
| 1989-91 | University Siegen, Studies of Art and Art History, Siegen, Germany |

### Selected Awards
| 1997 | Kodak Prize for Young Artists |
| 1996 | FOCUS prize |
| 1995 | Fulbright Grant |

### Selected Exhibitions
| 2007 | *Vraisemblances,* Gallery Xippas, Paris, France |
| 2007 | *In den Alpen,* Kunsthaus Zurich, Zurich, Switzerland |
| 2007 | *White Out,* Künstlerhaus Palais Thurn & Taxis, Bregenz, Switzerland |
| 2007 | *Überblick: Konstruktionen der Wahrheit,* Darmstädter Tage der Fotografie 2007 Darmstadt, Germany |
| 2006 | *Gletscherdämmerung,* Eres Stiftung, Munich, Germany |

| 2006 | *Fai da te. Il Mondo dell'Artista,* Centro D'Arte e Cultura San Paolo Esposizioni, Modena, Italy |
| 2005 | Kunstverein Ludwigshafen, Ludwigshafen, Germany |
| 2005 | *Ideal Worlds – New Romanticism in Contemporary Art,* Kunsthalle Schirrn, Frankfurt, Germany |
| 2005 | *Munch Revisited,* Museum für Kunst und Kulturgeschichte, Dortmund, Germany |
| 2005 | *Perspective Contemporaine,* Gallery Vedovi, Bruxelles, Belgium |
| 2004 | Städtische Galerie, Wolfsburg, Germany |
| 2004 | Kunsthalle Rostock, Rostock, Germany |
| 2004 | *Waves II - Tribute and Degressions,* Musée Malraux, Le Havre, France |
| 2004 | *Natur ganz Kunst,* Museum für Kunst und Gewerbe, Hamburg, Germany |
| 2004 | *Landscapes,* Special Exhibition, Art Cologne, Cologne, Germany |
| 2003 | *Wonderlands,* Museum Küppersmühle, Duisburg, Germany |
| 2002 | *Saar Ferngas Preis,* Wilhelm-Hack-Museum, Ludwigshafen, Germany |
| 2002 | *Franciscus,Kunstenaars brengen een ode,* Fries Museum Leeuwarden, The Netherlands |
| 2001 | Goethe Institut, Paris, France |
| 2001 | *Palais für aktuelle Kunst,* Glückstadt, Germany |
| 2000 | Künstlerhaus Bethanien, Berlin, Germany |

### Selected Publications
| 2008 | "Photo Art: Photography in the 21st Century." *Aperture* |

## ALICE LEORA BRIGGS
Born 1952, Borger, TX
Lives Lubbock, TX

### Education
| 1981 | University of Iowa. M.F.A. |
| 1980 | University of Iowa. M.A. |
| 1977 | Utah State University. B.F.A. |

### Selected Awards
| 2008 | Artist-in-Residence, Border Arts Residency, La Union, NM |
| 2007 | Artist-in-Residence, Jentel Foundation, Banner, WY |
| 2004 | Artists Project Grant, Arizona Commission on the Arts, Phoenix, AZ |
| 2003 | Arizona Artist Materials Fund Grant, Contemporary Forum and Cummings Endowment Fund, Phoenix Art Museum, Phoenix, AZ |
| 2002 | Grant, International Exchange (for exhibition in Slovak Republic), Tucson/Pima Arts Council, Tucson, AZ |

### Selected Exhibitions
| 2008 | *Texas Oklahoma Art Prize Biennial,* Wichita Museum of Art, Wichita, TX |
| 2007 | *The Diane and Sandy Besser Collection,* De Young Museum, San Francisco, CA |
| *2007* | *An Eclectic Eye: Selections from the Dan Leach Collection,* Tucson Museum of Art, Tucson, AZ |

| 2006 | *Deadly Sins/Measured Virtues*, Nora Eccles Harrison Museum, Utah State University, Logan, UT |
| 2004 | *What's Love Got To Do With It?,* Tucson Museum of Art, Tucson, AZ |
| 2002 | *Neviem Viem Neviem,* Galeria Mesta Bratislavi, Palffy Palace, Bratislava, Slovak Republic |
| 2001 | *Industry of Memory*, solo exhibition, Tucson Museum of Art, Tucson, AZ |
| 2000 | *Aesthetics of Water*, University of Joensuu, Rantasalmi, Finland |
| 1995 | *Poetic Existence: Surreal Images from the Permanent Collection of the Nora Eccles Harrison Museum of Art*, Utah State University, Logan, UT |
| 1982-84 | *Alice Brown-Wagner, Julia Kellman, Joan Mulgrew,* Cedar Rapids Art Center (now Cedar Rapids Art Museum), Cedar Rapids, IA |

## Selected Collections
Fine Arts Museums of San Francisco, De Young
Firestone Graham Foundation, Albuquerque, NM
Nora Eccles Harrison Museum of Art, Utah State University
University of Iowa Museum of Art, Iowa City, IA
Tucson Museum of Art, Tucson, AZ
Fort Hays State University, Fort Hays, KS

## Selected Publications
Bowden, Charles. *Deadly Sins/Measured Virtues.* Logan, UT: Nora Eccles Harrison Museum of Art, 2006.
Breuer, Karin. *The Diane and Sandy Besser Collection.* San Francisco: Fine Arts Museums of San Francisco, 2007.
McIntire, Frank. "'Ransacked Tombs' Place Art in a Clear Well-lighted Place." *The Salt Lake Tribune* (25 August 1994): 28.
Taylor, Stephanie L. *Art 5, Five State Regional Exhibition.* Las Cruces, NM: New Mexico State University. 2007.
Sasse, Julie. *An Eclectic Eye: Selections from the Dan Leach Collection.* Tucson, AZ: Tucson Museum of Art, 2007.
Sasse, Julie. "Inflections of Illusion: Alice Briggs." *Shade Magazine* (April – May 2006).

## DIANE BURKO
Born 1945, Brooklyn, NY
Lives Philadelphia, PA

### Education
| 1969 | University of Pennsylvania, Philadelphia, PA. M.F.A. |
| 1966 | Skidmore College, Saratoga Springs, NY. B.S. in Art |

### Selected Awards
| 2000 | Bessie Berman Grant in Painting, The Leeway Foundation |
| 1993 | Rockefeller Residence Fellowship, Bellagio Study and Conference Center |
| 1989, 81 | Pennsylvania Council on the Arts Individual Artists Grant |

### Selected Solo Exhibitions
| 2007 | *Invitational: Four Alumni-Skidmore College,* Saratoga Springs, NY |
| 2006 | *Flow,* Tufts University Art Gallery, Boston, MA, traveled to: James A. Michener Art Museum, Doylestown, PA |
| 1999 | *A Sense of Place: Paintings by Diane Burko*, The Parthenon Museum, Nashville, TN |
| 1991 | *Diane Burko at Giverny*, National Academy of Sciences, Washington, D.C. |
| 1987 | *Fifteen Years - 1972-1987*, Hollins College, Roanoke, VA |
| 1983 | *Waterways of Pennsylvania*, traveled to: Everhart Museum, Scranton, PA; Westmoreland County Museum of Art, Westmoreland, PA; Museum of Art, Penn State University, College Park, PA; Reading Public Museum, Reading, PA; Allentown Art Museum, Allentown, PA |
| 1977 | Arizona State University, Tempe, AZ |

### Selected Group Exhibitions
| 2008 | *The Delaware River*, James A. Michener Art Museum, New Hope, PA |
| 2006 | *Photography 26*, Perkins Center for the Arts, Moorestown, NJ |
| 2004 | *Terrestrial Forces*, Museum of Fine Arts, Florida State University, Tallahassee, FL |
| 2003 | *Extreme Landscape*, Hunterdon Museum of Art, Clinton, NJ |
| 2001-02 | *Artists of the Commonwealth: Realism in Pennsylvania Painting*, traveled to: Southern Alleghenies Museum of Art, Loretto, PA; Erie Art Museum, Erie, PA; Westmoreland Museum of American Art, Greensburg, PA; Everhart Museum of Art, Science and Natural History, Scranton, PA; The State Museum, Harrisburg, PA |
| 1998 | *Aspects of Representation*, Western Carolina University, Cullowhee, NC |
| 1997 | *An Extended View: Landscapes by Philadelphia Artists*, Moore College of Art and Design, Philadelphia, PA |
| 1996 | *Invitational Drawing Exhibition*, Smith College, Northampton, MA |
| 1993 | *Thick and Thin*, Islip Art Museum, East Islip, NY |
| 1992 | *Locks Gallery Group*, International Contemporary Art Fair, Yokohama, Japan |
| 1992 | *New Viewpoints: Contemporary American Women Realists*, World Expo, American Pavilion, Seville, Spain |
| 1991 | *Art Now: Artists Choose Artists*, Institute of Contemporary Art, University of Pennsylvania, Philadelphia, PA |

### Selected Publications
Genocchio, Benjamin, "Landscapes Push The Boundaries." *NY Times*, September 14, 2003.
Hampton, Brad. "Diane Burko at Locks." *Art in America*, March 2002: Illus.
McQuaid, Cate, "Touching the Void." *The Boston Globe*, March 19, 2006, Illus.
Newhall, Edith, "Painter a natural photographer." *The Philadelphia Inquirer*, June 16, 2006, Illus.
Rice, Robin. "Diane Burko." *ARTnews*, January 2002: Illus.

## Selected Collections

The Art Institute of Chicago, Chicago, IL
Colgate University, Hamilton, NY
DeCordova Museum, Lincoln, MA
The Pennsylvania Academy of the Fine Arts, Philadelphia, PA
The Philadelphia Museum of Art, Philadelphia, PA
Rutgers University Collection, Stedman, NJ
Woodmere Art Museum, Philadelphia, PA

## EDWARD BURTYNSKY

Born 1955, St. Catharines, Ontario, Canada
Lives Toronto, Ontario, Canada

### Education

1982   Ryerson University, Toronto, Ontario. B.A.
       Photographic Arts
1976   Niagara College, Welland, Ontario. Diploma,
       Graphic Arts

### Selected Solo Exhibitions

2009   *Burtynsky: Oil*, Corcoran Gallery/Museum of Art,
       Washington, D.C.
2008   *In Pursuit of Progress*, Winnipeg Art Gallery,
       Winnipeg, Canada
2008   *Edward Burtynsky: The China Series*, The Art
       Museum, University of Oregon, Eugene, OR
2007   *Manufactured Landscapes*, Gemeentemuseum
       Helmond, Helmond, Netherlands
2007-06 *Edward Burtynsky: The China Series*, Southeastern
       Center for Contemporary Art, Winston-Salem, NC;
       Tuft University Art Gallery, Medford, MA; Samek Art
       Gallery, Bucknell University, Lewisburg, PA
2006   *Edward Burtynsky: The Edmonton Art Gallery Gift*,
       Edmonton Art Gallery, Edmonton, Alberta
2005-04 *Manufactured Landscapes,* Brooklyn Museum of
       Art, Brooklyn, NY
2003   *Edward Burtynsky: Mid-Career Retrospective*, The
       National Gallery of Canada, Ottawa, Ontario and
       Finnish Museum of Photography at Cable Factory,
       Helsinki, Finland
2000   *Vues et points de Vue: L'architecture de Borromini
       dans les photographies d'Edward Burtynsky*,
       Canadian Centre for Architecture, Montréal, Québec
1988   *Breaking Ground*, The Canadian Museum of
       Contemporary Photography and Whyte Museum of
       the Canadian Rockies, Banff, Alberta

### Selected Group Exhibitions

2008   *Eastern Standard: Western Artists in China*,
       Massachusetts Museum of Contemporary Art,
       North Adams, MA
2008   *Ingenuity*, Palais des Beaux Arts, Brussels, Belgium
2008   *International Biennial of Photography and Visual
       Arts*, Liege, Belgium
2007   *Imaging a Shattering Earth / Contemporary
       Photography and the Environmental Debate*,
       Canadian Museum of Contemporary Photography,
       Ottawa
2007   *We are All Photographers Now!* Musée de l'Elysée,
       Lausanne, Switzerland

2007   *A History of Photography*, Victoria and Albert
       Museum, London, U.K.
2007   *Imaging a Shattering Earth,* Dalhousie Art Gallery,
       Halifax, Nova Scotia
2006   *Imaging Asia in Documents,* 1st Photo Biennale,
       Daegu, Korea
2006   *The Photographic Document: Aspects &
       Transformations*, Photography Museum of
       Thessaloniki, Greece
2006   *Made in China*, Museum of Contemporary
       Photography, Chicago, IL
2005   *Subjective Distance,* McMaster Museum of Art,
       Hamilton, Ontario
2002-03 *Altered Landscape: The Carol Franc Buck Collection,*
       Norsk Museum for Fotografi – Preus Fotomuseum,
       Horten, Norway & Nevada Museum of Art, Reno, NV
2002   *New Acquisitions: New Work / New Directions3/
       Contemporary Selections,* Los Angeles County
       Museum of Art, Los Angeles, CA
1993   *Embodied Spaces*, Le Mois de la Photo, Montreal,
       Quebec *Transitions: The Landscape*, Winnipeg Art
       Gallery, Winnipeg, Manitoba and The Canadian
       Centre of Photography, Toronto, Ontario

### Selected Collections

Albright-Knox Art Gallery, Buffalo, NY
Brooklyn Museum of Art, Brooklyn, NY
Canadian Museum of Contemporary Photography,
   Ottawa, Ontario
George Eastman House, Rochester, NY
Iris & B. Gerald Cantor Center for Visual Arts,
   Stanford University, Stanford, CA
Los Angeles County Museum of Art
Milwaukee Art Museum
Museum of Fine Arts, Houston, TX
Museum of Modern Art, NY
National Gallery of Art, Washington, D.C.
National Gallery of Canada, Ottawa, Ontario
Reina Sofia Museum, Madrid, Spain
San Francisco Museum of Modern Art, CA
Seattle Art Museum, Seattle, WA
Snite Museum of Art, University of Notre Dame, Notre Dame, IN
Solomon R. Guggenheim Museum, New York, NY
Victoria and Albert Museum, London, England, U.K.
Wadsworth Atheneum, Hartford, CT

### Selected Publications

*Burtynsky-Quarries.* Germany: Steidl, 2007.
Dieh, Carol L. "The Toxic Sublime." *Art in America* (February
   2006): 118.
Burtynsky, Edward. Burtynsky-China. Germany: Steidl, 2005.
Fishman, Ted. "The Chinese Century." *New York Times* (4 July
   2004): 24.
Whyte, Murray. "Beautiful Mines." *ARTnews* (February 2004): 70.
*Leffingwell, Edward. "Reviews: Edward Burtynsky at Charles
   Cowles." Art In America (June 2002):129.*
*Callahan, Sean. "Multiple Viewpoints." Smithsonian Magazine
   (April 2002).*

## CORWIN CLAIRMONT
Born 1947, St. Ignatius, MT
Lives Ronan, MT

### Education
1971     San Fernando State University, San Fernando, CA. Graduate Fellowship
1970-71   California State University at Los Angeles, Los Angeles, CA. M.A.
1967-70   Montana State University, Bozeman, MT. B.A.
1966-67   University of Montana, Missoula, MT

### Grants and Awards
2003     Fellowship Award, Eiteljorg Museum, Indianappolis, IN
1991     Montana Arts Council Grant
1979     National Endowment for the Arts, Visual Arts Grant
1977     Ford Foundation Grant

### Selected Exhibitions
2007     IAIA Museum, Santa Fe, NM
2007     MAM Art Museum, Missoula, MT
2007     Cultural Art Museum, Naples, FL
2004     Tacoma Art Museum, Tacoma, WA
2004     Te Manawa Museum, New Zealand
2004     Southland Museum, New Zealand
2003     Eiteljorg Museum, Indianapolis, IN
2001     *Halfway Between Here and There*, Art Museum of Missoula, MT
2001     University Rutgers, New Brunswick, NJ
1999     *Indian Reality Today*, "Begegnungen" State Historical Museum Munster, Germany
1996     *New Art of the West*, Eiteljorg Museum, Indianapolis, ID
1996     Washington Historical Museum, Artist in residence and presentation of art works, Tacoma, WA
1995     Museum of Art Washington State University, Pullman, WA
1992     University Art Museum, State University of New York at Binghamton, NY
1992     Herbert F. Johnson Museum of Art, Cornell University, Ithaca, NY
1992     *We The Human Beings*, The College of Wooster Art Museum, Wooster, OH
1992     Museum of Art, University of Oregon, Eugene, OR
1992     The Minneapolis Institute of Arts, Minneapolis, MN
1991     Robert Hull Fleming Museum, University of Vermont, Burlington, VT
1991     The Art Museum, The Museums at Stony Brook, Stony Brook, NY

### Selected Publications
*New Art of the West*, Eiteljorg Museum, Indianapolis, Indiana October 6, 1996.
*We the Human Beings*, The College of Wooster Art Museum, Wooster, OH. 1992.
*New York Sunday Times,* "Bridging Old and New Traditions," Art Review, p. 14, July 28, 1991.
*West Coast Art Week,* "A Habit of Spirit," October issue, 1990.

## ROBERT D. COCKE
Born 1950, Salzburg, Austria
Lives Oracle, AZ

### Education
1975     University of Iowa, Iowa City, IA. M.F.A.
1974     University of Iowa, Iowa City, IA. M.A.
1972     University of Arizona, Tucson, AZ. B.F.A.

### Selected Awards
2002     Juror's Award, New Works in Paint, Mesa Contemporary Arts Center, Mesa, AZ
1998     Best of Show, *Close to the Border/Cera de la Frontera*, New Mexico State University, Las Cruces, NM
1988     Western States Arts Federation, N.E.A. Visual Arts Fellowship (drawing)
1987     Visual Arts Fellowship, Arizona Commission on the Arts, Phoenix, AZ

### Selected Exhibitions
2007     *An Eclectic Eye: Selections from the Dan Leach Collection*, Tucson Museum of Art, Tucson, AZ
2005     *Big City: Cityscapes and Urban Life from the Collection*, Phoenix Art Museum, Phoenix, AZ
2002     *New Works in Paint*, Mesa Contemporary Arts Center, Mesa, AZ
1999     *Texas National '99*, Stephen F. Austin State University, Nacogdoches, TX
1999     *Border to Border 7*, Austin Peay State University, Clarksville, TN
1997     *Artist's Council 28th Annual Juried Exhibition*, Palm Springs Desert Museum, Palm Springs, CA
1997     *Seven from the Seventies*, University of Iowa, Iowa City, IA
1996     *Southwest '96*, Museum of Fine Arts, Santa Fe, NM Solo Exhibition, Gallery of Visual Arts, University of Montana, Missoula, MT
1993     *12th Annual September Competition*, Alexandria Museum of Art, Alexandria, LA
1989     *Evidence: Narrative Painters of the Southwes*t, San Antonio Museum of Art, San Antonio, TX
1988     *Rutgers National Drawing '87/'88*, Rutgers University, Camden, NJ
1987     *Invitational 1987*, University Gallery, University of Texas, Tyler, TX
1986     *Third Western States Biennial Exhibition*, Brooklyn Museum, Brooklyn, NY

### Selected Publications
Frank, Peter. "Robert D. Cocke, Tasende, West Hollywood." *Artnews* (June 2005):128.
Pincus, Robert. "2 Kinds of Inspiration." *San Diego Union Tribune* (23 April 2000): E4.
Regan, Margaret. "Best of the West." *Tucson Weekly* (12-18 June 1991): 24.
Reynolds, Gretchen. "Seriously Funny." *Southwest Art* (May 2008): 108-9.
Trafton, Robin. "Four Fine Artists...." *The Kansas City Star* (6 August 1999): 16.

## Selected Collections
University of Iowa Museum of Art, Iowa City, IA
Tucson Museum of Art, Tucson, AZ
Cedar Rapids Museum of Art, Cedar Rapids, IA
University of Arizona Museum of Art, Tucson, AZ
University of New Mexico Museum of Art, Albuquerque, NM
South Dakota Memorial Art Center, Brookings, SD

## ANNE COE
Born 1949, Henderson, NV
Lives Apache Junction, AZ

### Education
| | |
|---|---|
| 1980 | Arizona State University, Tempe, AZ. M.F.A. |
| 1973 | Universidad de Puerto Rico, Studies in Art and Spanish |
| 1970 | Arizona State University, Tempe, AZ. B.A. (cum laude) |

### Selected Exhibitions
| | |
|---|---|
| 2006 | Nicolaysen Museum, Casper, WY |
| 2000 | *An American Cowgirl: An Image of Her Own*, Jackson Hole Historical Museum, Jackson, WY |
| 1999 | *Miniature Art Show*, University of Wyoming Art Museum, Laramie, WY |
| 1996 | *Tres Amigos*, The Americana Museum, El Paso, TX |
| 1994 | *4th Annual New Art of the West*, Eiteljorg Museum, Indianapolis, IN |
| 1993 | *Art of the Spirit*, The Center for Transcultural Exchange, New York, NY |
| 1989 | *Inaugural Exhibition/Permanent Collection*, University Art Museum, Arizona State University, Tempe, AZ |
| 1987 | *Animals*, California State University at Fullerton, CA |
| 1987 | *American Painters*, Columbus Museum of Art, Columbus, GA |
| 1985 | *Women of the American West*, The Bruce Museum, Greenwich, CT |
| 1982 | *Arizona Biennial*, Tucson Museum of Art, Tucson, AZ |
| 1982 | Centro de Arte Moderna de Guadalajara, Mexico |
| 1982 | *Continuing Frontiers*, North Dakota Museum of Art, Grand Forks, ND |

### Selected Publications
Ewing, Robert. "Esthetic Badness." *Artweek* 18 December 1982, p. 4.
Johnson, Penny. "The Wolf is at the Window"-An Interview with Anne Coe, *Art-Talk* (November, 1995), p. 22,23.
Kotrozo, Carol. "Four Women Artists." *Artspace* Fall 1982, p. 40.
Millins, Jesse. "Razing Arizona." *Art Today* Spring 1988, p.38.
Pyne, Lynn. "The Art Of Healing." *Southwest Art* (November. 1997), p.81.
Robbins, Jim. "The Elks, Autumn Descent," *New York Times* 22 October 1989, Sec. 5, p. 20.

### Selected Collections
Museum of Modern Art, Glasgow, Scotland
Tucson Museum of Art, Tucson, AZ
Eiteljorg Museum, Indianapolis, IN
Whitney Museum of Western Art, Cody, WY

Centro de Atre Moderna, Guadalajara, Mexico
Museum of North Dakota, Grand Forks, ND
Smithsonian Institution, Washington, D.C.
Arizona State University, Tempe, AZ

## SUE COE
Born 1951, Tamworth (Staffordshire), England
Lives New York, NY

### Education
Royal College of Art, London

### Selected Solo Exhibitions
| | |
|---|---|
| 2002 | *Commitment to the Struggle: The Art of Sue Coe*, Brown University, Providence, RI |
| 2002 | *Sue Coe: Selections from Sheep of Fools*, Emmanuel Gallery at University of Colorado, Denver, CO |
| 2001 | *One Hand Washes the Other*, Colgate University, Hamilton, NY and SUNY-Oswego, Oswego, NY |
| 2000-01 | *Sue Coe: The Pit,* Lewis and Clark University, Portland, OR; William Benton Museum of Art, Storrs, CT |
| 1997-99 | *Heel of the Boot: Prints by Sue Coe,* University of Illinois, Normal, IL; Tacoma Art Museum, Tacoma, WA |
| 1990-91 | *Porkopolis - Animals and Industry,* University of Missouri, St. Louis, MO; Washington State University, Pullman, WA; Georgia State University Art Gallery, Atlanta, GA; Santa Monica Museum of Art, Santa Monica, CA |
| 1989 | *Police State*, Museum of Modern Art, Oxford, England |
| 1988 | *Prints*, Springfield Art Museum, Springfield, MO |

### Selected Group Exhibitions
| | |
|---|---|
| 2006-07 | The Downtown Show: The New York Art Scene, Austin Museum of Art, Austin, TX; Andy Warhol Museum, Pittsburgh, PA |
| 2004 | *Democracy in America,* Arizona State University Art Museum, Arizona State University, Tempe, AZ |
| 2001 | *One Hand Washes the Other: Prints and Drawings, 1985-2000*, Colgate University, Hamilton, NY |
| 2000 | *Open Ends*, Museum of Modern Art, New York, NY |
| 1997 | *Art and Provocation: Images from Rebels*, Boulder Museum of Contemporary Art, Boulder, CO |
| 1995 | *In the Light of Goya*, University Art Museum, Berkeley, CA |
| 1994 | *Artist's Sketchbooks: The Intimate Journeys*, National Museum of Women in the Arts, Washington, D.C. |
| 1993 | *Visible Outrage,* Ohio Wesleyan University, Delaware, OH |
| 1993 | *Malcolm X: Man, Ideal, Icon*, Walker Art Center, Minneapolis, MN |
| 1992 | *In Good Conscience: The Radical Tradition in 20th Century American Illustration,* Hood Museum, Dartmouth College, NH; Montgomery Museum of Fine Art, Montgomery, AL |
| 1991 | *Art of the 1980's: Selections from the Eli Broad Family Foundation Collection*, Duke University Museum of Art, Durham, NC |

1991   *Advocacy in Art,* Aldrich Museum of Contemporary Art, Ridgefield, CT
1990   *Contemporary Bestiary,* Islip Art Museum, East Islip, NY
1990   *Word as Image: American Art 1960-1990,* Milwaukee Art Museum, Milwaukee, WI; Oklahoma City Art Museum, OK; Contemporary Arts Museum, Houston, TX
1987   *The New Avant-Garde,* Los Angeles County Museum of Art, Los Angeles, CA
1987   *Process and Product,* Edith C. Blum Art Institute, Bard College, Annandale-on-Hudson, NY
1986   *75th American Exhibition,* Art Institute of Chicago, Chicago, IL
1984   *Biennale 111,* San Francisco Museum of Modern Art, San Francisco, CA

### Selected Collections
Baltimore Museum of Art, Baltimore, MD
University Art Museum, Berkeley, CA
Brooklyn Museum of Art, Brooklyn, NY
Metropolitan Museum of Art, New York, NY
Los Angeles County Museum of Art, Los Angeles, CA
Museum of Modern Art, New York, NY
Philadelphia Museum of Art, Philadelphia, PA
Portland Art Museum, Portland, OR
San Francisco Museum of Modern Art, San Francisco, CA
National Museum of American Art, Smithsonian Institution, Washington, D.C.
National Museum of Women in the Arts, Washington, D.C.
Tucson Museum of Art, Tucson, AZ
Whitney Museum of American Art, New York, NY

### Selected Publications
"Liverpool's Children." *The New Yorker.* December 13, 1993.
"Scenes from an AIDS Ward." *The Village Voice.* February 22, 1994
"Keeping Vigil." *The New Yorker.* January 9, 1995
"Hurricane." *Blab Magazine.* No. 17, September 2006.

## DAN COLLINS
Born 1953, San Mateo, CA
Lives Tempe, AZ

### Education
2006   Arizona State University, Tempe, AZ. Ph.D., A.B.D., Interdisciplinary Humanities
1984   University of California, Los Angeles, CA. M.F.A., Sculpture and New Forms
1976   California State Teaching Credential Stanford University, Stanford, CA. M.A., Art Education/Painting
1975   University of California, Davis. B.A., Studio Art/Art History

### Selected Awards
2008-07   Faculty Research Award, Herberger College of Fine Arts, Arizona State University, Tempe, AZ
2006-04   Mount Vernon Foundation, Forensic Reconstruction of George Washington

2003   National Science Foundation, ITR: An Interpretive Analysis of Digital Data derived from Cypriote Sculpture.

### Selected Exhibitions
2008   *Inaugural Exhibit,* SkySong Opening, Arizona State University, Tempe, AZ
2006   *Water Rising,* Santa Croce Cathedral, Florence, Italy
2006   *The New American City,* Arizona State University Art Museum. Tempe, AZ
2005   *International Rapid Prototyping Sculpture Exhibition,* Southwestern University, Georgetown, TX
2005-04   *International Rapid Prototyping Exhibition.* Southwestern University, Georgetown, TX; Illinois Institute of Technology, Chicago, IL
2004-03   *Return to the Garden,* The Stonewall Foundation Series, Tucson Museum of Art, Tucson, AZ (cat.)
2003   *Telesculpture,* Exploratorium Museum of Science, Art, and Perception, San Francisco, CA
2000   International Sculpture *Conference 2000,* Houston, TX
1997-99   *It's Only Rock and Roll,* Cincinnati Museum of Art, Cincinnati, OH, Traveled: Phoenix Art Museum, Phoenix, AZ; University of Arizona Museum of Art, Tucson, AZ
1995   *Emerging Images: Art By Computer,* Susquehanna Art Museum, Harrisburg, PA
1993   *Sette and Segura: One Decade...,* Neuberger Museum, SUNY, Purchase, NY
1991   *All Round Arizona Invitational Sculpture Exhibition,* Northern Arizona University Museum, Flagstaff, AZ
1974   *Information/Refreshment Booth,* San Francisco Museum of Modern Art, San Francisco, CA

### Selected Publications
Abrams, Amy. "3D Man." *New Times* (10 November 2005).
Leary, Warren E. "Makeover to Depict Washington as Young, Old and in Between." *New York Times,* Science Section (2 November 2004).
Ganis, William V. "Digital Sculpture: Ars Ex Machina." *Sculpture Magazine, International Sculpture Center* 23, no. 8 (October 2004).
Susser, Deborah. "Dan Collins." *Art in America* (October 2004): 164.
Cutajar, Mario. "Not Enough Brush Strokes," *Artweek* (Oakland, CA: Artweek, Inc., January 23, 1992), pp. 10 - 11.

### Selected Collections
Phoenix Art Museum
Scottsdale Center for the Arts
Arizona State University Museum

## JAMES P. COOK
Born 1947, Topeka, KS
Lives Tucson, AZ

### Education
Wichita State University, Wichita, KS. M.F.A.
Emporia State University, Emporia, KS. M.A.
Emporia State University, Emporia, KS. B.A.

## Selected Exhibitions

1999 *From Here to the Horizon: Artists of the Rural Landscape*, Whatcom Museum of History and Art, Bellingham, WA

1997 Solo Exhibition, Norman Eppink Gallery, Emporia State University, Emporia, KS

1996 *Plain Pictures: Images of the American Prairie*, Joselyn Art Museum, Omaha, NE; Kimball Art Museum, Fort Worth, TX

1994 *Invitational 1994*, Eiteljorg Museum, Indianapolis, IN

1994 Solo Exhibition, West Bend Art Museum, West Bend, WI

1992 *James Cook New Paintings*, Tucson Museum of Art, Tucson, AZ

1991 *Solo Exhibition*, Desert Caballeros Western Museum, Wickenburg, AZ

1989 *75th Anniversary Rock Mountain National Park Exhibition*, Boulder Art Center, Boulder, CO

1989 *The Face of the Land*, Southern Allegheny Museum of Art, Loretta, PA.

1989 *Trains and Planes: The Influence of Locomotion in American Paintings*, National Academy of Sciences, Washington, D.C.

1988 *The Persistence of Romantic Landscape in American Art*, Wilson Art Center, Rochester, NY

1987 *Art of the Law*, Albrecht Art Museum, St. Joseph, MO

1986 *Twentieth Century Watercolors and Drawings*, San Francisco Museum of Modern Art, San Francisco, CA

1986 *Adventures in Image Making*, Metropolitan Museum and Art Center, Coral Gables, FL

1986 *Watercolor USA 1986: Monumental Image*, Springfield Art Museum, Springfield, MO

## Selected Publications

2000 *American Artists* (February 2000)

1999 *New American Painting* XXIV (1997)

1987 *Arts Magazine* (February 1987)

1986 *American Realism: Twentieth Century Watercolors and Drawings.* New York: Harry N. Abrams, 1986.

1981 "New Faces, New Images." *Ocular Magazine* (Fall 1981).

1981 *Chicago Sun Times* (9 May 1981).

## Selected Collections

The Ackland Museum, Chapel Hill, NC
Boise Art Museum, ID
Denver Art Museum
Des Moines Art Center, IA
Milwaukee Art Museum
Phoenix Art Museum
Princeton University Collection, Princeton, NJ
Tucson Museum of Art

## SUSAN CRILE

Born 1942, Cleveland, OH
Lives New York, NY

## Education

1971-72 Hunter College, New York, NY
1965 Bennington College, Bennington, VT. B.A.

## Selected Awards

2007 Residency Grant, Bellagio Study and Conference Center, Rockefeller Foundation, Bellagio, Italy

1990 Residence in Painting, American Academy in Rome

1989-90 National Endowment for the Arts Fellowship in Drawing

1975, 78 Yaddo, Sarasota Springs, NY

## Selected Exhibitions

2006 *Hot Art: SUSAN CRILE, The Fires of War*, The University of Arizona Museum of Art, Tucson, AZ.

2005 *The Art of the Screenprint*, Detroit Institute of Art, Detroit, MI

2002 *177th Annual Exhibition*, The National Academy of Design, New York, NY

1998 *Oil Patch Dreams: Images of the Petroleum Industry*, Art Museum of Southeast Texas, Beaumont, TX; Art Museum of South Texas, Corpus Christi, TX; El Paso Museum of Art, El Paso, TX

1995-94 *The Fires of War*, The Herbert Johnson Museum, Cornell University, Ithaca, NY; Saint Louis Art Museum, St. Louis, MO; Blaffer Gallery, The University of Houston, Houston, TX

1993 *First Sightings: Recent Modern and Contemporary Acquisitions*, The Denver Art Museum, Denver, CO

1992 *The Depicted Unknown*, The William Procter Art Gallery, Bard College, Annandale-on-Hudson, New York, NY

1991 *Collaboration in Print: Stewart and Stewart Prints: 1980-1990*, Detroit Institute of Art, Detroit, MI; The Nelson-Atkins Museum of Art, Kansas City, MO

1990 *The 1980's - Prints from the Joshua P. Smith Collection*, The National Gallery of Art, Washington, D.C.

1987 *The Art of Music*, The Bronx Museum of Art, New York, NY

1986 *After Matisse*, exhibition organized by Independent Curators Inc., traveled to: Queens Museum, New York; Chrysler Museum, Norfolk, VA; Portland Museum of Art, Portland, ME; Bass Museum, Miami, Fl

1986 *70's into 80's: Printmaking Now*, Boston Museum of Fine Arts, Boston, MA

1985 *Large Drawings*, Winnipeg Art Gallery, Winnipeg, Manitoba, Canada; Santa Barbara Museum of Art, Santa Barbara, CA; Madison Art Center, Madison, WI

1985 *A Decade of Visual Arts at Princeton: Faculty 1975-1985*, The Art Museum, Princeton University, Princeton, NJ

1983 *22nd National Print Exhibition*, Institute of Contemporary Art, University of Pennsylvania, Philadelphia, PA

1982 *Block Prints*, Whitney Museum of American Art, New York, NY

1981 *Geometric Abstraction: A New Generation*, Institute of Contemporary Art, Boston, MA

1981 *22nd National Print Exhibition*, The Brooklyn Museum, Brooklyn, NY

1975 *Works on Paper*, Virginia Museum of Fine Art, Richmond, VA

1974    *Painting and Sculpture Today*, Indianapolis Museum of Art, Indianapolis, IN

1973    *The Way of Color*, 33rd Biennial Exhibition of Contemporary American Painting, Corcoran Gallery of Art, Washington, D.C.

## Selected Publications

2006    Scott, Andrea K. "Susan Crile." *The New York Times*, p. E 36.

2000    Goodman, Jonathan, "Susan Crile at James Graham & Sons." *Art in America*, July, pp. 98-99, illustrated.

1994    Frank, Elizabeth. "Susan Crile's 'The Fires of War'." *Art News*. October 1994, pp. 131-132.

1990    Mahoney, Robert. "Susan Crile." *Arts*, September, 1990, p.101.

1990    Cohen, Ronny. "Susan Crile." Artforum, October, 1990.

1979    Stevens, Mark. "The Restless Seventies." *Newsweek.* 26 March 1979, p. 89.

1973    Perreault, John. "Susan Crile." *The Village Voice*, 10 May.

## JOHANN RYNO DE WET

Born 1982, Johannesburg, ZA, South Africa
Lives Cape Town, South Africa

## Education

2005    Tswane University of Technology, Pretoria. B-Tech Photography degree

2001    The Design School South Africa

## Selected Exhibitions

2007    *The Last Painting Show*, Photo Miami, Miami, FL

2007    ReGeneration, *50 Photographers of Tomorrow*, Art Center College of Design, Pasadena. CA

2006    ReGeneration, *50 Photographers of Tomorrow*, Art Institute of Boston, MA

2006    ReGeneration, *50 Photographers of Tomorrow*, Museé de l'Elysée, Lausanne, Switzerland

## Selected Awards

2007    II Pilar Citoler International Award of Contemporary Photography, Spain

## Selected Publications

*Shot and Go.* Exhibition catalogue. Italy: Damiani Editore, 2007.
"No Man's Land." Review. *Lápiz* 231. 2007.
"No Man's Land." Review. *El Cultural.* April 2007.
*Arrebato.* Exhibition catalogue. Madrid, Spain, 2007.
*South African Journal of Photography* 1, issue 2 and 3, 2006.
"The Bigger Picture." *Sunday Times*, featured photographer, March 2006.

## Public Collections

Museé de l'Elysée, Lausanne, Switzerland

## MARK DION

Born 1961, New Bedford, MA
Lives Beach Lake, PA

## Education

1981-82    University of Hartford School of Art, Hartford, CT. B.F.A.

1982-84    School of Visual Arts, New York, NY

1984-85    Whitney Museum of American Art, New York, Independent Study Program, New York, NY

## Awards

2001    9th Annual Larry Aldrich Foundation Award

2003    University of Hartford School of Art. Doctor of Arts, Ph.D.

## Selected Solo Exhibitions

2007    *Systema Metropolis*, Natural History Museum, London

2006    *The South Florida Wildlife Rescue Unit*, Miami Art Museum, Miami, FL

2006    *Seattle Vivarium*, I AM SAM Olympic Sculpture Park, Seattle Art Museum, Seattle, WA

2005    *Dungeon of the Sleeping Bear, the Phantom Forest, the Birds of Guam and other Fables of Ecological Mischief*, Château d'Oiron, Oiron, France

2004    *Projects 82, Rescue Archaeology*, A Project for The Museum of Modern Art, Museum of Modern Art, New York, NY

2004    *Universal Collection*, Historisches Museum, Frankfurt am Main

2003    *The Ichthyosaurus, the Magpie, and Other Marvels of the Natural World*, Musée Gassendi and la Reserve Geologique de Haute Provence, Digne, France

2003    *Full House*, 9th Annual Larry Aldrich Foundation Award, The Aldrich Museum of Contemporary Art, Ridgefield, CT

2002    *Urban Wildlife Observation Unit*, The Public Art Fund, Madison Square Park, New York, NY

2001    *New England Digs*, Bell Art Gallery, Brown University, Providence, RI; University of Massachusetts, Dartmouth Cabinet of Curiosity for the Weisman Art Museum, Wiesman Art Museum, Minneapolis, MN

1999    *Two Banks (Tate Thames Dig)*, Tate Gallery, London

1999    *Adventures in Comparative Neuroanatomy*, Deutsches Museum, Bonn, Germany

## Selected Group Exhibitions

2008    *Folkestone Sculpture Triennial*, Folkestone, UK

2007    *Surrealism and Beyond in the Israel Museum*, The Israel Museum, Jerusalem die stadt von morgen, Beiträge zu einer Archäologie des Hansavierels, Berlin

2006    *Ecotopia: The 2nd ICP Triennial of Photography and Video*, International Center of Photography, New York

2005    *Drawing from the Modern 1975-2005*, The Museum of Modern Art, New York

| | | |
|---|---|---|
| 2005 | *Becoming Animal: Contemporary Art in the Animal Kingdom,* MASS MoCA, North Adams, MA | |
| 2005 | *Gordon Matta-Clark: Odd Lots,* Queens Museum of Art, NY | |
| 2004 | *São Paulo Bienal,* São Paulo, Brazil | |
| 2004 | *Birdspace: A Post-Audubon Artists Aviary,* Contemporary Arts Center, New Orleans, LA, traveling to Norton Museum of Art, West Palm Beach, FL; Tucson Museum of Art, Tucson, AZ | |
| 2003 | *Artist's Lecture as Performance,* Whitechapel Art Gallery, London | |
| 2002 | *Museutopia,* Karl Ernst Osthaus Museum der Stadt Hagen, Germany | |
| 2001 | *Museum as Subject,* National Museum of Art, Osaka | |
| 2000 | *Ecologies,* The David and Alfred Smart Museum of Art, Chicago, IL | |
| 1999 | *The Museum as Muse,* Museum of Modern Art, New York, NY | |
| 1999 | *Carnegie International,* 99/00, Carnegie Museum of Art, Pittsburgh, PA | |
| 1997 | *Venice Biennale,* Nordic Pavilion, XLVII | |
| 1995 | *Zeichen und Wunder/Signos y Milagros,* Kunsthaus Zurich; Centro Galego De Arte Contemporanea, Santiago De Compostela, Spain | |
| 1995 | *Platzwechsel,* Kunsthalle Zürich | |
| 1994 | *Living in Knowledge: An Exhibition About Questions Not Asked,* Duke University Museum of Art, Durham, NC | |
| 1994 | *Services,* Kunstverein München, Munich | |
| 1994 | *Frauenkunst/Männerkunst,* Kunstverein Kippenberger, Museum Fridericianum, Kassel, Germany\Cocido y Crudo, Museo Macional Centro de Arte Reina Sofia, Madrid | |
| 1993 | *Parallax View,* P.S. 1, The Institute for Contemporary Art, Long Island City; Goethe House, New York, NY | |
| 1993 | *Installation, Project for the Birds of Antwerp Zoo, On taking a normal situation and retranslating it into overlapping and multiple readings of conditions past and present,* Museum van Hedendaagse Kunst Antwerpen, Belgium | |
| 1992 | *Arte Amazonas,* Museu de Arte Moderna, Rio de Janeiro, Brazil | |

## MITCH EPSTEIN
Born 1952, Holyoke, MA
Lives New York, NY

### Education
| | |
|---|---|
| 1972-74 | The Cooper Union, New York, NY |
| 1971-72 | Rhode Island School of Design, Providence, RI |
| 1970-71 | Union College, Schenectady, NY |

### Selected Awards
| | |
|---|---|
| 2008 | The American Academy in Berlin: Berlin Prize in Arts and Letters, Guna S. Mundheim Fellow in the Visual Arts |
| 2003-02 | John Simon Guggenheim Memorial Foundation Fellowship |
| 1978 | National Endowment for the Arts, Individual Grant |

### Selected Solo Exhibitions
| | |
|---|---|
| 2004 | PhotoEspana, Madrid, Spain |
| 1998 | Springfield Museum of Fine Arts, Springfield, MA |
| 1994 | Cleveland Museum of Art, Cleveland, OH |
| 1991 | Fogg Art Museum, Cambridge, MA |
| 1989 | Santa Barbara Museum of Art, Santa Barbara, CA |

### Selected Group Exhibitions
| | |
|---|---|
| 2007-06 | *Ecotopia: The Second Triennial of Photography and Video,* International Center of Photography, New York, NY |
| 2007-06 | *Where We Live: Photographs of America from the Berman Collection,* The J. Paul Getty Museum, Los Angeles, CA |
| 2005 | *Garry Winogrand and the American Street Photographers,* Fotografie Museum Amsterdam, The Netherlands |
| 2002 | *NY after NY,* Musee de L'Elysee, Lausanne, Switzerland |
| 2001 | *Sense of Space,* Noorderlicht, Groningen, The Netherlands |
| 1998 | *Photography after Modernism: Extensions into Contemporary Art,* San Francisco Museum of Modern Art, San Francisco, CA |
| 1998 | *India: A Celebration of Independence,* Philadelphia Museum of Art, Philadelphia, PA |
| 1993-92 | *This Sporting Life,* High Museum of Art, Atlanta, GA |
| 1990 | *Romance of the Taj Mahal,* Los Angeles County Museum of Art, Los Angeles, CA |
| 1990 | *The Indomitable Spirit,* International Center of Photography, New York, NY |
| 1987 | *Color Photographs: Recent Acquisitions,* Museum of Modern Art, New York, NY |
| 1982 | *Color as Form/History of Color Photography,* International Museum of Photography at George Eastman House, Rochester, NY |
| 1981 | *New American Colour Photography,* Institute of Contemporary Art, London, England |
| 1980 | *Recent Acquistions Exhibition,* Corcoran Gallery of Art, Washington, D.C. |
| 1980 | *Recent Acquisitions Exhibition,* Museum of Fine Arts, Boston, MA |
| 1977 | *Color Photography,* Creative Photography Gallery, M.I.T., Cambridge, MA |

### Selected Collections
Metropolitan Museum of Art, New York, NY
Museum of Modern Art, New York, NY
Whitney Museum of American Art, New York, NY
J. Paul Getty Museum at the Getty Center, Los Angeles, CA
Los Angeles County Museum of Art, Los Angeles, CA
San Francisco Museum of Modern Art, CA
Art Institute of Chicago, IL
Philadelphia Museum of Art, PA
Museum of Fine Arts, Houston, TX
Museum of Fine Arts, Boston, MA
Corcoran Gallery of Art, Washington, D.C.
Australian National Gallery, Canberra, Australia
Museum of Contemporary Art, Mexico City, Mexico
Brooklyn Museum of Art, Brooklyn, NY

Santa Barbara Museum of Art, Santa Barbara, CA
St. Louis Museum of Art, St Louis, MO

## Selected Publications

Aletti, Vince. "Goings On About Town." *The New Yorker*, April 9, 2007.

Aletti, Vince. "Mitch Epstein's Recreation: American Photographs 1973-1988." *Photograph*, July/ August 2005.

Aletti, Vince. "*Best Photo Book of 2003.*" *Village Voice*, January 2004.

Coggins, David. "Mitch Epstein at Sikkema Jenkins." *Art in America*, June/July 2007.

Jones, Charisse. "Cities in Transition." *USA Today*, September 13th, 2006.

Pollack, Barbara. "Mitch Epstein at Yancey Richardson." *Art News*, January 2005.

Schwendener, Martha. "Mitch Epstein: American Power." *The New York Times*, March 30, 2007.

## VERNON FISHER

Born 1943, Fort Worth, TX
Lives Fort Worth, TX

## Education

1969    University of Illinois, Champaign-Urbana, IL. M.F.A.
1967    Hardin-Simmons University, Abilene, TX. B.A.

## Selected Awards

1995    John Simon Guggenheim Fellowship
1988    Award in the Visual Arts, Southeastern Center for Contemporary Art, Winston-Salem, NC
1981    Individual Artist's Fellowship, National Endowment for the Arts

## Selected Exhibitions

2004-06 *Misleading Trails*, China Art Archives and Warehouse, Beijing, China.

2003    110 Years: The Permanent Collection of the Modern Art Museum of Fort Worth, TX

2003    *The Cultural Desert: Inside Contemporary Sculpture*, Scottsdale Museum of Contemporary Art, Scottsdale, AZ

2003    *Time/Frame*, Jack S. Blanton Museum of Art, University of Texas, Austin, TX

2001    *Kinds of Drawing*, Herter Art Gallery, University of Massachusetts, Amherst, MA

2001    *On the Edge*, El Paso Museum of Art, El Paso, TX.

2000    *2000 Biennial*, Whitney Museum of American Art, New York, NY

2000    *A Lasting Legacy: Recent Additions to the Collection*, Orange County Museum of Art, Newport Beach, CA

1998    *Words & Images*, Miami Art Museum, Miami, FL

1998    *Double Trouble*, The Patchett Collection, Museum of Contemporary Art, San Diego, CA

1997    *A Singular Vision: Prints from Landfall Press*, Museum of Modern Art, New York, NY

1997    *Dis/Functional*, Arizona State University Art Museum, Tempe, AZ

1994    *Fictions*, Center for Creative Photography, University of Arizona, Tucson, AZ

1992    *Art at the Armory: Occupied Territory*, Museum of Contemporary Art, Chicago, IL

1988-90 *Looking South: A Different Dixie*, Birmingham Museum of Art, Birmingham, AL

1988    *Awards in the Visual Arts 7*, Los Angeles County Museum of Art, Los Angeles, CA

1987    *Past Imperfect: Eric Fischl/Vernon Fisher/Laurie Simmons*, Walker Art Center, Minneapolis, MN

1987    *Comic Iconoclasm*, Kunstmuseum, Bern, Switzerland

1986    *Seventy-Fifth American Exhibition*, Art Institute of Chicago, Chicago, IL

1986    *Public and Private: American Prints Today*, The 24th National Print Exhibition, The Brooklyn Museum, Brooklyn, NY; traveled to: Rhode Island School of Design, Providence, RI; Museum of Art, Carnegie Institute, Pittsburgh, PA

1984    *Content: A Contemporary Focus 1974-1984*, Hirshhorn Museum and Sculpture Garden, Smithsonian Institution, Washington, D.C.

1983-84 *Second Western States Exhibition - The 38th Corcoran Biennial Exhibition of American Painting*, Corcoran Gallery of Art, Washington, D.C.; traveled to: San Francisco Museumof Modern Art, San Francisco, CA

## Selected Collections

Albright-Knox Museum, Buffalo, NY
Art Institute of Chicago, IL
Corcoran Gallery of Art, Washington, D.C.
Dallas Museum of Art, TX
Denver Art Museum, CO
High Museum of Art, Atlanta, GA
Hirshhorn Museum and Sculpture Garden, Smithsonian Institution, Washington, D.C.
Los Angeles County Museum of Art, CA
Milwaukee Art Museum, WI
Modern Art Museum of Fort Worth, TX
Museum of Contemporary Art, Chicago, IL
Museum of Fine Arts, Houston, TX
Museum of Modern Art, New York, NY
New Orleans Museum of Art, LA
Phoenix Art Museum, AZ
San Antonio Museum of Art, TX
San Diego Museum of Contemporary Art, CA
San Francisco Museum of Modern Art, CA
Solomon R. Guggenheim Museum, New York, NY
Whitney Museum of American Art, New York, NY

## PAUL FUSCO

Born 1930, Leominster, MA
Lives New York, NY

## Education

1957    Ohio University, Athens, OH. B.A.

## Selected Exhibitions

2001    Leica Gallery, New York, NY
2000    Gallery of Photography, Dublin, Ireland
2000    BMP (Advertising Agency), London, UK

| 2000 | The Photographers' Gallery, London, UK |
|---|---|
| 2000 | Perpignan Festival, Perpignan, France |

**Books**

| 2001 | *Chernobyl Legacy,* de.Mo, USA |
|---|---|
| 2000 | *RFK Funeral Train,* Umbrage/Magnum USA |
| 1977 | *Marina & Ruby: Training a Filly with Love,* William Morrow, USA |
| 1974 | *The Photo Essay: Paul Fusco & Will McBride,* Crowell, USA |
| 1971 | *What to Do Until the Messiah Comes,* Collier, USA |
| 1970 | *La Causa: The California Grape Strike,* Collier, USA |
| 1968 | *Sense Relaxation: Below the Mind,* Collier, USA |

**Selected Publications**

*Time, Life, Newsweek, The New York Times Magazine
Mother Jones, Psychology Today*

# FRANCESCA GABBIANI

Born 1965, Montreal, Canada
Lives Los Angeles, CA

**Education**

| 1995-97 | University of California Los Angeles, Los Angeles, CA. M.F.A |
|---|---|
| 1993-94 | Rijksakademie van Beeldende Kunsten, Amsterdam |
| 1988-91 | École Supérieure des Beaux Arts, Geneva, Switzerland |

**Selected Awards**

| 2004 | Grant from the Canada Council for the Arts |
|---|---|
| 1996 | Providentia Award, Switzerland |
| 1995 | Federal Award of Art, Switzerland |

**Selected Exhibitions**

| 2006 | *New Trajectories: Relocations: Recent painting, drawing and multi-media work from the Ovitz Family Collection, Los Angeles,* Cooley Gallery, Reed College, Portland, OR |
|---|---|
| 2006 | *Off the Shelf: New Forms in Contemporary Artists' Books,* Frances Lehman Loeb Art Center, Vassar College, Poughkeepsie, NY |
| 2005 | CentrePasquArt, Kunsthaus Centre d'Art Biel Bienne, Switzerland |
| 2005 | *Recent Acquisitions,* Museum of Contemporary Art, Los Angeles, CA |
| 2003 | *Light and Spaced Out,* Fonds Regional d'Art Contemporain, Brest, France |
| 2003 | *Art Statements,* Art Basel Miami Beach, Karyn Lovegrove Gallery, Miami, FL |
| 2003 | *DreamSpace,* Kunstverein Wolfsburg, Germany |
| 2002 | *Painting On The Move,* Kunsthalle, Basel, Switzerland |
| 2001 | *By Hand: Pattern, Precision, & Repetition in Contemporary Drawing,* University Art Museum, California State University, Long Beach, CA |
| 2001 | *Hammer Projects: Francesca Gabbiani,* UCLA Hammer Museum, Los Angeles, CA |
| 2000 | *Art on Paper,* Weatherspoon Art Gallery, University of North Carolina, Greensboro, NC |

| 1998 | *Freie Sicht aufs Mittelmeer,* Kunsthaus, Zurich, Switzerland; Shirn Kunsthalle Frankfurt, Germany |
|---|---|
| 1998 | *Memories to chew,* MAMCO, Museum of Modern and Contemporary Art, Geneva, Switzerland |
| 1996 | *Young Art,* Kunsthalle Bern, Switzerland |
| 1995 | *Lost Property,* Kunsthalle Glarus, Switzerland |

**Selected Collections**

Metropolitan Museum of Art, New York, NY
Museum of Modern Art, New York, NY
Museum of Contemporary Art, Los Angeles, CA
CentrePasquArt, Biel, Switzerland
City of Geneva, Switzerland
National Collection, Switzerland

# SUSAN GRAHAM

Born 1968, Dayton, OH
Lives New York, NY

**Education**

| 1986-87 | The Ohio State University, Columbus, OH. B.A. Chemistry |
|---|---|
| 1987-90 | The Ohio State University, Columbus, OH. B.F.A. Sculpture |
| 1991-92 | School of Visual Arts, New York, NY. |

**Selected Awards**

| 2003 | New York Foundation for the Arts, Craft Fellowship |
|---|---|
| 2001 | Pollock-Krasner Foundation, Sculpture Grant |
| 1999 | Fellowship Recipient, Sculpture-New York Foundation for the Arts |
| 1998 | Grant Recipient-Ruth Chenven Foundation |

**Selected Exhibitions**

| 2008 | *Future Tense: Reshaping the Landscape,* Neuberger Museum of Art, Port Chester, NY |
|---|---|
| 2007 | *The Gun Show: Images of Guns in Contemporary Art,* The Shore Institute of the Contemporary Arts, Long Branch, NJ |
| 2007 | *I Want Candy: The Sweet Stuff in American Art,* Hudson River Museum, Yonkers, NY |
| 2006 | *BANG! BANG! Trafic d'armes de Saint-Etienne a Sete,* Musee d'art et d'industrie de Saint-Etienne, France; travels to Musee International des Arts Modestes, Sete, France |
| 2006 | *Armed,* Mandeville Gallery, Union College, Schenectady, NY |
| 2006 | *National Image,* Sherman Gallery, Boston University, Boston, MA |
| 2005 | *Heavenly - A Slice of White,* Hunter College Leubsdorf Gallery, New York, NY |
| 2005 | *High Caliber: Images of Guns in Contemporary Art,* Hunterdon Art Museum, Clinton, NJ |
| 2004 | *Rendering Gender,* Truman State University, Kirksville, MO |
| 2002 | Officina America/American Atelier, Bologna, Italy |
| 2002 | *Five by Five,* Whitney Museum of American Art at Philip Morris, New York, NY |
| 2001 | *Picture Prone,* Avram Gallery, Long Island University, Southampton, NY |

2000 *Demonstrosity: Deconstructing Monsters in Contemporary Art*, Tufts University Gallery, Boston, MA

## Selected Publications
2006 "Power from the People." Cate McQuaid, *The Boston Globe*
2004 "Reviews: A Stereoscopic Vision." Lauren Cornell, *TimeOut New York,* September 2-9.
2004 "Reviews: Up in Arms." Judith Page, *Sculpture Magazine*, January/ February
2003 "Review: Up in Arms." Holland Cotter, *The New York Times*, March 21
2003 "Woke Up This Morning, Got Myself a Gun." James Kalm, *NY Arts*
2002 Art in Review "Five By Five." Grace Glueck, *The New York Times*, June 14, 2002
2001 "Susan Graham & Kim MacConnel." Kim Levin, *The Village Voice*, April 24, 2001.

## HEATHER GREEN
Born 1961, Tucson, AZ
Lives Tucson, AZ

## Education
2008 University of Arizona, Tucson, AZ. M.F.A.
1995 University of Arizona, Tucson, AZ. B.F.A.

## Selected Exhibitions
2008 *MFA Thesis Exhibition*, University of Arizona Museum of Art, Tucson, AZ
2008 Center for Book Arts, New York, NY
2008 *Fresh Impressions: Letterpress Printing in Contemporary Art* Hoffman Gallery, Oregon College of Art & Craft, Portland, OR
2008 *Living Cosmos*, Flandrau Science Center, University of Arizona, Tucson, AZ
2007 *Arte Transpuesto*, Museo de Culturas Populares, Hermosillo, Sonora, Mexico
2007 *Living Cosmos*, Astrobiology & the Arts Symposium, Eller Dance Theatre, University of Arizona, Tucson, AZ
2007 *Exhibit 4*, Union Gallery, University of Arizona, Tucson, AZ
2007 *The Sea of Cortez*, Tohono Chul Gallery, Tucson, AZ
2007 *Living Cosmos*, Science and Engineering Library, University of Arizona, Tucson, AZ
2005 *Residual Pull*, Dinnerware Contemporary Arts, Tucson, AZ
2001 *Small Works on Paper*, Kentler International Drawing Space, Brooklyn, NY
2001 Metroform Limited, Tucson, AZ
2000 *Oil/Change*, Moca/Hazmat Gallery, Tucson, AZ
1996 *Recent Paintings*, Raw Gallery, Tucson, AZ
1992 *Collaborations*, 830 Gallery, Tucson, AZ

## Selected Publications
2007 Regan, Margaret. "Down by the Seashore." *Tucson Weekly*

2003 Homelund-Minarik, Else. *Little Bear's Valentine*, Illustrated by Heather Green, Harper Collins, New York, NY
Homelund-Minarik, Else. *Little Bear's New Friend*, Illustrated by Heather Green, Harper Collins, New York, NY
2002 Jackson, Ally. "Art and About." *Savannah Chronicle*
1998 Pence, Angélica. "Life as an Artist." *Arizona Daily Star*
1996 Regan, Margaret. "Human Scale." *Tucson Weekly*

## Selected Collections
BIO5 Institute, The University of Arizona, Tucson, AZ
Brown University Library

## EMILIE HALPERN
Born 1976, Paris, France
Lives Los Angeles, CA

## Education
2002 Art Center College of Design, Pasadena, CA
2000 Showhegan School of Painting and Sculpture, Showhegan, ME
1998 University of California Los Angeles, CA

## Selected Exhibitions
2008 *Abracadabra*, Anna Helwing Gallery, Los Angeles, CA
2008 *Multiverse*, Claremont Museum of Art, Claremont, CA
2007 *Island Fever*, Galerie Medium, Gustavia, St. Barthelemy, French West Indies
2007 *Overcast*, Bloom Project, Santa Barabara Contemporary Arts Forum, Santa Barbara, CA
2007 *Beyond Image: Photography in Contemporary Art,* Armory Center for the Arts, Pasedena, CA
2007 *Between Thought and Expression*, University of California Riverside, CA
2006 *Ragged*, Kate MacGarry Gallery, London, UK
2006 *Out of Paradise*, Galerie Arte Veintiuno, Madrid, Spain
2006 *Dead of Winter*, Hudson Valley Center for Contemporary Art, Peerskill, NY
2005 *The Last Generation*, ApexArt, New York, NY
2003 *Hidden Agenda or Hide & Seek*, Acme, Los Angeles, CA
2003 *PRSP*, The Breeder, Athens Greece
2002 *Nachgemacht: Reproduced Naturalness-simulated Nature*, Kunstraum Innsbruck, Austria

## Selected Publications
Geer, Suvan. "Vacancy." *ArtScene,* Vol 24, No. 11, July/August 2005: 26-27.
Meyers, Holly. "Themes of Light and Electricity." *Los Angeles Times,* April 28, 2006.
Murakami, Takashi. "L.A. Art Scene News." *Studio Voice* (Tokyo, Japan), Fall 1998.
Ollman, Leah. "Ambiguity is the essence of 'Beyond Image'." *Los Angeles Times*, April 14, 2007.
Threadgill, Brendan. "Emilie Halpern." Art US, Issue 14, July-September, 2006.
Woodard, Josef. "Art Review: Romance, humor forecast for cloudscape." *Santa Barbara News-Press*, March 16, 2007.

## JULIE HEFFERNAN

Born 1956, Peoria, IL
Lives New York, NY

### Education
1985    Yale School of Art and Architecture, New Haven, CT.
        M.F.A.
1981    University of California, Santa Cruz, CA. B.F.A.

### Selected Exhibitions
2004    *High Drama: Eugene Berman and the Theater of
        the Melancholic Sublimes,* McNay Art Museum, San
        Antonio, CA
2004    *Earthly Delights,* Massachusetts College of Art,
        Boston, MA
2003    *Through the Looking Glass: Women and Self-
        Representation in Contemporary Art,* The Palmer
        Museum of Art, Penn State, PA
2003    Sarah Moody Gallery, University of Alabama,
        Tuscaloosa, AL, and Wake Forest University Fine
        Arts Gallery, Winston-Salem, NC
2003    Herter Art Gallery, University of Massachusetts,
        Amherst, MA
2002    *Between Still-Life and Landscape,* Delaware Center
        for the Contemporary Arts, Wilmington, DE
2002    *American Academy Invitational Exhibition of
        Painting and Sculpture,* The American Academy of
        Arts and Letters, New York, NY
2002    *Collecting Contemporary Art: A Community
        Dialogue,* Ackland Art Museum, Chapel Hill, NC
2002    *The Divine* Fruit, Mont State College, Fairmont, WV
2001    *Pixeria Witcheria,* University Galleries, Illinois State
        University, Normal, IL
2000    *Self-Portraiture* The Korean Biennial, Korea
2000    *The Enduring Figure in Contemporary Art,* Norton
        Museum of Art, West Palm Beach, FL
        *Looking Back,* Bard College, The Center for
        Curatorial Studies Museum, Annandale-on-
        Hudson, NY

### Selected Awards
2002    The American Academy of Arts and Letters,
        New York, NY; Nominee
1996    New York Foundation for the Arts; Individual
        Artist's Grant
1986    Fulbright-Hayes, Grant to West Berlin/Annette
        Kade Grant for the Creative and Performing Arts

### Selected Collections
Virginia Museum of Fine Art, Richmond, VA
The Palmer Museum of Art, Penn State University, PA
Wake Forest University Collection of Contemporary Art, NC
Norton Museum of Art, West Palm Beach, FL
Columbia Museum of Art, SC
Knoxville Museum of Art, TN
Weatherspoon Art Museum, NC

### Selected Publications
Artner, Alan G. "Julie Heffernan's Deft Self-Fictions." *Chicago
    Tribune,* September 28, 2001, C Section 7, page 35.

Barandiaran, Maria Jose. "Julie Heffernan at Peter Miller
    Gallery." *The New Art Examiner,* May 1996.
Bourbon, Matthew. "Julie Heffernan." *New York Arts Magazine,*
    review and reproduction, April 1999, Vol. 3, No. 4, p.54.
Braff, Phyllis. "Flora." *The New York Times,* Sunday, August 9,
    1998.

## RODERIK HENDERSON

Born 1965, 's-Hertogenbosch, The Netherlands
Lives Amsterdam, The Netherlands

### Education
1985-90  Koninklijke Akademie voor Kunst & Vormgeving,
         's-Hertogenbosch
1990-92  Rijksakademie van Beeldende Kunst, Amsterdam

### Selected Awards
2006     Amsterdam Fund for the Arts: "Passage"
2004-06  The Netherlands Foundation for Art Design and
         Architecture: Stipend
2003     The Netherlands Foundation for Art Design and
         Architecture: *Our life in a town of ghosts*
1997     Amsterdam Fund for the Arts: New Short Films

### Selected Exhibitions
*Face On,* Fotomuseum Antwerpen, Antwerp, Germany
*Paradise: Our life in a town of ghosts,* 10 Epson Foto Festival
    Naarden, NL
Art Amsterdam 2007, *Our life in a town of ghosts,*
    Amsterdam, NL
*Our life in a town of ghosts,* Gallery van Wijngaarden/
    Hakkens, Amsterdam, NL
*In Transition,* Evagoras & Kathleen Lanitis Foundation,
    Limassol, Cyprus
*Urban Explorers Festival,* Dordrecht, NL
*Bad Lands,* Nevada Museum of Art, Reno, NV
*A Desert Odyssey,* Forest City Gallery, London, ON, Canada
*Beyond the Obvious,* The Arts Factory, Las Vegas, NV
Galeria Civica D'arte Moderna e Contemporanea Torino, Italy
*Mai de la Photo,* photo-biennial, Paris, France
*De Heelal Hoed,* de Vleeshal, Middelburg, & museum,
    Boymans van Beuningen, Rotterdam
*AVE,* festival, retrospective Dutch Experimental Film,
    Arnhem, NL
*Art Film festival,* Bratislava, Slovak Republic
*Host,* Otto Berchem-projects, exhibition, Amsterdam, NL
*Wish You Were Here,* exhibition, de Appel, Amsterdam, NL
*Arsenal,* film festival, Riga, Latvia
*Int. Festival of New Film 7,* Split, Kroatia
*Festival de Cinematographi ardanne,* Gardanne, France
*Corto Imola Film Festival,* Imola, Italy
*20th Goteborg Film Festival,* Goteborg, Sweden
*Dziga,* Cinema Nova, Brussels, Belgium
*Ear/Nerve 2,* festival, S. Giogio a Cremano, Italy
*I fili della memoria,* exhibition, Giardini, Italy

### Selected Publications
*ZOOM International Portfolio,* Sept/Oct '07 issue
*Color,* magazine, Canada
*Metropolis M,* magazine

*Force Meat 2*, magazine, Italy
*Vital 5,* magazine, Japan

## TRACY HICKS
Born 1946, San Antonio, TX
Lives Dallas, TX

### Education
Stephen F. Austin, Nacogdoches, TX

### Awards
| | |
|---|---|
| 1998 | Horace Cardwell Competition, Museum of East Texas, Lufkin, TX |
| 1994 | Dozier Travel Grant, Dallas Museum of Art, Dallas, TX |
| 1992 | NFRIG (New Forms Regional Initiative Grant) (Funded through the National Endowment for the Arts, the Rockefeller Foundation and the Warhol Foundation) |
| 1991 | Art in the Metroplex, Vance Award |

### Selected Solo Exhibitions
| | |
|---|---|
| 2005 | *Two Cultures Collection,* Hall Center, Lawrence, KS |
| 2002 | *Third Ward Archive*, Project Row Houses, Houston, TX |
| 2001 | *SSAR*, Society for the Study of Amphibians and Reptiles Annual Meeting, Indianapolis, IN |
| 2000 | *Glass Towers*, Site/work/s Chenevert Green, Houston, TX |
| 1999 | *Correlation and Collection*, CRCA The Gallery at UTA, Arlington, TX |
| 1998 | *Storeroom*, Museum of East Texas, Lufkin, TX |
| 1997 | *Change Exchange*, Hickory Street Annex, Dallas, TX |
| 1997 | *Freedmens Field*, African American Museum, Dallas, TX |
| 1994 | *Encounters 5*: Tracy Hicks-Damien Hirst, Dallas Museum of Art, Dallas, TX |
| 1993 | *Marking Time-Storehouse (an evolving exhibition)*, Hickory Street Annex, Dallas, TX |
| 1992 | *Patience and Change*, Center for Contemporary Arts, Sante Fe, NM |
| 1992 | *Patience and Time*, DiverseWorks, Houston, TX |
| 1992 | *Light and Rite*, Brookhaven College, Dallas, TX |
| 1989 | Historical/Hysterical, Hughes-Trigg Gallery, Southern Methodist University, Dallas, TX |

### Selected Group Exhibitions
| | |
|---|---|
| 2004 | *Personal Environments*, The Gallery at UTA |
| 2004 | *Glass*, Artist Alliance Center at Clear Lake |
| 2003 | *Pairings - Atelopus*, The Contemporary, Dallas, TX |
| 2002 | *Modalities of the Visible*, A Survey of Contemporary Art in North Texas, BrookhavenCenter for the Arts, Brookhaven, TX |
| 1999 | *The Aquarium Show*, Galveston Art Center, Galveston, TX |
| 1999 | *Bio- Between Image and Object*, Arlington Museum of Art, Arlington, TX |
| 1998 | *SMU Art Faculty Exhibition*, Meadows Museum, Dallas, TX |
| 1998 | *Do It*, Boise State University Art Gallery, Boise, ID |
| 1997 | Horace Cardwell Collection, Museum of East Texas, Lufkin, TX |

| | |
|---|---|
| 1996 | *SMU Faculty Exhibition*, Meadows Museum, Dallas, TX |
| 1995 | *Collected*, The Gallery SMU, Dallas, TX |
| 1994 | *Born Again*, Arlington Museum of Art, Arlington, TX |
| 1993 | *Ready Made*, City Arts Center, Oklahoma City, OK |
| 1991 | *The State I'm In*, Dallas Museum of Art, Dallas, TX |
| 1991 | *Art in the Metroplex*, TCU, Fort Worth, TX |
| 1989 | *Suitcase Curio Show*, Bathhouse Cultural Center, Dallas, TX |
| 1989 | *Excellence 89*, Texas Sculpture Association, Dallas, TX |
| 1980 | *Mixed Media*, Tarleton State University, Stephenville, TX |
| 1988 | *Kennedy Memorial*, Texas Theater, Dallas, TX |
| 1988 | *Group Show*, Abilene Museum of Art, Abilene, TX |

### Selected Publications
Aktar, Suzanne. "Flora and Fauna Specimens Inspire Ecosystem Statements." *Fort Worth Star Telegram*, April 11, 1999.
Armitage, Diane. "Tracy Hicks at CCA." *THE Magazine*, January/February, 1993.
Bass, Shermakae. "Marking Time." *The Dallas Morning News*, November 14, 1993.
Chadwick, Susan. "Bottled Up." *Houston Post*, September 25, 1992.
Daniel, Mike. "Preview: Tracy Hicks at Hickory Street Annex." *The Dallas Morning News*, Guide, March 28, 1997.
Kalil, Susie. "Retro Radical." *Houston Press*, October 8, 1992.
Kutner, Janet. "Tracy Hicks Finds Beauty in Simple Things." *The Dallas Morning News*, December 24, 1993.
Kutner, Janet. "Artist Imagination." *The Dallas Morning News*, May 1, 1994.
Mitchell, Charles Dee. "Connecting Images and Objects." *The Dallas Morning News*, October 19, 1999.
Nill, Annegreth. "Re-collections." Encounters 5, *Dallas Museum of Art*, July 1994.
Versace, Candelora. "The Spirit of Sentimentalism." *Sante Fe New Mexican*, November 20, 1992.
Weiss Jeffrey. "Of a People & Possibilities." *The Dallas Morning News*, November 30, 1996.

## DODO JIN MING
Born 1955, Bejing, China
Lives New York, NY

### Education
| | |
|---|---|
| 1978 | Hong Kong Academy for Performing Arts, Hong Kong |
| 1961-66 | Royal Academy of Music, Hong Kong |

### Selected Exhibitions
| | |
|---|---|
| 2005 | Michael Hoppen Gallery, London, UK |
| 2004 | *Water Fire Earth Air*, Laurence Miller Gallery, New York, NY |
| 2004 | Verve Gallery, Santa Fe, NM |
| 2002 | *Free Element*, Laurence Miller Gallery, New York, NY |
| 1996 | *Back to Egypt*, Laurence Miller Gallery, New York, NY |
| 1996 | *Back to Egypt*, Urban Council and The Hong Kong Museum of Art, Hong Kong |
| 1992 | *Dedicated to the Blue: Drawings and Photographs*, Attention Art Gallery, Hong Kong |
| 1991 | *A Feeling in Black and White*, Art & Soul Gallery, Hong Kong |

1991 *A Feeling in Black and White*, Y Gallery, Hong Kong
1990 *Life-Colour Prints*, Nikon Photo Gallery, Hong Kong
1988 *Impressions of Italy-Colour Prints*, presented by the
Consulate General of Italy, Raffles Gallery,
Hong Kong

## KIM KEEVER
Born 1950, New York, NY
Lives New York, NY

### Education
1976 Old Dominion University, Norfolk, VA. B.S.

### Selected Exhibitions
2007 *Global Anxieties: Nine Perspectives on a Changing
Planet,* The College of Wooster Art Museum, Ebert
Art Center, Wooster, OH
2006 *Between Mind and Nature: Exploring Other Realms*,
Brattleboro Museum & Art Center, Brattleboro, VT
2004 *Images of Time and Place: Contemporary Views of
Landscape*, Lehman College Art Gallery, Bronx, NY
2004 Naples Museum of Art, Naples, FL
2002 *Unreal*, Contemporary Museum of Art/ St. Louis,
St. Louis, MO
2002 *Staging Reality: Photography from the West Collection
at SEI*, University of the Arts, Philadelphia, PA
2002 *A Raining Day*, Fotogalerie Wein, Vienna, Austria
2001 *Lifelike,* Rockford Art Museum, Rockford, IL
2001 *Plaza Exhibition*, Lower Manhattan Cultural Council,
New York, NY
2000 *Assention*, Diozesan Museum, Freising, Germany
1999 Kunst Forum Berlin, Berlin, Germany
1999 *In View of Nature,* Lehman College Art Gallery,
Bronx, NY
1992 Queens Museum of Art, Queens, NY
1990 *Art Redux*, New England Museum of Contemporary
Art, Brooklyn, NY
1988 *Kaldewey Press,* Metropolitan Museum of Art,
New York, NY
1987 *Cutting Edge*, Patterson Museum of Fine Art,
Patterson, NJ

### Public Collections
Metropolitan Museum of Art, New York, NY
Museum of Modern Art, New York, NY
Brooklyn Museum of Art, Brooklyn, NY
Hirshhorn Museum and Sculpture Garden, Washington, D.C.
Virginia Museum of Fine Arts, Richmond, VA
Chrysler Museum, Norfolk, VA
New England Museum for Contemporary Art, Brooklyn, CT

### Selected Publications
2005 Leffingwell, Edward. *Art in America.* Oct. 2005: 172.
2002 Holg, Garrett. "Reviews." *Art News* May 2002.
2000 Johnson, Ken. "Almost Something: Depictive
Abstraction." *New York Times* 28 April: Art Section.
1999 Mahoney, Robert. "Synthetic Realism." Time Out
New York, Apr. 1999.
1999 "Reviews." The Village Voice, 27 Apr. 1999.
1993 Ottmann, Klaus. "The New Spiritual." *Arts Magazine*
Oct. 1993.

## ISABELLA KIRKLAND
Born 1954, Old Lyme, CT
Lives Sausalito, CA

### Education
1977–78 San Francisco Art Institute, San Francisco, CA
1975–76 Virginia Commonwealth University, Richmond, VA
1973–74 Worcester Museum School, Worcester, MA
1971–73 Guilford College, Greensboro, NC

### Selected Exhibitions
2008 Toledo Art Museum, Toledo, OH
2008 National Academy of Sciences, Washington, D.C.
2007 *Painting as Fact–Fact as Fiction*, de Pury &
Luxembourg, Zurich
2006 Sun Valley Center for the Arts, Sun Valley, ID
2005 *ECO: Art About the Environment*, Fine Arts Gallery,
San Francisco State University, San Francisco, CA
2004 *Continuities: Themes from the Fine Art Collection
Reflected in Recent Northern California Art*, Richard
L. Nelson Gallery, University of California, Davis, CA
2004 *Natural Histories: Realism Revisited,* Scottsdale
Museum of Contemporary Art, Scottsdale, AZ
2001 "*The Metal Party* by Josiah McElheny; *Preserve* by
Ellen Gallagher; *Taxa* by Isabella Kirkland," Yerba
Buena Center for the Arts, San Francisco, CA
2000 *Beauty on the Wing: The Double Lives of Butterflies*,
Harvard Museum of Natural History, Cambridge, MA
2000 *6th Anniversary Group Exhibition*, Heritage Fine
Arts, San Jose, CA
1999 *Natural World Observed 1999*, Bedford Gallery, Dean
Lescher Center for the Arts, Walnut Creek, CA
1991 *LOCOmotion*, ArtSpace, San Francisco, CA
1987 *Perdurabo*, Bard College, Annandale-on-Hudson, NY
1984 *Pandora's Box: SFAI Annual*, New Langton Arts,
San Francisco
1983 *Sacred Artifacts, Objects of Devotion*, Alternative
Museum, New York

### Selected Publications
Ames, Michael. "Going, Going, Almost Gone." *Idaho Mountain
Express*, 15 February 2006. C1.
Bossick, Karen. "'Gone,' 'Back' and 'Nova.'" *Wood River
Journal,* 15 February 2006. B2.
Nilsen, Richard. "How Real Can It Get?" *Arizona Republic,* 30
May 2004, E:1, 10.
Tropiano, Dolores. "Natural World Show." *Scottsdale
Republic,* September 2002.
Nickas, Bob. "Best of 2002: Top Ten." *Artforum*, December
2002. 116–117.
Bonetti, David. "Three Artists Who Grapple with History."
*San Francisco Chronicle,* 20 November 2001. D1.
Brand, Stewart. "Whole Earth Covers." *Whole Earth*, Fall
2000. 58–59.

## DIMITRI KOZYREV

Born 1967, St. Petersburg (Leningrad), Russia (USSR)
Lives Tucson, Arizona

### Education
2000    University of California, Santa Barbara, CA. M.F.A. in Studio Arts
1997    Ohio University, B.F.A. in Painting
1996    Ohio University, Associate Degree in Individualized Studies, Visual Arts

### Selected Exhibitions
2008    *Future Tense: Reshaping the Landscape*, Neuberger Museum of Art, Purchase, NY
2008    Ben Maltz Gallery, Otis College of Art and Design, Los Angeles, CA
2008    *Phenomenon: New Perspectives in Painting*, Al-Sabah, Dubai
2008    Claremont Graduate University, Pomona, CA
2007    Raid Projects, Los Angeles, CA
2006    *Space/Vision/Perception*, Gulf Coast Museum of Art, Largo, FL
2006    *Scapes/Environments Interpreted*, The Irvine Fine Arts Center, Irvine, CA
2004    *Incognito*, Santa Monica Museum of Art, SM, CA
2004    Contemporary Arts Forum, Santa Barbara, CA
2002    *Faculty Show*, UCSB Art Museum, Santa Barbara, CA
2002    *The Armory Show*, New York, NY
2002    Contemporary Arts Forum, Santa Barbara, CA
2001    *Lost Landscapes*, Contemporary Arts Forum, Santa Barbara, CA
2001    Group Exhibition, LA Art Core, Los Angeles, CA
2001    *Invitational Exhibition*, Contemporary Arts Forum, Santa Barbara, CA
2000    Villa Montalvo Center for the Arts, Saratoga, CA
2000    *MFA Exhibition*, Santa Barbara Museum of Art, Santa Barbara, CA
2000    *Group Exhibition*, The Fielding Institute, Santa Barbara, CA
1999    *College Art Association MFA Juried Exhibition*, LA Municipal Gallery, CA
1996    *Printmaking Group Exhibition*, The Alternative Gallery, Ohio University, Athens, OH
1996    *McArthur Library Juried Exhibition*, McArthur, Ohio
1996    *Painting Group Exhibition*, The Alternative Gallery, Ohio University, Athens, OH
1994    State College Community Library, State College, PA
1993    Pennsylvania State University, State College, PA

### Selected Awards
2005    Art Omi Residency
2000    Abrams Prize, University of California, Santa Barbara
1999    Levitan Fellowship, University of California, Santa Barbara
1997    Margaret Brown Krecker Award, Ohio University School of Art
1996    Dean's Scholarship, Ohio University School of Art

### Selected Publications
Frank, Peter. "Picks of the Week." *LA Weekly*, August 5-11, 2005.
Pagel, David. "Giving Substance to a Virtual World," *Los Angeles Times*, May 13, 2005.
Green, Tyler. "On Miami Scope." http://www.artsjournal.com/, December, 2004.
Green, Tyler. "Modern Art Notes." http://www.artsjournal.com/, 17 March 2004.
Pagel, David. *Los Angeles Times*, November 2003.
Artner, G. Alan. "All's Fair at 'Art Chicago'." *Chicago Tribune*, May 10, 2003.
Janku Richard, Laura. *Artsweek*, Abstract-ed , May 2003
Myers, Holly. "Reinventing the Wheels." *Los Angeles Times*, Feb. 28, 2003.
Pagel, David. *Los Angeles Times*, September 2002
Miles, Christopher. *Artforum*, Critic's picks, February 2002
Pagel, David. "Kozyrev Details the Open Road at Hurtling Speed." *Los Angeles Times*, January 19, 2002
Gipe, Lawrence. "On the Road with Dimitri." *The Independent*, 31 May 2001.
Kozyrev, Dimitri. "How to Change the World." *Spectrum*, vol. XLI. 1999.

## NEVAN LAHART

Born 1973, Kilkenny, Ireland
Lives Dublin, Ireland

### Education
2001-03  National College of Art and Design, Dublin, Ireland. M.F.A.
1998-00  National College of Art and Design, Dublin, Ireland. B.F.A.
1992-95  Limerick School of Art and Design, Limerick, Ireland

### Selected Exhibitions
2007    *Art in the Life World*, Ballymun, Dublin, Ireland
2007    *The Big Store*, Temple Bar Gallery, Dublin, Ireland
2007    *Thirty Two Thousand Years Later*, Pallas Contemporary Projects, Dublin, Ireland
2007    *Aqua Arts Fair*, Kevin Kavanagh Gallery, Miami, FL
2007    *07 Arts Fair*, Kevin Kavanagh Gallery, London, England
2007    *Zoo Art Fair*, Colony Art Gallery, London, England
2007    *Docks Art Fair*, Kevin Kavanagh Gallery, Lyon, France
2007    *Paintaholics #2*, Product Arts Festival, Varna, Bulgaria
2007    *Moraltarantualla*, Electrohaus, Hamburg, Germany
2006    *The First and Last and Always*, Axis Arts Center, Dublin, Ireland
2006    *Failure*, Kilkenny Arts Festival, Kilkenny, Ireland
2006    *Ding Dong*, Altona, Hamburg, Germany
2005    *Showy Off Shit*, Irish Museum of Modern Art, Process Room, Dublin, Ireland
2005    *Flagged*, Visualise, Carlow, Ireland
2005    *From the Liberties to Parramatta*, Parramatta Campus, N.S.W., Australia
2004    *Contemporary Art in the Cathedral*, St. Fin Barre's Cathedral, Cork, Ireland

| 2004 | *Summer Short's*, Parkers Box, Brooklyn, NY |
|---|---|
| 2004 | *Retreat*, Billboards, Sydney, Australia |
| 2003 | *Feeding the Well-Feed*, The Goethe Institute, Dublin**,** Ireland |
| 2001 | *Vacationland,* Arthouse, Dublin, Ireland |
| 1998 | *The Mighty Right Show*, Fuse 98, Crawford Art College, Cork, Ireland |
| 1997 | *Articulate Intelligence,* Infusion,University of Limerick, Limerick, Ireland |
| 1996 | *Shambolic*, Triskel Arts Center, Cork, Ireland |
| 1996 | *Beuys Black Board*, Crawford Municipal Art Gallery, Cork, Ireland |
| 1995 | *Pain-Thing* Diploma Show, Limerick School of Art & Design, Ireland |
| 1994 | *In the Beginning*, Limerick City Gallery of Art, Limerick, Ireland |

## Awards
Arts Council Bursary 2005, 2006.
Arts Council Materials Award: 2000 & 2001.

## Residences
| 2005 | Irish Museum of Modern Art, Dublin, Ireland |
|---|---|
| 2003 | St. Andrews Community Center, Rialto, Dublin, Ireland |
| 1998 | National Sculpture Factory, Cork, Ireland |

## ROSEMARY LAING
Born 1959, Brisbane, Australia
Lives Sydney, Australia

## Education
| 1992-96 | College of Fine Arts, University of New South Wales. M.F.A. |
|---|---|
| 1990-91 | Sydney College of the Arts, University of Sydney |
| 1982 | Tasmanian School of Art, University of Tasmania, Hobart |
| 1976-79 | Brisbane College of Advanced Education, Queensland |

## Awards
| 2000 | Australian Research Council Grant, University of New South Wales |
|---|---|
| 1999 | National Photographic Purchase Award, Albury Wodonga Regional Art Foundation |
| 1998 | Industry and Cultural Development Grant, Australian Film Commission |
| 1997 | New Work, Visual Arts / Craft Fund, Australia Council |

## Individual Exhibitions
| 2007 | *Flight*, Frist Center for the Visual Arts, Nashville, TN |
|---|---|
| 2006 | *The unquiet landscapes of Rosemary Laing* Kunsthallen Brandts, Odense, Denmark |
| 2005 | *The unquiet landscapes of Rosemary Laing* Museum of Contemporary Art, Sydney, Australia |
| 2002 | *Groundspeed & bulletproofglass* Museo Nacional Centro de Arte Reina Sofia, Salamanca, Spain |
| 2000 | *Gradience*, The Australian Centre for Photography, Sydney |

| 2000 | *Aero-zone*, The Perth Institute of Contemporary Art, Perth |
|---|---|
| 1999 | *Aero-zone,* Australian Centre Contemporary Art, Melbourne |
| | *Aero-zone*, The National Museum of Art, Osaka, Japan |
| 1992 | *From Paradise work* (works 1-6), Queensland Art Gallery, Brisbane |
| 1978 | *Views and Influences*, Queensland University, Brisbane |

## Group Exhibitions
| 2007 | *Jano: La Doble Cara de la Fotografía. Fondos de la Colección Permanente*, Museo Nacional Centro de Arte Reina Sofia, Madrid, Spain |
|---|---|
| 2007 | *Think with the Senses – Feel with the Mind. Art in the Present Tense*, 52nd International Art Exhibition, Venice Biennale, Venice, Italy |
| 2007 | *The BIG picture*, North Carolina Museum of Art, Raleigh, NC |
| 2006 | *Shifting Terrain: Contemporary Landscape Photography*, Wadsworth Atheneum, Hartford, CT |
| 2006 | *Mite!*, The Okayama Prefectural Museum of Art, Okayama-shi, Japan |
| 2005 | *Revealing Secret Treasures: Women Artists from the Reg and Sally Richardson Collection*, Maitland Regional Gallery, New South Wales, Australia |
| 2005 | *Beyond Real: Making a Scene*, Australian Centre for Photography, Paddington, Australia |
| 2005 | *A Kind of Magic: The Art of Transforming*, Kunstmuseum Luzern, Switzerland |
| 2005 | *Out There: Landscape in the New Millenium*, Museum of Contemporary Art, Cleveland, OH |
| 2005 | *The Forest: Politics, Poetics, and Practice,* Nasher Museum of Art, Duke University, Durham, NC |
| 2004 | *2004: Australian Culture Now*, National Gallery of Victoria, Melbourne |
| 2004 | *Flock and Fable: Animals and Identity in Contemporary Art,* Chelsea Art Museum, New York, NY |
| 2004 | *Busan Biennale,* Busan Metropolitan Art Museum, Busan, Korea |
| *2004* | *Adelaide Biennial of Australian Art: Contemporary Photomedia*, Art Gallery of South Australia, Adelaide |
| 2003 | *Face Up Contemporary Art from Australia*, Nationalgalerie im Hamburger Bahnof, Berlin, Germany |
| 2002 | *Tales of the Unexpected,* National Gallery of Australia, Canberra |
| 2000 | *Zeitgenössische Fotokunst aus Australien/ Contemporary Photographic Art from Australia*, Neuer Berliner Kunstverein, Berlin, Germany |

## Selected Publications
Genocchio, Benjamin, "The Listings." *The New York Times*, Friday March 2, 2007, p. E 19.

Darwent, Charles. "Art at the Extremes." *Art Review*, June, 2006, p.78-83.

Kalina, R. "Down Under No More." *Art In America,* April 2005, pp. 77-85.

Solomon-Godeau, Abigail, "The Unique Landscapes of Rosemary Laing," *Aperture*, No. 175, p. 64-73 (cover).

Rees, S. "At the Galleries: Sydney - Rosemary Laing at Gitte Weise Gallery," *Flash Art,* Vol.XXXVII No. 234 January - February, 2004.

Itoi, K. "The Heretic of Kanazawa, International News Spotlight," *ARTnews*, March 2001.

Fitzgerald, M. "Suspension of Disbelief," *Time Magazine*, June 12, 2000.

### Collections
Griffith University Collection, Brisbane, Australia
Modern Art Museum of Fort Worth, TX
Museo Nacional Centro De Arte Reina Sofia, Madrid, Spain
Museum of Contemporary Art, Sydney, Australia
Museum Kunst Palast, Düsseldorf, Germany
National Gallery of Australia, Canberra, Australia
National Gallery of Victoria, Melbourne, Australia
North Carolina Museum of Art, Raleigh, NC
Queensland Art Gallery, Brisbane, Australia
21st Century Museum of Contemporary Art, Kanazawa, Japan

## DAVID MAISEL
Born 1961, New York, NY
Lives Sausalito, CA

### Education
2006    California College of the Arts. M.F.A.
1988-89 Harvard University, Graduate School of Design
1984    Princeton University, Princeton, NJ. B.A., summa cum laude.

### Selected Awards
2008    Headlands Center for the Arts; Visiting Artist Residency, Sausalito, CA
2007    Getty Research Institute; Visiting Scholar Residency.
1990    National Endowment for the Arts Visual Arts, Individual Visual Artists Fellowship.
1984    Princeton University, Francis LeMoyne Page Award in the Visual Arts.

### Solo Exhibitions
2008    *Oblivion*, Santa Barbara Museum of Art, Santa Barbara, CA
2008    *Library of Dust*, Portland Art Museum, Portland, OR
2007-06 *Black Maps*, Nevada Museum of Art, Reno, NV
2006-03 *The Lake Project,* Fotografie Forum International, Frankfurt, Germany,

### Selected Group Exhibitions
2009    *First Light: Optical Confusion In Modern Photograph,* Yale University Art Gallery, New Haven, CT
2008    Imaging a Shattering Earth: *Contemporary Photography and the Environmental Debate.* National Gallery of Canada Ottawa, Canada
2008    *It's Not Easy Being Green,* Tampa Art Museum, Tampa, FL
2007    *Re-SITE-ing the American West: Contemporary Photography from the Permanent Collection,* Los Angeles County Museum of Art, Los Angeles, CA

2007    *Global Anxieties: Nine Perspectives on a Changing Planet,* College of Wooster Art Museum, Wooster, OH
2006    *Ecotopia; the Photography Triennial,* International Center of Photography New York, NY
2006    *Shifting Terrain: Contemporary Landscape Photography,* Wadsworth Atheneum, Hartford, CT
2006    *Imaging a Shattering Earth: Contemporary Photography and the Environmental Debate,* Museum Of Contemporary Canadian Art, Toronto, Canada
2005    *Convergence at E116/N140: Beijing,* China Off-Biennial, Beijing, China
2005    *ECO: Art about the Environment*, San Francisco State University Fine Art Gallery, San Francisco, CA
2005    *Traces and Omens,* Noorderlicht Photography Festival, Groningen, Netherlands
2004    *Contemporary Photographs from the Permanent Collection,* Princeton University Art Museum, Princeton, NJ
1991    *Recent Acquisitions to the Permanent Collection,* Brooklyn Museum of Art, Brooklyn, NY

### Selected Collections
Aldrich Museum of Contemporary Art
Brooklyn Museum of Art
George Eastman House
Houston Museum of Fine Art
Los Angeles County Museum of Art
Metropolitan Museum of Art
Museum of Contemporary Photography
Portland Museum of Art
Princeton University Museum of Art
San Jose Museum of Art
Santa Barbara Museum of Art
Victoria & Albert Museum
Yale University Art Gallery

### Selected Publications
Aletti, Vince. "David Maisel." *The New Yorker*, December 11, 2006.

Gambino, Megan. "Danger Zones: David Maisel's Troubling Earth Images." *Smithsonian*, January 2008.

Gaston, Diana. "Immaculate Destruction: David Maisel's Lake Project." *Aperture,* Fall 2003.

Landi, Ann. "Review." *Art News*, March 2007.

Lang, Karen. "Voluptuous Unease: David Maisel's Library of Dust." *Insights:* The Getty Research Institute Journal, Winter 2009.

Roth, Michael. Ed. *Library of Dust*. San Francisco: Chronicle Books, 2008.

Maisel, David, William L. Fox, and Mark Strand. *Oblivion.* Portland: Nazraeli Press, 2006.

Maisel, David and Robert Sobieszek. *The Lake Project.* Tucson, AZ; Nazraeli Press, 2004.

Wallach, Amei. "Hell from the Air: Turning the Owens Valley into Environmental Art." *The New York Times*, May 9, 2004.

## MARY MATTINGLY

Born 1978, Rockville, CT
Lives New York City, NY

### Education
2002    Pacific Northwest College of Art, Portland, OR. B.F.A.
2002    Parsons School of Design, New York, NY
2001    Yale School of Art, Norfolk, CT

### Selected Solo Exhibitions
2007    *Time Has Fallen Asleep*, New York Public Library,
        Columbus Branch, NY
2002    Scope Art Fair (Lyonswiergallery), Miami, FL

### Selected Group Exhibitons
2008    *Future Tense,* Neuberger Museum, NY
2007    *Other Worlds: Fact and Fiction*, Mattatuck Museum,
        Waterbury, CT
2007    *Ecocentric*, Sonoma County Museum, Santa Rosa, CA
2007    *Bivouac*, Art Omi, Ghent, NY
2006    *Ecotopia*, International Center of Photography
        Triennial, New York, NY
2005    *Waterways and Beyond*, Istanbul Biennial,
        Istanbul, Turkey
2005    *Lifeboat – Hamptons*, Micro-scope, Scope Art Fair,
        Hamptons, NY
2005    *Waterways, Independent project during the Venice
        Biennial*, Venice, Italy
2004    *Lifeboat, artist initiative project*, Art Basel/
        Postitions, Miami, FL
2004    *Peekskill Projects*, Hudson Valley Center for
        Contemporary Art, Peekskill, NY
2004    *DNA: Art & Science - The Double Helix*,
        Contemporary Art Museum,Tampa, FL
2002    *Feast*, Parsons School of Design, New York, NY
2001    *End of the Summer*, Gallery at Yale, Norfolk, CT
2000    *Deck the Walls*, Portland Institute of Contemporary
        Art, Portland, OR

### Selected Publications
2007    "Ils veulent mettre la Terre sous cloche." *Le Monde
        2*, October 27, 2007.
2007    Wolff, Rachel, Fine. "We'll Start Recycling." *New
        York Magazine*, September 2007.
2007    Delematre, Jackie. "Gimme Shelter." *New York
        Press*, April 2007.
2006    VV Picks. "Ecotopia." *Village Voice*, September
        2006.
2006    "Ecotopia at the ICP." *New York Magazine*,
        September 2006.
2006    Schwendener , Martha. "Mary Mattingly at Robert
        Mann Gallery." *Artforum*, March 2006.
2006    Gelber, Eric. "Mary Mattingly." *Art Critical*,
        February 2006.
2004    Hasted, Sarah. "Mary Mattingly." *Photography
        Quarterly*, March 2004.
2003    Alletti, Vince. "Mary Mattingly." *Village Voice*,
        February 26, 2003.

### Awards
2004    London Photographic Awards
2002    Grant for Photographic Studies, New York
2001    Yale School of Art Fellowship
2001    Opal Filteau Photography Scholarship
2001    The Stephen Swirling Award for Digital Arts

### Selected Collections
International Center of Photography
Portland Art Museum
Yale University

## RICHARD MISRACH

Born 1949, Los Angeles, CA
Lives Los Angeles, CA

### Selected Awards
1992    National Endowment for the Arts Fellowship
1988    International Center of Photography Infinity Award
        for Outstanding Publication of 1987
1988    DIA Art Foundation Commission (to photograph
        Michael Heizer's, The City)
1979    John Simon Guggenheim Memorial Fellowship

### Selected Collections
Art Institute of Chicago, Chicago, IL
Australian National Gallery, Canberra, Australia
Center for Creative Photography, Tucson, AZ
Cleveland Museum of Art, Cleveland, OH
Corcoran Gallery of Art, Washington, D.C.
Denver Art Museum, Denver, CO
Fogg Art Museum, Harvard University, Cambridge, MA
High Museum, Atlanta, GA
Los Angeles County Museum of Art, Los Angeles, CA
Metropolitan Museum of Art, New York, NY
Museum of Contemporary Photography, Chicago, IL
Museum of Fine Arts, Boston, MA
Museum of Modern Art, New York, NY
National Gallery of Art, Washington, D.C.
Philadelphia Museum of Art, Philadelphia, PA
Saint Louis Art Museum, Saint Louis, MO
San Francisco Museum of Modern Art, CA
Seattle Art Museum, Seattle, WA
Smithsonian Institution, Washington, D.C.
Victoria & Albert Museum, London, England
Whitney Museum of American Art, New York, NY
Yale University Art Gallery, New Haven, CT

### Selected Solo Exhibitions
2002    Richard Mirk, Berkeley Art Museum, Berkeley, CA
2000    *Cancer Alley*, High Museum of Art, Atlanta, GA
1999    *Desert Cantos del Desierto*, Diputacion De
        Granada, Spain
1998    *Crimes and Splendors: The Desert Cantos*, San Jose
        Museum of Art, San Jose, CA
1998    *Nuclear Legacies*, Aidekman Art Center, Tufts
        University, Boston, MA
1997    *Crimes and Splendors: The Desert Cantos*, The
        Museum of Contemporary Art, Chicago, IL

1996    *Crimes and Splendors: The Desert Cantos of
        Richard Misrach*, The Museum of Fine Arts,
        Houston, TX; travels to: Center for Creative
        Photography, Tucson, AZ; Tacoma Art Museum,
        Tacoma, WA
1986    *Desert Cantos*, Houston Center for Photography,
        Houston, TX
1983    *Recent Desert Photographs,* Los Angeles County
        Museum of Art, Los Angeles, CA

**Selected Group Exhibitions**
2002    *Visions from America: Photographs from the
        Whitney Museum of American Art, 1940-2001*, The
        Whitney Museum of American Art, New York, NY
2001    *In Response to Place: Photographs from the Nature
        Conservancy's Last Great Places,* Corcoran Gallery
        of Art, Washington, D.C.
1998    *Measure of Nature: Landscape Photographs from
        the Permanent Collection*, The Art Institute of
        Chicago, Chicago, IL
1998    *The Paving of Paradise*, Seattle Art Museum,
        Seattle, WA
1997    *Scene of the Crime,* Armand Hammer Museum, Los
        Angeles, CA
1997    *Under the Dark Cloth: The View Camera in
        Contemporary Photography*, Museum of
        Photographic Arts, San Diego, CA
1996    *Legacy of Light: Master Photographs from the
        Cleveland Museum of Art,* Cleveland, OH
1994    *After Art: Rethinking 150 Years of Photography
        (Selections from the Joseph and Elaine Monsen
        Collection)*, Henry Art Gallery, University of
        Washington, Seattle, WA; traveled to The Friends
        of Photography, Ansel Adams Center,
        San Francisco, CA; Portland Museum of Art,
        Portland, ME
1994    *Visions of America: Landscape as Metaphor in
        the Late Twentieth Century,* Denver Art Museum,
        Denver, CO and the Columbus Museum of Art,
        Columbus, OH
1993    *Between Heaven and Home*, National Museum of
        American Art, Smithsonian Institution, Washington,
        D.C.
1993    *Mexico Through Foreign Eyes*, International Center
        for Photography, New York, NY
1985    *Mark Klett/Richard Misrach,* University of New
        Mexico, Albuquerque, NM
1984    *New Acquisitions, Recent Color*, Museum of Modern
        Art, New York, NY
1984    *Photography in California: 1945-1980,* San Francisco
        Museum of Modern Art, San Francisco, CA
1982    *California Photography*, Rhode Island School of
        Design, Providence, RI
1980    *Photography's Recent Directions,* Decordova
        Museum, Lincoln, MA

**Selected Publications**
2002    "Battleground Point #20." reproduction and review,
        Goings on about Town, *The New Yorker*, March 25
        and April 1.
2002    "Richard Misrach." review of Battleground Point by
        Rex Weil, *ARTnews*, May 2002 .
2002    "Richard Misrach at Fraenkel Gallery." Mark Van
        Proyen, *Artweek*, July/August.
2000    "Richard Misrach: Curt Marcus Gallery," review of
        sky exhibit by Justin, Spring, *Artforum*, November.
1997    "On Location with Richard Misrach." by Myriam
        Weisang Misrach, *Aperture*, February.
1996    "Fertile Images Out of the Desert." by Grace Glueck,
        *The New York Times*, Friday, September 27.
1995    "Richard Misrach." by Vince Aletti, *The Village Voice*,
        March 21.
1995    "Richard Misrach: Curt Marcus." by Matthew Ritchie,
        *Flash Art*, Summer, Vol. XXVIII, No. 183, P. 127.

## MATTHEW MOORE
Born 1976, Phoenix, AZ
Lives Phoenix, AZ

**Education**
2003    San Francisco State University, San Francisco, CA.
        M.F.A.
1998    Santa Clara University, Santa Clara, CA. B.A.

**Selected Awards**
2005    Arizona Commission on the Arts,
        Artist Project Grant
2005    Phoenix Art Museum, Contemporary Forum
        Artist Grant

**Selected Exhibitions**
2006    *New American City,* Arizona State University,
        Tempe, AZ
2006    *Hybrid Fields*, Sonoma County Museum,
        Santa Rosa, CA
2006    *Matthew Moore: Concerning Development*,
        University of Southern Mississippi Art Museum,
        Hattiesburg, MS
2006    *Contemporary Forum Grants Awards Exhibition,*
        Phoenix Art Museum, Phoenix, AZ
2005    *Regarding the Rural,* MASS MoCA, North Adams, MA
2004    *Tender Land*, Armory Center for the Arts,
        Pasadena, CA
2004    *Space Invaders*, Arts Center of the Capital Region,
        Troy, NY
2004    SouthwestNET: PHX/LA, Scottsdale Museum of
        Contemporary Art, Scottsdale, AZ
2004    *Land: Unconventional Landscape*, Shemer Arts
        Center, Phoenix, AZ
2004    *Trace*, Sonoma Museum of Visual Art, Santa Rosa, CA
2003    *Introductions South*, San Jose Museum of
        Contemporary Art, San Jose, CA
2003    *MFA Exhibition,* San Francisco State University Fine
        Art Gallery, San Francisco, CA
2002    *From Gardens to Main*, Hearst Center for the Arts,
        Cedar Falls, IA

| 2002 | *E+merging Artists*, SFSU Fine Art Gallery, San Francisco, CA |
| 2001 | *Santa Clara Biennial Outdoor Sculpture Exhibition,* Triton Museum, Santa Clara, CA |
| 2001 | *Bride of Alumillennium*, Santa Clara University Gallery, Santa Clara, CA |

**Selected Publications**

Bloomston, Carrie. "SouthwestNET:PHX/LA at SmoCA." *Art Papers*, August 2004.

Cheng, DeWitt. "Introductions South at SJICA." *Artweek*, October, 2003, page 17.

Nilsen, Richard. "Environmental Conscience." *Arizona Republic*, E1, May 16, 2004.

Potts, Leanne. "The Farmer and the Belle." *New Times*, April, 2006, page 23.

Vanesian, Katherine. "You Draw Like a Girl." *artUS*, January, 2004.

## MICHAEL NAJJAR

Born 1966, Landau, Germany
Lives Berlin, Germany

**Education**

| 1993 | Bildo Academy, Berlin, Germany. M.F.A., Media Art |

**Selected Exhibitions**

| 2007 | Wilhelm Hack Museum, Ludwigshafen, Germany |
| 2006 | *Mascarada*, Dormus Artium 2002, Museum for Contemporary Art DA. Salamanca, Spain |
| 2006 | *Cities, Architecture and Society*, Venice Biennale's 10th International Architecture Exhibition, Venice, Italy |
| 2006 | *Photo-trafic*, Center Pour l'Image Contemporaine, Geneva, Switzerland |
| 2006 | *Urban Dynamics,* 9th Havana Biennale, Cuba |
| 2006 | *Visibilities*, Edith-Russ-Haus for Media Art, Oldenburg, Germany |
| 2005 | *The Junction of East Longitude 116.65 and North Latitude 40.13,* Convergence Biennale Beijing, China |
| 2005 | *Traces and Oments*, Noorderlicht Photography Festival |
| 2005 | *DFoto '05*, San Sebastian, Spain |
| 2004 | *The Beauty of Failure/ The Failure of Beauty*, Fundació Joan Miró, Barcelona, Spain |
| 2003 | *A Clear Vision*, International House of Photography, Hamburg, Germany |
| 2003 | *Designkrokken*, Museum Traphold, Kolding, Denmark |
| 2003 | *Information and Apocalypse*, Goethe-Institut, New York |
| 2002 | *No Memory Access*, Kunsthalle Hamburg, Galerie der Gegenwart, Germany |
| 2002 | *Mythos St. Pauli*, Museum f. Kunst Und Gewerbe, Hamburg, Germany |
| 2000 | *Nexus Project Part 1*, Kodak, Photokina, Cologne, Germany |
| 1998 | *¡Viva Fidel!- Reise in die Absurdität*, Museum f. Kunst und Gewerbe, Hamburg , Germany |
| 1994 | *Annäherung*, European League of Institutes of Arts, Berlin, Germany |

**Selected Publications**

| 2006 | Itoi, Kay. "Tokyo:Return of the Rising Sun." *Art and Auction*, P 128-30, June. |
| 2006 | Herstatt, Claudia. "A Clear Vision. Photographische Werke Aus Der Sammlung F.C. Gundlach." *In Kunstforum International*, No. 168, January/February. |
| 2006 | Arackal, Sebastian. "Zukunft Der Städte", (The Future of the Cities), *Photographie*- Portfolio, No.1, January/February. |
| 2003 | Gardner, Ralph. "Michael Najjar- Information and Apocalypse, Pietà or Porn? Uptown Attacks Nudes." *The New York Observer*, 24 November. |
| 2003 | Johnson, Ken. "Exhibition Review: Information and Apocalypse." *New York Times*, 7 November 2003. |

**Selected Collections**

International House of Photography, Hamburg, Germany, F.C. Gundlach Collection

Museum Ludwig, Cologne Germany

Museum Für Kunst Und Gewerbe, Hamburg, Germany

Fundacio Coff, San Sebastian, Spain

Teutloff Collection, Bielefeld, Germany

Rappoport Collection, New York

## JOE NOVAK

Born 1941, Cedar Rapids, IA
Lives Rancho Mirage, CA

**Education**

The New York Studio School of Drawing, Painting and Sculpture, New York, NY

New York University, New York, NY

Parsons School of Design, New York, NY

Harvard Law School, Cambridge, MA. J.D.

Dartmouth College, Hanover, NH. B.A.

**Selected Exhibitions**

| 2006 | Palm Springs Art Museum Juried Exhibition ( V.J. Jacobs Abstract Award), Palm Springs, CA |
| 2006 | *Recent Acquisitions,* Museum of Fine Arts, Santa Fe, NM |
| 2004 | *Contemporary Works on Paper from the Collection,* Museum of Fine Arts, Santa Fe, NM |
| 2003 | *New Mexico Printmakers,* Santa Fe Art Institute, Santa Fe, NM |
| 2002 | *Joe Novak: Paintings, 1993-1999,* Hood Museum of Art, Dartmouth College, Hanover, NH |
| 1995 | *Light Emanations*, Santa Fe Council for the Arts, Santa Fe, NM |
| 1987 | *New Faces/New Spaces*, Guild Hall Museum, East Hampton, NY |
| 1984 | *30th Juried Exhibition*, Parrish Art Museum, South Hampton, NY |

**Selected Publications**

Braff, Phyllis. *Joe Novak: Paintings, 1993-1999*. Hood Museum of Art: Hanover, NH, 2002.

Braff, Phyllis. "Guild Hall Features New Faces." *The New York Times*, July 26, 1987.

Cline, Lynne. "Excursion Into Color and Light." *The Santa Fe New Mexican*, August 9, 2002.

Frank, Peter. "Art Pick of the Week." *Los Angeles Weekly*, November 18-24, 2005.

Graham, Bob. "Joe Novak: Color & Light." *San Francisco Chronicle*, March 22, 1998.

Harrison, Helen. "Winners in Parrish Biennial." *The New York Times*, December 28,1984.

Indyke, Dottie. "Joe Novak." *Art News,* February 2005.

Isaacson, Philip. "Works by Joe Novak." *Portland Telegram,* December 17, 1995.

Knight, Christopher. "Possibilities at Play in Fields of Color." *Los Angeles Times*, September 30, 2005.

Laget, Mokha. "Pyro: Burned Melted Smoked." *THE Magazine*, December 2003.

Regan, Margaret. "Variations on Light & Site." *Tucson Weekly*, February 26, 2004.

## Public Collections

Boston Museum of Fine Arts, Boston, MA
Cincinnati Art Museum, Cincinnati, OH
Frost Art Museum, Florida International University, Miami, FL
Guild Hall Museum, East Hampton, NY
Hood Museum of Art, Dartmouth College, Hanover, NH
Museum of Art, Ft. Lauderdale, FL
Museum of Fine Arts, Santa Fe, NM
Palm Springs Art Museum, Palm Springs, CA
Riverside Art Museum, Riverside, CA
Springfield Museum of Fine Arts, Springfield, MA
Tucson Museum of Art, Tucson, AZ
UC Berkeley Art Museum, Berkeley, CA

# LEAH OATES

Born 1969, Boston, MA
Lives Brooklyn, NY

## Education

1995-97  The School of the Art Institute of Chicago, Chicago, IL. M.F.A.
1993-94  Edinburgh College of Art Post-Graduate Diploma Fulbright Fellowship, Edinburgh, Scotland
1988-91  Rhode Island School of Design, Providence, RI. B.F.A., Merit Scholarship

## Selected Awards

1995  Trustee Scholarship, The School of the Art Institute of Chicago, Chicago, IL
1993-94  Fulbright Fellowship United Kingdom Grant, Edinburgh College of Art, Edinburgh, Scotland

## Selected Exhibitions

2005-06  Minnesota National Print Biennial Minneapolis, MN
2005-06  *Draw_ Drawing _ 2,* The London Biennial, London, England
2005-06  *Full Circle/Random Journey,* University of Northampton, Northampton, England, U.K.
2005-06  *4th International Artists' Book Triennial,* Vilnius, Lithuania

2004-05  *Power: Sex, Politics and the Pursuit of Global Domination,* Florida State University Museum, Tallahasse, FL
2004-05  *Art Futura, An Exhibition of American Art 2005,* Rehabilitation Institute of Chicago, Chicago, IL
2004-05  *What the Book?* The Fisher Art Gallery at Bard College, Annandale-on-Hudson, NY
2004-05  *Multi Tasking,* Islip Art Museum, Islip, NY
2002  *Parallel World of Sensation,* Williamsburg Arts & Historical Center, Brooklyn, NY
2002  *5th American Print Biennial Marsh Art Gallery,* University of Richmond, Richmond, VA
2002  *Collage/Assemblage/Montage,* Pennsylvania School of Art and Design, Lancaster, PA
2001  *Reflections in Hope,* Rockford Art Museum, Rockford, IL
2001  *Doppleganger,* Northern Illinois University Art Gallery, Chicago, IL
2000  *Society of Scottish Artists 2000 Contemporary Art Open,* Royal Scottish Academy, Edinburgh, Scotland
2000  Rhode Island School of Design, On the Road Printmaking and Photography Exhibit, Providence, RI

## Selected Collections

Getty Research Institute Artists' Book Collection, Los Angeles, CA
Sloan Library University of North Carolina at Chapel Hill, Chapel Hill, NC
Museum of Contemporary Art Artists Book Collection, Chicago, IL
Victoria and Albert National Art Library, Artists Book Collection, London, England
Dartmouth College Artists Book Collection, Dartmouth, ME
Brooklyn Museum of Art, Brooklyn, NY
Walker Art Center, Minneapolis, MN
Tate Museum, London, England
Rhode Island School of Design, Providence, RI
Carnegie-Mellon University Hunt Library, Pittsburgh, PA
Yale University Art of the Book Collection, New Haven, CT
National Museum of Women in the Arts, Washington, D.C.
Museum of Modern Art Franklin Furnace Artists Book Collection, New York, NY

## Selected Publications

*New York Arts Magazine* "Dark Nature: Part 1 Opens September 8th." September/October 2005, Volume 10, No 9/10.

*The Village Voice* "Savvy Magazine Members only: Editions clubs offer great deals on fine-art prints." April 6-12, page 3, New York, NY.

*The New York Times* "When Painting Picture is Just One of Your Jobs, Multitasking, Islip Art Museum." By Helen A. Harrison, Sunday, October 24th, 2004, Long Island Art Section.

*Chicago Reader* "Time Lapse, Anchor Graphics, The Culture Club, Section Two, Galleries." June 15, 2001.

## ROBYN O'NEIL

Born 1977, Omaha, NE
Lives Houston, TX

### Education

2000-01 Graduate Studies in Fine Art, University of Illinois, Chicago, IL
2000     Bachelor of Fine Art, Texas A&M University-Commerce, Commerce, TX
1997     Kings College, British Studies, British Art and Architecture, London, England

### Selected Awards

2005     Arthouse Texas Prize Finalist, Austin, TX
2003     Artadia Grant, Artadia - The Fund for Art and Dialogue, New York, NY
2003     ArtPace Foundation for Contemporary Art, San Antonio, International Artist in Residence
1999     DeGolyer Grant, Dallas Museum of Art, Dallas, TX

### Selected Exhibitions

2006     Contemporary Arts Museum, Houston, TX
2006     Herbert F. Johnson Museum of Art, Cornell University, Ithaca, NY
2006     Frye Art Museum, Seattle, WA
2007     *Size Matters: Large Drawings from the MFAH Collection*, Museum of Fine Arts, Houston, TX
2007     *New Directions in American Drawing*, Columbus Museum, Columbus, OH, traveling to Telfair Museum of Art in Savannah, GA, Knoxville Museum of Art in Knoxville, TN
2005     *Trials and Terrors*, MCA Chicago, Chicago, IL
2005     *Drawing Narrative*, The College of Wooster Art Museum, Wooster, OH
2004     *The Whitney Biennial*, Whitney Museum of American Art, New York City, NY
2004     *The Drawn Page*, The Aldrich Museum of Contemporary Art, Ridgefield, CT
2004     *I Feel Mysterious Today*, Palm Beach Institute of Contemporary Art, Lake Worth, FL
2004     *Young Americans*, Hof and Huyser, Amsterdam, The Netherlands
2003     *Come Forward*, Dallas Museum of Art, Dallas, TX
2002     *Bad Touch*, Ukranian Institute of Modern Art, Chicago, IL
2000     *Hi Jinx*, Arlington Museum of Art, Arlington, Texas and University of Texas-Dallas, Richardson, TX

### Selected Collections

Whitney Museum of American Art, New York City, NY
Herbert F. Johnson Museum of Art, Cornell University, Ithaca, NY
Blanton Museum of Art, Austin, TX
Dallas Museum of Art, Dallas, TX
Microsoft Corporation Art Collection, Redmond, WA
Museum of Fine Arts, Houston, TX
Ulrich Museum of Art, Wichita State University, Wichita, KS

## TOM PALMORE

Born 1945, Ada, OK
Lives Edmond, OK

### Education

1967-69 Pennsylvania Academy of the Fine Arts, Philadelphia, PA
1965-66 North Texas State University, Denton, TX
1963-65 University of Nevada, Reno, NV

### Selected Exhibitions

2006     LewAllen Contemporary, Santa Fe, NM
2002     Newman and Saunders Gallery, Philadelphia, PA
1998     *Other Earthlings*, J. Cacciola Galleries, New York, NY
1998     Moriani Arts Center, Philadelphia, PA
1991     Sherry Frumkin Gallery, Santa Monica, CA
1989     *Birds, Bulls, and a Couple of Monkeys*, Gerald Peters Gallery, Santa Fe, NM
1985     *Alumni Show*, Pennsylvania Academy of the Fine Arts, Philadelphia, PA
1985     *Artists of Santa Fe*, Dallas Theater Center, Dallas, TX
1983     *Texas Wildlife*, F.C.I., Fort Worth, TX
1983     *The West as Art*, Palm Springs Desert Museum, Palm Springs, CA
1981     Philadelphia Museum of Art, Philadelphia, PA
1979     Louis K. Miesel Gallery, New York, NY
1978     *Decade of American Painting*, Whitney Museum of American Art, New York, NY
1978     *Art in Philadelphia*, Pennsylvania Academy of the Fine Arts, Philadelphia, PA
1976     Marion Locks Gallery, Philadelphia, PA

### Selected Collections

Albuquerque Museum of Art, History, and Science
Allentown Museum of Art
Brooklyn Museum
Denver Art Museum
Everson Museum of Art
Indianapolis Museum of Art
Museum of Fine Arts Santa Fe
New Orleans Museum of Art
Pennsylvania Academy of Fine Art
Philadelphia Museum of Art
Princeton University
Smithsonian Institution
St. Louis Art Museum
Whitney Gallery of Western Art at the Buffalo Bill Historical Center
Whitney Museum of Art

### Selected Publications

McGarry, Susan. *Earthlings: The Paintings of Tom Palmore.* Oklahoma City: University of Oklahoma Press, 2008.

## ROBERT PARKEHARRISON
Born 1968, Fort Leonard Wood, MO
Lives Bedford, MA

## SHANA PARKEHARRISON
Born 1964, Tulsa, OK
Lives Bedford, MA

### Education
**Robert ParkeHarrison**
1994    University of New Mexico. M.F.A.
1990    Kansas City Art Institute. B.F.A.

**Shana ParkeHarrison**
1991-94    Graduate Studies, University of New Mexico
1986    William Woods College, B.F.A.

### Selected Solo & Group Exhibitions
2007    *Envisioning Change,* Nobel Peace Center,
Oslo, Norway
*Flight of Fancy,* Museum of Fine Arts, Santa Fe, NM
2006    *C on Cities,* Venice Biennale of Architecture,
Venice, Italy.
*The Missing Peace: Artist Consider the Dalai Lama,*
Loyola University Museum of Art, Chicago, IL
*Hand in Hand: Domestic and Creative Partnerships
in the Digital Age,* Minneapolis Center for
Photography, Minneapolis, MN
2005    *Architect's Brother,* Mois de la Photographie,
Montreal, Canada
*Recent Works,* Gallery of Photography,
Dublin, Ireland
2005    *Landscape,* Whitney Museum of American Art,
New York, NY.
2004    *Silver Images: The Photography Collection at 25,*
Chrysler Museum of Art Norfolk, VA
2003    *Portrait of the Art World: A Century of ARTnews
Photographs,* The Smithsonian Institute,
Washington, D.C.
2002    *Recent Acquisitions,* Whitney Museum of American
Art, New York, NY
2002    *New Acquisitions/ New Work/ New Directions 3:
Contemporary Selections,* Los Angeles County
Museum of Art, Los Angeles, CA
2001    *Crafted Image: 19th Century Techniques in
Contemporary Photography,* Boston University Art
Gallery, Boston, MA
1999    *The 3rd Tokyo International Photo-Biennale:
Fragments of Document and Memory,* Tokyo
Metropolitan Museum of Photography, Tokyo, Japan

### Grants, Fellowships, and Awards
2003    Peter Reed Foundation, Artist Grant
1999    John Simon Guggenheim Memorial Foundation
Fellowship, New York, NY
1997    Aaron Siskind Foundation Fellowship, School of
Visual Arts, New York, NY

### Selected Collections
The Chrysler Museum, Norfolk, VA
Cleveland Museum of Art, Cleveland, OH
Fogg Art Museum, Harvard University, Cambridge, MA
Houston Museum of Fine Arts, Houston, TX
Los Angeles County Museum, Los Angeles, CA
Museum of Fine Arts, Boston, MA
Museum of Photographic Arts, San Diego, CA
National Museum of American Art, Washington, D.C.
Nelson-Atkins Museum, Kansas City, MO
Rhode Island School of Design Art Museum, Providence, RI
San Francisco Museum of Modern Art, San Francisco, CA
Whitney Museum of American Art, New York, NY

### Selected Publications
Adlmann, Jan Ernst. "Report from Santa Fe: Going
Mainstream." *Art in America,* January 1995: 52.
Artner, Alan. "Two Artists Click with Collaborative
Photos."*Chicago Tribune,* May 18, 2007.
Boxer, Sarah. "Following A Shifting Gaze As Portraiture
Evolves." Photography Review, *The New York Times,*
November 22, 2002.
Goldberg, Vicki. "Everyman Tries to Save the Earth, One
Image at a Time." *The New York Times,* February 4, 2000.
(Review: *Earth Elegies* exhibition.)
Marien, Mary Warner. "Photography: A Cultural History."
Harry N. Abrams Inc. Publishing, 2002.
Stapp, William F. "Portrait of the Art World: A Century of
*ARTnews* Photographs." Yale University Press, 2002.
Temin, Christine. "He's Out to Save a World of his Own
Making." *Boston Globe,* September 19, 2004.
"The Missing Peace: Artists and the Dalai Lama," forward by
H.H., the Dalai Lama, Earth Aware Editions, 2006.
Van De Walle, Mark. *Artforum,* March 1995: 95-96. (Review)
Wolf, Sylvia. "Visions from America: Photographs from the
Whitney Museum of American Art." 1940 - 2002, Prestal
Books, 2002.
Wolinski, Natacha. "Sur La Terre Comme Au Ciel." *Beaux Arts
Magazine,* February 2003.

## ANTHONY PESSLER
Born 1962, Pittsburgh, PA
Lives Phoenix, AZ

### Education
1991    University of Wisconsin, Madison. M.F.A.
1989    St. Cloud State University, St. Cloud, MN. M.A.
1988    St. Cloud State University, St. Cloud, MN. B.F.A.,
Summa Cum Laude
1980-83  University of North Dakota, Grand Forks, ND

### Selected Exhibitions
2007    Archiv Massiv, Leipziger Baumwoll Spinnerei,
Leipzig, Germany
2005    Kohler Art Center, Sheboygen, WI
2005    McDonough Museum of Art, Youngstown, OH
2004    The Hudson River Museum, Yonkers, NY
2004    Norton Museum of Art, West Palm Beach, FL
2004    Center for Contemporary Art, New Orleans, LA

| 2003 | *Biennale Internazionale Dell' Arte Contemporanea*, Florence, Italy |
|------|------|
| 2002 | Nicolaysen Museum, Casper, WY |
| 2001 | North Dakota Museum of Art, Grand Forks, ND |
| 2000 | Mobile Museum of Art, Mobile, AL |
| 2000 | Leigh Hawley Woodson Museum, Wassau, WI |
| 2000 | San Diego State University, San Diego, CA |
| 2000 | Nelson Fine Art Center, ASU Faculty Exhibition, Tempe, AZ |
| 1999 | Gibbes Museum of Art, Charleston, SC |
| 1997 | Tucson Museum of Art, Arizona Biennial, Tucson, AZ |
| 1996 | Harry Wood Gallery, Arizona State University, Tempe, AZ |
| 1995 | Atwood Gallery, St. Cloud State University, St. Cloud, MN |
| 1994 | Chicago Botanic Garden, Chicago, IL |
| 1993 | Boise State University, Boise, ID |
| 1991 | Wichita Center for the Arts, Wichita, KS |
| 1989 | Sioux City Art Center, Sioux City, IA |

## Selected Collections
Tucson Museum of Art, Tucson, AZ
Madison Art Center, Madison, WI

## Selected Publications
Highton, Luke and Sarah James. "Leipzig: The City According to Art." *Artview*, (January 2008) 83-89.
McLellan, Marion. "The Birds." *New Orleans Art Review* (March/April 2004).
Parker, Oriana. "Artist's Inner Voice Doesn't Follow Current Trends." *The Arizona Republic* (September 7, 2002).
Turner, Elisa. "Taking Flight: Art of a Feather Flocks Together." *The Miami Herald* (August 6, 2004).

## ROBERT POLIDORI
Born 1951, Montreal, Canada
Lives New York, NY

## Education
| 1980 | State University of New York at Buffalo, NY. M.A. |
|------|------|

## Awards
| 1998 | World Press Award for Art |
|------|------|
| 2000-99 | Alfred Eisenstadt Award for Magazine Photography, Architecture |

## Selected Exhibitions
| 2007 | *After the Flood*, Jarach Gallery, Venice, Italy |
|------|------|
| 2007 | *After the Flood*, Nicholas Metivier Gallery, Toronto, Canada |
| 2006 | *New Orleans after the Flood*, Metropolitan Museum of Art, New York, NY |
| 2006 | *Fotografien*, Martin-Gropius-Bau Museum, Berlin |
| 2006 | *The Living is Easy*, Flowers, London |
| 2004 | *Havana*, Peabody Essex Museum, Salem, MA |
| 2003 | *Esther haase –Kuba*, CameraWork, Berlin |
| 1997 | Institut du Monde Arabe, Paris |
| 1994 | *Conseil Generale de la Nievre*, Nevers, France |
| 1991 | *Galerie Jaques Gordat*, Paris |
| 1990 | Galerie Urbi et Orbi, Paris |

| 1989 | Chicago Art Institute, Chicago, IL |
|------|------|
| 1988 | *Atelier des Cannettes*, Mois de la Photo, Paris |
| 1978 | International Center of Photography, New York, NY |
| 1975 | Whitney Museum of Art-New Filmmakers Program, New York, NY |
| 1970-75 | Anthology Film Archives, New York, NY |

## Selected Collections
MOMA, New York, NY
Los Angeles County Museum of Art, Los Angeles, CA
The Metropolitan Museum of Art, New York, NY
The Museum of Fine Arts, Houston, TX
Foundacion "La Caixa," Barcelona, Spain
First National City Bank, New York, NY
Walker Art Center, Minneapolis, MI

## Selected Publications
*After The Flood*, Photographs by Robert Polidori, Editions Steidl, Gottingen, Germany 2006.
*Robert Polidori's Metropolis*. Photographs by Robert Polidori, text by Robert Polidori and MartinC. Pedersen. Metropolis/ D.A.P., New York 2004.
*Condé Nast Traveller; GEO; GQ; Numero; House and Garden; Wired; Metropolis; Fortune, Architecture; Amica; De la Republica; Architectural Digest France; Nest; Newsweek; Vanity Fair*

## ALEXIS ROCKMAN
Born 1962, New York, NY
Lives New York, NY

## Education
| 1980-82 | Rhode Island School of Design, Providence, RI |
|------|------|
| 1983-85 | School of Visual Arts, New York, NY |

## Selected Solo Exhibitions
| 2008-09 | *The Weight of Air: Works on Paper*, Rose Museum, Brandeis University, Waltham, MA |
|------|------|
| 2007 | *Barometric Pressure*, Galerie Sabine Knust, Munich, Germany |
| 2004 | *Manifest Destiny*, Brooklyn Museum of Art, Brooklyn, NY; Rhode Island School of Design, Providence, RI; Addison Gallery of American Art, Andover, MA; Grand Arts, Kansas City, MO; Mural version, Wexner Center for the Arts, Columbus, OH |
| 2001 | *Future Evolution*, Henry Art Gallery, University of Washington, Seattle, WA |
| 1999 | *A Recent History of the World*, The Aldrich Museum of Contemporary Art, Ridgefield, CT |
| 1997 | *Dioramas*, Contemporary Arts Museum, Houston, TX |
| 1996 | *Alexis Rockman: Second Nature*, Cincinnati Art Museum, Cincinnati, OH |
| 1995 | *Neblina*, Koyanagi Gallery, Tokyo, Japan |
| 1992 | The Carnegie Museum of Art, Pittsburgh, PA |

## Select Group Exhibitions
| 2006 | *Into Me / Out of Me*, curated by Klauss Biesenbach, P.S. 1 MoMA, New York, NY; KW Institute for Contemporary Art, Berlin, Germany; MACRO Museo d'Arte Contemoranea Roma, Rome, Italy |
|------|------|

2003    *Pulp Art: Vamps, Villains, and Victors from the Robert Lesser Collection*, Brooklyn Museum of Art, Brooklyn, NY

2000    *Desert & Transit*, Schleswig-Holsteinischer Kunstverein, Kunsthalle zu Kiel, Kiel, Germany; Museum der bildenden Kunste, Leipzig, Germany

2000    *Paradise Now*, Museum of Art, University of Michigan, Ann Arbor, MI

2000    *I World: Dioramas in Contemporary Art*, Museum of Contemporary Art, San Diego, CA

1999    *Get Together*, Kunst als Teamwork, Kunsthalle Wien, Vienna, Austria

1998    *Gothic*, The Institute of Contemporary Art, Boston, MA; Portland Art Museum, Portland, OR

1993    *Some Went Mad, Some Ran Away...*, The Serpentine Gallery, London, England; Nordic Arts Centre, Helsinki, Finland; Kunstverein Hannover, Hannover, Germany; Museum of Contemporary Art, Chicago, IL; Louisiana Museum of Contemporary Art, Humlebæck, Denmark

1990    *The (Un)Making of Nature*, Whitney Museum of American Art, Downtown at Federal Reserve Plaza, New York, NY

### Selected Collections
Baltimore Art Museum, Baltimore, MD
Brooklyn Museum, Brooklyn, NY
Carnegie Museum of Art, Pittsburgh, PA
Cincinnati Art Museum, Cincinnati, OH
Solomon R. Guggenheim Museum, New York, NY
Los Angeles County Museum of Art, Los Angeles, CA
Museum of Fine Arts, Boston, MA
The Museum of Modern Art, New York, NY
Whitney Museum of American Art, New York, NY

### Selected Publications
2008    Genocchio, Benjamin. "Today's Landscape, Tomorrow's Dystopia." *The New York Times*, June 1.

2008    Corbett, Rachel, and Adam P. Schneider. "Global Warning." ArtNews, June, p.110.

2004    Sicha, Choire. "Top Ten." Artforum, September, p. 60.

2004    Muschamp, Herbert. "Brooklyn's Radiant New Art. Palace Introduces Itself to Museumgoers." *The New York Times*, April 16, p. E 31, 37.

2000    "Around Town: Alexis Rockman." *The New Yorker*, November 7.

2000    Levin, Kim. "Voice Choices: Alexis Rockman." *The Village Voice*, October 31, p.102.

1998    Turner, Grady T. "Alexis Rockman." *Art in America*, p.104 (review: Jay Gorney Modern Art).

1993    Dion, Mark. "The Origin of Species: Alexis Rockman on the Prowl." *Flash Art*, October, p.114-115.

# BARBARA ROGERS
Born 1937, Newcomerstown, OH
Lives Tucson, AZ

### Education
1963    University of California, Berkeley, CA. M.A. Painting
1959    Ohio State University, Columbus, OH. B.S. Art Education

### Selected Awards
1999    Richard Florsheim Art Fund Grant
1991    Research Grant, Office of Vice President for Research, University of Arizona, Tucson, AZ
1991    Professional Development Grant, Arizona Commission on the Arts
1963    Eisner Prize in Painting, University of California

### Selected Solo Exhibitions
2005    Bustan al Janaa, University Gallery, University of Sharjah, United Emirates
2001    Natural Facts: Unnatural Acts, Tucson Museum of Art, Tucson, AZ
2000    Dreaming of Eden: Meditations on the Garden, Contemporary Art, Scottsdale, AZ
1996    Personal Eden, One West Art Center, Fort Collins, CO
1994    Constructing Paradise, University of Arizona Museum of Art, Tucson, AZ
1987    University of the Pacific Gallery, University of the Pacific, Stockton, CA
1973    San Francisco Museum of Modern Art, San Francisco, CA

### Selected Group Exhibitions
2001    *Neobotanica: Flora by Four Contemporary Artists*, Jacksonville Museum of Modern Art, Jacksonville, FL
1999    *Organic Matters*, Carlsten Gallery, University of Wisconsin, Stevens Point, WI
1998    *Another Arizona*, Nelson Fine Arts Center, Arizona State University Art Museum, Tempe, AZ
1995    *Skirting the Decorative*, Harbor Gallery, University of Massachusetts, Boston, MA
1989    *Selections 49*, Drawing Center, New York, NY
1989    *Embracing Change*, San Jose State University, San Jose, CA
1989    *Primal Forces*, Women's Caucus for Art, Cooper Union, New York, NY
1989    *Landscape: A Presence*, San Jose Institute of Contemporary Art, San Jose, CA

### Selected Publications
*Southwest Art*, May 2007. "Gardens of the Imagination, Barbara Rogers." Micro Landscapes. Combine the Beauty and Drama of the Natural World." Virginia Campbell.
*Artweek*, August 1995, Clarissa J. Welsh. "Preview: Barbara Rogers at Frederick Spratt Gallery."
*Art in America*, March-April 1978, p.142, Knute Stiles. "Barbara Rogers at Hansen Fuller."
*Arts Magazine*, May 1975, p. 14, Ellen Lubell.

*The New York Times*, July 14, 1974, p. 19, Hilton Kramer. "New Art of the 70's in Chicago" includes image of " Renee With An Indian Prince."
*Artforum*, January 1970, p. 80, P.D. French.

## THOMAS RUFF
Born 1958, Zell am Harmersbach, Germany
Lives Düsseldorf, Germany

### Education
1977-85 Staatlichen Kunstakademie, Düsseldorf, Germany

### Awards
2006     International Center of Photography Infinity Award, New York, NY
2003     Hans-Thoma Preis, Hans-Thoma Museum, Bernau, Germany

### Selected Solo Exhibitions
2007     *Thomas Ruff: Jpegs*, Moderna Museet, Stockholm, Sweden
2004     *Thomas Ruff: Les Oeuvres de la Collection Pierre Huber*, MAMCO Musée d'Art Moderne et Contemporain, Genève, France
2003     *Identificaciones*, Museo Tamayo, Mexico City, Mexico
1997     *Oeuvres 1979 - 97*, Centre National de la Photographie, Paris, France
1997     *Thomas Ruff*, Goethe Institut, Paris, France
1995     *Thomas Ruff. Andere Porträts + 3D*, German Pavilion, Venice Biennale, Venice, Italy
1992     *Thomas Ruff*, Museum für Moderne Kunst, Frankfurt, Germany
1990     *Porträts, Häuser, Sterne*, Kunsthalle Zürich, Zürich, Switzerland
1989     *Porträts, Häuser, Sterne*, Stedelijk Museum, Amsterdam, The Netherlands

### Selected Group Exhibitions
2008     *CONTACT Toronto Photography Festival: Between Memory and History*, Museum of Contemporary Canadian Art, Toronto, Canada
2008     *Photography on Photography: Reflections on the Medium since 1960*, The Metropolitan Museum of Art, New York, NY
2008     *Archive Fever: Uses of the Document in Contemporary Art*, International Center of Photography, New York, NY
2007     *Contemporary Outlook: German Photography*, Museum of Fine Arts, Boston, MA
2006     *Face. The New Photographic Portrait*, Musée de l`Elysée, Lausanne
2006     *Ecotopia: The Second ICP Triennial of Photography and Video*, International Center of Photography, New York, NY
2005     *Rückkehr ins All*, Kunsthalle Hamburg, Hamburg, Germany
2004     *The Last Picture Show: Artists Using Photography*,
1960-82 Walker Art Center, Minneapolis, MN

2002     *Moving Pictures: Contemporary Photography and Video from the Guggenheim Museum Collections*, Solomon R. Guggenheim Museum, New York, NY and Guggenheim Bilbao, Bilbao, Spain
2002     *Limits of the Perception*, Fundació Miró, Barcelona, Spain
2001     *Picturing Media: Modern Photographs from the Collection*, The Metropolitan Museum of Art, New York, NY
2001     *Mies in Berlin*, The Museum of Modern Art, New York, NY and Altes Museum, Berlin, Germany
1998     *Artificial. Figuracions Contemporànies*, Museu d'Art Contemporani de Barcelona, Barcelona, Spain
1995     *Szenenwechsel VIII*, Museum für Moderne Kunst, Frankfurt, Germany
1992     *Photography in Contemporary German Art: 1960 to the Present*, Dallas Museum of Art, Dallas, TX
1991     *Typologies: Nine Contemporary Photographers*, The Corcoran Gallery of Art, Washington D.C.
1990     *New Work: A New Generation*, San Francisco Museum of Modern Art, San Francisco, CA
1990     *For 20 Years: Editions Schellmann*, The Museum of Modern Art, New York, NY
1988     *Aperto 88*, Venice Biennale, Venice, Italy

### Selected Publications
2007     Rosenberg, Karen. "Modern Photography in a Brand-New Space." *The New York Times* (September 28, 2007): E36.
2005     Aletti, Vince. "Voice Choices." *The Village Voice*, Vol. L, No. 12 (March 23-29, 2005): C44.
2003     Birnbaum, Daniel. "Thomas Ruff talks to Daniel Birnbaum." *Artforum* (April 2003): 218-219.
2003     Leffingwell, Edward. "Thomas Ruff at David Zwirner." *Art in America* (November 2003): 166.[ill.]
1998     Hess, Barbara. "Thomas Ruff. Johnen & Schöttle." *Flash Art*, Vol. 31, No. 199 (March/April 1998): 118.
1989     Kuspit, Donald. "The Repressed Face." *Aperture*, No. 114 (1989): 48-55.

## CHRIS RUSH
Born 1960, Tucson, AZ
Lives Tucson, AZ

### Selected Exhibitions
2008     Phoenix Airport Museum, AZ
2007     Togonon Gallery, San Francisco, CA
2006     Solo Exhibition, Jack the Pelican Presents, New York, NY
2006     Solo Exhibition, Etherton Gallery, Tucson, AZ
2006     Graficas Gallery, Tucson, AZ
2004     Gescheidle Gallery, Chicago, IL
2003     Tatistcheff Gallery, New York, NY
2002     The Drawing Center, New York, NY
2002     Solo Exhibition, Phoenix Art Museum, AZ

2001     Solo Exhibition, La Galería Akumal, Quintana Roo, Mexico
2000     Museum of Contemporary Art, Tucson, AZ
1999     Peter Bartlow Gallery, Chicago, IL

| 1998 | The Alternative Museum, New York, NY |
| 1998 | Olga Dollar Gallery, San Francisco, CA |
| 1998 | Tucson Museum of Art, Tucson, AZ |

## Selected Awards
| 2006 | Wurlitzer Foundation, NM, Fellowship/Residency |
| 2005 | Pastel Journal, National Art Competition, First Prize |
| 1999 | Puffin Foundation, NJ, Fellowship |
| 2001 | Arizona Commission on the Arts, Fellowship |
| 1999 | Ludwig Vogelstein Foundation, ME, Fellowship |
| 1999 | Tucson Arts Council, AZ, Fellowship |
| 1998 | The Phoenix Art Museum, AZ, Fellowship |

## Selected Collections
Phoenix Art Museum
Tucson Museum of Art
City of Tucson

## Selected Publications
| 2009 | *Stare*, Essays by Rosemarie Garland Thomson, Oxford University Press. |
| 2006 | *Artists Magazine* (cover story), Profile by Christine Proskow. |
| 2006 | *Pure Color*, Maureen Bloomfield, North Light Books. |
| 2005 | *The Pastel Journal*, Profile by Michele Norris. |
| 2004 | *Shade* Magazine, Exhibition Review by Rudy Navarro. |
| 2002 | *Contemporary* (UK), Exhibition Review by Katherine Koepf. |
| 2002 | *The Drawing Papers* (The Drawing Center, NY), Essay by Luis Camnitzer. |
| 2000 | *Open Range and Parking Lots*, Virgil Hancock; Univ. of New Mexico Press. |
| 1999 | *Miami Herald*, International Edition, Profile by Kathy Loretta. |
| 1998 | *New American Paintings*; Open Studios Press. |

## SUSAN SHATTER
Born 1943, New York, NY
Lives New York, NY

### Education
| 1972 | Boston University, Boston, MA. M.F.A. |
| 1965 | Pratt Institute, New York, NY. B.F.A. |
| 1964 | Skowhegan School of Painting & Sculpture, Skowhegan, ME |

### Selected Awards
2004-05 Pollack Krasner Foundation Grant
| 2003 | William Paton Prize, National Academy of Design, New York, NY |
| 1999, 03 | Childe Hassam Purchase Award, American Academy of Arts & Letters, New York, NY |
| 1987 | National Endowment for the Arts Grant |
| 1985 | New York State Foundation for the Arts Grant |

### Selected Exhibitions
| 2002 | *Art on Paper*, Weatherspoon Art Museum, Greensboro, NC |

| 2001 | *Susan Shatter, Selected Works*, Southeastern Center for Contemporary Art, Winston-Salem, NC |
| 2001 | *Invitational*, National Academy of Design, New York, NY |
| 1999-00 | *Green Woods and Crystal Waters*, Philbrook Museum, Tulsa, OK |
| 1999 | *Susan Shatter, Selected Works*, The Huntington Museum of Art, Huntington, WV |
| 1996-97 | *Partners in Printmaking*, The National Museum of Women in the Arts, Washington, D.C. |
| 1991-92 | *American Realism & Figurative Art: 1952-1991*, Traveling: Sogo Museum of Art, Yokohama; The Tokushima Modern Art Museum, Tokushima; The Museum of Modern Art, Shiba; Otsu |
| 1991 | *Presswork*, National Museum of Women in the Arts, Washington, D.C. |
| 1986-87 | *A Contemporary View of Nature*, The Aldrich Museum of Contemporary Art, Ridgefield, CT |
| 1985-86 | *American Realism: Twentieth Century Drawings and Watercolors*, San Francisco Museum of Modern Art; traveling to DeCordova Museum, Lincoln, MA; University of Texas, Austin, TX |
| 1983-84 | *Watercolor on a Grand Scale*, Danforth Museum of Art, Farmington, MA |
| 1982 | *The Gund Collection*, Museum of Fine Arts, Boston, MA |
| 1981-82 | *Contemporary American Realism Since 1960*, Pennsylvania Academy Fine Arts, Philadelphia, PA; The Oakland Museum, Oakland, CA |
| 1976-78 | *America 1976*, The United States Department of the Interior Bicentennial Traveling Exhibition, The Corcoran Gallery of Art, Washington, D.C. The San Francisco Museum of Art, San Francisco, CA, Fogg Art Museum, Harvard University, Cambridge, MA, Milwaukee Art Center, Milwaukee, WI, The High Museum of Art, Atlanta, GA, The Wadsworth Atheneum, Hartford, CT; The Brooklyn Museum, Brooklyn, NY |

### Selected Publications
Arthur, John. *American Landscape Traditions Since 1950.* Tucson, OK: The Philbrook Museum, 1999.

*American Figurative Art, 1952-90*, the Miyagi Museum of Art, Sendai, Japan and the Japan Association of Art Museums, 1991.

Carl Belz. *Painted in Boston.* Boston: The Institute of Contemporary Art, 1975.

Brenson, Michael. Review, *The New York Times* January 9, 1987.

Dervaux, Isabelle and David Dearing. *Challenging Tradition. Women of the Academy.* New York: National Academy of Design Museum, 2003.

Christopher Finch. Twentieth Century Watercolors. New York: Abbeville Press, 1990.

Fine, Ruth. *Contemporary American Realism: The Jalane and Richard Davidson Collection*, New York, Hudson Hills Press, 1999.

Heller, Jules and Nancy. *North American Women Artists of the Twentieth Century*, New York: NY: Garland Publishing, 1995.

Henry, Gerrit. Review, *Art in America* June 1987.

Kuspit, Donald. *Tracking the Terrain.* Donald Kuspit, Stonybrook, NY: Staller Center for the Arts, Stonybrook University, 2003.

Kuspit, Donald. Review, *Art in America* October 1982.
Larson, Kay. Review, *The Village Voice* March 24, 1980.
Martin, Alvin. *American Realism: Twentieth-Century Drawings and Watercolors from the Glenn C. Janns Collection.* New York: Harry N. Abrams, Inc., 1984.

**Selected Collections**
Dartmouth College, Hanover, MA
Massachusetts Institute of Technology, Cambridge, MA
Museum of Fine Arts, Boston, MA
National Academy of Design, New York, NY
National Museum of American Art, Smithsonian Institution, Washington, D.C.
Philadelphia Museum of Art, PA
The Art Institute of Chicago, IL
Tufts University, Medford, MA
University of Texas, San Antonio, TX
Walker Art Museum, Brunswick, ME
Yale University Art Museum, New Haven, CT

## JEFF SMITH
Born 1959, Macon, GA
Lives Tucson, AZ

**Education**
1983    Associate of Arts Degree, Pima Community College, Tucson, AZ

**Selected Exhibitions**
2008    *16th Small Works Invitational*, Davis Dominguez Gallery, Tucson, AZ
2007    *2nd Annual All Souls Procession Fine Art Photography Exhibition Competition.* Honorable mention. Hotel Congress, Tucson, AZ
2007    *Out of a Clear Blue Sky*, Etherton Gallery Tucson, AZ
2007    *7th Biennial Exhibition*, Museum Of Modern Art, A.I.R. Gallery, New York, NY
2007    Solar Culture Gallery and Studio, Tucson, AZ
2007    *Out of a Clear Blue Sky*, Etherton Gallery Tucson, AZ
2006    *All Souls Procession Photo Exhibition*, Fox Theatre, Tucson, AZ
2006    *GLOW*, Triangle L Ranch, Oracle, AZ
2002    *Louis Carlos Bernal: Mentor*, Pima Community College, Tucson, AZ

**Selected Publications (Featured Artworks)**
2008    *Shutterbug Magazine*
2008    *Desert Leaf*
2008    *Digital Output Magazine*
1990    *Discover*
*Smithsonian Air and Space Magazine, Sky & Telescope, Terre Sauvage, The Philadelphia Inquirer Magazine, Ciel et Space, IBM, Insight, Stern, Photographer's Forum Magazine, Omni Magazine, Time, Newsweek, Esquire*

## MIKHAEL SUBOTZKY
Born 1981, Cape Town, South Africa
Lives Johannesburg, South Africa

**Education**
2004    University of Cape Town, Cape Town, South Africa. B.F.A

**Selected Awards**
        Civitella Ranieri Fellowship, Italy
2007    City of Perpignan Young Photographer Award, Perpignan, France
2006    South African National Arts Council Grant

**Selected Exhibitions**
2008    *New Photography 2008: Josephine Mecksepe and Mikheal Subotzky,* Museum of Modern Art, New York, NY
2007    *Beaufort West*, Photographic Museum Amsterdam (FOAM), Netherlands
2006    *Snap Judgements: New Positions in Contemporary African Photography* at the International Center for Photography, New York, NY
2006    *Contemporary Art Photography from South Africa: Reality Check* , Neuer Berliner Kunstverein, Berlin
2005    *Die Vier Hoeke* in the Nelson Mandela Cell at Pollsmoor Prison

**Selected Collections**
The Museum of Modern Art, New York
South African National Gallery
Johannesburg Art Gallery

## TOM UTTECH
Born 1942, Merrill, WI
Lives Saukville, WI

**Education**
1967    University of Cincinnati, Cincinnati, OH
1965    Layton School of Art, Milwaukee, WI

**Selected Awards**
1998    National Endowment for the Arts
1995    E.D. Foundation Award, New York, NY
1987    Fifteenth Union League Club Art Competition and Exhibition. Chicago, IL

**Selected Exhibitions**
2004    Images of Time and Place: Contemporary Views of Landscape, Lehman College Art Gallery. Bronx, NY
2004    *Magnetic North: The Landscapes of Tom Uttech*, Milwaukee Art Museum. Milwaukee, WI

2002    *Life: The Other Tradition*, Polk Museum of Art. Lakeland, FL
2001    *Re-Presenting Representation*, Corning Incorporated Galleries. New York, NY
2000    *Of Darkness and Light: Recent American Landscape Painting*, Art Museum of Western Virginia. Roanoke, VA

2000 *Green Woods and Crystal Waters: The American Landscape Tradition Since 1960*, The Philbrook Museum of Art. Tulsa, OK; traveled to: John and Mable Ringling Museum of Art, Sarasota, FL; Davenport Museum of Art, Davenport, IA

1998 *Waking Dream: Psychological Realism in Contemporary Art*, Castle Gallery, College of New Rochelle, New Rochelle, NY

1997 *Animal Tales: Contemporary Bestiary and Animal Painting*, Whitney Museum of American Art at Champion, Stamford, CT

1996 R*ediscovering the Landscapes of the Americas.* Traveling to: Tucson Museum of Art, Tucson, AZ; Art Museum of South Texas, Corpus Christi, TX; Western Gallery, Western Washington University, Bellingham, WA; Memorial Art Galler, University of Rochester, Rochester, NY

1992 *Mind & Beast: Contemporary Artists and the Animal Kingdom*, Leigh Yawkey Woodson Art Museum, Wausau, WI. Traveling to: Art Museum of South Texas, Corpus Christi, TX; Knoxville Museum of Art, Knoxville, TN

1981 Minneapolis Art Institute. Minneapolis, MN

## Selected Collections
The Columbus Museum of Art, Columbus, GA
The Contemporary Museum, Honolulu, HI
Madison Art Center, Madison, Wisconsin
Milwaukee Art Museum, Milwaukee, WI
The New Orleans Museum of Art, New Orleans, LA
The Philbrook Museum of Art, Tulsa, OK

## Selected Publications
Andera, Margaret, *Magnetic North: The Landscapes of Tom Uttech*, Milwaukee: Milwaukee Art Museum, 2004
Arthur, John, Green Woods and Crystal Waters: *The American Landscape Tradition*, Tulsa: The Philbrook Museum of Art, 1999.
Driscoll, John. T*he Artist and the American Landscape.* Northampton: Chameleon Books, 1998.
Berman, Avis, *Contemporary Country Landscapes: New Views of Pastoral American Life*, Architectural Digest, June 1996, pp. 136-141, 205.
Garver, Tom. *Mind and Beast: Contemporary Artists and the Animal Kingdom.* Wausau, WI: Leigh Yawkey Woodson Art Museum Art Museum, 1992.
Garver, Tom. *Spirit of Place: Contemporary Landscape Painting and the American*
*Tradition*. Boston: Bulfinch, 1989.

## ELLEN WAGENER
Born 1964, Maquoketa, IA
Lives Phoenix, AZ

## Education
1989 Corcoran School of Art, Washington, D.C.. B.F.A.
1985 University of Iowa, Iowa City, IA

## Selected Exhibitions
2005 *The Cultivated Desert*, Inaugural Exhibition, Mesa Arts Center, Mesa, AZ
2004 *Selections from the Permanent Collection*, Davenport Museum of Art, Davenport, IA
2003 *Recent Acquisitions*, Cedar Rapids Museum of Art, Cedar Rapids, IA
2002 *Seven Days in Iowa*, Iowa State Capital, Des Moines, IA
2001 *On the Horizon*, Cedar Rapids Museum of Art, Cedar Rapids, IA
2001 Evansville Museum of Art, Evansville, IN
2000 I*nspired by Grant Wood*, Dubuque Museum of Art, Dubuque, IA
2000 *Beautiful Landscape*, Barrington Art Center, Barrington, IL
1999 *The Midwestern Landscape*, Springfield Art Museum, Springfield, IL
1998 *Urban and Rural Landscapes*, Charles H. Mac Nider Museum, Mason City, IA
1997 *Rural Inspirations*, Rockford Museum of Art, Rockford, IL
1996 *Expedition: American Rivers, along the Banks of the Ohio*, Owensboro Museum of Art, Owensboro, KY
1993 *Prairiescapes*, University of Dubuque, Dubuque, IA
1993 *Biennial Invitational*, Muscatine Art Center, Muscatine, IA
1989 *Paperworks*, White Walls Gallery, Corcoran Gallery of Art
1989 *New Artists*, Corcoran Gallery of Art, Washington, D.C.

## Selected Collections
Cedar Rapids Museum of Art, Cedar Rapids, IA
Davenport Museum of Art, Davenport, IA
Dubuque Museum of Art, Dubuque, IA
Grinnell College, Grinnell, IA
Iowa State University, Ames, IA
University of Iowa Museum of Art, Iowa City, IA
University of Iowa Hospitals and Clinics, Iowa City, IA
University of Northern Iowa, Cedar Falls, IA
U.S. State Dept., U.S. Embassy, Caracas, Venezuela

## Selected Publications
Collins, Gina Cavallo. "Pastel Skies." *The New Time*s, April 15, 2004.
Kane, Marie Louise. "Diversity is Key to Iowa Artist Show." Des Moines Register, July 13, 1999.
McIntyre, Ernest. "Artist Doesn't Stray For Subject Matter." *Arizona Republic*, April 9, 2004.
Nilsen, Richard. "Artists Find Power in Landscape." Arizona Republic, September 12, 2004.
Rose, Joshua. "Ellen Wagener." *American Art Collector*, October 2005.

## WILLIAM T. WILEY
Born 1937, Bedford, IN
Lives Marin, CA

### Education
1961 San Francisco Art Institute, San Francisco, CA. B.F.A.
1962 San Francisco Art Institute, San Francisco, CA. M.F.A.

### Selected Awards
2005 Guggenheim Fellowship Award
2005 Lifetime Achievement Award in Printmaking from the Southern Graphics Art Council
2004 Recipient of Honor and Awards, American Academy of Letters and Arts, New York, NY
2004 Life Work Award, Marin Arts Council
1980 Honorary Doctorate at San Francisco Art Institute, San Francisco, CA

### Selected Solo Exhibitions
2003 *Nothing Lost From the Original*, M.H. deYoung Museum, San Francisco, CA
1995 *William T. Wiley*, Walker Hill Museum, Seoul, Korea
1991 *William T. Wiley: Struck! Sure? Sound/Unsound*, The Corcoran Gallery of Art, Washington, D.C., traveling to Contemporary Arts Center, Cincinnati; Southeastern Center for Contemporary Art, Winston-Salem, NC; Laguna Art Museum, Laguna Beach, CA,
Robert Hudson: Sculpture/William T. Wiley: Painting, Rose Art Museum, Brandeis University, Waltham, MA
1986 *Steal Witness for the Time Being*, touring to: Newport Harbor Art Museum, Newport Beach, CA; Palm Springs Desert Museum, Palm Springs, CA; Boise Art Gallery,
Boise, ID; San Francisco Museum of Modern Art, San Francisco, CA; University of Northern Iowa, Cedar Falls, IA; Center on Contemporary Art, Seattle, WA
1981 *Wiley Territory*, Walker Art Center, Minneapolis, MN, touring to: Dallas Museum of Fine Arts, Dallas, TX; The Denver Art Museum, Denver, CO; Des Moines Art Center, Des Moines, IA; San Francisco Museum of Modern Art, San Francisco, CA; Phoenix Art Museum, Phoenix, AZ
1976 Museum of Modern Art, Project Room, New York, NY
1960 San Francisco Museum of Modern Art, San Francisco, CA

### Selected Group Exhibitions
2005 *Print Portfolio: Drawn to Representation*, Corcoran Gallery of Art, Washington, D.C.

2004 *The True Artist Is An Amazing Luminous Fountain*, from The di Rosa Preserve, Kreeger Museum, Washington, D.C.
2000 *Crossroads of American Sculpture, David Smith, George Rickey, John Chamberlain, Robert Indiana, William T. Wiley, Bruce Nauman*, Indianapolis Museum of Art, Indianapolis, IN, New Orleans Museum of Art, New Orleans, LA

1983 Whitney Biennial, Whitney Museum of American Art, New York, NY
*1976* *Painting and Sculpture in California: The Modern Era*, San Francisco Museum of Modern Art, San Francisco, CA and the National Collection of Fine Arts, Washington, D.C.

### Selected Collections
Art Institute of Chicago, Chicago, IL
Corcoran Gallery of Art, Washington, D.C.
Dallas Museum of Art, Dallas, TX
Denver Art Museum, Denver, CO
Fort Worth Art Center, Fort Worth, TX
Hirshhorn Museum and Sculpture Garden, Washington, D.C.
Los Angeles County Museum, Los Angeles, CA
Museum of Fine Art, Boston, MA
The Museum of Modern Art, New York, NY
National Museum of American Art, Washington, D.C.
Nelson Atkins Museum, Kansas City, MO
Philadelphia Museum of Art, Philadelphia, PA
San Francisco Museum of Modern Art, San Francisco, CA
Seattle Art Museum, Seattle, WA
University Art Museum, University of California, Berkeley, CA
Walker Art Center, Minneapolis, MN
Whitney Museum of American Art, New York, NY

## A. T. WILLETT
Born 1963, Bloomington, IN
Lives Tucson, AZ

### Education
1981-83 Pima Community College, Tucson, AZ; University of Arizona, Tucson, AZ
1990 New York University, Intensive Film Program, New York, NY

### Selected Exhibitions
2008 *Severe Weather*, Canyon Ranch, Tucson Arizona
2007 *SPACE-AEGG* and *Interactive Water Tank Project*, Glow, Oracle, AZ
2007 *Out of a Clear Blue Sky*, Etherton Gallery, Tucson, AZ
2006 *Tower of Light*, Glow, Oracle, AZ
2005 *Stargate*, Glow, Oracle, AZ
2005 *Hot Shoe Salon Group Show*, Studio 455, Tucson, AZ
2002 *Louis Carlos Bernal Fundraiser Exhibition,* Drawing Studio, Tucson, AZ
2000 *Pima College Dedication Show*, Louis Carlos Bernal Gallery, Pima Community College, Tucson, AZ
2000 *Annual Group Show*, Studio 455, Tucson, AZ
1992-93 *Nikon Contest International*, Tokyo, Japan

### Selected Collections
University of Arizona Special Collections
City of Tucson Public Art Collection
Tucson Police Department West Side Police Station
Alliance Bank Archive, Tucson, AZ

**Selected Publications/Photographs Featured**

*"Weather: The Ultimate Book of Meteorological Events."* Cover Andrews McMeel 2008.

*Tucson Guide.*, The Arizona Trail, KXCI Personality Petey Mesquity, Artist Royce Davenport. Fall 2007.

*English Journal.* Cover. Lightning over Tucson. November, 2006.

*Mind over Body.* Book cover shot at Miraval Spa. August 2006.

*University Medical Center.* Photographed CFO Kevin Burns (heart surgery live). February 2006. *IBM.com.* Front page. Ultrium Tape Drive. September, 2003.

*Royal Mail Society.* London, England. Stamp Lightning. February, 2000.

Other Publications: Full page Omega Watch Advertisement; Saturn Car Billboard, West Coast region; Renault Car Advertisement, France; Swiss-post Lightning Poster, Switzerland; Visual Communications Cover "VISCOM," New York City; Book Cover "All the Money in the World," Book Cover, France "Pouvoir Créateur de la Colère."

**Selected Professional Experience**

1983-85  Tucson Citizen Newspaper Photojournalist
1986-08  Imagebank / Getty Images contract photographer
2000-08  Alamy.com contract photographer
1985-08  Freelance Assignment Photographer

## JOEL-PETER WITKIN

Born 1939, Brooklyn, NY
Lives Albuquerque, NM

### Education
1986  Photography, University of New Mexico, M.F.A.
1974  Cooper Union School of Art, New York, NY. B.F.A.

### Selected Awards
1992, 86,
1984, 82  National Endowment for the Arts, Photography Fellowship
1977-78  Ford Foundation Grant

### Selected Solo Exhibitions
2002  Stadtische Museen, Jena, Germany
2001  *Joel Peter Witkin: Unpublished and Unseen*, Athens School of Fine Art, Athens, Greece
1998  *Unpublished and Unseen*, The Museum of Fine Arts, Santa Fe, New Mexico
1998  The Cultural Center of Bruges- Bruges, Belgium
1998  Solomon R. Guggenheim Museum, New York, NY
1989  Museum fur Fotographie und Zeitkunst, Breman, Germany
1985  *Forty Photographs*, San Francisco Museum of Modern Art, San Francisco, CA
1983  Museum voor Acutele Kunste, Hasselt, Belgium

### Selected Group Exhibitions
2002  *The Nature of Still Life: From Fox Talbot to the Present Day*, Galleria d'Arte Moderna, Bologna, Italy
2000  *Chorus of Light: Photographs from the Elton John Collection*, The High Museum of Art, Atlanta, GA
1998  *Photography's Multiple Roles*, Museum of Contemporary Photography, Chicago, IL

1993  *Mexico Through Foreign Eyes*, Museo de Art Contemporanea, Rufino Tamayo Mexico City
1989  *On the Art of Fixing a Shadow, One Hundred and Fifty Years of Photography*, National Gallery of Art, Washington, D.C.
1989  *The Photography of Invention*, National Museum of American Art, Washington, D.C.
1987  *Crosscurrents, Forty Years of Photographic Art*, Los Angeles County Museum of Art, Los Angeles, CA
1986  *Sacred Images in Secular Art*, Whitney Museum of American Art, New York, NY
1986  *Signs of the Times: Some Recurring Motifs in Twentieth Century Photography*, San Francisco Museum of Modern Art, San Francisco, CA
1985  *Whitney Biennial*, Whitney Museum of American Art, New York, NY
1982  *Form, Freud and Feeling*, San Francisco Museum of Modern Art, San Francisco, CA
1980  *Contemporary Photographers of New Mexico*, Art Institute of Chicago, Chicago, IL

### Selected Collections
Centre Georges Pompidou, Paris, France
High Museum of Art, Atlanta, GA
The J. Paul Getty Museum, Malibu, CA
The Metropolitan Museum of Art, New York, NY
Museum of Fine Arts, Boston, MA
The Museum of Modern Art, New York, NY
The National Gallery of Art, Washington, D.C.
National Museum of American Art, Smithsonian Institute, Washington, D.C.
San Francisco Museum of Modern Art, San Francisco, CA
Tokyo Metropolitan Museum of Photography
Victoria and Albert Museum, London, England
Walker Art Center, Minneapolis, MN

### Selected Publications
1999  *The Bone House*, Twin Palms Publishers, Santa Fe, NM.
1995  *Joel-Peter Witkin: A Retrospective*, (Monograph), Scalo/DAP, New York, NY.
1994  *Harms Way*, Twelve Trees Press, Santa Fe, NM.
1991  *Gods of Earth and Heaven*, Twelvetrees Press, Pasadena, CA.
1988  *Joel-Peter Witkin*, Centro de Arte Reina Sofia Museum, Madrid, Spain.
1985  *Joel-Peter Witkin: Forty Photographs*, San Francisco Museum of Modern Art, San Francisco, CA.

## FUNDING FOR THIS EXHIBITION AND CATALOGUE IS MADE POSSIBLE BY:

Stonewall Foundation
University of Phoenix Foundation
The Kautz Family Foundation
The Annenberg Foundation
JP Morgan Chase Foundation
Contemporary Art Society of the Tucson Museum of Art
Frank and Betsy Babb
Cox Communications
Arizona Commission on the Arts
Drs. Lisa Fogle and Ray Novak
Tucson Pima Arts Council
Anne and Edward Lyman
The Art Institute of Tucson
Loews Ventana Canyon Resort
Jean Braucher and David Wohl
Joyce Broan
Gebert Contemporary, Santa Fe and Scottsdale
Jane Hallett
Marilyn and Bob Joyce
Jane Kirkeby
Burt Lazar
Ellen Lewis
Pamela J. Parry
Suzanne Saxman and Peter Labadie
William and Margarita Joffroy
Tucson Electric Power

Paul Winick and Ronda Lustman Family Fund
The Oakland Museum of California Art Guild
Etherton Gallery, Tucson
Sara Dobbis
Robert D. Cocke
Mayme Kratz
Etherton Gallery
Paperworks
Anonymous
Albert Kogel

**Additional support provided by:**
The Sterling and Francine Clark Art Institute
*Tucson Lifestyle Magazine*
American Association of Museum Curators
F.A.R. (Future Art Research) @ ASU
Lewis Framing
The Medici Scholars Program, School of Art,
    The University of Arizona
University of Arizona Art History Travel Grant
The University of Arizona School of Art,
    Department of Theory and History of Art
College of Fine Arts Dean's Fund for Excellence,
    University of Arizona
Mayfield Florists

## LENDERS TO THE EXHIBITION

Adam Weinstein and Kira Dixon-Weinstein
Alexandre Gallery, New York, New York
Arizona State University Art Museum, Tempe, Arizona
Arthur Roger Gallery, New Orleans, Louisiana
bitforms gallery, New York, New York
David Burtka
Charles Cowles Gallery, New York, New York
Davis Dominguez Gallery, Tucson, Arizona
Diane and Sandy Besser Collection
Etherton Gallery, Tucson, Arizona
Feature Inc., New York, New York
Galerie Lelong, New York, New York
Galerie Poller, New York, New York, New York
Jack Shainman Gallery, New York, New York
Kevin Kavanagh Gallery, Dublin, Ireland
Kinz + Tillou Fine Art, New York, New York
Laurence Miller Gallery, New York, New York
Lisa Sette Gallery, Scottsdale, Arizona

Littlejohn Contemporary, New York, New York
Locks Gallery, Philadelphia, Pennsylvania
Magnum Photos
Private Collection
Private Collection
Private Collection, Pennsylvahia
Private Collection, New Jersey
Richard Levy Gallery, Albuquerque, New Mexico
Robert Mann Gallery, New York, New York
Schroder Romero Gallery, New York, New York
Sikkema Jenkins & Co., New York, New York
Tanya Bonakdar Gallery, New York, New York
Jason and Leigh Taylor

*All other art works are from the permanent collection of the Tucson Museum of Art or lent by the artists*

# ACKNOWLEDGMENTS

Many thanks to all the artists included in this exhibition and special thanks to the following individuals

Ulrike Adler
Matthew Affron
Sky Asay
Anne Asu
Daniel Aycock
Beth Azaroff
Brent Beamon
Natasha Becker
Elisa Benavidez
Laura Blereau
Michael Briggs
Peter Briggs
Ellie Bronson
Elizabeth Burden
Michael Conforty
Anne Doran
Brenna C. Drury
Meta Duevelle
Terry Etherton
Marie Evans
Hudson Feature
Rachel Flax

Hannah Glasston
Frank Goldman
Robert Greenberg
Peter Haffner
Emily Handlin
Heather Harmon
Vicki Harris
Linda Roscoe Hartigan
Mark Hughes
Viviette Hunt
Dr. Paul Ivey
Danielle Jackson
Therese James
Brandon Johnson
Dennis Jones
Michael Kelly
Lance Kinz
Marilu Knode
Isabel Kunigk
James Lavender
Heather Lineberry
Jacquie Littlejohn

Elaine Litvack
Julie Lohnes
Annabel Manning
Bea Mason
Michael Mazzeo
Jacqui McIntosh
Brooke Mellen
Abby Messitte
Sumner Milender
Caroline Miller
Dr. Sarah Moore
Mr. and Mrs. Irving Olson
Erin O'Rourke
Dawne Osborne
Gail Parker
Sylvie Patry
Thomas Poller
Katie Rashid
Amy Regalia
Ashley Rice
Nathaniel Robinson
Arthur Roger

Lindsay Russell
Steve Sacks
Dr. Mary Sasse
Doug Schaller
Lisa Schroeder
Dana Sherwood
Marcus Schubert
Martina Shenal
Marcus Shubert
Michael Shulman
Daphne Srinivasan
Adrienne Starr
Michael Steinberg
Sarah Stork
Joanne Stuhr
Phil Taylor
Michelle Tillou
Rebecca Underwood
Caroline Wall
Emily Wiggins
Matthew Witkovsky
Joseph Wohlin

## TUCSON MUSEUM OF ART STAFF

**Office of the Museum Director**

Robert E. Knight
*Executive Director*

Carol Bleck
*CFO and Deputy Director*

**Administration**

Katie Hiedeman
*Chief Accountant*

Gaye Lynn Kreider
*Administrative Assistant*

**Curatorial and Exhibitions**

Julie Sasse
*Chief Curator and Curator of
Modern and Contemporary Art*

Fatima M. Bercht
*Curator of Latin American Art*

Susan Dolan
*Collections Manager/ Registrar*

Rachel Shand
*Assistant Registrar*

David Longwell
*Preparator*

**Education**

Stephanie J. Coakley
*Director of Education*

Katie Samson
*Manager of Youth and Family Programs*

**Public Relations**

Meredith Hayes
*Director of Public Relations and Marketing*

Serena Tang
*Graphic Designer*

**Development**

Leslie A. Schellie
*Director of Development*

Alison Sylvester
*Grants Manager*

**Museum Shop**

John McNulty
*Retail Manager*

Anne Reider
*Museum Store Volunteer*

Diane Lauffer
*Museum Store Clerk*

Sherri Green
*Museum Store Clerk*

**Maintenance**

Allan Uno
*Buildings and Grounds Supervisor*

Ernie Olivas
*Interior Maintenance*

**Security**

Delmar Bambrough
*Head of Security*

*Guards:*
Wanda Blair
Carl Hanson
Risa Hanson
David Hopkins
Nanette Jepson
Ed Jones
Daniel Lenihan
Mike Montano
Bill Newbold
Judy Newbold
Angela North
Sandy O'Neil
Sean O'Neil
Teresa Patterson
Stephanie Salazar
Dan Walters
Al Weiler
Virginia Whitten

**Curatorial Assistants**

Sean Cannon
Brittany Corrales
Emily Handlin
Caroline Miller
Lindsay Russell
Sealia Thevenau

Right: Leah Oates, **Transitory Space, Chicago (double electric 3)**, 2007, *detail*
Page 208: Dan Collins, **Flood**, 2008-2009, *detail*